the basics of filmmaking

screenwriting, producing, directing, cinematography, audio & editing

blain brown

the basics of filmmaking

screenwriting, producing, directing, cinematography, audio & editing

blain brown

First published 2020
by Routledge
2 Park Square, Milton Park, Abingdon, Oxon OX14 4RN

and by Routledge
52 Vanderbilt Avenue, New York, NY 10017

Routledge is an imprint of the Taylor & Francis Group, an informa business

British Library Cataloguing-in-Publication Data
A catalogue record for this book is available from the British Library

Library of Congress Cataloging-in-Publication Data
A catalog record has been requested for this book

ISBN: 978-0-367-02605-9 (hbk)
ISBN: 978-0-367-02606-6 (pbk)
ISBN: 978-0-429-39876-6 (ebk)

Publisher's Note
This book has been prepared from camera-ready copy provided by the author.

Visit the companion website: www.routledge.com/cw/brown

TABLE OF CONTENTS

THE BASICS OF FILMMAKING .. III
 There are no rules in filmmaking, right? xi
 Telling Stories Visually .. xi
 Top Ten Ways to Screw Up Your Movie xii
 Production Mistakes .. xii

WRITING YOUR STORY ... 1
 Telling Stories With Pictures ... 2
 Is It Plot Or Story? ... 2
 How Short Films Are Different ... 2
 It All Starts With Conflict ... 3
 External Conflict .. 3
 Internal Conflict ... 3
 Protagonist v Antagonist .. 4
 The Need .. 4
 Changing Direction .. 5
 Obstacles ... 5
 Roadblocks .. 5
 Premise ... 6
 The Theme: What Is Your Story Really About? 6
 Aristotle ... 6
 Creating Characters .. 7
 Write Their Backstory ... 7
 Point-of-View .. 7
 What is their Dramatic Need? Their Goal? 7
 25 Words Or Less .. 7
 The Cards and the Outline ... 8
 The Step Outline .. 8
 The Cards .. 8
 Synopsis .. 8
 Three Act Structure ... 10
 Beginning, Middle and End ... 10
 Story Points .. 11
 Getting The Story Started ... 11
 Plot Point One .. 11
 Act Two .. 12
 Midpoint ... 12
 Plot Point Two ... 13
 Wrapping It Up ... 13
 Don't Jump The Shark! ... 14
 We're Gonna' Need A Bigger Boat! 14
 Emotionally Satisfying Ending ... 14
 Let's Review ... 14
 Dialog That Is Not On the Nose .. 16
 Subtext ... 16
 Fully Cooked .. 16
 Not Exposing Your Exposition .. 17
 Why is it a necessary evil? .. 17
 Show, Don't Tell .. 17
 Formatting A Script ... 17
 A Sample Script Page ... 18
 Loglines, Treatment and Synopsis 19
 Synopsis .. 19
 Logline ... 19
 Presentation ... 20
 Binding .. 20
 Pitching .. 20
 The Elevator Pitch ... 20

PRODUCTION .. 21
 What Is a Producer? .. 22
 Executive Producer ... 22
 Producer ... 22
 Associate Producer ... 22
 Line Producer ... 22
 Unit Production Manager ... 22
 The Production Team ... 23
 The Production Office .. 23
 On The Set .. 23

Pre-production ... 23
 Other Departments ... 23
 Location Scouting ... 23
Making a Budget ... 24
 The Budget Form ... 24
The Top Sheet ... 25
Budget Details ... 26
Script Marking .. 27
 Eighths of a Page .. 27
Breakdown Pages ... 28
Tech Scout ... 29
 The Walk Through .. 29
Script Pages and Scene Numbers .. 30
 Locked Script .. 30
 Script Page Color Code ... 30
Putting a Crew Together .. 31
Permits .. 32
 Stealing Scenes ... 32
 Pickup Day ... 32
 Reshoots ... 32
Location Scouting .. 33
 Location Checklist ... 33
 Tech Scouts .. 33
Location Checklist ... 34
Contact Lists ... 35
 Day Out of Days .. 35
Transpo .. 36
 Transpo Coordinator .. 36
Production Report .. 37
Releases and Deal Memos .. 38
 Contracts .. 38
 Deal Memos .. 38
 Crew Deal Memo .. 38
Talent Releases .. 39
 Why Releases Are Important ... 39
 Talent Release Form ... 39
Location Release .. 40
Sides .. 41
Catering/Craft Services .. 42
Walkie-Talkies ... 43
Setiquette .. 43
What Production Assistants Do ... 44
 Receipts .. 44

THE AD TEAM .. **45**
Running the Show .. 46
 First Assistant Director .. 46
 Second AD .. 46
 Second Second AD .. 46
 Production Assistants .. 46
The Jobs of the First Assistant Director ... 47
 First AD — Pre-production ... 47
 Things you should do: .. 47
 Things not to do: ... 47
Creating the Schedule .. 48
 Strip Boards .. 48
 Cover Sets ... 48
Strip Boards on Computer ... 50
 Other Schedule Considerations ... 50
How the First AD Runs the Set ... 51
 Rough In .. 51
 Blocking Rehearsal .. 51
 Lighting .. 51
 Final Rehearsal ... 51
 Last Looks .. 51
Second AD ... 54
Second Second AD .. 54
Production Assistants ... 55
 What a PA doesn't do ... 55
Ways for a PA (or anybody) to Get Fired .. 56
 How to Survive As An Extra: .. 56

CONTINUITY AND COVERAGE .. **57**

Continuity: Making Sure It Works ... 58
 Continuity .. 58
 Cutability ... 58
 Screen Direction ... 58
 The Line ... 58
 The 20% Rule ... 60
 The 30 Degree Rule .. 60
 Two Lens Sizes .. 60
Point-of-View .. 60
 True Subjective POV ... 60
Screen Direction In Dialog Scenes ... 61
 Jump Cuts .. 62
 Ellipsis ... 62
 Door and Window Match .. 62
 Location Stitching ... 63
 Faking it with Redressing .. 63
Types of Continuity ... 64
 Wardrobe ... 64
 Screen direction .. 64
 Props .. 64
 Time ... 64

THE WORK OF THE DIRECTOR ... **65**

Director and Producer ... 66
 The Director's Jobs ... 66
 The Stages of Filmmaking ... 66
Getting Started .. 67
 Understanding The Script ... 67
 Table Read ... 67
 Rehearsal ... 67
 Page Turn .. 67
Director's Pre-Production .. 68
 Casting ... 68
 Location scout ... 68
 Collaborations ... 68
A Director Prepares ... 69
 The shot list .. 69
 Setups .. 69
 Sketches ... 69
 Overheads .. 70
 Storyboards .. 70
Working With Actors .. 71
 Action, Attitude, Activity .. 71
Blocking the Actors .. 72
 Blocking For The Camera .. 72
Block, Light, Rehearse, Shoot .. 73
Action, Cut, Circle That .. 74
The Shooting Methods ... 74
 The Master Scene Method ... 74
 Overlapping or Triple-Take Method 75
 In-One ... 76
 The Developing Master .. 76
 Walk and Talk ... 76
 Freeform Method .. 76
 Montage ... 78
 Invisible Technique ... 78

CINEMATOGRAPHY .. **79**

The Camera Department .. 80
 Director of Photography .. 80
 First AC ... 80
 Second AC ... 80
 Clapper-Loader ... 80
 DMT .. 80
 DIT .. 80
 Operator .. 80
 Second Unit .. 80
Shooting Digital .. 81
 Aspect Ratio .. 81
 Frame Rate .. 81

Camera Terms .. 81
Focal Length ... 82
 The personality of a lens ... 82
Iris/Aperture .. 82
 Rack Focus / Focus Pull ... 83
 Shallow Focus .. 83
Exposure .. 84
 Don't Blow Out the Highlights, Don't Get Into Noise 84
 Histogram .. 84
 Zebras .. 84
Color Balance ... 85
Composition ... 86
Point-of-View ... 87
The Shots: Building Blocks of a Scene ... 88
 Character Shots .. 89
Typical Character Shots .. 91
Inserts .. 92
Framing People .. 93
Camera Support .. 94
Camera Angles .. 95
Camera Movements .. 96
The Prime Directive ... 97
Managing Your Media .. 97
Marking .. 98
 Marking During Blocking Rehearsal .. 98
Pulling Focus .. 99
 Some focus practices: ... 99
Shooting Greenscreen ... 100
 Background Plates .. 100
 The Foreground Plate ... 100
 Tracking Marks Are Important .. 100

LIGHTING AND GRIP .. **101**
Why Lighting Matters .. 102
 The Most Important Thing About Lighting .. 102
 The Lighting Process .. 102
Types of Lights .. 103
 Fresnels .. 103
 Open face .. 103
 LEDs .. 103
 Fluorescent ... 103
 Practicals .. 103
Hard vs. Soft .. 104
 Hard Light ... 104
 Soft Light ... 104
Lighting Terms and Concepts ... 105
Basic Principles .. 106
 Let The Set and the Scene Motivate Your Lighting 106
 Back Cross Keys ... 106
 Less Is More ... 106
Lighting Methods ... 106
Controlling Light ... 108
 The Amazing C-Stand ... 109
How To Set a Light .. 109
Getting Power .. 109
Expendables ... 110
Lighting Order ... 110
Lighting Definitions ... 112

THE ART DEPARTMENT .. **113**
The Art Department ... 114
 Production Designer ... 114
 Art Director .. 114
 Set Construction, Scenic Artists .. 114
 Set Decorator ... 115
 Set Dresser ... 115
 Props .. 116
Finding the Look of a Film ... 116
 The Right Details ... 117
 Wardrobe ... 117

Continuity ... 118
Makeup and Hair .. 119
Building Sets ... 120

SLATING AND SCRIPTY ... **121**
Scripty .. 122
Lining A Script .. 122
A Sample Lined Script .. 123
Sample Script Notes .. 124
Script Notes Key .. 125
End of Day Report ... 126
Anatomy of a Slate .. 127
Slate Numbers For Coverage .. 127
Clapboards .. 128
Scene Numbers .. 128
Slate Like A Pro .. 129
Tail Slates .. 130
Reshoots .. 130
VFX Plates and Room Tone .. 130

AUDIO BASICS .. **131**
Double System vs. Single System Sound 132
Sound Recordist Team .. 132
Microphones ... 133
Phantom Power ... 134
Audio Basics .. 134
Rule #1 .. 134
Rule #2 .. 134
Scratch Track ... 134
Room Tone .. 135
ADR Is Expensive .. 135
Headphones ... 135
Boom Operating .. 135
Mixing Audio .. 136
Shooting To Playback .. 137
Sound reports .. 137
Syncing .. 138
Timecode Slate .. 138

THE WORK OF THE EDITOR .. **141**
Why Do We Edit? ... 142
What the Editor Does .. 142
The Director/Editor Collaboration .. 142
The Six Steps of Editing .. 142
Logging .. 142
First Assembly ... 142
Rough Cut ... 142
First Cut .. 143
Fine Cut .. 143
Final Cut ... 143
What Is an Edit? ... 143
Post-Production ... 143
Continuity Cutting .. 143
Seven Elements of Editing ... 144
Types of Edits .. 145
Establishing The Geography ... 146
Invisible Technique .. 146
J and L Cuts .. 146
Jump Cuts ... 146
Hidden Cuts .. 146
Walter Murch's Rule of Six .. 147
Emotion .. 147
Story .. 147
Rhythm ... 147
Eye-Trace ... 147
Two-Dimensional Place On Screen ... 147
Three-Dimensional Space ... 147
Ellipsis and Cross-Cutting .. 148

SAFETY ON THE SET .. **149**
Get Out Alive! .. 150

GETTING STARTED IN THE BUSINESS .. 151

Film School? ... 152

 Working as a PA ... 152

 Shoot a Trailer .. 152

 Make a Short Film, or Even A Whole Movie 152

 Work as Background/Extra .. 152

TERMINOLOGY ... 153

RESOURCES ... 161

How To Read a Movie .. 162

 The Story .. 162

 The Frame ... 162

 Movement ... 162

 Lighting .. 162

 Editing .. 163

 Time .. 163

 Audio .. 163

Resources ... 164

 Books .. 164

 Movies About Movie Making ... 164

 Great Movies Made on Absurdly Small Budgets 164

 Short Films Worth Seeing .. 164

Movies To Watch To Learn About Filmmaking 165

Websites for Filmmakers ... 166

 Job Search .. 167

 Online Classes in Filmmaking ... 167

 Dedication .. 168

About The Author ... 168

 The Website .. 168

INDEX ... **169**

WHAT'S ON THE WEBSITE

The website that accompanies this book is at: www.routledge.com/cw/brown

VIDEOS

- Lighting basics
- Seven ways of lighting a scene
- Types of lights and controlling light
- Exposure and color balance
- Microphones, audio recording, and timecode
- Boom operating technique and how to use lavaliers
- Methods of shooting a scene
- Proper slating techniques

DOWNLOADABLE PRODUCTION FORMS

- Budget Form
- Budget Top Sheet
- Breakdown Sheet
- Call Sheet
- Lighting and Grip Order
- Expendables Order
- Actor Release
- Location Release
- Crew Deal Memo
- Location Scout Form
- Wardrobe Continuity Sheet
- Camera Report
- Sound Report
- End of Day Report

There are no rules in filmmaking, right?

People often say "there are no rules in filmmaking." I've probably even said it myself. Well, as it turns out, there are dozens of rules in filmmaking. Not creatively, not artistically, not in what you want to say in a film — for those, the sky's the limit! But for the fundamental mechanics of getting a film made, there are rules that if you break them, your movie might be uneditable, unwatchable, or unreleasable, and possibly all three. While it is not at all easy to get your first movie made, a lot of people manage to do it. The real barrier comes when you try to make your second movie. Many people never get a chance to make a second movie because their first film demonstrates that they lack knowledge of these basic principles of filmmaking — and it's there for everybody to see. Don't be one of those people!

Much of what we are going to explore here are not so much rules as SOP — Standard Operating Procedures. These are important for a lot of reasons. If you get a chance to observe the first day of a project being produced professionally, you will see that sometimes, few of the people actually know each other, and yet everybody knows what to do, what others are doing, and what is expected. They can all work together for one simple reason — professional film crews know "how things are done." They have learned the techniques and procedures of how a movie gets made. Sure, there are small variations in how people do things, but overall, they all share the same knowledge of techniques.

Over 30 years in the film business and ten years teaching in film schools I learned "the hard way" what works and doesn't work in film production. Fortunately, you learn from your mistakes, and I made plenty of them, especially as I was new to the business working as a gaffer, then a DP and then a screenwriter, director and producer. Before that, as a PA and then electrician (lighting technician), I was able to observe the people in charge doing it the right way, the wrong way, and the very, very wrong way. Small mistakes that make editing a project difficult (and expensive reshoots necessary), up to big mistakes that mean disaster — to the point of a film being unreleasable, or even not getting finished.

TELLING STORIES VISUALLY

As a teacher I assigned, helped with, or screened hundreds of student projects, so I was able to see the kinds of mistakes that were made over and over again. I'm hoping this book will help you avoid those kinds of mistakes, and even more, that the advice here will make you a better filmmaker. I've seen that if you're really solid on the basics of how to get a film project made, you have much more time and attention to devote to the creative side of things; more time to do what is the heart of filmmaking — telling stories visually.

We're not going to get "inspirational" in this book — you know, "just do it!" "follow your heart!" "write what you know!" that sort of thing. Nothing wrong with that, it's all (or pretty much all) true but that is not our purpose here. What I hope you get from this book is the real fundamentals, the basic concepts of how to write, produce, direct, shoot, record, and edit your movie — the things that every filmmaker should know.

I've had the good fortune to work on feature films, commercials, documentaries, music videos, and corporate films in the US and many other countries, and also to observe local film crews at work in places like India, Mexico, Singapore, Canada, Japan, and China; they all follow the same basic practices. Why? Because there are ways that work and are efficient and there are ways that don't work, waste time and money, and don't tell the story effectively. Interestingly, it's not really a matter of "they learned from how Hollywood did it." For the most part, film industries all over the world developed the basic methods of how to make a movie the same way Hollywood did — by trial and error.

It's in the editing room that most of these fundamentals were revealed; only because it is there that you really see what works, and what doesn't work. For example, if you don't observe proper screen direction in a dialog scene, you simply can't edit it together, not at all. At least not in a way that isn't going to confuse and irritate the audience and make them laugh at your incompetence. Same thing applies to lighting, use of lenses, continuity, dialog, framing and all the rest.

It is heartbreaking to see student filmmakers put so much work, so much time, effort and commitment into a film only to see them produce something that "might have been great" if only.... Don't let this happen to you!

If you plan to show your film in order to get a job in the industry, be recognized as a filmmaker, or to try to get investors interested in your next script, then showing that you actually know the mechanics of how a film gets made is just as important as showing your creative inspiration and artistic drive. Think about it, what investor is going to give money to someone who might make a film that is uneditable and unreleasable — that would be throwing money down the drain. I really hope this book helps you avoid these pitfalls and makes you a better filmmaker!

Top Ten Ways to Screw Up Your Movie

There are some mistakes that beginning filmmakers make over and over again and then deeply regret when they are in the editing room or, worse, at the first screening in front of an audience. The key thing to remember about filmmaking is that *reshoots* (shooting a scene over again to correct mistakes) are always very expensive, and may often be impossible — the location is no longer available, the actors are engaged elsewhere, you can't afford to rent the equipment again, and so on.

Many of these mistakes are things that "seemed like a good idea at the time," and most fatally, are made by filmmakers who fool themselves into thinking "I know all the ways that filmmakers are supposed to do this, but I'm smarter than all of them." We will discuss what these mean and why they are important in later chapters. In order of occurrence and severity they are:

- Not shooting enough *coverage*.
- Not shooting *cutaways* for every scene.
- Not getting good, *clean audio* of the dialog.
- Bad *exposure*.
- Bad *focus*.
- Not recording *room tone at* every location.
- Shaky camera movement when you don't intend it.
- Camera off level.
- No *establishing* shots.
- Fooling yourself into thinking "we'll fix it in post."
- Undercooked script. "But I see it in my head." "Yeah, but we don't."

PRODUCTION MISTAKES

On the production side, the most common mistakes include:

- Insufficient planning and pre-production.
- Director not prepared with a shot list for every shoot day.
- Thinking it will cost less, and take less time than it really will. Wishful thinking.
- The director and the DP not informing the crew of what their plans are.
- Schedule not well worked out.
- Not scheduling enough time to shoot scenes properly.
- Director saying "I'll be my own AD" (assistant director).
- Not putting out *call sheets* so actors and crew know when and where to show up.
- Call sheet not including contact numbers for AD, UPM, Production Office, etc.
- Director trying to micromanage everything going on.
- AD not keeping control of the set and crew.

And finally: failing to properly feed the cast and crew — this one really invites disaster. Doesn't matter if they are being paid or working free, a crew that doesn't get coffee and breakfast snacks in the morning, craft service snacks all day, and a decent lunch *no later than 6 hours* after start time is not going to perform at their best and may very likely develop resentment and anger. Provide plenty of water and soft drinks as well. The craft services table should be well-stocked all day with a variety of snacks and drinks.

Writing Your Story

Telling Stories With Pictures

All films are about storytelling. Even films that are purely visual have some kind of story to tell. It is a basic human instinct to respond to a narrative story. "Narrative" refers to a sequence of events in verbal, written or picture form that are put together in a way that tells a story. Features and short films are narrative fiction. A documentary is narrative non-fiction. Reality shows are narrative fiction constructed from bits of non-fiction.

In filmmaking we are in the business of telling stories with pictures. Now of course this is a simplification: most films use dialog, music, titles, subtitles and other media to tell the story, but the visual images are fundamental to filmmaking: without them we're really just making radio. It's an old saying that a film is well made if you can turn off the sound and still have a pretty good idea of what is going on. In the end, it really doesn't matter if the visuals or the dialog are the stronger element — what really matters is that you are telling a good story.

So what makes a good story? Many very wise people have analyzed and thought about what makes good film stories and they have almost all come to agree on certain basic elements that are essential to film narrative. We'll talk about those basic elements in this chapter.

IS IT PLOT OR STORY?

There is a good deal of confusion about the difference between *plot* and *story*. Many people think they are the same thing, but they aren't at all. Plot is the *sequence of events* that occur in the narrative. "This happened, and then that happened." It is possible to have a plot with tons of action and it turns out to be a boring screenplay — most often this is because the *story* isn't engaging and interesting. What is story as opposed to plot? The most famous example is this: "The Queen died, then the King died." That is *plot*. One thing occurs and then something else occurs. Two events, one after the other — nothing more.

THE QUEEN DIED, THEN THE KING DIED

Here is a *story*: "The Queen died and then the King died... of grief." What is the difference? Very simple: *causation*. We see how they are connected; how one thing *caused* the other. It's heart wrenching; not only do we see how the two events are connected, we also experience the sadness of a King so heartbroken by the death of his Queen that he simply can't go on living without her.

You need both: you really can't tell a story without plot — it is the sequence of events that tells the story, but don't get so caught up in the details of the plot that you forget to tell your basic story. Think of it this way: a story can be summed up in a few sentences, whereas to tell a plot you have to start at the beginning and recite every major event that takes place, beginning to end.

HOW SHORT FILMS ARE DIFFERENT

As a student or a beginning filmmaker, you are most likely going to start by making short films. The concepts we are presenting here apply to all types of narrative filmmaking, but there are some differences in a short film. The obvious one is that you have much less time to establish characters, set up the situation, introduce the conflict, and then resolve it.

You have to be efficient in laying these building blocks, getting right to the point, and making sure each and every scene is necessary and does its job of introducing the character, showing the action, and moving the story along. This is why making short films is important to learning filmmaking — it gets down to the basics, the key elements of storytelling and forces you to carefully consider the need for each scene, each character, each location. These skills will serve you well when you move up to longer form filmmaking.

There are a million ideas in a world of stories. Humans are storytelling animals. Everything's a story, everyone's got stories, we're perceiving stories, we're interested in stories. So to me, the big nut to crack is how to tell a story, what's the right way to tell a particular story.

Richard Linklater
(*Dazed and Confused, Before Sunrise*)

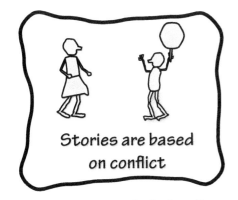

Stories are based on conflict

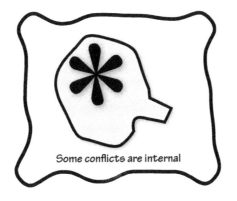

Some conflicts are internal

Figure 1.1. (left) *Conflict* is fundamental to stories. There are many types of conflict that propel a story forward.

Figure 1.2. (right) Really interesting characters often have an *internal conflict*: some mental turmoil that they have to deal with in addition to the external conflicts of the story.

It All Starts With Conflict

There is one thing that is absolutely fundamental to storytelling: *conflict*. If there is no conflict, there is no story, it's really as simple as that. Conflict in the story is sometimes referred to as trials and tribulations, or the "ring of fire." No good story can exist without some conflict the hero or heroine has to face and overcome. These troubles are part of the rite of being the main character. This character should undergo some kind of change or transformation, and the conflicts he or she faces is what causes this change. Conflict is the obstacle or obstacles that stand in our hero's way, and essential to any great film, drama or comedy. These conflicts or obstacles can be external, internal, or both. No matter what the kind of conflict the character faces, it is essential that they eventually confront them. If the character spends the whole movie just avoiding conflict, how boring is that?

EXTERNAL CONFLICT

Some conflicts are big and obvious: Neo fights the Agents inside *The Matrix*. Austin Powers battles Dr. Evil, Batman battles the Joker. These are large *external* conflicts: the main character has someone or something that they have to fight against.

External conflicts might be person vs. person, person vs. society (*Scarface*), person vs. machines (*Terminator*) or people vs. zombies (lots of movies). It might even be person vs. supernatural (*The Lost Boys*) or person vs. monster (*Alien*).

Some external conflicts are small and confined: Vinny in *My Cousin Vinny* has to win the case by fighting the local district attorney in court while *also* overcoming the objections of the stern judge and also trying to maintain his relationship with his girlfriend — multiple conflicts; one of the things that makes it such a good story.

When our main character is faced with conflict and opposition, either from the antagonist or elsewhere, they have to confront this opposition. Without confrontation, our protagonist would be just a victim who surrenders — not a very interesting type.

Usually, we combine internal and external conflicts for a richer story. That means we have to understand how our characters approach and resolve conflict.

Jami Gold
(*Using Conflict to Understand Our Characters*)

INTERNAL CONFLICT

Sometimes, the basic conflict of the story is *internal* — it is something *inside the main character* that he or she has to overcome by themselves or with help. Think of the Bill Murray character in *Groundhog Day*. In the beginning, he is totally selfish and self-centered, he doesn't care about anybody but himself. These are *internal conflicts* within his own personality. It is only when he overcomes these internal problems and discovers the joy of being nice to other people that he is able to stop living the same day over and over again. You might think of the fact that he can't escape from living the same day over and over again as his conflict but it's really just a *plot device* that forces him to deal with his internal conflicts.

Another example is Sgt. Riggs in the first *Lethal Weapon* movie. He faces external conflicts of course (drug dealers) but he also has an internal conflict — he feels suicidal over the loss of his wife. Remember how we first meet him? He jumps off a building with a potential suicide. After that, we see that he has a one special bullet that he sometimes loads in his revolver and puts in his mouth — that's a serious internal conflict. A story can have more than one conflict but almost always there is one main conflict that is central to the story. A story can also have a combination of external and internal conflicts.

Usually, we combine internal and external conflicts for a richer story. That means we have to understand how our characters approach and resolve conflict.

Jami Gold
(*Using Conflict to Understand Our Characters*)

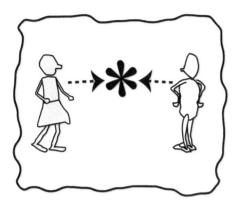

Figure 1.3. Conflict and tension between the protagonist and antagonist is crucial to a story.

Figure 1.4. The characters, especially the main character (protagonist) must have a need, something they desperately want; in this case, a carrot.

I don't want to show you the character, I want to show you their need.

Aaron Sorkin
(*A Few Good Men, Moneyball, The Social Network*)

Protagonist v Antagonist

Every story has to have a *main character*. A story generally has many characters, but there is always one person who is at the center of the story. Also called the *protagonist* or the *hero*, the main character doesn't have to be male or female, young or old. In fact, it doesn't even have to be human; think of *Wall-E*, or a small fish in *Finding Nemo*. The audience needs to feel *empathy* for our main character; otherwise why would they care what happens to them? Empathy doesn't mean they necessarily have to love the character, they just need to care about them in some way.

Lt. Ripley is the main character in the *Alien* movies; most often (but not always) the main character is "the good guy," (male or female) and they are fighting against *the bad guy*, which is also known as the *antagonist*.

As we said, the antagonist is not always a person: sometimes it is a horde of zombies, or "the machines" or society itself, but most of the time it is embodied by a single character, such as Ernst Stavro Blofeld. The antagonist is the person or thing the main character has to fight against in order to resolve the conflict. In *Thelma and Louise*, it is society that is the antagonist. In *Gladiator*, the protagonist is Maximus and the antagonist is Commodus, the Emperor — it is a big story with dozens of characters but at its heart it is one man against another. The antagonist is a very important part of the story; as Alfred Hitchcock said "The more successful the villain, the more successful the picture."

THE NEED

The absolute most important thing about a character, especially the main character, is that they have a *need* — something that they absolutely must possess or achieve: it is what drives the story forward. The main character is who carries the story. If the audience isn't involved with what is happening to the main character there is little chance that they will be engaged by your story. So what makes the main character "work?" Some examples of a main character's dramatic need:

- She needs to save the world by getting the nuclear codes back from the spies.
- He needs to help the kids regain their self-respect by helping them to win the big soccer game.
- The little dog needs to find her way back home.
- The robot needs to find another robot to love.
- She needs to get that promotion so she can keep her home for her foster children.

All of these are things that the main character *needs*; this is what drives them to take action, to constantly move forward. If a character doesn't have a need, they have no reason to do anything except brush their teeth and go to work. If a main character has a real need, such as saving the world (which is usually James Bond's character need), then they will take action, they will *do things*. Watching characters *do things* is what interests us in a story.

What a character's need is will not always be obvious from the first page; many times a character might not even realize themselves what their need is until very late in the story. It would be pretty odd for a character to walk in the room in the very first scene and say "Wow, I really need to find some purpose for my life." Yeah, there are probably people who say things like that but who wants to hang out with them? To summarize:

- The story is about somebody with whom we have some **empathy**.
- This somebody wants something very badly: their **need**.
- This goal is difficult, but possible, to do, get, or achieve.
- The story accomplishes maximum emotional impact and audience connection.
- And the story comes to an *emotionally satisfying ending*, not necessarily a happy one.

Changing Direction

So how do we kick off a story? What gets it going, sets it in motion? Most stories begin by throwing the main character *off balance* — something happens that dramatically changes their situation. In many cases at the beginning we find the main character more or less in equilibrium, in balance. They might be happy or they might be miserable, but they are relatively balanced — static.

This is what kick-starts the story — something happens to throw the character out of balance: they are marooned on a desert island, he loses his job, her child is diagnosed with a deadly disease, she discovers deadly secrets in the company safe — all these things are a major change in their situation. They force the character to *take action*.

These things that force a change in direction in the story are major *plot points*. A single major change of direction in the beginning of the story is not enough to keep things going for a 90 minute or a two hour story; probably not even enough for a 5 or 10 minute short film. That's why a feature film script will have many changes of direction in the story — if they didn't it would be very hard to keep the audience engaged for two hours or more.

Let's take the example of the woman who finds deadly secrets in the company safe. If the rest of the story was just this: she finds a clue, then she finds another clue, then she finds another clue, then she finds another clue.... By the fourth or fifth time she finds a clue, the audience is going to be thinking "who cares, we've already seen this."

The story needs to *change direction* frequently. Let's try this: She finds the deadly secrets, then she finds another clue, then... a big change in direction — the incriminating documents are found... in her own home. She is being framed for the secret, but she can't prove it! She has to escape from the police. She finds proof that the company she works for is a CIA cover, and then a dead body turns up in her car, there is a gun with her fingerprints on it!

These are major changes in direction for the story — they energize the story and keep it turning. They accomplish one of the most important goals of a story: they keep the audience asking the essential question: "I wonder what is going to happen next?" Think of it this way: if they already know what is going to happen next... you've lost 'em.

OBSTACLES

So the story is about conflict, but it can't just be the same confrontation over and over again — it has to build. If you start out with the big, final ultimate battle in the first scene, then where do you go from there? Remember that a story has to have a beginning, a middle and an end. It would be a big mistake to just go right to the big fight that wraps it all up. Usually, the conflicts start small and get bigger and bigger. It's called "raising the stakes."

From the very beginning, however, there have to be obstacles for the protagonist to overcome. Imagine this: you are describing your story to someone and it goes like this: "Well, first he breaks out of prison which he was in for a crime he did not commit, and then he has to elude the federal marshall who is obsessed with capturing him, and then he has to trick his ex-wife into revealing the secret of where the money is buried and she tries to poison him but he escapes, and then for about 60 pages we see some great scenes of him fly fishing in Canada and the scenery is beautiful and he catches a lot of fish and there will be some really great music. It's really wonderful how much he loves to fish."

Wow, you had a great story going and then it just stopped... ground to a total halt. What happened? The character stopped having conflicts; there were no more obstacles to overcome. Without conflicts there is no story!

ROADBLOCKS

Think of these conflicts as *roadblocks* in the character's path. Every time the character tries to do something, there is something blocking her way — another obstacle to be overcome. If something comes easily for the hero, then it's boring. Overcoming these obstacles is what makes a story move forward.

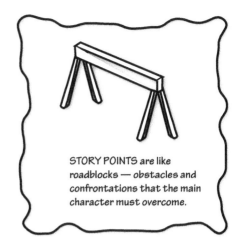

STORY POINTS are like roadblocks — obstacles and confrontations that the main character must overcome.

Figure 1.5. As the main character pursues their need, they must meet *roadblocks*, obstacles that prevent them from achieving their goal. Without obstacles, the story will be very boring.

The one story question that matters most is this: "I wonder what's going to happen next?" If the audience isn't constantly asking that question — you've lost 'em.

Cissi Colpits
(*Project For a New Physical World*)

Premise

The *premise* is sort of the "seed" from which the story grows; the basic idea that gets things started. Generally, it is quite simple. The premise is usually expressed as a "what if..." It is often what gets you started thinking about a story. Here are some examples:

- What if you lived the same day over and over again? — *Groundhog Day*
- What if the "real world" wasn't real at all? — *The Matrix*
- In space, no one can hear you scream — *Alien*

THE THEME: WHAT IS YOUR STORY REALLY ABOUT?

Robert McKee, one of the greatest screenwriting teachers ever, says this: "When you find out what your story is really about, print it out and tape it to your wall." Now that may sound odd — "*when* you find out what your story is about." Wouldn't you know that before you start?

It is quite common to not really understand your story until you are well into the process — indeed many failed screenplays result from the fact that the writer never really figured it out at all. What your story is "about" is the *theme*.

The theme is most often the "life lesson" or the "moral" of the story; think of it as what the writer is trying to say about life (or adventure, or love, or death, or anything at all). Again, the best themes are often very simple. For example: "Love conquers all" is the theme of many classic novels, plays, and movies. What are some other great themes?

- Money can make you do things you don't want to do — *Wall Street*.
- True love sometimes ends tragically — *Romeo and Juliet*.
- Crime doesn't pay — *Scarface*.
- Clever and stylish crime pays well — *Oceans 8, 11, 12,* and *13*.
- Money can't buy happiness — *Citizen Kane*.
- Money can buy happiness, and really good lawyers — *The Wolf of Wall Street*.

ARISTOTLE

Aristotle was one of those crazy Greek guys who turned out to be right about a lot of things. Many writing courses still use his book *Poetics* as a standard textbook, over two thousand years after he wrote it! His basic ideas are still very relevant for writers today. The ones that are most often referred to are *The Unities*. They are:

- *Unity of action*: as much as possible, stick to the main story; don't get lost in a tangle of subplots.
- *Unity of place*: the story is stronger the more it sticks to one place. Of course, this isn't always possible, but think of some of the great films that happen in one place only: *Die Hard, Titanic, Rear Window, Aliens, Dial M For Murder* and so on. Confining all the action to a single place makes it stronger and more intense. Obviously, this doesn't apply if you're writing a James Bond movie where part of the adventure is traveling to exotic places.
- *Unity of time*: the whole action takes place in a single span of time — it doesn't lose energy by jumping around to different times: past, present and future. *Flashbacks* are something you want to be very careful with. Try to avoid them unless absolutely necessary.

So does every story have to take place in one day in the same room? Of course not, but if you analyze a huge story that sprawls across hundreds of years and takes place in 30 or 40 locations you'll often find that the reason audiences lose interest is that it gets so far away from these basic principles. If you see a movie that has more than one title that says something like "Ten Years Later," you know there might be some trouble ahead. Having a plot that at least approaches some sort of unity of time and place concentrates and focuses the story and makes it more intense. As for unity of action — sticking to the main story and not getting lost in a bunch of subplots — that is very much still a good idea.

When you make a movie, always try to discover what the theme of the movie is in one or two words. Every time I made a film, I always knew what I thought the theme was, the core, in one word. In *The Godfather*, it was succession. In *The Conversation*, it was privacy. In *Apocalypse*, it was morality.

The reason it's important to have this is because most of the time what a director really does is make decisions. All day long: Do you want it to be long hair or short hair? Do you want a dress or pants? Do you want a beard or no beard? There are many times when you don't know the answer. Knowing what the theme is always helps you.

I remember in *The Conversation*, they brought all these coats to me, and they said: Do you want him to look like a detective, Humphrey Bogart? Do you want him to look like a blah blah blah. I didn't know, and I said the theme is 'privacy' and chose the plastic coat you could see through. So knowing the theme helps you make a decision when you're not sure which way to go.

Francis Ford Coppola
(*The Godfather, Apocalypse Now, The Conversation*)

Creating Characters

Your story needs characters; besides the protagonist and antagonist, there are likely to be supporting characters on both sides and in between. You need every one of these characters to be interesting, engaging and three-dimensional, in other words you don't want them to just be cardboard cut-outs, what is often called a "caricature."

Your characters need to seem like real people, with complexity, many dimensions and their own internal thoughts and processes. If your antagonist is just a "standard issue bad guy" without anything else going on, they are likely to be uninteresting and drag your story down. The same applies to the other characters as well: the more they seem like real people, the more they will help your story.

WRITE THEIR BACKSTORY

How do you come up with good, interesting characters? One way to start is to write their *backstory*. The backstory is what happens to the character before the movie starts. Think of Indiana Jones' backstory: he is an archeology professor, his dad was very strict, as a young man he was frightened by snakes, he was given the hat by a guy who he was trying to stop and so on. These are some of the things that helped make him who he is.

POINT-OF-VIEW

Every character has to have a *point-of-view*, a way of looking at things. In Austin Powers movies, Dr. Evil has a point-of-view: he has a passion for doing evil, he looks at every situation only in terms of how he can do something bad. Other characters may see almost everything in terms of their search for love, money, or fame — these things heavily influence how they view things and think about things. A character's point-of-view may not always be obvious, often it is hidden; frequently the characters themselves do not understand their own point-of-view.

WHAT IS THEIR DRAMATIC NEED? THEIR GOAL?

Just as with the main character, other people in the story need to have a character need. For the antagonist (the villain) it may very well be as strong and dramatic as it is for the protagonist; think of Bane in *The Dark Knight Rises*. Secondary characters should have a need as well, although the more minor the character the less dramatic it might be. If the character is a bartender in one scene, his need might be "I just want to get through this shift without punching somebody."

But think about this example, see how much it tells us about this particular bartender? If you start writing a character and just think "He's a bartender," it doesn't tell you a great deal about him. If you think about the character as "A bartender who struggles to contain a hidden rage that drives him nearly to violence every night." Wow, that's a guy we want to know more about; even if your story doesn't have time to let us know what it is, it certainly makes him seem like a real guy that interests you, even if he's someone you definitely want to avoid.

If nothing else, understanding the need of your characters will get you a long way toward understanding how to write them; how they will act and react in certain situations. Kurt Vonnegut said "Before you write, take a moment to think about what each character wants, even if it's only a glass of water."

25 WORDS OR LESS

Before you really start putting things down on paper, it's a very good idea to have a general idea of the basic story. You probably won't have every little plot point figured out; you certainly won't know how every scene will work out — that is all part of the writing process. You have probably heard the phrase "tell me your story in 25 words or less." (It's a scene in Robert Altman's *The Player*, for example; a movie you should definitely watch if you want to have an understanding of the motion picture industry at the studio level.)

The old joke is that you have to keep it to 25 words or less because producers have very short attention spans — their lips get tired while reading. That may be true, but it's not the real reason. In reality, if you can't explain your story in a few simple sentences, then you probably don't understand your story!

If you start telling your story and you get hung up in tiny details of a particular scene or wander off on a tangent about some interesting location, then maybe it means you don't have a good grasp of the big sweep of your story, the narrative thread that is going to propel the story forward and keep the audience engaged and involved.

> People, and characters are made up of their past experiences. When crafting a character, one of the most important aspects we consider is their past.
>
> Gang Lion
> (*Project For a New Physical World*)

> Characters are the bedrock of your story. Plot is just a series of actions that happen in a sequence, and without someone to either perpetrate or suffer the consequences of those actions, you have no one for your reader to root for, or wish bad things on.
>
> Icy Sedgwick
> (*A Man of Good Character*)

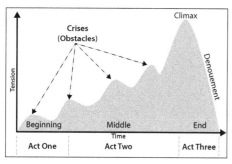

Figure 1.6. Stories should always have *rising action* — as the story moves along, the tension gets higher, the stakes are raised, the consequences become more serious.

A movie, I think is really only four or five moments between two people; the rest of it exists to give those moments their impact and resonance. The script exists for that. Everything does.

Robert Towne
(*Chinatown, Mission Impossible,*
Tequila Sunrise)

Rewriting isn't just about dialogue; it's the order of the scenes, how you finish a scene, how you get into a scene.

Tom Stoppard
(*Brazil, Shakespeare In Love,*
Empire of the Sun)

The Cards and the Outline

Some writers start by just opening up a word processor and starting to type. In the old days, they just put a blank page in the typewriter; in fact most stories about authors who have writer's block center around the image of staring at the frightening sheet of blank paper.

To just start writing like that is, in fact, a terrible way to write. Taking notes on pieces of paper or even dashing out ideas for a scene are fine, but they are not an organized way to doing things. Screenplays demand organization in their structure and they demand organization in how you think them through.

THE STEP OUTLINE

Before you start writing dialog and action, it is extremely useful to make an outline of your story points — this is usually called the *step outline*. It's important to keep it simple — stick to the main story points, don't get bogged down in details or you'll lose sight of the big picture.

Different writers do this in different orders, sometimes even differently from project to project — some people write an outline first and take the cards from that; some write the cards first and develop an outline from that. Screenwriting software usually lets you do it either way.

THE CARDS

Fortunately, there are some very simple but extremely effective methods that can not only help you get started but can carry you through the entire process, even into revisions and "fixes." It is called "the cards" and it couldn't be simpler. Get yourself a pack of 3x5 index cards and a felt-tip marker. For every *story point* in your story, make a card. Keep it to a few simple words and write big, clear letters. Why write so big? Because one of the most useful things you do with the cards is to pin them up on a wall or lay them out on a table and look at them as a whole. This is what gives you the big picture — you can see the whole flow of your story and not get lost in the details of each scene.

Many writers take their stack of cards with them wherever they go, just wrapped with a rubber band. This way you can take them out, go through them one at a time and shuffle them around to see if maybe there is a better order for the scenes to go in. You can also see if maybe some of the scenes are not necessary or if some important story point is missing. Some writers even go so far as to color code them: maybe making action scenes on green cards or very important plot points on yellow cards, or whatever system you prefer. What's important about the story cards is to not get hung up in too much detail — they should only be the main story points.

Most screenwriting applications also have an outlining and index card capability. It can be very useful to have your cards on screen so you can easily rearrange them. The problem is that unless you have a gigantic monitor for your computer, it is hard to get the effect of seeing them all at once, so that you really get an overall idea of your story. Fortunately, most software also allows you to print them out. Printable 3x5 cards are available. Printing or writing them out allows you to pin them up on the wall, keep them in your pocket and quickly look at them in a different order.

SYNOPSIS

A synopsis is a brief summary of your story points. It doesn't get into dialog or long descriptions of locations or scenes — it is just the bare bones of the story told narratively. Some people write a synopsis and some don't; some producers want to see a synopsis and some don't. If you're writing a screenplay you should try to write a synopsis of the story in 5 or 10 pages; if you find it helpful, great. If not, then at least it gave you another chance to think through your story as a whole. Also, it gave you some practice at writing a story synopsis — you never know when a producer or financier will ask for one.

Script Outline Raiders of the Lost Ark

Indy survives the booby-trapped cave.

Dr. Belloq steals the idol statue.

Indy escapes to his airplane.

The Army has a German cable about a Nazi dig in the Egypt.

They have discovered possible burial site of the Ark of the Covenant.

Indy needs the headpiece to the Staff of Ra.

Flies to Nepal to find Abner Ravenwood.

Introduce Marion, Indy's ex-girlfriend. Can outdrink anybody.

She's not willing to help him locate the medallion.

Secretly, she wears the piece around her neck.

Toht about to torture Marion for the headpiece.

Firefight with Toht and Sherpa heavies in Marion's bar.

Indy and Marion escape with the headpiece.

Meet Sallah. Insider working on the Nazi dig.

Indy and Marion attacked by thugs.

Marion gets trapped in a truck of explosives.

The truck crashes, and it explodes.

Indy drowns his sorrows in whiskey.

Belloq brags about finding the Ark.

Figure 1.7. (left) Part of a *step outline* for *Raiders of the Lost Ark*. Only the plot points, no dialog, no long descriptions.

Figure 1.8. (below) The *cards* are mostly just the step outline a little simplified, with each plot point written on a single index card. This is a computer-generated example of a few cards but many people just write them by hand with a felt-tip marker — it's important that you be able to read them at a distance when you pin them up on a corkboard.

Indy survives the booby-trapped cave	**Belloq steals the idol statue**	**Indy escapes in seaplane**
Introduce Indy as character — treasure hunting archeologist.	Introduce Belloq as Indy's antagonist.	He hates snakes.

The Army knows of Nazi dig in Egypt	**Indy flies to Nepal to find Ravenwood**	**Introduce Marion, his ex-girlfriend**
Possible site of the Ark of the Convenant. For Indy — it's the ultimate treasure hunt.	Indy is looking for the father, but only finds Marion, Ravenwood's daughter.	She's tough and runs a bar in Nepal. She can outdrink anybody.

She refuses to help find the medallion	**Toht going to torture her for medallion**	**Indy helps her escape Nazi thugs**
She hates Indy for abandoning her.	Introduce Toht as another antagonist.	She actually has the medallion around her neck.

Three Act Structure

By far the most widely used story form in filmmaking is the *three act structure*. Very roughly, *Plot Point One* (the first major story point) comes at the end of the first act, *Midpoint* occurs somewhere in the middle of *Act Two* and *Plot Point Two* is about the start of *Act Three*. These three acts are almost never equal in length. Specifically, *Act One* and *Act Three* are almost always much shorter than *Act Two*. In the next few sections we'll define these terms more precisely.

The way of looking at scripts presented here is based on the ideas of Syd Fields and Robert McKees, and many other great teachers. There are a few other ways of analyzing story structure but the basics are really the same in all of them; sometimes they are just using different terminology.

BEGINNING, MIDDLE AND END

The old saying is that "every story needs a beginning, a middle and an end — but not necessarily in that order." The exact order of things is not crucial: look at films like *Memento*, *Citizen Kane* or *The Usual Suspects* — but for our purposes now, it's better to focus on films that take place in the traditional order: beginning, middle, end.

The beginning is pretty straightforward: there is a *Setup* where we get to know the situation and the characters. This is followed by the *Plot Point One*, which throws our main character out of balance and presents them a challenge which they have to overcome.

As our main character struggles to overcome these *obstacles* and achieve their *need*, they come to a *Midpoint*, where the stakes are raised and they have new, unexpected obstacles to overcome. So after the *Midpoint*, where do things go? We need our story to achieve resolution and come to an end. This resolution comes about late in *Act Two* — where the main character overcomes the obstacles and brings things to a conclusion.

So all of this adds up to a *Three Act Structure*. In *Act One*, we have the *Setup* where we get to know the situation and the characters. *Act One* concludes with *Plot Point One* — where the story changes direction and the main character is presented with a challenge.

At *Midpoint*, the story changes direction again, but not in a way that resolves the central challenge. The characters are now presented with new challenges that raise the stakes and make it more difficult.

At *Plot Point Two*, the crisis climax starts to brings the story to a resolution. In the *Crisis Climax*, the main character either wins or loses against the forces that oppose them.

Act Three is what comes after *Plot Point Two* and the *Crisis Climax*. It sums up what has happened and brings everything to a resolution.

Figure 1.9. The act structure of *The Shawshank Redemption*, as analyzed by Syd Fields. The basic progression of *SetUp*, *Confrontation* and *Resolution* applies to films of all lengths, from a short film to a multi-part series like *Chernobyl*.

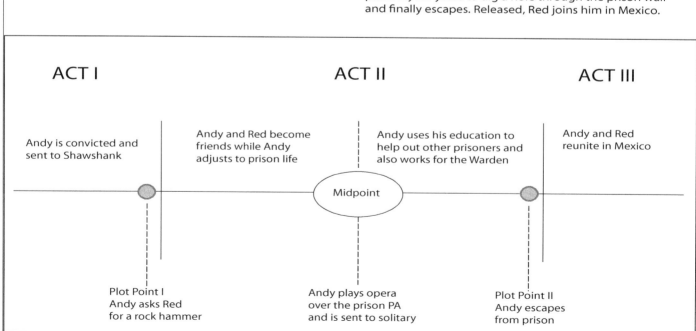

Syd Fields Diagram of
The Shawshank Redemption

The Story: Andy Dusfresne is convicted of murdering his wife and is sent to Shawshank prison. He meets Red, another convict and they become friends and allies. Andy works patiently for years to dig a hole through the prison wall and finally escapes. Released, Red joins him in Mexico.

ACT I ACT II ACT III

Andy is convicted and sent to Shawshank

Andy and Red become friends while Andy adjusts to prison life

Andy uses his education to help out other prisoners and also works for the Warden

Andy and Red reunite in Mexico

Midpoint

Plot Point I
Andy asks Red for a rock hammer

Andy plays opera over the prison PA and is sent to solitary

Plot Point II
Andy escapes from prison

Story Points

There will be many story points in your script, but a few of them have special significance. We talked before about how to get a story started by creating a serious change in the circumstances of the main character: something that throws her or him off balance — a challenge, an obstacle that they must overcome.

GETTING THE STORY STARTED

This first change of direction that starts the story is called *Plot Point One* or the *Inciting Incident* — they are the same thing — that one big change that presents the challenge that the main character will be dealing with in our story.

It generally comes about 30 minutes (30 pages) into the script (obviously this applies only to feature films, in short films it occurs earlier). This is not an absolute rule, but you'd be surprised how often it turns out to be true. The first part of the story before the *Inciting Incident* is where the story is *set up* — characters are introduced, we learn about their situation, and the groundwork is laid for what is going to happen later. This is a very important part of the storytelling — if we don't get to know these people, how are we going to care about what happens to them later?

Think about the first act of *Speed*. First we get to see the Keanu Reeves character staying cool and calm in a dangerous situation; he improvises to save the life of his partner. In the next sequence we learn more about him: he takes the bus to work, not a BMW, he is friendly with everyone at his regular coffee shop — he knows everybody by name. When a bus explodes, he doesn't stand around screaming, he gets into action! When the bomber calls him and makes him personally responsible for saving the people on the bus — that is *Plot Point One*. There is no going back for him — something has changed in a way that can only lead to obstacles, struggle, danger and some kind of dramatic resolution.

PLOT POINT ONE

You need to be sure that your *Plot Point One* is strong and clear. It's what gets your story started, so it's important to have a good one. Here are some *Plot Point One* moments from great films:

* *Alien*: A deadly life form is let onto the ship.
* *Die Hard*: McClain is trapped in a building held by a brilliant criminal.
* *Saving Private Ryan*: The Captain is assigned the task of finding Ryan.

Many writers consider *Plot Point One* to be the most important moment in the story — if it doesn't really change the direction of the story and put the main character in a seemingly insurmountable situation, then it hasn't done its job. It's very unlikely that the rest of the story is really going to grab the audience and keep them interested in the coming story developments. The purest definition of the *Plot Point One/Inciting Incident* is this: it is the moment when something happens in the story that seriously affects the main character's situation, forcing her or him to take action in response.

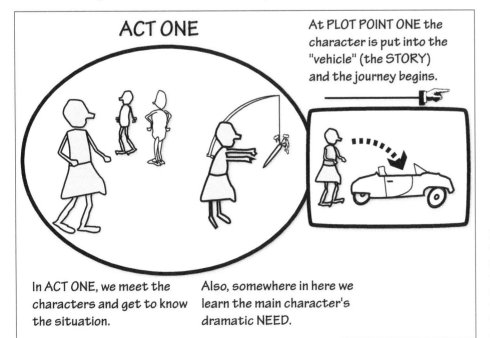

Figure 1.10. *Act One* is all about introducing the characters, learning the main character's need (in this example, a carrot) and *setting up* the story. At the end of *Act One* is *Plot Point One*, which kicks the story off by throwing the main character out of balance, by putting them in a situation that they absolutely must deal with.

Act Two

Act Two is the bulk of the story. It's where things progress and develop; where the main character meets many difficulties and overcomes them. These obstacles cause the story to *change direction.*

MIDPOINT

Somewhere around the middle of the story comes the *Midpoint* — it is a major change in direction for the story but not one that solves the essential conflict. The *Midpoint* usually adds an extra twist to the story to keep the audience engaged and interested.

Most often the *Midpoint* is also a way of "raising the stakes." At first it seemed like all the hero had to do was find the gold, but it turns out that she must save the life of the innocent child in order to find the gold — a more difficult challenge; that's why it is "raising the stakes." The *Midpoint* is also often *The Point of No Return,* the point in the story where the main character has to totally commit and there is no way to just "bow out."

THE MIDPOINT OFTEN "STARTS THE CLOCK"

Here's a classic example of a *Midpoint* when both the "stakes are raised" and a "time clock" appears: In the film *Titanic,* Kate Winslet plays a pampered Victorian debutante when she begins her journey, engaged to the wrong man, tied to her mother, suicidal, and then she meets the love of her life... Leonardo DiCaprio.

For the first half of *Act Two,* she and Leo fall in love, then at *Midpoint,* two key things happen: they confirm their love and, most importantly, the ship hits an iceberg — a very real obstacle. These two "stakes-are-raised" incidents force Kate to decide. Is she really in love with Leo; can it last? Also, can she not die?

Is she really committed to leaving the world of wealth and privilege? Kate must decide — and fast, because the ship is sinking. Meanwhile, the captain, having learned his ship is sinking, asks "How much time do we have?" This "time clock" serves the function of accelerating the pace of the story to the end. The clock makes it an "all or nothing" proposition. If a story might lead to "well, we'll try again next week" — that's not very gripping is it?

Most action films have some sort of ticking clock — perhaps the most perfect is in *Goldfinger,* where there is an actual clock on the nuclear bomb that is counting down as Bond fights for his life and then the clock is only stopped at the last moment: 007 seconds to be exact. But it's not just action films that have the time limit, the ticking clock, the "all or nothing" moment. In *Sleepless In Seattle,* they need to meet at midnight on top of the Empire State Building. This is an "all or nothing" moment.

> There is only one plot — things are not what they seem.
>
> Jim Thompson
> (*The Killing, Paths of Glory, The Getaway*)

Figure 1.11. *Act Two* is all about *confrontation* and *raising the stakes,* making it even harder for our character to achieve their goal. *Midpoint* happens somewhere in here — it is a big turning point for the story.

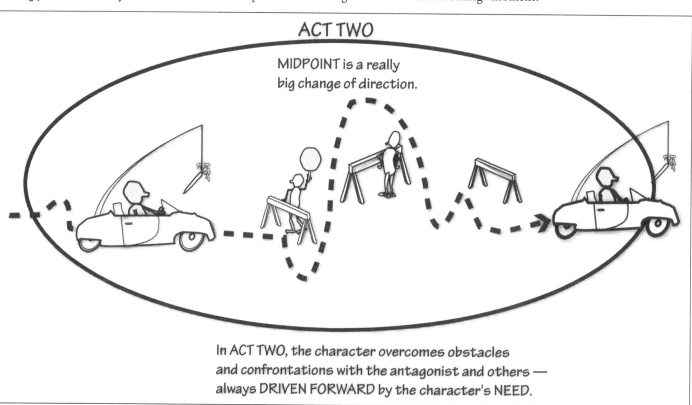

ACT TWO

MIDPOINT is a really big change of direction.

In ACT TWO, the character overcomes obstacles and confrontations with the antagonist and others — always DRIVEN FORWARD by the character's NEED.

Plot Point Two

Most of the time, *Plot Point Two* is when all seems lost for our character; where things have got as bad as they can possibly get, but then something happens that changes the story in a very big way — a dramatic reversal that ends *Act Two* and begins *Act Three*: the *Resolution*.

Plot Point Two is usually together with the *Crisis Climax*. It is the *do or die* moment in the story. It's often a big battle (as in the final *Harry Potter* or any *James Bond* film). Sometimes it's the big game, which by Hollywood rules is never won or lost until the final pitch of the final out of the final inning of the final game. Sometimes it is emotional, such as when they finally meet at the end of *Sleepless In Seattle*. This is where the main character either wins or loses — where all the elements of the story come together for the big resolution.

WRAPPING IT UP

After the *Crisis Climax* there are still loose ends to be tied up: the hero rides off into the sunset, the rogue cop gets his badge back, the guy gets the girl, all that sort of stuff. All the loose ends of the story are resolved and tied up. Of course, this is also where you set up the situation for the sequel!

SOME EXAMPLES

The definition of *Plot Point Two* is a little fuzzier than for *Plot Point One*, so some examples will help. Here's one from the movie *Bridesmaids*:

- *Plot Point Two* is the moment when Megan comes to Annie's apartment to ask her help in finding the missing Lillian — the two frenemies combine forces.
- The *Crisis Climax* comes when Annie finds Lillian at her own apartment and Lillian asks her to help with the wedding.
- The *Resolution* is when the policeman Rhodes returns and they are reunited: she has found someone who loves her for who she is. Also part of the resolution is that she is now back together with her best friend, despite all they've been through. And what might have been a disaster turns into a great wedding.

Generally speaking, things have gone about as far as they can possibly go when things have gotten about as bad as they can reasonably get.

Tom Stoppard
(*Shakespeare In Love, Brazil, Empire of the Sun*)

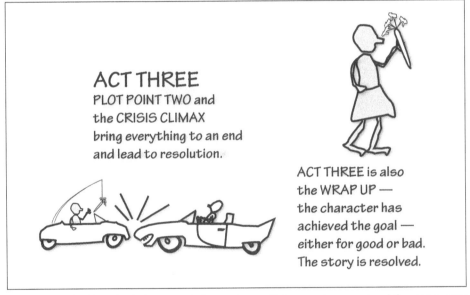

ACT THREE
PLOT POINT TWO and
the CRISIS CLIMAX
bring everything to an end
and lead to resolution.

ACT THREE is also
the WRAP UP —
the character has
achieved the goal —
either for good or bad.
The story is resolved.

Figure 1.12. *Act Three* is all about *resolution* — the conflicts come to an end and the story wraps up. In this case, it's an up ending — she gets the carrot.

Don't Jump The Shark!

Figure 1.13. Like a shark, your story needs a *bite* to hook the audience and get them interested in your story, a *body* to let the story play out and develop, and a *tail*, where things are brought to a conclusion, and the story is wrapped.

The Bite The Body The Tail

WE'RE GONNA' NEED A BIGGER BOAT!

Some writers think of story structure like a shark. The parts are not equal in size or purpose, but each one has an important job to do.

- *The Bite.* You have to *hook* your audience right from the start. You need to get their attention, and get them interested in the characters and their situation, even before the big turn of *Plot Point One*.
- *The Body.* This is the main chunk of the film — *Act Two*. The story progresses and develops. New twists and turns constantly *up the stake*s and make the situation more difficult for our main character.
- *The Tail.* This is the *Resolution* — where the screenplay wraps up all the story threads and resolves the body of the film. Plot elements and characters come to a climax. Finally we see where things have been heading, and as a result of their actions, the main characters have changed and grown.

Here's another important way that a story is like a shark: it always has to keep moving forward or it dies! Also, don't forget: live every week like it's *Shark Week*!

EMOTIONALLY SATISFYING ENDING

Should your ending be happy or sad? If you ask Hollywood executives, they will always say it should be a happy ending — but do you really want those folks to decide how you conclude your story? Well, that's really up to you.

Some stories end happily, some don't. Take a look at *The Bicycle Thief* or *Chinatown*, two truly great, memorable films that have decidedly *down endings*. In the end it's not about what's happy or sad. The point is to have an *emotionally satisfying* ending — one that brings the story to a conclusion in a way that makes sense within the realm of human emotion. *Amélie*, *Groundhog Day*, and *The Shawshank Redemption* have happy endings. Do we love them? Yeah, we do!

Do *Scarface*, *Titanic*, *Se7en*, or *Gladiator* have happy endings? Absolutely not, but somehow they are emotionally satisfying. They are tragedies, and it should happen that way. The great writer Tom Stoppard puts it this way: "The bad end unhappily, the good unluckily. That is what tragedy means."

LET'S REVIEW

To sum up:

- The story is about somebody with whom we have some **empathy**.
- This somebody wants something very badly: their **need**. This goal is difficult to achieve. They persevere.
- The story accomplishes maximum emotional impact and audience connection as the main character overcomes **obstacles** through **confrontation**.
- The story comes to an **emotionally satisfying ending**. Things are resolved, one way or another.

Figure 1.14. (below) In an *up ending* (more or less a happy ending), the main character has achieved her goal and balance is restored — she has her carrot!

Figure 1.15. (opposite page) The basic elements of storytelling.

STORY ELEMENTS

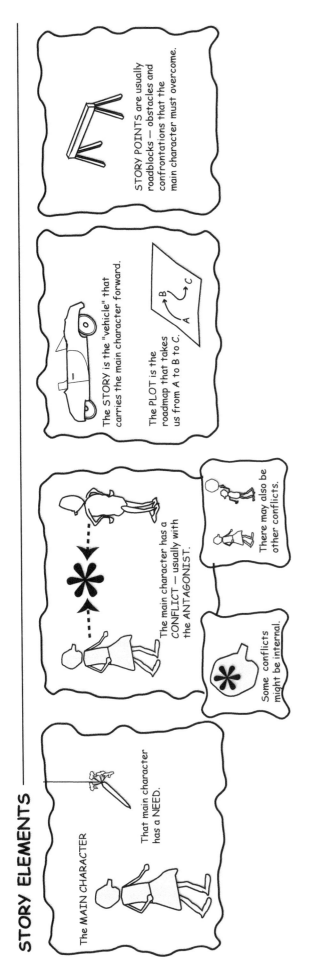

The MAIN CHARACTER

That main character has a NEED.

The main character has a CONFLICT — usually with the ANTAGONIST.

Some conflicts might be internal.

There may also be other conflicts.

The STORY is the "vehicle" that carries the main character forward.

The PLOT is the roadmap that takes us from A to B to C.

STORY POINTS are usually roadblocks — obstacles and confrontations that the main character must overcome.

STORY STRUCTURE

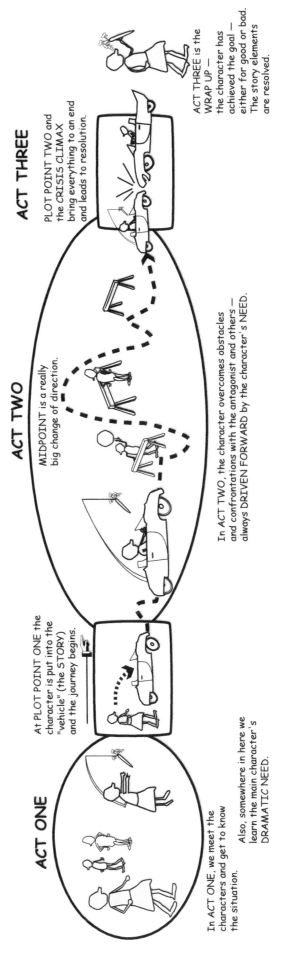

ACT ONE

In ACT ONE, we meet the characters and get to know the situation.

Also, somewhere in here we learn the main character's DRAMATIC NEED.

At PLOT POINT ONE the character is put into the "vehicle" (the STORY) and the journey begins.

ACT TWO

MIDPOINT is a really big change of direction.

In ACT TWO, the character overcomes obstacles and confrontations with the antagonist and others — always DRIVEN FORWARD by the character's NEED.

ACT THREE

PLOT POINT TWO and the CRISIS CLIMAX bring everything to an end and leads to resolution.

ACT THREE is the WRAP UP — the character has achieved the goal — either for good or bad. The story elements are resolved.

Dialog That Is Not On the Nose

Writing dialog takes a lot of practice, especially if you don't want readers or actors to comment that your dialog is "on the nose." When they say that it means that what the characters are saying is obvious and not realistic.

SUBTEXT

In reality, particularly in tense, difficult or awkward situations, people rarely just come out and plainly say what they really mean. People tend to speak in *subtext* — rather than just saying things outright, they imply things, they hint around, they use irony or a joke to make their point. Being obvious and overstated is a big mistake in any art form and certainly in filmmaking.

You want to avoid anything that makes it seem like a character is "making a speech," or that what they are saying is pre-programmed and they have memorized it. Of course, some of this is up to the actors, but even very good actors can have trouble with dialog that is written in an artificial, unrealistic manner that isn't at all like real people speak. Sometimes we want to show that a certain character is stiff, inhuman and remote, so their dialog should be written that way. After all, how not so scary would it be if the HAL 9000 computer in *2001: A Space Odyssey* talked like this:

> HAL
>
> Yo, dude! Don't touch that freaking button!

Instead when he says:

> HAL
>
> I'm sorry, Dave. I can't do that.

It is vastly more frightening. To have one of your characters say, "I'm very, very angry" is totally on the nose. Better writing would be to "write around the emotion without actually stating it." Here's another example of on the nose dialog:

> LENNY
>
> Why don't you trust me? You never do. I love you so much but you always doubt me. It hurts me so much when you do these things, makes me feel worthless. Why don't you trust me? I don't understand.

Instead of having your character plainly say that they are angry, you might have them punch a wall, or throw a coffee cup at the wall. This is all the more convincing because it also shows that this particular character can't express their emotions verbally, another source of frustration. Even more intriguing are characters are who intentionally hide their feelings, hide their true self or maybe don't even know what their true inner self is like. Many great scenes of characters who are about to explode with anger and rage are acted by having them suddenly become very calm and talking slowly and deliberately.

FULLY COOKED

An *undercooked* script is one where there are lots of loose ends, key elements go unexplained and important points are only hinted at. They occur most often when the director is also writing the script and when the writing and pre-production phases are rushed because they want to get to the fun part — shooting the movie. And when there is no feedback, not enough tough editing of the script, or outside critiques.

One of the danger signs is when the director responds to questions about the story by saying "It's OK, I see it in my head." Maybe so, but the rest of the production team can't see it, which means their ability to help the director achieve that vision is limited. Example: a few years ago, I worked with a production company that didn't always trust their writers and directors to make a story point visually. They insisted that every thought be verbalized. They didn't like the script to say something like "We know from her glance exactly what she is thinking." After I had written and directed a couple of films for them, they saw that I really could say it with a visual instead of on the nose dialog, and no longer bugged me about such things.

The lies are in the dialogue, the truth is in the visuals.

Kelly Reichardt
(*Wendy and Lucy, Certain Women*)

My scripts are possibly too talkative. Sometimes I watch a scene I've written, and occasionally I think, 'Oh, for God's sake, shut up.'

Tom Stoppard
(*Shakespeare In Love, Empire of the Sun, Brazil*)

Not Exposing Your Exposition

Exposition is a necessary evil. What is exposition? It is things your audience needs to know but it's not part of the story or the action. Think of it as background information the audience needs in order to understand the characters and the action.

A great deal of it usually happens in the first ten pages, that's when the viewer is likely to need the most background information to understand what's going on. You have to let the audience know something about the backstory of the situation and the characters and you want to do it as soon as possible so that you can get the story started.

WHY IS IT A NECESSARY EVIL?

What makes it difficult in movies is that we don't have the tools that other kinds of writers have. A novelist can just stop the action for a while as she fills you in about the city or the childhood of a character or about whaling (like all those chapters in *Moby Dick* about whales that you were supposed to read in high school but really you only skimmed through. Yeah, me too.)

You could possibly use a *voice-over narrator* to fill in the background; like in *Full Metal Jacket* or *Apocalypse Now*. Surprisingly, neither Kubrick or Coppola originally wanted voice-over narration; they only realized in editing that it would be useful. Certainly the narration is an essential part of those great films, but in general, you don't want to use a narrator unless you really have to. Most filmmakers consider it something to avoid if at all possible because it often becomes a crutch, an excuse for not telling the story properly through dialog and action.

In both of these examples, it is the main character speaking his thoughts. It is also possible to have an anonymous outside voice narrating the action, but this comes off as very old-fashioned. All this means that it can sometimes be tough to work in the exposition without making it seem obvious or bringing the story to a grinding halt. Bad exposition is something we make fun of; remember *Basil Exposition* in the *Austin Powers* films?

As a writer you will always be trying to *hide* the exposition — to get it into the script without making it obvious and delaying the story. Just try to slip it in wherever you can. For example, you could start the movie by having a *voice-over narrator* say something boring like "Lars Thorwald, winner of the Nobel Prize in physics, awakens in his apartment." That would be *on the nose*: obvious and clumsy. Instead you might first see him in the kitchen holding a cup of coffee and using his other hand to open drawer after drawer. A woman in a bathrobe enters with some keys and says:

> ANA
> You'd think a Nobel Prize winner could
> find his own car keys.

> LARS
> The prize was for physics, dear, not
> housekeeping — that's what I have you
> for.

With this *buried exposition*, we have learned not only that he is an award-winning physicist but also a little about his personality, and his relationship with his wife — which is about to turn into a pretty big argument.

SHOW, DON'T TELL

Even better than using exposition is to *show, don't tell*. Instead of explaining things to the audience, show them. Let actions speak louder than words. Not only does it keep the story going, it engages the audience by not lecturing to them. One basic idea of storytelling is that *action is character*. We really know people by what they do, not what they say. Let the actions of your characters tell us who they are; let the actions in the story give us the background ideas — only use exposition if there is absolutely no other way to get the essential information across.

Formatting A Script

How you format a script is important, for two reasons. First of all, it shows that you know about the reality of the film business, but more importantly, it is a standard that is used for film production, where page count is used as a measure of how the script is shot, budgeted and scheduled. Figure 1.16 on the next page shows the important points of a properly formatted script.

> Audiences are less intrigued, honestly, by battle. They're more intrigued by human relations. If you're making a film about the trappings of the period, and you're forgetting that human relationships are the most engaging part of the storytelling process, then you're in trouble.
>
> Ridley Scott
> (*Blade Runner, Alien, Gladiator, Thelma and Louise, The Martian*)

A Sample Script Page

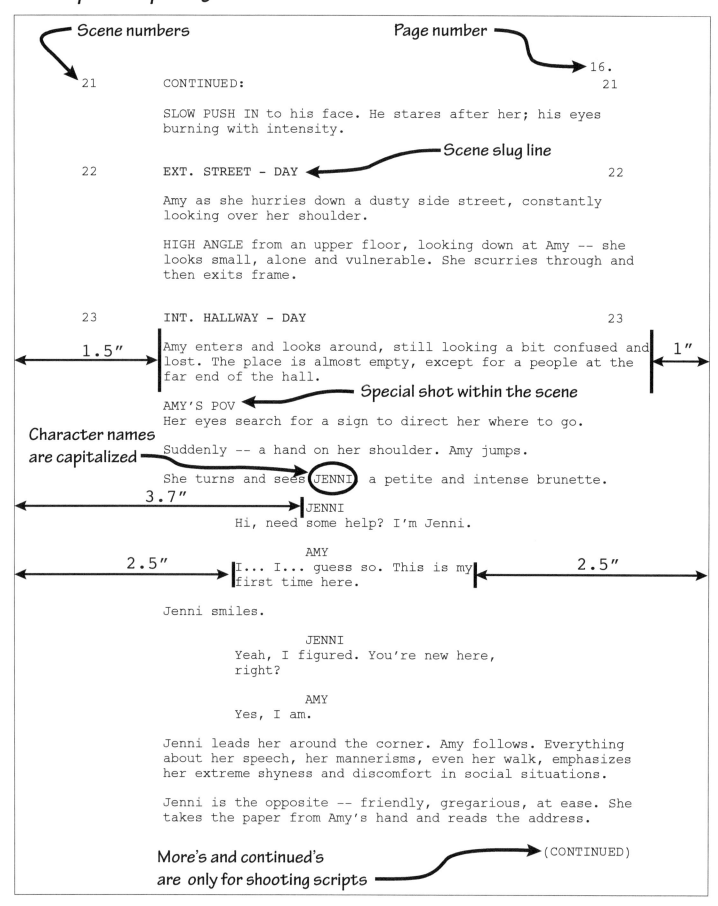

Scene numbers

Page number

16.

21 CONTINUED: 21

SLOW PUSH IN to his face. He stares after her; his eyes
burning with intensity.

Scene slug line

22 EXT. STREET - DAY 22

Amy as she hurries down a dusty side street, constantly
looking over her shoulder.

HIGH ANGLE from an upper floor, looking down at Amy -- she
looks small, alone and vulnerable. She scurries through and
then exits frame.

23 INT. HALLWAY - DAY 23

1.5"

Amy enters and looks around, still looking a bit confused and
lost. The place is almost empty, except for a people at the
far end of the hall.

1"

Special shot within the scene

AMY'S POV
Her eyes search for a sign to direct her where to go.

Character names
are capitalized

Suddenly -- a hand on her shoulder. Amy jumps.

She turns and sees JENNI a petite and intense brunette.

3.7"

 JENNI
 Hi, need some help? I'm Jenni.

2.5"

 AMY
 I... I... guess so. This is my
 first time here.

2.5"

Jenni smiles.

 JENNI
 Yeah, I figured. You're new here,
 right?

 AMY
 Yes, I am.

Jenni leads her around the corner. Amy follows. Everything
about her speech, her mannerisms, even her walk, emphasizes
her extreme shyness and discomfort in social situations.

Jenni is the opposite -- friendly, gregarious, at ease. She
takes the paper from Amy's hand and reads the address.

More's and continued's
are only for shooting scripts

(CONTINUED)

Figure 1.16. Formatting a script page.

Loglines, Treatment and Synopsis

If you're trying to sell your script or get financing for your movie, you'll need to write a *synopsis*, a *treatment* and a *logline*. So what are they?

A *treatment* is a long-form summary of your story. It may be anything from a couple of pages to a hundred or more (although treatments this long are rare). It doesn't need a lot of detail, and including key bits of dialog is optional. Don't get hung up in the little ins and outs — focus on the main story. A treatment is very much part of the writing process and it should help you get a better picture of the major through-lines of the story and a little bit about any subplots and how it all fits together. A good way to start writing a treatment is to create a one line summary of each scene of your script. Be sure the treatment explains who the main character is, what their need is, what challenges they face, who the main antagonist is, and how it is all resolved.

SYNOPSIS

A *synopsis* is just a summary of the plot. Most of the time it is what you will show to people to get them interested and help them understand where you're going with this script. Even more so than with a treatment — don't get lost in the details. Stick to the major plot points and key elements of your story — a couple of pages at the most.

LOGLINE

Very often, producers don't want to read scripts or even a synopsis at all until they have seen your *logline*. If you've been writing for a while, producers who are looking for projects will sometimes say "Send me your loglines." A *logline* is a very brief description of your story. Absolutely no details or even story points. It is really just a one or two-sentence description of the general idea of your story. Some sample *loglines*:

- A young man and woman from very different social classes fall in love on an ill-fated ship destined to sink. *Titanic.*
- With the help of a German bounty hunter, a freed slave sets out to rescue his wife from a brutal Mississippi plantation owner. *Django Unchained.*
- A treasure-hunting archeologist is sent by the US government to recover the Ark of the Covenant before the Nazis can harness its power. *Raiders of the Lost Ark.*
- A Las Vegas-set comedy centered around three groomsmen who lose their about-to-be-wed buddy during their drunken misadventures, then must retrace their steps in order to find him. *The Hangover.*

That's it — very simple and to the point. A *logline* only has a few essential elements:

- Some idea of who the main character is.
- The main action: "searches for treasure," "finds love in an unexpected place," "battles the Empire's *Death Star.*"
- What challenge they are going to be facing.
- Some idea of the time and setting, especially if it's not a contemporary story set in the city. If it's on a farm, say that. If it's about 18th century pirates, it's important to say that.

It's very few words, so you have to choose them carefully. *Loglines* may seem simplistic, but they serve a purpose. You don't want to waste your time pitching a love story to a producer who never does anything but action films, and that producer certainly doesn't want to waste time reading a script that is absolutely not the sort of thing they are looking for.

VARIATIONS

You can say a lot with your *logline*. Here are two of them for the same movie:

- Mysteriously transported to a dangerous alien landscape, a young girl kills the first woman she meets, then teams up with three bizarrely non-human strangers to kill again.
- A tornado transports a Kansas farm girl and her dog to a magical land where she must undertake a dangerous journey to battle a witch, then find the power to take her back to her home.

They both describe *The Wizard of Oz*, but clearly one is a fantasy story for kids, and the other sounds like a very disturbing horror/thriller alien movie.

> You start selling the movie before you make it.
>
> David Cronenberg
> (*Videodrome, The Fly, Dead Ringer*)

Presentation

As with everything you do, you want your script to present you as a professional. This starts with how you package it. Obviously, be sure that you stick to the rules of formatting. Deviations from these formatting principles will scream out "amateur" to any reader in the film industry or a potential investor.

BINDING

The cover page can be plain white 20 lb. paper for shooting scripts, but many people use card stock for the cover on sales or spec scripts. Always print on three-hole paper. Use brass brads to hold them together. The most frequently used are Acco #5 Brass Fasteners. Even though there are three holes, only use two fasteners. To really flatten the fasteners and make them secure so they don't stick out in the back, cover them with something fairly heavy (like a magazine) and whack them with a hammer; it makes everything tight and secure. Some copy shops have covers that fold back and cover the brass fasteners; these are acceptable and are often used in the professional world, but are by no means necessary.

COVER

For a card stock cover, different colors are acceptable, but there should be no artwork or logos, just the title centered on the page, and in the lower left corner, the author and contact information. The next page after the cover is the *title page*, sometimes called the *fly page*. There are three sections on the title page: title, author, and contact information. Many people also include copyright and sometimes a WGA (Writer's Guild of America) registration number. Do *not*:

- Use clear plastic covers, spiral binding, or any other type of binding besides the brass fasteners.
- Write the name of the script on the spine.
- Add any cute little notes or drawings on the cover or pages.

BE PREPARED

Always have a copy of your script with you, in your bag, or in your car. You never know when you'll run into somebody who agrees to take a look at your script, or pass it along to someone who can make a decision. Don't be a clown, don't show your script to everyone you meet at the supermarket. Don't leap out from behind a car and try to force a copy of your script on an unsuspecting movie star or producer — this is more likely to get you put in a headlock by their security guard than it is to get you a movie deal.

Pitching

Most of the time, you're going to need to convince someone to give you money to make your film. Just handing someone a script is not usually the best way to convince them — people just don't want to read a random script that someone just put in their hands. The way it's done is by *pitching* the project. It's the same as a traditional sales pitch and that's what it really is — you're selling the idea of your film to somebody who has the cash or the ability to *greenlight* your project. There is no magic formula, but it's best to keep it short and sweet. You might want to start with your logline, just to get them interested, then be sure you're ready to answer their questions about the script, the budget, and where you want to go with it.

THE ELEVATOR PITCH

Speaking of keeping it short and sweet, there is a special version of pitching your project called the *elevator pitch*. It's for when you happen (purely by chance, of course!) to get on the same elevator as a producer. In this case you might only have 30 or 40 seconds to deliver your message, so you've got to boil it down to the bare minimum.

Here's one example: "I have an idea for an action film that takes place entirely in one location — an abandoned hospital. I know one we can get for free. Our characters have to fight super-strength zombies created by an insane scientist. We can do it for $600,000." If this gets their attention, you have to be ready to follow up with a logline, synopsis, script, budget, and any other material they might ask for, such as casting ideas. For more on pitching movie ideas, watch Robert Altman's great film *The Player*. It works, I actually sold a movie this way.

Production

What Is a Producer?

You have probably seen movies where the list of "producers" goes on and on; even movies that have six or seven "Executive Producers." What do all these people do? The simple truth these days is that a lot of these people do little or nothing other than help "make the deal."

On the other hand, large studio movies today are huge and complex and it does require a lot more supervision so many of the people listed as producers work long and very hard to get the movie made.

How many people does it actually take to produce a movie? Take a look at a studio movie made in the 1940s or 50s. Often there is only one Producer listed along with maybe an Associate Producer. This is how it was done back then: one person was in charge. Of course it was much simpler back then: everything was done right on the studio lot. The producer didn't have to seek out and hire a cinematographer, an art director, a set building crew and so on — all of those people already worked on the lot. Needless to say, it doesn't work that way anymore. So what does a producer do? There are several types and the exact duties are different on almost every production, but here are the broad definitions:

EXECUTIVE PRODUCER

Most often the *Executive Producer* is the person who "made the deal." In some cases, they bought the film rights to a book or a play or found a worthwhile script. In many cases, the Executive Producer is the one who arranged the financing. To be honest, nobody actually knows exactly what most Executive Producers do, other than have the power to get themselves the title in the credit roll.

PRODUCER

The *Producer* is technically the person in charge of the entire operation; they hire the crew, arrange for locations, confer with the director or the studio on the marketing strategy for the film, and many other jobs. In general they are the CEO of the operation. Sometimes you will see that the director of the movie is also the producer. This is possible if you have good people doing the actual work and all you do is approve a few decisions. On the other hand, some producers rarely even have time to sleep — their jobs are endless.

ASSOCIATE PRODUCER

The definition of what an *Associate Producer* is and does is ambiguous. They are basically whatever the producer needs them to be. Sometimes *Associate Producer* is a vanity credit given to a UPM or Line Producer.

LINE PRODUCER

The *Line Producer* is the real day-to-day manager of the operation. The Line Producer makes the budget for the Producer and Executive Producer to approve. The LP negotiates the contracts, runs the production office and tries to keep everything under control — it's a tough job with long hours and tons of headaches.

UNIT PRODUCTION MANAGER

The UPM is hands-on management. They generally stay in the *production office* and spend a lot of time on the phone keeping things running smoothly: deliveries, pickups, crew contracts, payments — all the thousands of details and paperwork that are necessary to keep a movie set operating. They may negotiate deals for locations, transportation, crew and other things. Frequently, the Line Producer and UPM are the same person and may go by either title. On many low-budget and ultra-low-budget productions, of course, we are often back to the old way of producing: producer, line producer, UPM — one person does it all — no sleep.

The Production Team

The Executive Producer and Producer may seldom or never visit the set; it's up to the production team to actually make the movie. There's two parts to this — the *Production Office* and the *Set*.

THE PRODUCTION OFFICE

The Line Producer and UPM will usually work in the office, assisted by a *Production Office Coordinator* and several *Office PAs* (*Production Assistants*). There might also be a bookkeeper and other personnel, all depending on how big the project is.

ON THE SET

The *AD* (*Assistant Director*) is in charge of production on the set, assisted by *Second ADs* and *PAs*. We'll talk about them more in the chapter *The AD Team*.

Pre-production

Pre-production is extremely important. If you are not thorough and careful in *pre-pro* or *prep* (as it is usually called), don't expect things to go smoothly on the set! In the pre-production phase, the movie is designed and planned. The production company is created and a production office established. A production budget will also be drawn up to establish the cost of the film.

Pre-production usually only commences once a project has been developed and is *green lit* (given the go ahead to start production). At this stage a project will generally be fully financed and have most of the key elements such as principal cast, director and cinematographer in place, as well as a screenplay which is satisfactory to the financiers. Or not.

During pre-production, the script is *broken down* into individual scenes and all the locations, props, cast members, costumes, special effects and visual effects are identified (we'll talk about *breakdowns* later). An extremely detailed *schedule* is produced and arrangements are made for the necessary elements to be available to the filmmakers at the appropriate times. Crew is hired and *deal memos* are signed. Sets (if there are any) are constructed, the crew is hired, financial arrangements are put in place and a start date for the beginning of *principal photography* is set. *Location scouting* is an important part of pre-pro and should start as soon as possible. At some point in pre-production there will be a *read-through* of the script which is usually attended by all cast members with speaking parts, all heads of departments, financiers, producers, publicists, and of course the director.

Even though the writer may still be working on it, the screenplay is generally *page-locked* and *scene-numbered* at the beginning of pre-production to avoid confusion. This means that even though additions and deletions may still be made, any particular scene will always fall on the same page and have the same scene number. How to lock pages and scene numbers will be detailed later in this chapter.

OTHER DEPARTMENTS

The *Director*, the *Cinematographer*, the *AD*, the *Art Director*, the *Gaffer* and the *Key Grip* will all have pre-production to do as well. It might be as little as a day or two on short films up to weeks or months on a large feature.

LOCATION SCOUTING

We'll talk about this in more detail later, but finding locations is an important part of pre-production. It involves the director, producer, cinematographer, gaffer, key grip, audio and art department heads.

Figure 2.1. Good, fast, cheap. Pick any two.

The Basic Law of Producing: Everything takes longer than you thought it would; everything costs more than you ever imagined.

Making a Budget

There are three key documents that guide a production: the *script*, the *budget* and the *schedule*. Scripts we talk about elsewhere but the budget is central to the producing of a film and the schedule is critical to the actual work on the set.

The budget is crucial to almost everyone who works on the film: it determines how everything it will be done. Will you rent a studio and build elaborate sets or will you need to try to borrow somebodys house for the weekend? Will you shoot on Imax film or will you use a borrowed DSLR camera, or even shoot on an iPhone? Can you get Al Pacino or will you have to act the part yourself?

Most often, the budget starts out with a final figure in mind, usually the amount of money you know you will have available or the amount of money you are going to go looking for. You might decide that it will be a $50,000 movie or a $50 million movie or that you are going to shoot it for $500 in your own apartment.

Whatever the final amount is: you have to make the movie "work" for what you have. The next step is figuring out how to allocate that amount of cash toward all the right things: making sure none of it gets wasted but also trying to be sure that the important things have enough money to get the job done as well as possible. That's the budget process: figuring out how much to spend on each separate thing that needs to get done.

THE BUDGET FORM

Blank budget forms for small, medium and large projects can be found on the website that goes with this book. They are in both printable form and in Excel/Numbers format. You can also make your own budget form on your computer. On the website are budget forms for medium budget productions, low budget, and extremely low budget. There is also very good software available for doing movie budgets, but for low and low-low budget productions it often isn't necessary, or is far too detailed to be helpful.

BUDGET CATEGORIES

All budgets work the same way, no matter if they are for a $200 million studio movie, a $10,000 ultra low-budget independent film or a $500 student film — they divide the items that need to be paid for into logical categories and then break those down into individual items.

For example, the lighting. We know we are going to need lighting, but there is more to it than that. If you are going to use your own lights and camera, then these are not a problem, but they make a good example for understanding budgets. Lighting has three categories: people, equipment and *expendables*. People consists of the *gaffer* (head of the lighting crew) and *electricians* (who work for the gaffer). The second category is the lighting equipment itself — most likely a rental.

RENTALS, KIT FEES AND EXPENDABLES

The third category is *expendables*. What is that? Expendables are things that you need to purchase and which get "used up." Some examples: *gels* (which change the color of the light) and *diffusion* (which makes a hard light "soft"). Other examples of lighting expendables is things like *clothes pins* (*C-47's*) (which hold the gels or diffusion on the lights), *gaffer tape*, or maybe spare bulbs.

On most productions, the lighting and grip equipment is rented, but sometimes a crew member supplies some or all equipment. Even if the *gaffer* is bringing his or her own lights, there still might be a rental fee involved — this is sometimes called a *kit fee*: a reasonable fee paid to crew members who bring equipment for your project or use up items they paid for. For example, makeup artists generally get a kit fee for the makeup supplies that get used on the film — only fair as cosmetic items are very expensive. This is sometimes called a *box rental*.

If you hire people, you have to feed them, so other categories are grouped under *set operating expenses*. Another obvious category is payments to actors. The sample *top sheet* on the next page will give you an idea of the standard budget categories.

OTHER CATEGORIES

Of course, we are just using the lighting section of the budget as an example: the same apples to all the other categories as well — you have to consider both the people who will do the job and the supplies and equipment they need to do the job. There is also housing accommodations (if you're going on location), transportation and of course the very important consideration of food — both meals and *craft services* — the snacks that are available to the crew throughout the day. Don't even dare to bring in a film crew and not feed them!

The Top Sheet

The top sheet is a summary of the budget — this one is for a very low-budget production. When you give a budget to someone, it will generally have a top sheet summary, so they can get the "big picture" of the overall budget, before they get into the details. Full sample budgets and blank budget forms for small, medium and large projects are on the website.

Figure 2.2. A budget top sheet for a very low-budget film.

Acct #	Category	Specifics	Budget
	Vampires Stole My Lunch Money	Budget Draft Date: 4/10	
001	Script & Rights		$2,000
002	Producer		$3,000
003	Director		$3,000
004	Cast		$3,200
		ABOVE THE LINE TOTAL:	**$11,200**
005	Travel		$0
006	Hotel & Lodging		$0
007	Catering/Craft Services		$2,400
008	Camera	Equipment, Expendables	$1,200
009	Grip	Equipment, Expendables	$900
010	Lighting	Equipment, Expendables	$1,050
011	Production Designer		$3,000
012	Art Dept. Crew		$2,500
013	DP		$3,600
014	Camera Crew		$3,200
015	Still Photographer		$500
016	Grip Crew		$2,500
017	Electric Crew		$2,500
018	Locations	Fees & Permits	$1,000
019	Art Dept	Props, Set Dressing, Wardrobe etc.	$1,200
020	Transportation	Rentals and Parking	$900
021	Office Expenses	Paper supplies, fax, internet etc.	$400
022	Petty Cash		$500
		PRODUCTION TOTAL:	**$27,350**
023	Cards and Hard Drives		$350
024	Editorial		$1,200
025	Color Correction		$1,200
026	Audio Post		$800
027	Shipping		$100
028	Marketing	Festival fees, postage, posters	$500
029	Insurance		$1,400
030	Contingency	10% of production costs	$5,835
		POST-PRODUCTION TOTAL:	**$11,385**
		GRAND TOTAL BUDGET:	**$49,935**

Budget Details

Here's a sample page from a typical medium budget film that will be shot in LA and on location in Maryland. This is just one page of many. You'll notice an item "Key Grip Box." *Box rental* is the same as a *Kit Fee* — paying a crew member for equipment or supplies they provide. This is only one page of many.

Figure 2.3. One page of a typical budget form.

Acct #	Description	Amount	Units	X	Rate	Subtotal	Total
25-00	SET OPERATIONS (CONT'D)						
25-04	DOLLY GRIP (CONT'D)						
	LA Hire						
	Prep	28	p.hrs		30.18	845	
	Shoot LA	88	p.hrs		30.18	2,656	
	Wrap	22	p.hrs		30.18	664	$13,324
25-05	AIR CONDITIONING		Allow		5,000	5,000	$5,000
25-08	CRAFT SERVICE						
	MD Hire						
	Prep	14	p.hrs		24.21	339	
	Shoot	292	p.hrs		24.21	7,069	
	Wrap	8	p.hrs		24.21	194	
	LA Hire						
	Prep	14	p.hrs		29.13	408	
	Shoot LA	88	p.hrs		29.13	2,563	
	Wrap	8	p.hrs		29.13	233	$10,806
25-09	MISCELLANEOUS LABOR						
	Rigging Labor Location	630	p.hrs		24.21	15,252	
	Rigging Labor LA	350	p.hrs		29.13	10,196	
	Craft Service Labor Addtl	180	p.hrs		29.13	5,243	$30,691
25-16	PURCHASES						
	Expendables						
	Lumber		Allow		2,000	2,000	
	Gels, etc.		Allow		5,000	5,000	
	Craft Service Supplies	26	Days		750	19,500	$26,500
25-17	OUTSIDE RENTALS						
	Key Grip Box	26	Days		50	1,300	
	Craft Service Box	26	Days		75	1,950	
	Grip Package	5	Weeks		1,500	7,500	
	Bus Mounts		Allow		1,500	1,500	
	Condors, Scissors		Allow		4,500	4,500	
	Dollies	5	Weeks		1,500	7,500	
	Crane	3	Days		2,000	6,000	
	Other Miscellaneous		Allow		2,500	2,500	
	First Aid Box Rental	26	Days		20	520	$33,270
25-85	OTHER COSTS						
	Loss & Damage		Allow		1,500	1,500	$1,500
25-86	FIRST AID - LABOR						
	MD Hire						
	Prep	8	p.hrs		24.21	194	
	Shoot	292	p.hrs		24.21	7,069	
	LA Hire						

Script Marking

The first step in making a budget is to *mark up* the script. This identifies important things that will affect the budget and the schedule: how many actors for how many days each, how many stunts, props and so on. It is usually done by the AD or the Line Producer/ UPM.

EIGHTHS OF A PAGE

Each scene, (slug line) is divided into 1/8ths of a page by its number of inches. Standard script pages are eight inches, so each inch is an 1/8. The number of 1/8ths is then marked in the top left corner of the scene and circled. If a scene lasts longer than eight 1/8ths (a full page), it is converted to 1. So, a scene lasting 1 page and 3 1/8ths is marked 1-3/8ths.

MARKING

An AD or UPM marks the *elements* found in each scene. This process repeats for each new scene. By the end, you will be able to see which scenes need which elements, and can begin to schedule accordingly. Of course, software is now available that allows you do this on a computer instead of manually marking the scripts with colored pens. There are widely accepted standards for color coding:

ELEMENT	MARKING	DESCRIPTION
Cast	Red	Speaking role.
Stunts	Orange	Any action that may require a stunt performer or stunt coordinator.
Extra	Yellow	Any extra needed to perform specific action, but has no spoken lines.
Atmosphere	Green	Any extra or group of extras needed for the background.
Special Effects	Blue	Any special effect.
Props	Purple	All objects used by an actor.
Vehicles/Animals	Pink	Vehicles or animals, especially if it requires an animal trainer or vehicle coordinator.
Music/Sound EFX	Brown	Sounds or music requiring specific use on the set.
Wardrobe	Circle	Specific costumes needed for production. Also noted for wardrobe continuity (such as ripped or blood-stained).
Makeup/Hair	Asterisk	Special makeup, hair or wigs required.
Special Equipment	Box	Any special equipment, such as crane, underwater camera, etc.
Production Notes	Underline	Any other questions about how a scene will go or how something happens.

Figure 2.4. Script marking conventions.

Breakdown Pages

Once you have marked up the script, you'll record the elements of each scene on a *breakdown form* (of course, there are software apps that will do this, but they are not cheap). A *breakdown* is a summary that lists the needed elements for a scene: props, wardrobe, stunts, and so on.

Often each department will do their own breakdown: the DP and gaffer will do a breakdown of what lights are needed and when, the art department will list what set dressing is needed for each scene, hair and makeup will have a list of wigs needed, and so on. A breakdown form you can use on the computer or as a printout is on the website.

Figure 2.5. A breakdown sheet.

BREAKDOWN PAGE # _____

SHOW _____ PRODUCTION # _____

EPISODE _____ DATE _____

LOCATION _____

SCENE #'S	DESCRIPTION	NO. OF PAGES
	(INT)(EXT) (DAY)(NIGHT)	
	TOTAL	

NO.	CAST	BITS/DOUBLES	ATMOSPHERE
		WARDROBE	PROPS/SET DRESSING
		SPEC. EFFECTS	TRANS/PIC VEHICLES
	STUNTS	MUSIC/SOUND/CAMERA	WRANGLERS/LIVESTOCK
	HAIR/MAKEUP	SPECIAL REQUIREMENTS	

Tech Scout

Once the locations have been chosen, there will be a *tech scout*. Often this is in the last week before production, when all key crew members are on the payroll. On this scout (called a *recce* in the UK and elsewhere — a reconnaissance), the director will be joined by the AD, production designer, cinematographer, gaffer, key grip and the sound recordist; possibly also *transpo* (transportation coordinator), mechanical effects and others who need to know about the location.

Don't just look at a location to decide if it has the right look or not — that's important, but it is also critical to look at it from a practical, logistical point-of-view: is there a place to park the vehicles, is it noisy? All these factors will be important if you don't want your shoot day to be painful and chaotic.

THE WALK THROUGH

Of all the things that happen on the tech scout (or on later visits), one of the most important is the *walk through*. This is where the director walks through each scene that will be shot at that location and describes her ideas about how the scenes will be staged and shot.

As the director walks through the scenes and explains what she wants to do, the DP, AD and others carefully observe and make notes about how they will help the director accomplish his or her goals for the scenes. The DP will be starting to think about the lighting and camera moves; the AD will be thinking about how long it will take to set up and shoot the scene (and thus how it fits into the schedule).

As they watch, the gaffer and grip will be thinking about their contributions as well. The DP might be whispering in the gaffer's ear (or vice versa) about lighting possibilities or potential problems. One thing the DP, gaffer and grip will want to know is which way are we looking (where is the camera pointing) for each scene. More importantly, they need to know which way are we *not* looking. This is important for deciding where they can place lights, stage equipment, run cable, etc. The director may not know right then, but eventually that decision has to be made and the sooner the better.

The grip is going to be alert for any mention of dolly moves, crane shots or anything else he might have to order special equipment for, add additional crew (*day players*) for or prepare in any way. Possibly the DP and gaffer will be discussing putting a large light outside a window. If the room is not on the first floor, this might involve scaffolding or a crane or something else that the grip needs to attend to. Hopefully, the location scout video and photos will have told them if there is a fire escape or roof outside the window where they can place a light.

POWER

The gaffer will also be checking out the power situation. Depending on what the DP is thinking about for lighting, is the available power sufficient, either through the wall outlets or through a *tie-in* (direct connection to the power supply of the building) or is a generator going to be needed? If a generator is called for, then the gaffer needs to talk to the AD about where to park it and possibly discuss this with the sound recordist if it is going to create a noise problem. The sound department is always going to ask for it to be as far away as possible and this is something the gaffer needs to think about when deciding how much power cable to order.

ACCESS

Don't forget to check out access. Will it be possible to get the grip truck close enough? Are there staging areas for electric (lighting), grip, camera and the art department? Are some doors locked at certain hours? If so, who has the key? Do you have their contact phone number? Is there a loading dock? What's the elevator situation?

Will bathrooms be available? If not, you may need to provide a portable rest room of some sort, either a camper, a portable toilet, or on larger productions, a special vehicle called a *honey wagon* will be rented. This may be in conjunction with dressing rooms in the same trailer.

Script Pages and Scene Numbers

As mentioned in the last section, the script is the key document that coordinates the whole production. It's what the AD or line producer bases the *breakdown* on, but each department does their own breakdown as well (although not usually as formal as the breakdown sheets that production does). For example, the props department will make a list of all the props required for each scene and decide if they are to be bought, rented or made. The cinematographer will analyze the script and decide if special camera or lighting equipment is required for a particular scene and then share that information with the gaffer, who will make a list of the electrical equipment needed to support that special lighting, also any gels, diffusion or additional gear that is required. Of course, if it's not in the budget, there will be some negotiation with the line producer or production manager.

LOCKED SCRIPT

All this means that everyone makes notes in their own copies of the scripts, and importantly they refer to specific scene numbers. For example, the key grip and gaffer may talk about the scaffolding required for a big light in scene 27 but not needed for the rest of the film. The prop people may note that a laptop computer is needed for scene 27 and so on. Now suppose there's a rewrite of the script (there always is) and a new scene is added before 27. We change the script so that scene 27 is now scene 28, right?

Obviously not — that would create chaos. When the script is changed, especially in big ways, it's very tempting to just print out a whole new set of scripts and distribute them. That isn't the way it's done — it's wasteful and people would lose all of their notes in the script. Instead, the new scenes are given special numbers; for example, a new scene before scene 27 is called A26. If another scene is added after that, it is AA26, etc. If a scene is eliminated, the number stays there, but in the new pages it is listed as "Scene omitted." The same applies to page numbers: if the new scene that's added results in an extra page after page 66, it is then called A66, so that the rest of the page numbers will stay consistent. Many times the script revisions will include adding new pages. The numbering will not change, but again letters are added in. So there may be 3 different page 22s but they will be numbered 22, 22A and 22B.

This means that it's important that everyone receives a copy of the original white paper script that has the same page and scene numbers. In order to do that, the script is "locked" at a certain point — meaning the original scene numbers don't change for the rest of the production. Traditionally, this was a decision made by the AD, but now many screenplay apps also have an option to lock the script pages. Ultimately, though, it is up to the AD to lock the script; it's not a decision to be made by the screenwriter.

Each changed page (or pages) is then printed out and distributed to everyone who has a script — not just the actors, but the DP, gaffer, wardrobe, makeup — everybody. Clearly, this could get to be very confusing very quickly. How is anyone going to know what is the latest, most up-to-date version?

It's done with a simple color code that's been around for a long time. The original script is printed on white paper and then each round of new changes is printed on a different color of paper. This way, when people add new pages to their script, it's easy to keep track of what's new and to see if your script is the most recent version.

SCRIPT PAGE COLOR CODE

The color code for pages is:

- Original locked draft — White Paper
- Blue Revision
- Pink Revision
- Yellow Revision
- Green Revision
- Goldenrod Revision
- Buff Revision
- Salmon Revision
- Cherry Revision

Putting a Crew Together

On a student film your crew will consist mostly of friends and classmates, but on anything larger, you're going to need outside help. There are competent film technicians in just about every city and every country, and finding them isn't usually difficult. Many have websites or other contact information, many will respond to ads but the most effective resource is referrals from people you trust. Since a typical film crew even on a small independent film is 40 people or more, assembling a crew can seem daunting.

It's not as daunting as it sounds; actually, the line producer only has to hire the *keys* (top person in each department), and then the keys hire the rest of the people for their department. The departments are:

- Production
- AD (Assistant Directors)
- Camera
- Digital Imaging Technician
- Production Design
 - Set Dressing
 - Props
 - Armorer (if weapons are involved)
- Audio
- Video Assist (sometimes)
- Lighting
- Grip
- Makeup
- Hair
- Stunts (sometimes)

As an example, it would be a big mistake to hire a key grip, and then on your own hire a second grip, and third grip. The key grip has to be their supervisor and is responsible for their work. If you hired people he or she can't get along with or someone who doesn't do their job, it's unfair to the key who has to deal with it. Similarly, it is always the director's privilege to select their cinematographer — the two of them have to work closely together for days, weeks or even months.

The cinematographer then selects their own camera operator (if there is one) and First AC. Technically, the First AC is the head of the camera department as crew members. Of course, the DP calls the shots of what goes on in the camera area, but it's the first AC who hires the assistants, supervises them, signs time sheets, and so on.

> Collaborate, don't dictate. Every department head has something to offer. Listen and gratefully accept their offerings. They're moviemakers, too.
>
> George A. Romero
> (*Night of the Living Dead*)

Permits

What permits are needed depends on what city, town or county you are shooting in. Some places are easy and some are very strict. Shooting without a permit is a big risk; not that you'll be put in jail, but you've spent all the time, energy and money to get ready to shoot and if the police shut you down, all that is wasted. In most localities, getting a permit is quick and easy. Be sure to have your permit with you any time you're on location.

In general, how difficult and expensive it is to get permits depends on how much filming is done in that area — the more that city is used for filming, the more strict they become about permits. For example, in Los Angeles, if you are shooting in a *fire zone*, you may also need to employ a county approved fire marshal. If there are any *traveling shots* (shooting with moving vehicles) then a motorcycle deputy sheriff or police officer will also be required. This may seem like an unnecessary burden, but you will find that these motorcycle officers in particular really know their business and can be very helpful to your production.

In most localities, a film commission or film board handles permits. In some cases, another city or county office handles them, sometimes the police or sheriff's department. Be sure you have all the necessary information before going to the office. It isn't usually enough to say "We'll be shooting in some alleys downtown on Tuesday." They will need to know what exact locations you need, day and times, approximately how many people will be there, how many vehicles, that sort of thing. Just give them a call and most of the time they'll be really helpful.

STEALING SCENES

Sometimes you gotta' do what you gotta' do. For very short scenes and especially if you're shooting off the beaten path, it is sometimes possible to steal a scene or steal a shot; in other words, quickly shoot without a permit. The reality is that you probably aren't going to get carted off to jail but you have to realize that it's still a risk: if you put all that effort, time and money into equipment, transportation and crew, you have to seriously ask yourself the question of what will be the consequences if you aren't able to get the shot or if you are only able to finish half the scene before you are stopped.

PICKUP DAY

Stealing scenes like this is most common on *pickup days* where the shooting is *run-and-gun*. No matter how carefully a production is planned; no matter how thorough the director, DP and crew are, there is always the chance that as the editor is working on the film, they will discover a few shots that are just absolutely essential to making a scene work. The director and editor may also decide that some essential scene just isn't working for the story and needs to be reshot, or perhaps was never shot at all.

Pickup days generally happen after the film has been in editing for a few days or even weeks, usually when a rough cut has been completed and everyone can view the complete story and get a better idea of what is working and what needs improvement. Once a list of required shots is put together, a small *skeleton crew* is put together, often just the DP, a camera assistant, a grip, the script supervisor and maybe a prop person. Often they will all just jump in a van with a camera, tripod and maybe a few flags and C-stands. Along with the director, the actors and the First AD, this small unit will then drive around to various locations and quickly grab the needed shots or short scenes.

In some cases, bigger scenes are needed which involve sets, locations, lighting and maybe a dolly or crane. In that case, a more substantial crew will be needed, along with the necessary vehicles, permits, catering and so on.

RESHOOTS

Having to reshoot a scene is a big deal, and not in a good way. It looks bad for the director to have to reshoot a scene, very bad. Most of the time it's much more expensive to reshoot a scene — the location you rented by the week for a reasonable rate, you now have to rent at a much higher daily rate. Same with the crew, props, vehicles, actors and so on. Worse, the actors or locations may no longer be available. It's why everyone has to pay close attention when shooting a scene — you don't call wrap until everybody, especially the director, is absolutely sure they really have the scene and all the shots that make it up. On bigger films, it is normal to not tear down the sets until the producers, editor, and director have looked at the *dailies* — the footage of what was shot that day.

Location Scouting

Locations are an important part of any film; unless you're building everything in a studio of course (which isn't likely on a low or even a medium budget film). Finding the right locations is an important job and it's usually done by a *location scout*. There are many fine location scouting services and also state film commissions can be very helpful in finding the right places for your production. If you can't afford a location scout, then it's often the director and producer who have to find the right places to shoot.

It's important to think about locations not just as having "the right look" for your film — you have to think about them as practical and logistical problems as well. When you're scouting locations, think about what it's going to mean to bring a whole film crew there — is there enough parking for the actors, crew and the production vehicles? Is there electrical power? Are the neighbors going to object to the noise? Is this a place that's hard to get permits for? Is there a lot of ambient noise, such as a freeway nearby?

IT'S ABOUT TIME

If at all possible, scout the location at the approximate time you'll be shooting there: day or night, weekday or weekend, etc. Observe the light, listen for traffic noise, think about when gardeners might be mowing the lawn, etc.

LOCATION CHECKLIST

Here's a checklist of things to think about as you scout locations:

- Travel time — how long will it take to get there? Will cast and crew have to stay overnight? If so, are there accommodations nearby?

- Is there parking for cars and trucks? Will the parking be free or cost money? Note that cast and crew should never be required to pay for their own parking.

- Is there enough electrical power or will you need a generator? Remember that it's not just the lights that need power — makeup, hair, recharging batteries, all these things need electricity as well. If there is power, does the electrical breaker box get locked up? Who has the key? Will he or she be available when you're shooting there? Do you have to pay them to be there?

- Are permits needed? Is this city easy with permits or very strict? Are there time limits? — some cities absolutely require *tail-lights at 10*, for example. *Tail-lights* doesn't mean you stop shooting, or you start packing up — it means the trucks are actually pulling away at 10.

- Are there stairs or elevators? If there's a service elevator, can anyone use it or do you need building personnel to operate it?

- Is there a loading dock? Is the door locked? Who has the key? Do you need to pay them to stay after hours?

REPORTING BACK

When location scouting, be sure to take lots of photos and videos of the location (do both). Get wide shots and be sure to get 360° views. Photograph the parking, entrances, and so on, not just the "pretty view" you're thinking of using — document the entire location, including even where you think catering might be set up, the loading dock, etc. Show how high the ceiling is, where the windows are, and so on. Draw a diagram and be sure to include elevators, stairs, access points for cable, windows and doors. If there are problems, be sure to show them. If you're doing a medieval knights picture, for example, get a photo of the microwave tower on the nearby hill and indicate what direction it is from the location so the director, DP and production designer can think about how to solve it.

TECH SCOUTS

There is another type of location scout called a *tech scout*; it's where the UPM, AD, director, DP, gaffer, key grip and sound recordist visit the sets to finalize plans. These are very important, don't skimp on tech scouts. For the DP, gaffer and key grip, tech scouts will be about seeing what problems they face, what equipment needs to be ordered and if any extra crew might be required.

Location Checklist

Location Scouting Form

Production Title: _____

Scene #s: _____

Location Name & Address: _____

Contact Name and Phone: _____

Key Held By: _____ Phone: _____

Availability: _____

Restricitons: _____

Parking: _____ How Close to Set? _____

Bathrooms: _____ Place For Catering: _____

Closest Hospital: _____ Phone: _____

Loading Dock: _____ Key Held By: _____

What Floor is the Set On?_____ Stairs and Elevators: _____

Electrical Power (amps): _____ In a Locked Area?_____ Key: _____

Potential Audio Problems: _____ At Time of Day: _____

Condition of the Space: _____

Windows, Skylights, Ambient Light: _____

Overall Look: _____

Potential Problems: _____

Photos and Video Stored With: _____ Phone: _____

Figure 2.6. A location scouting form

Sample Contact List				
Position	Name	Cell	Phone	Email
Producer	Jamie Dogh	555-100-5592	555-666-1212	Gotdedoh@somemail.com
UPM	Alonzo Unidad	555-362-7821	555-656-5623	Goturunin@somemail.com
Director	Lothar Hasmat	555-111-5592	555-323-1234	Anddehandpeople@somemail.com
First AD	Don Atello	555-100-5592	555-424-5678	donatello@somemail.com
Second AD	Samy Smarts	555-212-5592	555-525-9101	Likedewhip@somemail.com
Second Second AD	Dulles Nives	555-323-5592	555-626-1112	Notdebritest@somemail.com

Contact Lists

Everyone needs to know how to contact crew members, actors, producers, caterers and so on. Some actors don't want their phone numbers made public; those contacts are only given to the production team. Figure 2.7 is an example of a contact list.

DAY OUT OF DAYS

The *Day Out of Days* report is a chart that marks the actor's work days. It's an important organizational tool to make sure the actors are being used efficiently. It also helps ensure that the schedule of each actor is reasonable. It would be wrong to have an actor work one day at the beginning of the shoot, then expect them to hang around until they work one more day at the end of the shoot. This could prevent them from getting other jobs, traveling, etc. It's just a good idea to be as considerate as possible of other's people's time.

The standard abbreviations that are used include: *SW* stands for *Start Work*, which indicates the actor's first day working on set. *W* stands for *Work*. *WF* stands for *Work Finish* — the actor's last day on the job. *SWF* stands for *Start-Work-Finish*, for when an actor is only needed on one day.

The rest are optional: *H* stands for *Hold*. Used when an actor isn't needed, but is still on call and paid. *I* stands for *Idle*. This functions just like a *Hold*, but is not paid. *T* stands for *Travel*. It means your actor is traveling. *R* is for *Rehearsal*. Use this when your actor is called to rehearse, but not shoot. *WD* stands for *Work-Drop*. Some people use this on the actor's last day before a seven or more day hiatus. *PW* stands for *Pickup-Work*. Use this when an actor comes back from hiatus. *PWF* stands for *Pickup-Work-Finish*. Use this when it's your actor's first and last day on the job. *SR* stands *Start-Rehearsal*. Use this when your actor is rehearsing and it is his or her first day.

Figure 2.7. A sample contact list. This is only part of it; the contact list should include every member of the production staff, cast, crew, services (such as the rental houses) and locations.

Figure 2.8. (opposite page) A location scouting checklist.

Figure 2.9. A *Day-Out-Of-Days* report.

Actor #	Day/Month	8/9	8/10	8/11	8/12	8/13	8/14	8/15	8/16	8/17	8/18	8/19	8/20	8/21	8/22	8/23
	Day of the Week	Mon	Tues	Wed	Thurs	Fri	Sat	Sun	Mon	Tues	Weds	Thurs	Fri	Sat	Sun	Mon
	Shooting Day	1	2	3	4	5	6	7	Off	8	9	10	11	12	13	Off
	Character Name															
1	Samy	SW	W	W	W	W	W	H		W	W	W	W	W	WF	
2	Sosi		SW	W	W	W	W	W		W	H	H	W	W	WF	
3	Tulse Luper		T	SW	W	W	WF									
4	Doc Watson											SW	W	W	WF	
5	Julius C. Ser	SW	W	W	W	W	WF									
6	Daniel						SW	W		W	W	WF				
7	Cal Worthington			SW	W	W	W	SW								
8	Lillies O. L'Vallet									SW	W	W	WF			
9	Lettitia Von Picklebottom			SWF												
10	Harris Unford			SWF												
11	Teacher			SW	W	W	W									
12	Teacher's Assistant			SW	WF											
13	Model #1		SWF													
14	Model #2			SW	W	WF										
15	Student #1		SW	W	W	WF										
16	Student #2		SW	W	W	WF										
17	Bartender									SW	WF					
18	Guy at the end of the bar #1									SW	WF					
19	Guy at the end of the bar #2									SW	WF					
20	Guy at the end of the bar #3									SW	WF					
21	Delivery Guy											SWF				
22	Driver											SWF				
23	Lady Waiting												SWF			
24																

W=Work SW=Start Work. H=Hold. T=Travel WF=Work Finish SWF= Start Work Finish Dr=Drop. P=Picked up

Transpo

Vehicles are part of just about every production: cast and crew have to be transported if they don't drive to the set themselves, trucks are used and there might be car chases and so on. Generally, vehicles fall into three categories:

- Cast and crew transportation.
- Equipment transportation — trucks or vans. Generators, if you're using them.
- *Picture cars* — vehicles that appear in the movie, either driven by actors or stunt drivers.

TRANSPO COORDINATOR

All vehicles fall under the supervision of the *Transportation Coordinator*, often called *Transpo*. On a union project, this will be the *Teamster Captain*. These folks know what they're doing — listen to their advice. On very small projects, camera gear, sound cart, props and wardrobe departments may need to squeeze into one cube truck or even a van.

Finding places for all the cars and trucks is an important consideration — you will be amazed at how many vehicles are involved in even small, low-budget productions. For cast and crew, vans or buses can be used to get them to the shooting location or shuttle buses can bring them from a parking lot nearby, but the production trucks absolutely have to be very close to the place where you're actually shooting. At an absolute minimum there will be at least a *grip truck*, which despite its name will often have both the grip and lighting equipment, as well as the cameras on small films. These trucks are usually classified as being either *five-ton* (smaller) or *ten-ton* (larger) trucks. Most will have lift-gates but some smaller ones may have a ramp.

On large productions, the trucks will be *forty-footers* — the same kind of tractor-trailer truck you see on the highways. On bigger productions, grip and lighting will each have their own trucks, but so will the art department and possibly special EFX and wardrobe. Production may sometimes rent an RV (recreational vehicle) to use as a mobile production office; makeup and hair also sometimes use RVs.

SWING TRUCKS

How many trucks or vans there are depends on how big the production is, whether you're on location or a stage, etc., but one principle applies at all levels: you can't use the main production vehicles for pickups, deliveries, lab runs and so on. The most obvious example is lighting. The grip truck or whatever vehicle has the lighting equipment absolutely must stay on the set. However, it frequently happens that additional gear needs to be picked up or returned (especially big lights that you might only need for a day or two). For this you'll need one or more *swing trucks*.

HONEY WAGONS

Particularly in larger cities, specialized vehicles with dressing rooms and cubicles for makeup and hair are available. Importantly, *honey wagons* can also be rented in many cities — these are trailers with several bathrooms for cast and crew. If it's not in your budget or there isn't one available, sometimes you can use an RV, or make arrangements with a local store, diner, or service station to use theirs. People have to use the bathroom — provide for it!

THE MOST IMPORTANT TRUCK OF ALL

There is one vehicle that everyone will use: the *catering truck*. While lunch might be served on the set and *craft service* snacks might just be on a table, many productions will hire a catering truck that serves as a mobile kitchen and serving center for meals and snacks. On the West Coast in particular, but in other places as well, it is hard to think about starting a shoot day without a breakfast burrito and a cup of hot coffee!

On smaller productions where there is no catering of meals, it will be up to the Production Assistants to make sure coffee is available in the morning. Coffee pots take quite some time to heat up, so the PA in charge of coffee needs to show up early to plug it in and it's important that electrical power be available for them to get started. A crew without their morning coffee and some breakfast is not a happy crew! Also be sure the bottled water and soft drinks are on ice well in advance.

PARKING

Finding places to park the vehicles is a huge task. You can usually get permits to park the camera, grip, wardrobe, makeup, and honey wagons on the street near the set, but parking for crew and cast vehicles is also important.

Production Report

The *Daily Production Report* (also called the *Daily Progress Report* or *End of Day Report*) is to keep the production office and producers up to date on what is happening on the set: what was accomplished, what scenes were finished, how much footage was shot, etc. The very top lists the production company name, production title, director, producers, unit production managers, assistant directors, the total number of scheduled production days, and the current production day. Some production reports also summarize information from the paperwork of other departments. These include:

- Detailed script notes from the Continuity Supervisor.
- The Sound Report details. What was recorded, what reel (or hard drive) it's on, what takes are where, etc.
- If the actors are union, some paperwork that documents start times, meal times, meal penalties, etc. are important for the payroll people in the office. The actors sign these documents at the end of their work day. Similar forms cover the extras (background artists) and details of their work day that relate to how much they are due from payroll.
- In/out and lunch times for the crew. This is especially important for union shoots.

The report is usually completed by the *Script Supervisor (Scripty)*, a *Second AD*, or someone designated as the *Paperwork PA*.

DAILY PROGRESS REPORT
Teen Vampires In Love

Shoot Call	9:00 AM	Date	10/4/2017
1st Shot	11:00 AM	Shoot Day	3
		Prod. Per.	Fall 17
Lunch	12:55 AM		
1st Shot	1:10 PM	Title	Teen Vampires In Love
Dinner		Director	Stephanie Troy
1st Shot			
Cam. Wrap	6:45 PM		

	Scenes	Pages	Minutes	Setups
Total. Script	16	9 6/8	9:58	60
Added				1
Deleted				3
New Total				58
Shot Prior	7	3 4/8	4:56	20
Shot Today	4	2 6/8	1:15	17
To Date	11	6 2/8	6:11	37
To Do	5	3 4/8		

Scenes Covered	Wild Tracks	Retakes	Remarks
6, 8, 11, 16			

Jonathan Barbato
Continuity Supervisor

Figure 2.10. A sample Daily Progress Report prepared by the script supervisor. (Courtesy Jonathan Barbato).

Releases and Deal Memos

Talent releases, contracts and deal memos are important! Don't neglect them or they are likely to cause you real problems later on.

CONTRACTS

Contracts are needed for the producers, the writer, the director and other key people. There might also be contracts for locations, studio rental and so on. Contracts must be signed by both parties — the individual and by someone from the production who has the authority to sign.

DEAL MEMOS

For the DP, designer and the rest of the crew, *deal memos* are generally used. A deal memo is briefer and less formal than a contract and it is also different in that only the crew member signs it. It's mostly for keeping track of the basic terms of the deal — what their daily or weekly pay rate is, whether they are to be paid a *kit fee* (payment for use of their tools, equipment or supplies), etc. It may also be used for tax purposes in addition to other government forms that need to be filled out.

CREW DEAL MEMO

Production Company: _____

Date: _____

Project Name: _____

Crew Member: _____

Address: _____

City: _____

State: _____ Zip _____

SS# _____
(Or)

Fed. I.D# _____

Phone #: _____

Driver's License # _____

Email Address: _____

★★★★★★★★★★★★★★★★★★★★★★★

(Items Below To Be Completed By Production Company)
Position: _____
Start Date: _____
Est. Finish Date: _____

Production Rate: $ _____

Kit Rentals: _____
Total For Production: $ _____

Additional Terms_____

Screen Credit: (End Credits): _____

Figure 2.11. A sample *Crew Deal Memo*.

Talent Releases

Perhaps no other piece of paperwork can screw up your movie more than the *releases*, or rather, the lack of them. Maybe you hire an actor and in the beginning everybody loves everybody else, everybody is happy with the money arrangements and so on. But things change. By the end of the shooting, there might be bad feelings or financial arguments or any one of a dozen other problems. If that actor has not signed a release, they can then refuse to sign one later and as a result you can't show your movie anywhere. It doesn't matter if you spent a million dollars making your movie, the lack of that one release can mean it all was wasted. So don't forget to have everyone sign releases. If they are members of the actor's union (SAG) then there are more detailed and complex forms that also need to be filled out.

Besides actor releases, you will need releases for specific locations. Many famous buildings are also protected by copyright or trademarking, so you might need permission and a release in order to show them in your film. As with all these forms, it is on the website, where you can print it out, save as a PDF or use it in whatever form you like.

WHY RELEASES ARE IMPORTANT

- An actor who didn't sign a release might later ask you not to use the footage — they don't even have to give a reason.
- Someone might not like the way they're portrayed and ask you to remove any footage with them in it.
- The location where you shot that one scene might decide they don't want to be in your film anymore.

Get them to sign a release form. Every time. You must have all the necessary forms. You also must bring them to every shoot — every day. Always get the forms signed up front — before shooting starts. This is important!

TALENT RELEASE FORM

Project Title: _____

Talent Name: _____

I hereby consent for value received and without further consideration or compensation to the use (full or in part) of all video or film taken of me and/or recordings made of my voice and/or written extraction, in whole or in part, of such recordings or musical performance for the purposes of illustration, broadcast, or distribution in any manner.

at _____ on _____
(Shooting Location) (Date)

by _____ for _____
(Producer) (Production Company)

Talent's signature_____

Print Name_____

Address _____ City _____

State _____ Zip code _____

Email _____

Date: _____

If the subject is a minor under the laws of the state where modeling, acting, or performing is done:

Legal guardian signature: _____

Legal guardian print name:_____

Address _____ City _____

State _____ Zip Code _____ Date: _____

Figure 2.12. A sample *Talent Release Form*.

Location Release

Permission is hereby granted to _____ ("Producer") and its employees, agents, independent contractors and suppliers to enter in the property located at_____ (the "property") for the purpose of photographing and recording certain scenes for a motion picture. For the amount of $_____ dollars, the sufficiency of which you acknowledge, you agree to the statements and conditions stated in this contract concerning your Property.

Use of Property

Producer may use the inside and outside of the Property located at

from the day of _____ to the day of _____ during the hours of _____ to _____.
Producer will use the Property as a location for photographing, videotaping, filming, and/or making sound recordings. In the event of a delay in schedule due to photographically unfavorable conditions, or reasons beyond our control, an extension of this permission may be necessary.

Recording of Footage

Producer may photograph, film, videotape and record sound on the Property and use the resulting materials in any way Producer chooses.

Rights to Footage

You give us permanent, worldwide, exclusive right to own all rights to all production records and photographs. You agree to have no right to inspect or approve recordings.

Crew and Equipment

Producer may bring into the Property our crews, actors and equipment. Producer may construct temporary sets and, after completing photography and recording, will restore the Property to its original condition as of the initial date of occupancy unless otherwise agreed to by both parties in writing, reasonable wear and tear excepted.

Assignment

You give us the right to assign all terms stated in this contract. You agree to waive any further compensation or demand of any kind forever.

Hold Harmless

Producer agrees to hold you harmless from any liability and loss which may be caused by employees or equipment.

Authority

You understand the terms described in this contract. You are over 18 years of age. You have the authority to sign this contract and grant us the rights given under this contract.

Insurance

Producer represents that they are covered by Public Liability and Property Damage Insurance.

_____ _____
Date Signature

Print Name

Address

Phone

Sides

Sides are copies of the scenes to be shot each day which have been reduced down to a size that will fit in a back pocket (Figure 2.12). Scenes that are on the pages but are not intended to be shot that day are x'ed out. The small pages are then stapled together in the upper left corner and a copy is made for everyone that works on the set. A marker is used to cross out completed scenes — it's a good way to keep track of what has been shot and what is still to be done for the day. Be sure to not cross a scene out until all of the coverage, pickups and inserts have been done for that particular scene.

Figure 2.13. (opposite page) A sample *Location Release*.

Figure 2.14. (below) *Sides*, as they are distributed to cast and key crew.

38 EXT. STREET - DAY 38

 In front of butcher shop.

 From high above, we look down at the empty street. In the upper window, we can see the flashlight beam occasionally hit the window.

39 INT. BUTCHER'S APARTMENT 39

 Amy continues searching the apartment, she is now in the kitchen.

40 EXT. HIGHWAY - NIGHT 40

 The car approaches a turnaround point.

41 INT. CAR - NIGHT 41

 The Butcher sees it. He slows down as the rain intensifies; he starts to turn.

42 INT. BUTCHER SHOP - NIGHT 42

 Amy is again down in the back room of the butcher shop.

 She sees something that catches her attention. She moves to the shelves against the walls and probes them. An accidental push against the side makes the whole self move. It startles her. She pushes it again.

 The shelf unit slides aside, revealing a small door. She trains her flashlight on it.

 ON HER FACE

 Clearly she is worried and frightened by this secret door. She hesitates. She takes a deep breath and turns the door handle.

43 INT. VIDEO ROOM - NIGHT 43

 Amy pushes into the small room.

 HER POV as the flashlight beam stabs through the darkness. The walls are covered with photographs, newspaper items, printouts of video frames. Some of them are photos of the butcher. In most of them he is standing next to a freezer door. His expression is one of both happiness and a cer

tain maniacal look.

But then, the flashlight beams shows us the rest of the photos.

They are all pictures of her!

ECU OF AMY

She quivers with fear. It is terrifying to see the evidence of his obsession. She looks closer.

They are all photos of her in her high school years -- her playing soccer, her on the basketball team, newspaper clippings of her athletic wins, even her picture from the school yearbook.

Curling, yellowing photos of her at birthday parties; of her leaving the front door of her house.

The main part of it are dozens of telephoto shots of her face, her legs, her chest. Her in sexy outfits as she comes out of her house, waits for a cab. In the photos she seems to be teasing, luring the viewer.

ON AMY

She is both horrified and enraged. Amy is shaking with emotions -- shock at what she has found, terror and seeing his obsession with her and utter confusion at she is seeing.

ON THE WALL

Photos of her at home with her family. The final one is a picture of a birthday party -- a large sign in the room says "Happy Birthday Amy and..." The rest of the photo is covered by an adjoining newspaper clipping.

FLASHLIGHT BEAM MOVES ON — to photos of her working.

Finally, the beam slowly reveals a printed out video frame -- it is her on the sofa, touching herself. It is the very image she has seen in her dream!

 AMY
 (to herself)
 No... No... it's not possible.

44 EXT. HIGHWAY - NIGHT 44

 The car is on its way back.

45 INT. CAR - NIGHT 45

 The Butcher drives; peering into the rain on the road ahead.

46 INT. VIDEO ROOM - NIGHT 46

 Amy is in horror but her search continues.

 FLASHLIGHT beam REVEALS

 The DVD player. Amy's quivering hand turns it on and hits "Play."

47 VIDEO FOOTAGE - INT. LIVING ROOM - NIGHT 47

 ON THE VIDEO SCREEN is almost exact recreation of of her dream.

48 INT. VIDEO ROOM - NIGHT 48

 ECU OF AMY'S EYES

 She is overcome with panic.

49 VIDEO FOOTAGE - INT. LIVING ROOM - NIGHT 49

 THE VIDEO

 Shows her on the sofa.

 It is almost the same angle she saw it from in her dream, but not quite. The TV sizzles with static. The figure on the sofa squirms with passion.

50 INT. CAR - NIGHT 50

 The lightning is getting closer and more intense.

51 INT. VIDEO ROOM - NIGHT 51

 Amy slowly retreats from the video room.

52 INT. BUTCHER SHOP - NIGHT 52

 She backs out the video room door.

 A stab of lighting slashes through the room revealing

something she hasn't seen before...

FLASHBACK - PHOTO

...it is the freezer door that she saw in the photographs in the video room.

BACK TO SCENE

She pushes the door. It is locked. Frustrated, she stops for a moment, then...

...an inspiration.

53 INT. VIDEO ROOM - NIGHT 53

 She goes back to the video room and looks around. There on a hook on the wall is a key. She takes it.

54 INT. BUTCHER SHOP - NIGHT 54

 She tries the key. It works.

 The door CREAKS loudly as she slowly pushes it open.

 HER POV

 As she peers into the dimly lit darkness of the freezer. Fluorescent lights give it a deathly blue glow. Sides of beef and huge dressed pigs hang from giant hooks. The light shimmers on the ice that coats the walls.

 ON AMY

 The blue glow reflects on her face. She takes a deep breath and slowly moves into the freezer.

55 INT. FREEZER - NIGHT 55

 She can see her breath as moves inside. She is breathing heavily now.

 She seems small and vulnerable among the huge sides of beef. The eerie blue glow makes it a scene from a frozen hell.

56 EXT. STREET - NIGHT 56

 The cab turns a corner.

57 INT. FREEZER - NIGHT 57

 AMY'S POV

Catering/Craft Services

Smaller productions can get away with ordering in food. The occasional sandwich is possible, but technically (and certainly on union shoots) hot meals must be provided. Most producers (even on small low-budget films) have found that it is cheaper and far easier to have a caterer handle all the details. They usually work out of food trucks and provide full hot meals.

BREAKFAST

It's not an absolute rule that a production needs to provide a hot breakfast, but most projects do so anyway — it's just good business. Sometimes (especially) in a studio, it may be a *craft service* person who has a wide variety of cereals, vegetables, pastries and also has a hot plate to make eggs, omelets or the universally loved *breakfast burrito*. Hot coffee and tea is a given, of course. Even the smallest student film should have breakfast snacks and hot coffee, and hot water for tea available.

LUNCH

Lunch has to be called no more than six hours after crew call. If the production is providing lunch on or near the set, it's a 30 minute break. If you are allowing people to leave to get their own lunch, it's an hour (but it always turns out to be more than an hour). The really wrong thing (and something that will make you look like a real dimbulb rookie) is to call "lunch, half-hour") and then 30 minutes later call "We're back in!" Why is that bad? Because the last people who went through the slow-moving lunch line may well have had only five or six minutes to eat. The standard practice everywhere is that the 30 minutes starts when the last crew member has gone through the line. This is universal. A second AD or PA will be stationed at the end of the lunch table to start the clock when the last crew member goes through.

This does not apply to actors, PAs, directors or anybody else, which is why the other universal rule is that "Crew eats first!" Not even the producer or director go through the lunch line first, unless they want to be thought of as amateurs, greedy pigs or both; however, it's not unusual for the director and maybe the first AD to have a plate brought to them — they are often working during the lunch break.

Don't forget to provide for tables and chairs, preferably shaded or protected from rain; and plenty of trash bags, napkins and paper towels. Often, the caterer will provide these, but if not, then they need to be rented or borrowed. You can not get with away with having people sit on the ground to eat and calling it a picnic! Always have plenty of beverages and make sure they are cold well before you call lunch! Have plenty of water available at all times during the shoot day.

SECOND MEAL

The universal rule is that you must feed people every six hours. This means that if six hours have passed since lunch was called it's time for another meal. This is sometimes called dinner but more often is referred to as *second meal*. Keep in mind that this means that the crew and actors have now been working for 12 hours, which is something you want to avoid. Pizza or sandwiches are fairly common for second meal, and crews don't generally mind it if the day is just going to last another hour or two after second meal is over. In most cases, the caterer has already left, but they're not taking it easy; they are generally up at four or five in the morning shopping for the next day's meals.

CRAFT SERVICES

One of the oldest traditions in the movie business is the *craft service table*: it is a table near the set where there is coffee, hot water for tea and a variety of snacks: chips, vegetables with dip, cold soft drinks, and plenty of water. Peanut butter and jelly sandwiches are also popular. It used to always be doughnuts in the morning, but, for obvious reasons, people are tending to go easy on that. Don't forget to keep lots of ice on hand. Also, water — lots of water; if it's a hot day, even more water! Craft service is not an amenity, it is a requirement. A large coffee pot takes a long time to heat up; either the craft service person or a designated PA has to show up extra early to plug it in. At this time, also put the beverages on ice.

Walkie-Talkies

It is absolutely essential that the batteries be charged at all times. The Second AD or PA in charge of them must be sure that they are charged the night before use and get plugged in as soon as they arrive on set.

CHECKING OUT WALKIES

The PA in charge of walkies needs to keep track of who gets one. Keep a list of the number of the unit and who it is assigned to. It's also a good idea to put white tape on them with their assignment, such as "Grip #1, Grip #2," etc.

ASSIGNING CHANNELS

Each group using the walkies gets assigned a channel. Typically production (the ADs and PAs) get channel one, camera department gets channel two, electrics (lighting technicians) get three, grips get four, and so on.

Radio Check

Once you receive your radio, turn it on and say "Radio check." Hopefully, someone will respond with "Good on radio check."

CB Radio Codes

- 10-4 Ok, Message Received, or say "Copy that."
- 10-20 What's your Location? or "What's your 20?"
- 10-100 Bathroom Break "He's 10-100 right now."

Setiquette

- Never run on the set. Safety first.
- Never leave drinks or food on the set.
- Never leave anything on a ladder. Especially tools: guaranteed injury.
- Only necessary conversations, and those as quietly as possible.
- Don't make the AD constantly shush you.
- If you don't know something, don't act like you do.
- Stick to your job, and keep your cell phone switched off.
- Don't move *anything* on set unless told to.
- When turning on a light, loudly say "Striking," and wait for a couple of seconds after the call to switch it on. Otherwise you blind people who looked at you (just because they heard something) when you don't give them time to look away.
- No eye contact with the talent — especially while the camera is rolling. Don't stand in an actor's eyeline — it's very distracting for them.
- Don't crowd the camera.
- Don't talk to the director or the DP unless they initiate a conversation.
- Don't offer an opinion to anybody unless they ask.
- Never forget the chain of command. It's not a democracy.
- Don't be late.
- Never leave until you are released.
- Don't put drinks on the camera cart. Or anywhere on the set.

GOOD ADVICE

- Keep your mouth shut.
- You should never be who they're waiting on.
- Never try and guess your wrap time, you're just jinxing yourself.
- Just. Be. Cool.

The Radio Phonetic Alphabet

A = Alpha
B = Bravo
C = Charlie
D = Delta
E = Echo
F = Foxtrot
G = Golf
H = Hotel
I = India
J = Juliet
K = Kilo
L = Lima
M = Mike
N = November
O = Oscar
P = Papa
Q = Quebec
R = Romeo
S = Sierra
T = Tango
U = Uniform
V = Victor
W = Whiskey
X = X-Ray
Y = Yankee
Z = Zulu

Figure 2.15. The phonetic alphabet as used to make communications clear and unmistakable.

What Production Assistants Do

Anything the AD, Second AD or Second Second AD needs them to do. Yes, they might be *gofers* — go for this, go for that. They might be doing *lock-down* — standing by outside the set to call "lock it up" (call for quiet) before each take (and releasing the lock when cut is called). They might be working in the production office, on the set, or running around town picking up whatever is needed.

Everybody wants to work on the set, but gaining experience in the office or running errands can be valuable too. Getting to know who and where the various suppliers are and how to deal with them will be very useful later on in your career.

Some PAs work as assistants to the director, key actors or the producer. These are especially coveted jobs as the possibility of making contacts and even friendships is very real. Some PAs might work with specific departments; they might be a camera PA, a lighting PA or a props PA. These positions are especially valuable if you want to get into those crafts later on. Since most PAs work for the AD department, we'll go into much greater detail in the next chapter.

RECEIPTS

Keeping track of your receipts is critical to a production. Get a receipt for everything you pay for: props, paint, a cab ride, lunch while on a location scout — everything. How do you turn them in to the production office coordinator? Just hand her a wad of loose paper? Never! Each receipt is taped to a 8-1/2x11 sheet of paper, individually, or as many as you fit on a page — the Production Coordinator will tell you which way they want it. Some coordinators might also want a summary — a list of what each receipt is for, the date, and the amount. There are receipt envelopes available that have a summary form on the front.

The AD Team

Running the Show

FIRST ASSISTANT DIRECTOR

The *First AD* is a crucial part of any production. They make the *lined script*, make the *schedule* (which is then approved by the director and the line producer). On the set the AD is in charge of running the entire operation. The director is in control artistically, of course, but as far as just keeping things running, the AD is in charge. The AD functions as the director's right hand person, doing whatever is necessary to see that the director gets what they need to achieve the production goals. Probably the most important function of the AD is to keep things running smoothly and on schedule. The AD never leaves the set; if they do have to be away for a few minutes, they get a *Second AD* to take over for them.

SECOND AD

The *Second AD* is the assistant director's chief lieutenant. They perform many of the AD functions that require being away from the set. This includes preparing the call sheet for the next day; calling actors or crew to give them call times or directions; filling out time sheets or actor's contracts and so on.

SECOND SECOND AD

Second Second ADs do whatever the AD or Second AD need to be done, but most often they are involved in helping run the set, especially a larger set with lots of extras or action.

ADDITIONAL SECOND SECONDS

There is no such thing as a "third AD" — any time more people are needed to help control the set or location, they are called *Additional Second Second ADs*.

PRODUCTION ASSISTANTS

PAs generally work for the production department. They might also be called *gofers* or *runners* (especially outside the US). They do anything and everything that is needed. Some PAs are more specialized: there are *Set PAs*, *Office PAs*, *Camera PAs*, and so on.

Office PAs usually spend most time in the project's production office handling such tasks as answering phones, deliveries, script copies, lunch pickups, and related tasks in coordination with the production manager and production coordinator. Usually everybody wants to be "on the set," because it seems cool, but being an office PA is a great learning experience as well and a prime way to show you are a team player.

Set PAs work on the actual set of the production. They report to the assistant director (*AD*) department and *Key Set PA* if there is one. Duties include echoing (calling out) what the AD calls over the radio such as "lock it up," "rolling," "that's a cut," etc. They "lock it up" by politely holding pedestrian traffic, calling "hold the work," etc. Be careful when dealing with the public — don't be abusive or unnecessarily inconvenience people. Technically, only a police officer can stop traffic. PAs also help "wrangle" the talent and the background players, distribute paperwork, run messages, get coffee, pick up lunch orders and just about anything else that needs to be done. They don't do things that are someone elses's job, such as move lights or push the dolly — that is a huge no-no, even on non-union jobs. There's a good reason for this. Along with the AD and Second AD, PAs are the first to arrive and last to leave. It means some long, long days, but working your way up as a PA is probably the most time-honored way of getting into the movie business.

Department PAs work for the chief of each section: camera, grip, lighting, art department, sound, etc. If you are aiming to get into one of these crafts, looking for jobs as a department PA is a good idea. No matter what your goal, even producer or director, having a sound knowledge of how the crew works is useful.

The Jobs of the First Assistant Director

The *First AD* (often just called the *AD*) has many responsibilities in pre-production; we'll discuss these in detail later and show you the forms necessary to get the job done properly.

FIRST AD — PRE-PRODUCTION

- Line the script. Mark the script.
- Create the schedule.
- Run the *page turn*, *script readings* and *rehearsals* to organize them for the director.
- Assist the director in any way necessary.
- Go on tech scouts.
- Coordinate all the departments to keep things running smoothly.

THE ASSISTANT DIRECTOR

Working on the set, the AD has to be a real multi-tasker; he or she is overseeing many aspects of the production. Duties include:

- Create a realistic *shooting schedule*. Look at the scenes and identify all the elements needed. Shooting schedules don't contain a great amount of detail but they are the overall skeleton of the production. They are very important.
- Make sure the director provides a *shot list* for you and the DP. Having a shot list on hand is important when creating a plan for the day.
- Touch base with departments (camera, lighting, grip, props, wardrobe, etc.). As the central hub of information, an AD's job is to collect the latest intel from various departments as quickly as possible, and take preemptive action if something isn't going to plan.
- Communicate effectively — and often. The best ADs are not only great communicators, but also strategic thinkers. They know what to say, when to say it, and how to say it.
- Provide a heads-up for the next scene or setup. Let the team know where the day is going.
- Be a problem solver. It's an important part of your job. Never complain about problems. Your job is solve them. Whether it's a conflict amongst the crew or a safety hazard, it's your responsibility to resolve it swiftly.

THINGS YOU SHOULD DO:

Be a good listener. If you notice frustration brewing in a crew member, pull them aside and let them vent. It will only take a few minutes, but it's critical in getting the person (or department!) back on track.

- Take ownership of a mistake, even if you didn't make it. Let your entire team know that you're working on a solution. This will help build confidence and respect from your team.
- Involve only those required. This becomes especially important if things get heated. No need to drag the energy of the crew down.

THINGS NOT TO DO:

- Don't point fingers. The buck stops with the AD. Not only does playing the blame game undermine trust with your people, but it will make others fearful to approach you in the future. Don't say "you did that wrong," say "we have a problem here." This applies to everyone, from the director to department heads and PAs.
- Don't take sides. If there's a conflict between crew, you need to speak with them separately to understand every perspective and find a mutual solution. Oftentimes, all they need to do is vent to someone to alleviate the tension.
- Don't lecture. Nobody likes feeling like they're being talked down to, so briefly make your point and move on. Don't let tension escalate. Word-of-mouth travels fast on a set, so anything negative that happens has a chance to infect the energy of the cast and crew.
- Learn people's names. Nobody likes being called 'hey' or by their crew position. You're not expected to know everyone's name on day one. This is one of the reasons that *call sheets* exist. Start by learning key cast and crew members' names.

Creating the Schedule

The script and the schedule are the two key guiding documents of the production. Since the First AD is responsible for keeping the shoot on schedule, it is also up to them to create it in the first place. In order to do it properly, the AD needs to have a good understanding of the script and a thorough knowledge of how movies get made. A crucial rookie mistake is to say "the scene is only 2/8th of a page, shouldn't take more than an hour," when in fact the scene calls for a car blowing up and a motorcycle to jump a river. That 2/8th of a page could easily take all day or even multiple days on a big production.

STRIP BOARDS

Strip boards (sometimes called *production boards*) are the traditional way to organize a schedule. Long cardboard strips summarizing the important data about each scene, they could easily be rearranged as the schedule was organized and changed. Today, they have been mostly been replaced by computer based scheduling software, but almost all of these applications precisely mimic the layout and arrangement of the old cardboard strips. For a full color version of a strip board, see the website.

ORGANIZING THE SCENES

Making the strips, whether cardboard or in software, starts with the *breakdown sheets*: they have all the necessary information for each scene. So what is the key information about a scene that needs to appear on the strips? One of the most important things we need to know about a scene when making a schedule is whether it is day or night, interior or exterior. Since this is so fundamental to the scheduling decisions, the strips are color coded so that it's not even necessary to read anything to see what scenes belong together. The color code is:

TYPE OF SCENE	STRIP COLOR
Day Interior	White
Day Exterior	Yellow
Night Interior	Blue
Night Exterior	Green
Day Separator	Black
Week Separator	Orange
Free Day	Grey
Holiday	Red

THE HEADER

Each scene strip should include:

- Scene number
- Breakdown page number
- Page count
- Scene name
- Location and number
- Day/night
- Interior/exterior
- Character names with a number. Every character in the script is assigned a number, usually based on how many lines of dialog they have.
- Extras along with number (such as E11)
- Notes: Vehicles (V), Animals (A), Music (M), Special Equipment (SE)

Notice that it says "Character names with number." What is that? In order to keep track of the speaking actors, each one is assigned a number. Not surprisingly, the lead actor is #1, the second lead is #2 and so on. It's the same with locations. On the following page is a sample strip board page for the film *It's a Wonderful Life*. We can only show the boards in black and white here. For the color versions, see the website.

COVER SETS

Sometimes, weather can ruin the best made plans. If at all possible, try to have another interior set nearby you can move to if shooting outdoors becomes impossible. If that's not possible, get creative. Of course, the First AD should always know the weather prediction.

Table 3.1. Standard colors for parts of the strip board.

Figure 3.1. (opposite page) One page of a strip board. For a color version of this board, see the website.

IT'S A WONDERFUL LIFE

Director: Frank Capra

Producer: Frank Capra

Asst. Director:

Script Dated: March 4, 1947

	Sheet 24	Sheet 18	Sheet 22	Sheet 23	Sheet 21	Sheet 25	Sheet 19	Sheet 16	Sheet 20
Sheet Number:	24	18	22	23	21	25	19	16	20
Page Count:	1/8	1 4/8	2/8	3 5/8	6 3/8	4 2/8	6 3/8	3/8	6 1/8
Shoot Day:	1	1	1	2	3	4	5	6	7
Scene	EXT - BAILEY BUILDINGS AND LOAN SI — Scs. 24	EXT - MAIN STREET - DAY — Scs. 18	EXT - FRONT PORCH OF HOUSE - NIG — Scs. 22	EXT - STREET - NIGHT — Scs. 23	EXT - TREE-LINED RESIDENTIAL STRE — Scs. 21	INT - BAILEY BUILDING AND LOAN OFF — Scs. 25	INT - BAILEY DINING ROOM - NIGHT — Scs. 19	INT - GOWER'S DRUGSTORE - DAY — Scs. 16	INT - HIGH SCH OOL GYM - NIGHT — Scs. 20
Caption	Establishing Bldg. & Loan sign.	George takes a cab ride.	Grumpy old man watches George & Mary.	George and Mary make a wish.	George and Mary's moonlight walk.	B & L Directors meeting.	Dinner at the Baileys'.	George re-visits drugstore.	George and Mary at High School Dance.

End of Day markers

- -- End Of Day 1 -- 7/6/1992 -- 1 7/8 pgs.
- -- End Of Day 2 -- 7/7/1992 -- 3 5/8 pgs.
- -- End Of Day 3 -- 7/8/1992 -- 6 3/8 pgs.
- -- End Of Day 4 -- 7/9/1992 -- 4 2/8 pgs.
- -- End Of Day 5 -- 7/10/1992 -- 6 3/8 pgs.
- -- End Of Day 6 -- 7/13/1992 -- 3/8 pgs.

Character

Character	No.	Character	No.
George	1		
Mary	2	Harry	3
Uncle Billy	4	Mr. Potter	5
Mr. Gower	6	Ernie	7
Bert	8	Joe	9
Clarence	10	Violet	11
Ma Bailey	12	Mrs. Hatch	13
Mr. Martini	14	Cousin Tilly	15
Annie	16	Peter Bailey	17
Cousin Eusta...	18	Ruth	19
Pete Bailey	20	Goon	21
Carter	22	Marty	23
Sam Wainwri...	24	Maria Martini	25
Ed	26	Freddie	27
Nick	28	Tommy	29
Janie	30	Charlie	31
Tom	32	Zuzu	33
Dr. Campbell	34	Mr. Carter	35
Principal	36	Grumpy Old ...	37
Jane Wainwr...	38	Tollkeeper	39
Mickey	40	Lawyer	41
Real Estate ...	42	Insurance Ag...	43
Suitor #1	44	Suitor #2	45
Passerby	46	Randall	47
Mrs. Thomps...	48	Poster Man	49
Schultz	50	Mr. Reineman	51
Nurse	52	Bank Teller	53
Mr. Welch	54	Owner	55
Truck Driver	56	House Owner	57
Cop	58	Sheriff	59
		Extras.	

Cast IDs per strip

Sheet	Cast / Extras
18	1, 7, 8, 11, E:1
22	37
23	1, 2/3, 4, 37
21	1, 2
25	1, 4/5, 21, 34, 41, 42/43
19	1, 3, 12, 16/17
16	1, 6, E:15
20	1, 2/3, 11, 23, 24, 27, 36, 40, E:106

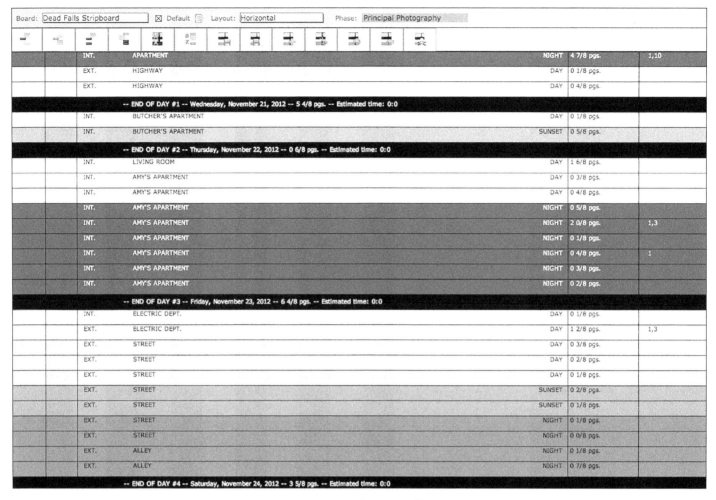

Board:	Dead Falls Stripboard	☒ Default	Layout: Horizontal	Phase: Principal Photography

	INT.	APARTMENT	NIGHT	4 7/8 pgs.	1,10
	EXT.	HIGHWAY	DAY	0 1/8 pgs.	
	EXT.	HIGHWAY	DAY	0 4/8 pgs.	
-- END OF DAY #1 -- Wednesday, November 21, 2012 -- 5 4/8 pgs. -- Estimated time: 0:0					
	INT.	BUTCHER'S APARTMENT	DAY	0 1/8 pgs.	
	INT.	BUTCHER'S APARTMENT	SUNSET	0 5/8 pgs.	
-- END OF DAY #2 -- Thursday, November 22, 2012 -- 0 6/8 pgs. -- Estimated time: 0:0					
	INT.	LIVING ROOM	DAY	1 6/8 pgs.	
	INT.	AMY'S APARTMENT	DAY	0 3/8 pgs.	
	INT.	AMY'S APARTMENT	DAY	0 4/8 pgs.	
	INT.	AMY'S APARTMENT	NIGHT	0 5/8 pgs.	
	INT.	AMY'S APARTMENT	NIGHT	2 0/8 pgs.	1,3
	INT.	AMY'S APARTMENT	NIGHT	0 1/8 pgs.	
	INT.	AMY'S APARTMENT	NIGHT	0 4/8 pgs.	1
	INT.	AMY'S APARTMENT	NIGHT	0 3/8 pgs.	
	INT.	AMY'S APARTMENT	NIGHT	0 2/8 pgs.	
-- END OF DAY #3 -- Friday, November 23, 2012 -- 6 4/8 pgs. -- Estimated time: 0:0					
	INT.	ELECTRIC DEPT.	DAY	0 1/8 pgs.	
	EXT.	ELECTRIC DEPT.	DAY	1 2/8 pgs.	1,3
	EXT.	STREET	DAY	0 3/8 pgs.	
	EXT.	STREET	DAY	0 2/8 pgs.	
	EXT.	STREET	DAY	0 1/8 pgs.	
	EXT.	STREET	SUNSET	0 2/8 pgs.	
	EXT.	STREET	SUNSET	0 1/8 pgs.	
	EXT.	STREET	NIGHT	0 1/8 pgs.	
	EXT.	STREET	NIGHT	0 0/8 pgs.	
	EXT.	ALLEY	NIGHT	0 1/8 pgs.	
	EXT.	ALLEY	NIGHT	0 7/8 pgs.	
-- END OF DAY #4 -- Saturday, November 24, 2012 -- 3 5/8 pgs. -- Estimated time: 0:0					

Figure 3.2. A strip board created on a computer. Having the strips arranged horizontally does make them easier to read.

Strip Boards on Computer

Some people still use traditional strip boards, but by far the vast majority of scheduling is now done on the computer. Not only is it fast and convenient, it is also much easier to share and send copies to the appropriate people. With cardboard strips, the only way to share the board was to get color photocopies made — expensive and inconvenient. For a color version of this strip board, see the website.

OTHER SCHEDULE CONSIDERATIONS

From the strip board, you can work out a schedule that maximizes your resources and gets the production done in the most efficient way. There are some important considerations as you put the schedule together:

- Seasonal — shorter days in winter, snow or rain, etc.
- Locations: company moves to another location during a shoot day are enormously time-consuming. Try to avoid them if at all possible.
- Cast members — try to have them on the clock for as little time as possible.
- Day/Night requires 10-12 hour *turnaround* (time between when the crew finishes and has to show up the next day). Try to group night shoots together. Twelve hour turnaround is the accepted standard on most shoots.
- Ext/Int: try to shoot exteriors first so you can move to an indoor cover set if it rains.
- Sequence: try to keep scenes in script order as much as possible.
- Wardrobe/makeup changes: special EFX makeup can sometimes take hours.
- Weather: cold and rain slow down production.
- Special effects/stunts: may require extensive setup and testing.
- Second unit/camera: may save time having second camera or 2nd unit.
- Special equipment: cranes, helicopters, underwater equipment, etc.
- Miscellaneous: may have special reasons for shooting in a strange way.

How the First AD Runs the Set

The First AD has many jobs on the set, in addition to the things they do in pre-production. Traditionally, the AD is the first to arrive on the set and one of the last to leave. The AD is the NCO in charge of the set: they keep the whole thing rolling and organized. Here's a summary of what the AD does when shooting a scene. At the beginning of the day, everyone will be at the craft services table or the catering truck having coffee and breakfast burritos. It's up to the AD to announce "We're in." Get everyone to work at the start of the day by announcing over the radio and out loud the scene number and what set it will be shot on. Example: "We're at work, scene seven."

ROUGH IN

Before the director and actors get started with a scene, the crew will "rough in" the lighting — just a first pass to take a guess at the lighting for the scene and certainly to get power and the main lights in place and ready. The set dressing and props people will have made sure everything is in place and ready to go. When all that is in place the AD will ask for a *blocking rehearsal*. When the *rough in* is done, get the director and actors on set by calling: "First team please" over the radio. The 2nd AD will see that they are delivered to set.

BLOCKING REHEARSAL

The director and actors will roughly work out what they want to do for blocking. When they are ready, you call: "Stand by for blocking" over the radio. The crew should stop all work and be absolutely quiet. The director will call "action on rehearsal" and the actors will work their way through the scene. The 2nd camera assistant will (as unobtrusively as possible) sneak in to place some *marks*. The director will call "cut on rehearsal."

The director and director of photography (DP) will discuss the shots. The actors may ask to change some of the moves or entrances or exits. If needed, the director will block the scene again until everyone is familiar with what they are going to do. When they are, you make sure the crew knows the shooting plan for the scene and move on to lighting by calling (to the 2nd AD)... "Put 'em in the chairs." or "Put 'em in the process," (meaning they are to be taken to hair, makeup and wardrobe). You then say to the DP "The set is yours." or "The set belongs to lighting and camera." At this point, the DP, gaffer and key grip own the set; actors shouldn't wander in to "get a feel," and set dressers should stay out of the way if they have something to do. It's not just protocol, it's about safety, too.

LIGHTING

You call "Second team please" over the radio, which means bring in the *lighting stand-ins*. Immediately find out from the DP how long they estimate it will take to have the set ready for shooting. This information must immediately be relayed to all departments so they will know how to pace their work. If the DP tells you 45 minutes you would call "We're 45 away" over the radio. You watch the work during lighting and if it looks like the camera department is getting ahead of or behind the estimate, you ask. You also keep in touch with the 2nd AD, to see that the set estimate is syncing up with the estimate they have from hair, makeup and wardrobe for the actors — no point in annoying the DP to hurry up if the actors still have an hour to go in makeup. When the 45 minutes are up, you ask the DP if camera needs more time. If they do, you announce the new estimate.

FINAL REHEARSAL

When the camera/lighting department is ready, you call for *Final Rehearsal*: "First team please." This will bring the director and actors back to set. You must check with any other departments you see still working on the set before you call for the first team. When the actors come in, ask them to take their first marks. Call "Stand by to rehearse please" over the radio. The crew will get absolutely quiet and the director will call "action on rehearsal." The actors will play the scene and the director, when ready, will call "cut on rehearsal."

LAST LOOKS

If the director is ready to shoot the scene, ask camera. If they are ready, ask sound. If they are good to go, you call "last looks." Makeup and hair will do final touch-ups on the actors while camera and sound do any final "tweaks" they need to do. The director may have a final word or two for the actors. When makeup, wardrobe and hair leave the set — make sure the director is still ready and call... "Lock it up for picture, please," then "roll sound," "roll camera," and then it's up to the director to call "action," and when she feels the time is right: "cut." Then the process starts over again, either for another take or "moving on," to another scene.

Calling The Set When Ready to Shoot

First AD asks camera and sound if they are ready. If they are:

First AD: "Lock it up, please."

Second AD and **PAs** echo: "Lock it up, please. Picture's up."

First AD: "Roll sound."

Sound Mixer: "Sound speed."

First AD: "Roll camera."

First AC: "Camera speed." (If there is more than one camera, it's "A speed," "B speed," "C speed," and so on).

Director: "Action." The scene plays out, when the time is right, the director (and *only* the director) calls "Cut."

First AD: "Release the lock."

Second AD and **PAs**: "We're cut."

After asking the director, **First AD** calls either "Going again," or "Moving on." The director might choose to say it themselves: "Back to one," (meaning reset for another take) or "We're on the wrong set," which means it's time to move on.

CALL SHEET

Vampires Stole My Lunch Money

Prod. Co.: PLAN D

DIRECTOR: Gang Lion

EXEC. PRODUCER: Sissi Colpits

PRODUCER: Van Houyten

PRODUCTION OFFICE: Overlook Hotel

Highline, CO

TELS: (555) 313-0574 FAX: (555) 313-0698

DATE	1-Jun-12
DAY	10 OUT OF 21
LEAVE HOTEL:	5:00 AM
CREW CALL:	7:00 AM

LOCATION:	Overlook Park
SUNRISE 5:50 AM	SUNSET 7:27 PM
FORECAST:	Cloudy. 30% chance rain.

DESCRIPTION (SET)	SCENES	CAST	D/N	PGS	LOCATION
She walks in the park	27, 28, 29	1	D	5/8th	Overlook Park
He finds her	30, 31, 31B	1, 2	D	1- 2/8th	Overlook Park
They buy ice cream	32, 32B	1, 2, 12	D	1-1/8th	Overlook Park
She drives past the park	78, 79	1	D	1/8th	Overlook Park

CAST & DAY PLAYERS	PART OF	LV HOTEL	MAKEUP	SET CALL	REMARKS
Andrea Simpson	Denise	5:00 AM	6:00 AM	8:00 AM	
David Drake	Daniel	5:00 AM	6:00 AM	8:00 AM	
Sammy Dellos	Ice Cream Vendor	LOCAL	8:00 AM	9:00 AM	

ATMOSPHERE AND STANDINS	RPT TO	SET CALL	REMARKS
Crowd at Park (10)	2nd AD	10:00 AM	ND extras, cast locally.

SPECIAL INSTRUCTIONS

Ice Cream push cart should be fully stocked to supply main action and extras.

ADVANCE SHOOTING NOTES

SHOOT DAY	SCENE #	DESCRIPTION (D/N-PGS)	CAST	LOCATION
11	58	She searches the room. D. 1-3/8 pages.	1	Overlook Hotel, Rm. 237

In Case of Emergency, Contact Samantha — 555-692-3800, Rm. 705
Nearest Hospital: Downlook General, 512 Route 10, 555-313-2553

Figure 3.3. The front page of a typical *call sheet*. Every member of the cast and crew should receive one the day before the scenes are to be shot. *Atmosphere* is *background people* or *extras*. Technically, there is a difference between an extra, a background artist and an atmosphere person, but the terms are sometimes used interchangeably. Under remarks, it says "ND extras." ND is the term for *nondescript*, meaning there is to be nothing outstanding about them, just an average crowd. Some scenes might call for *ND cars*, for example, meaning just a random assortment of cars.

PRODUCTION: "PLAN B" **DATE** 12-Jun-12

NO.	TITLE	NAME	TIME		NO.	TITLE	NAME	TIME
	PRODUCTION					**PROPERTY DEPT.**		
1	DIRECTOR		7:00 AM		1	PROPMASTER		7:00 AM
1	UPM		6:00 AM		1	ASST. PROPS		7:00 AM
1	1ST AD		6:00 AM			**MAKEUP/HAIR DEPT.**		
1	2ND AD		6:00 AM		1	MAKEUP ARTIST		7:00 AM
1	PRODUCER'S ASSISTANT		6:00 AM		1	HAIR STYLIST		7:00 AM
1	PRODUCER'S ASSISTANT		6:00 AM		1	ADD'L MAKEUP/HAIR		7:00 AM
1	SCRIPT SUPERVISOR		7:00 AM			**WARDROBE DEPT.**		
1	PROD. COORD.		7:00 AM		1	WARDROBE DESIGNER		O/C
1	ASST. PROD. COORD.		7:00 AM		1	WARDROBE SUPERVISOR		7:00 AM
1	OFFICE PROD ASST.		7:00 AM		1	SET COSTUMER		7:00 AM
5	SET PRODUCTION ASST.		6:00 AM		1	WARDROBE ASSISTANT		7:00 AM
1	2nd UNIT DIRECTOR		5:00 PM			**EDITORIAL**		
1	2nd UNIT AD		5:00 PM		1	EDITOR		O/C
	LOCATIONS				1	ASST. EDITOR		O/C
1	LOCATION MGR.		6:00 AM		1	APPREN. EDITOR		O/C
1	ASST. LOC. MGR.		6:00 AM			**MISCELLANEOUS**		
					1	CRAFT SERVICE		6:00 AM
	CAMERA DEPT.				1	MEDIC		7:00 AM
1	D.P.		7:00 AM		1	ADDITIONAL MEDIC		5:00 PM
1	CAMERA OPERATOR		7:00 AM			POLICE	Per Locations	
1	1ST A.C.		7:00 AM			FIRE	Per Locations	
1	2ND A.C.		7:00 AM			SECURITY	Per Locations	
	LOADER		7:00 AM			**TRANSPORTATION**		
	STILLS		7:00 AM		1	TRANS. COORD.		6:00 AM
	2nd UNIT DP		5:00 PM		1	TRANS. CAPT.		6:00 AM
	2nd UNIT AC		5:00 PM			DRIVERS:		
	ART DEPARTMENT							P
1	PROD. DESIGNER		O/C					E
1	SET DECORATOR		O/C					R
1	LEADMAN		O/C					
2	SWING GANG		7:00 AM					T
								R
1	ADD'L SWING		7:00 AM					A
1	ART COORDINATOR		7:00 AM					N
1	ON SET DRESSER		7:00 AM					S
1	LAYOUT BOARD PA		6:00 AM					P
1	SWING GANG/DRIVER		6:00 AM					O
								R
								T
	GRIP DEPT.							A
1	KEY GRIP		7:00 AM					T
1	BEST BOY GRIP		7:00 AM					I
1	DOLLY GRIP		7:00 AM					O
1	COMPANY GRIP		7:00 AM					N
1	COMPANY GRIP		7:00 AM					
1	2nd UNIT KEY GRIP		5:00 PM					
2	2nd UNIT GRIPS		5:00 PM					
	ELECTRICAL DEPT.							
1	GAFFER		7:00 AM			**SPECIAL EQUIP.**		
1	BEST BOY ELECTRIC		7:00 AM			DOLLY(s)		Fisher 11
1	COMPANY ELECTRIC		7:00 AM			CRANE(s)		
1	COMPANY ELECTRIC		7:00 AM			CONDOR(s)		
1	2nd UNIT GAFFER		5:00 PM			RITTER FAN		
2	2nd UNIT ELECTRICS		5:00 PM			WALKIE-TALKIES		24
	SOUND DEPT.							
1	SOUND MIXER		7:00 AM			CATERER		PER AD
1	BOOM		7:00 AM			BREAKFAST	RDY @ 7:00 AM	
	SPECIAL EFFECTS/STUNTS					LUNCH	RDY @ 1:00 PM	
1	SPECIAL FX COORD.		7:00 AM			DINNER	RDY @ 7:00 PM	2nd UNIT
1	SPECIAL FX ASST.(s)		7:00 AM					
1	STUNT COORDINATOR		5:00 PM					

NOTES: 2nd Unit grip and electrics to begin prepping for second unit night scenes @ 5:00PM.
Refueling truck for generator to arrive by 4:00PM.

Assistant Director: Jan Van Houeten UPM: Dolores Del Rio

Figure 3.4. Back page of a typical call sheet. Notice, for example, that the second unit DP and AC aren't needed until 5PM. In this case, it was decided that they would shoot some small inserts after the key crew is *wrapped* (done for the day). Doesn't mean that the scene will be over at 5PM, just that the second unit needs to be ready to go, when the last scene is wrapped. The *Wardrobe Designer* is listed as O/C or "on call." This just means that he or she knows when and where they need to be better than the AD might know; same with the editors. For the *drivers* — the *Transportation Captain* (*Transpo*) has a much better picture of when and where they need to be. Transpo is going to be thinking about traffic conditions, parking problems and other issues.

Second AD

Second ADs are the first people on set and often the last to leave. Among the many duties they perform are:

- Make sure that the actors arrive on time and get them started in makeup, wardrobe and hair. If they aren't there on time, get on the phone and find out what's wrong.

- Deliver the actors to the set when the First AD calls, "first team."

- Keep checking to see that the off-set departments are aware of what the First AD is calling over the radio: scene numbers, time estimates, etc.

- Keep communication open between the production office and the set.

- Prepare the *call sheet* for the following day's shooting before the meal break, get it checked and signed off by the First AD and see that it gets back to the office for production manager approval and photocopying and back to the set in time to be handed out at wrap.

- Echo the First ADs calls that prepare the company for shooting: "Lock it up for picture," "quiet please," "we're rolling!"

- Actor's contracts, especially the SAG long form.

- *Wrangle* the actors and extras (unless you have a Second Second AD doing this). Wrangle means telling them they are needed on the set (or in makeup, hair or wardrobe) and making sure they get there. This might also be done by a Second Second AD.

- Checking that actors show up at call time and get signed in.

- Make sure they have signed their paperwork before they leave the set.

- Supervise the PAs (might also be done by the Second Second AD if there is one).

- Make phone calls for the AD when he or she is busy on the set (which is pretty much always).

- If the First AD needs to step off of set for any reason, maybe just for a bathroom break, the Second AD may need to step in for a while. This means you need to keep current on what is happening on set.

Second Second AD

There is no such thing as a third AD; any extra ADs after the Second are called *Second Second ADs* and sometimes there might be *Additional Second Second ADs*. They assist the 1st and 2nd AD. Generally, they take care of the following:

- Check with makeup, wardrobe, and hair to be sure things are running smoothly and update the first AD with reports on whether they are on schedule or not.

- Take charge of all the radios, including making sure they are charged every night. Not having charged batteries for the walkies at the beginning of the day is definitely a fireable offense. Don't let it happen to you!

- Do the daily production report, if the Script Supervisor doesn't do it.

- Wrangle the extras and talent to and from the set — often coordinating with transportation for the movement of shuttle vehicles. The main responsibility of the Second Second AD of assisting the 1st Assistant Director and the 2nd Assistant Director. Typically the Second Second AD will be responsible for the background talent off the set; they may have to sit with them on standby for most of the day, then get them to set.

- You need to constantly communicate with the 1st and 2nd AD. Communication is key. You do not want to show up on set with 20 background performers an hour before the 1st is ready for them, or especially ten minutes after they were needed. This involves anticipating timing — you will need to estimate how long it takes to get a group from point A to point B.

- While on set you may need to stop traffic, vehicles as well as pedestrians, from going through a shot — this called "*locking it up*." All of your set PA's on walkie will also call out "Lock it up." You will be responsible for positioning "lockup PAs" to places where they can control traffic, outside work, whatever might be a problem when rolling. Don't forget to call it when lockup is released; if you don't do this, eventually people will ignore the lockup.

- Assist the 2nd: If there is a day without any background performers then you will help out the 2nd with anything that may be needed; you may have to transport talent to set or communicate timing with the 1st AD.

- You will need to supervise the PAs as well, if you need help with anything they are there for you and the AD team.
- Always have your walkie on (but turn the volume down when the camera is rolling), you will need to communicate on all channels, when lunch is called, when wrap is called, etc. When making announcements, be sure to go to all channels in use and relay the information.
- Charging the walkies is an extremely important duty. If the walkie talkies are not charged every night, it is a serious problem for the production the next day — and everybody will know whose fault it is; that is, if you're still employed on the project, which you might not be if you forget this. In many cases, this job will be assigned to a trusted PA.
- The Second Second AD has to be prepared to do anything that the 1st or 2nd needs of you. You are a key member of the production team and will help to make sure that things run more smoothly. Keep your eyes and ears open and be ready to jump in at any time. Don't wait to be asked to do something, take initiative.

Production Assistants

Working as a *PA (Production Assistant)* is the most reliable and most often used method of getting started in the movie business. People use it as a way to learn how things work, make contacts, learn what is involved in different jobs on the set, and get started on the career ladder. For many, it allows them to see what it is they really want to do — maybe they didn't have an interest in working in production design, for example, but when they see the production design team at work, they realize it's something that they'd like to do.

WHAT DOES A SET PA DO?

Basically, anything they are told to do by the AD, Second AD or sometimes the Key PA, but generally they:

- Gofer (yes, including gofer coffee).
- Wrangle actors (while working for the Second AD).
- Do *lockup*, and *crowd control*.
- Run errands, pickups, and deliveries including taking hard drives to the editors.
- Absolutely anything that needs to get done. Anything.

WHAT A PA DOESN'T DO

You don't do anything that is a crew job. There is a real reason for this; I know you're eager to get involved and eager to please the 1st AD, but you do not touch props, lighting equipment, grip equipment, set dressing, or anything that is someone else's job. It is not a union thing, it is a logical and realistic way to run a production. It's the way that works; it's been proven for a hundred years. Say you're on a set and some C-stands are in the shot. The director angrily shouts "get those stands out of my shot." The Key Grip has stepped away for a moment to handle an emergency off-set. An overeager PA moves the stands behind the set wall. The Key Grip comes back, and the DP asks "Give me a flag here as quick as possible." But..... the grips can't find the C-stands, and it becomes a big deal. Guess who's going to get fired? Hint — it's not the Key Grip, or the director who yelled at you.

OTHER TYPES OF PAS

Some PAs work in the Production Office; some work as *Set PAs*. Other PAs work as personal assistant to the main actors, the director or the producers. Some PAs are assigned to the camera department, grip, lighting or props. In that case, they do whatever the AC, gaffer, Key Grip or seconds need them to do. This might include things like cleaning up the truck, standing guard over equipment, counting inventory or many other miscellaneous tasks.

All of these positions are valuable to your learning experience and to your advancement in the business. Every PA initially wants to be "on the set" and stand next to the director, or the camera (something you should never do) but there is valuable learning to be had in every PA position. Often, Set PAs are chosen for knowing that you don't crowd the camera and the director, and know how to stay in the background but always be available for any task — the most important skills of a PA, or really, any part of the filmmaking team. Be patient, work your way up to the position you want by being excellent at the job you have in front of you.

Some things a PA <u>always</u> has with them: a writing pen, pocket notebook, a Sharpie marker, and a flashlight (even if it's just a small keychain one).

Ways for a PA (or Anybody) to Get Fired

- Leave before you are released.
- Show up late more than once.
- Keep talking on the set after quiet is called for.
- Have to be constantly "shushed" by the First or Second AD.
- Don't listen to your orders.
- Don't complete your assigned tasks.
- Make somebody have to search for you.
- Don't pay attention to what's going on.
- Be sloppy or careless about your tasks.
- Offer "advice" to the director or DP.
- Make off-color, gender or racial comments/jokes or other inappropriate talk.
- Don't turn in your receipts.
- Cause a disturbance on the set.
- Constantly crowd the camera or the video monitor.
- Repeatedly get in the way of the director, actors or crew.
- Be loud, obnoxious or inconsiderate.
- Constantly chatter on the walkies.
- Create a safety hazard or injure someone by carelessness.
- Spread rumors or talk badly about people on the production.
- Park in the AD's parking spot.
- Act like an idiot.

HOW TO SURVIVE AS AN EXTRA:

Listen carefully to the directions you are given by members of the AD team in relation to where you should go and what you should do. Clarify anything you do not understand.

- Be quiet on set. The film crew need to work without interruption.
- Never be late and never be rude.
- Do not leave the set or location until you have been told officially by an assistant director that you have been "wrapped." Before you leave make sure you have *signed out* with a member of the AD team and you have returned any costume or props.
- Never look into the camera when filming.
- It is strictly forbidden to talk to the actors, ask for autographs, or take photographs. This can result in you being fired immediately. They are doing a job that requires intense concentration — respect that.
- Stay out of the eyeline of the principal actors unless it is part of your direction. This may seem minor, but it's actually a big deal as it totally breaks their concentration. Just ask Christian Bale.
- You are never allowed to bring a friend or family member with you; this also applies to costume fittings. Obviously, this does not apply to performers under 18.
- Talking to the local media is not cool.
- No personal belongings are to be brought onto set. Extras will usually have a *holding area* and a PA should be assigned to watch over things so actors can feel secure in leaving personal items there safely.
- Mobile phones must be switched off! Not silenced — off!
- If you must take regular medication or have medication on hand in case of emergency, make a member of the assistant director team aware when signing in. If your medication cannot be on your person due to your costume, they will take measures to have it kept in a safe place or with the on-set medic.
- No smoking is allowed on set, or in the extras holding areas. This includes vaping. There should be a designated smoking area.
- Once filming begins, it may not be possible to release you from set until the next break. Please ensure you go to the bathroom, etc. in plenty of time before you are called to the set. The Second Second AD or PA designated as extras wrangler needs to know where you are at all times.

Early in my career, I worked with a PA in New York who would drive the van down avenues with his head out the window screaming "Get out of my way, I'm in PRODUCTION!" It's people like this who make the public resent film crews in their area and make it more difficullt to get permits and co-operation. Don't be that guy. You're working on a movie; it's not the apocalypse. Do your job, but don't be a jerk about it.

Brian McLaren

Continuity and Coverage

Figure 4.1. This is what most people think of when they talk about film continuity — the strap across his chest suddenly reverses direction in the close-up. While *wardrobe continuity* is the most visible and most often noticed kind of mistake, it is only one aspect of continuity. If you look closely, you will see that the shot has been reversed.

Continuity: Making Sure It Works

Your most important obligation is to make sure the scene "works" in editing. If you don't get the proper coverage, it might not. It's an easy mistake to make — to think that all you really need for a scene is a shot here and a shot over there. Sometimes you might be right, but think about the consequences if you're wrong. You won't know about it until days or weeks later in the editing room. At that point you might see that those few shots were not enough or just wish that you had more coverage of the scene in order to make the editing flow more smoothly or to speed up or slow down the pace of the scene. Know what? It's too late! Reshooting is a big deal. It's expensive, time consuming and in many cases may not be possible at all — actors or locations may be completely unavailable. The moral of this story is don't shoot like an amateur, get all the proper coverage of every scene!

CONTINUITY

You may think of continuity as just making sure there are no big "mistakes" in a scene — such he's not wearing a hat in the wide shot but we cut to a close-up and suddenly there's a hat on him, but actually there's a lot more to continuity than this (Figure 4.1). In general, it refers to continuity editing, which is the way almost all movies are edited. Continuity editing is the process of combining related shots into a scene so as to create consistency of story across both time and physical location.

CUTTABILITY

Ultimately, the director and DP are responsible for one thing above all — delivering cuttable footage to the editor. Some shots just won't edit together without being awkward and confusing. If two shots are too similar, it will be an obvious mistake — it will look like a jump cut. Figure 4.18 is an example of two shots that would not be cuttable — they are too similar in camera position and object size (how big the actors are in the frame).

SCREEN DIRECTION

A major issue in all types of shooting is screen direction. There are a couple of types of screen direction we need to be aware of:

- Direction of travel. Example: if the cowboys are coming to save the town and we see them traveling toward screen right, it important that in all the subsequent shots of them, they still be traveling toward the right, otherwise if we all of a sudden see them traveling toward the left, the audience might think they gave up and turned around.

- When two people are in a scene, one is on the left and one is on the right. It is important to maintain this screen direction throughout all the shots of the scene — otherwise the audience will get confused.

THE LINE

Look at these two close-ups from the same master (Figure 4.7). He's OK, but her shot is all wrong. She is on the wrong side and facing the wrong way. If you cut these two shots together it wouldn't look at all like she is talking to him.

What went wrong? The actors haven't moved. What happened is the camera moved to the other side of "The Line." The Line is an imaginary axis drawn between the two characters. Once we shoot the master on one side or the other, then all the rest of the shots for that scene must remain on the same side of the line, otherwise you will end up with shots that have the wrong screen direction, as we see in her close-up.

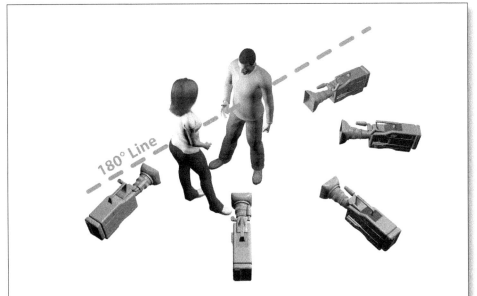

Figure 4.2. (top) As long as the camera stays on one side of the 180° line, the screen direction will remain consistent — she is on the left, he is on the right (middle, left and right). If the camera goes to the other side of the line, then screen direction is reversed — now she is on the right and he is on the left (bottom, left and right). It's confusing for the audience and may take their minds away from your story for a moment.

TO GET TO THE OTHER SIDE

So what if you want to get a shot that is on the other side of the line? There are a couple of ways to do this. You can also change screen direction with a visible movement of the camera across the line to the other side. It can be a dolly move, a handheld or Steadicam move. However, if you use this method to get to the other side, remember — you are committed to using that shot in the edit, no matter how bad it is.

Another way to get to the other side is to cutaway to something else in the scene and then when you come back to the actors it's OK to be on the opposite side. A third way is to cut to a neutral angle. A neutral angle and neutral axis is one that does not show screen direction. For example if you have a car that is traveling left in all your shots, if you then cut to a shot of the car traveling straight toward the camera or straight away from the camera, that is a neutral axis.

ON-SCREEN MOVEMENT ACROSS THE LINE

If you are on the correct side of the line and you want to get to the other side, it's OK to do it, as long as the audience can see it on screen. For example, a dolly shot that goes to the other side would be fine. The idea is that the audience sees the camera move and the screen direction change, so they are not confused by it. There is a danger here though. Say you shot the master and then shot some coverage that is on the same side of the line as the

Figure 4.3. Screen direction is especially important to keep consistent when something is moving, whether it be a car, an actor or anything else.

> To receive footage that has been shot with editing in mind, it is a blessing.
>
> Thelma Schoonmaker
> (*Raging Bull, The Aviator,*
> *The Departed*)

> Not getting enough coverage is the number one mistake beginning filmmakers make. Once they discover in the editing room that the scene doesn't work, it is often too late! Reshoots are expensive and sometimes not even possible.

master — this is all as it should be — correct screen direction. Then you do a dolly shot (or handheld) that shows the movement to the other side of the line. In editing, you find you don't really want that dolly shot or it is too bumpy. Too bad — you're stuck with it. Otherwise, if you don't use it, you'll have some footage that has correct screen direction and some that doesn't. You won't be able to edit these together smoothly.

A TRUE REVERSE

So we can never do a single shot that is on the wrong side of the line? There is a way. It's called a reverse or a true reverse. Some rules apply (and these are very general guidelines):

It needs to be a fairly big change. Crossing the line just a little bit will be confusing. If you do it in a big way, the audience will more easily understand that the camera has merely gone to the other side of the room. The background needs to be visibly different — again, this is to reduce the chance of the audience being momentarily confused.

It's important to remember that shooting on the set is never an end in itself — what you are really doing is providing the raw material for the editor. In addition to all the other requirements, it is essential that your material be "cuttable." This simply means that they are shot in a way that the editor can put them together in accordance with the basic rules of editing.

This is primarily the director's job, but it is absolutely essential that the cinematographer know what these rules are; not only as a backup for the director and continuity supervisor, but also for situations such as shooting second unit, where no director might be present.

Screen direction and correct eyelines are important to cuttability, but there is another requirement: that the two shots are different enough that editing them together won't make it seem like there is just a break in the film. This is called "jump cut," which means that there is no rhyme or reason for the edit — it just seems like a mistake.

THE 20% RULE

One general guideline is that the camera angle should change by at least 20%, horizontally or vertically. This is pretty much the same as saying that the angle should change by at least 30°. This is the bare minimum, when in doubt make the change more noticeable.

THE 30 DEGREE RULE

This is the absolute minimum the shot must change for the two angles to be cuttable. This illustrates moving the camera horizontally, but the same principle applies for a vertical move of the camera. Of course if a smaller move is combined with a lens change, it might cut together seamlessly. Better safe than sorry when it comes to cuttability (Figure 4.14).

TWO LENS SIZES

Changing the lens can make enough difference to make two shots cuttable. Thinking in terms of prime lenses, you will generally find that one lens size is not enough to make most shots cuttable by itself. For example — changing from a 25mm to a 35mm lens is not likely to be enough of a difference. Changing two lens sizes is safer: for example — from a 25mm to a 50mm will always ensure cuttability.

Point-of-View

POV stands for point-of-view. As it is most often used on the set, it means when the camera sees the scene as a character would see it (Figure 4.16). For example, if a character leans over a balcony and looks down and then we place the camera where he was standing and get a shot of the street under the balcony, we are shooting "his POV."

TRUE SUBJECTIVE POV

In most cases, we place the camera very near where the character's eyes would be and that is called a POV. In cases where we actually want the camera to "act like" the character so that the camera really becomes his or her eyes, then we are shoot a "true subjective POV."

Subjective POVs are an essential part of filmmaking. They really get the viewer involved in the scene and they also tend to make the audience identify with the character. It is important to follow a few simple rules in order to make them successful.

The real magic of the subjective POV look is that you don't really have to have an airplane there to make us believe that the character is looking at an airplane — we can put things into the scene through "movie magic." You can use stock footage or get the airplane shot some other time.

Screen Direction In Dialog Scenes

 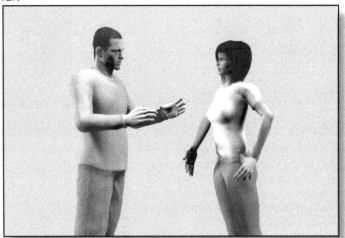

Figure 4.4. (top) We see the master: a normal two shot (right) and the camera placement that gets that shot (left). **Figure 4.5.** (middle): Close-up on him and the camera placement. **Figure 4.6.** (bottom): To get the close-up on her, the camera just shifts to the left. What is important to notice is that two close-ups will edit together nicely: he is on the left facing right, just as he is in the master shot. She is on the right facing left, just as she is in the master shot.

Figure 4.7. Because the camera crosses the 180° line between shooting these two close-ups, the two people do not appear to be talking to each other (right) — this is why screen direction is so important. Mistakes in screen direction are confusing to the viewer.

JUMP CUTS

If two shots just don't fit together in editing, that can result in a *jump cut*. Take the example of a man standing by the door and then we immediately cut to a shot of him standing by the window: that would be a jump cut. It has the effect of making the audience think that piece of the scene is missing. In this example, it will seem that the part where he walked over to the window has been left out. Normally, when we are editing for continuity, we try to avoid jump cuts: they are jarring and distracting, they break the illusion of reality. However, sometimes they are used for artistic purposes. French director Jean-Luc Goddard pioneered the deliberate use of jump cuts in his film *Breathless* (he was not the first to use them, but his work started a trend). They are now sometimes used in action or horror films and extensively in music videos — which in most cases are not intended to be realistic continuity editing.

ELLIPSIS

An *ellipsis* is a gap, something left out. For example, if you end a sentence without finishing... Those three dots are also called an *ellipsis*.

Some people take continuity too far — they feel you have to show every single thing a character does, that nothing can be left out of a sequence of actions. One example: she goes to a party. We might see her putting on her makeup, going out the door and then getting in a cab, arriving at the door and then coming in to the party. It all makes sense, there are no gaps in the timeline. It all makes sense but is it all necessary? Not really.

Do we need to see her riding in a cab? It doesn't advance the story, we don't learn anything new. It is not necessary. It is perfectly OK to see her putting on makeup and then in the very next shot, she's at the party. Sure there is a gap in time, but the audience understands it. They won't be confused.

DOOR AND WINDOW MATCH

Figure 4.8. (below, left) The clock shows ten minutes till nine.

Figure 4.9. (below, middle) We cut to a tight over-the-shoulder of her.

Figure 4.10. (below, right) Cutting back to him, the clock has jumped several hours ahead. This would not be unusual for a scene that takes a long time to shoot or there is a break for lunch in the middle. It's up to the prop master to reset the clock so it is consistent. The script supervisor also needs to keep an eye on things like this.

Matching is a big part of continuity. Here is an example: let's say a character is in a room and they walk over and lean out the window to shout something to a person on the sidewalk. Inside the room (an interior shot) we see him raise a double-hung window (slides up and down). Then we cut to a shot from outside the building and we see the actor open a casement window (opens with a crank) and lean out. Clearly this would be an error in continuity, and the audience would notice.

Often, the interior shot of the actor opening the window will be shot in a completely different location than the exterior shot of him leaning out the window. It is not necessary that the windows match in every tiny detail — they just have to be similar enough that the audience won't notice; generally they just have to be the same type of window. The same thing applies to doors. If we see an actor inside a building and exiting out of a glass door, we can't then cut to the exterior shot of him coming out of a wooden door.

 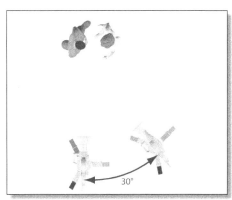

Figure 4.11. (above) These two shots would *not* be cuttable. The camera has moved but not enough and they are too similar. Trying to edit them together would produce a jumpy edit that would seem like a mistake — as though a few frames were missing; not smooth and seamless.

Figure 4.13. (above) An illustration of the 30° rule (or 20% rule).

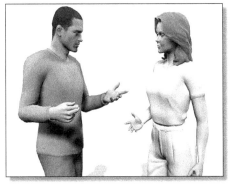 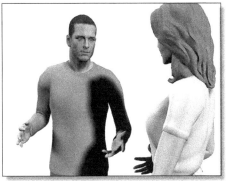

Figure 4.12. (above) These two shots *would* be cuttable. There is enough of a difference that cutting the two shots together would produce a smooth, seamless edit.

LOCATION STITCHING

All these kinds of problems come up because we frequently use two or three different locations and make them appear to be all one location. When an actor leans out the window, it may look great from inside the building but the outside view of that same window might be a terrible shot. It is often better to use a different window, even a different building.

The same kind of thing often applies to walking shots. We see two actors in the hospital lounge; they stand up and walk out the door. We cut to them walking out the door and follow them down the hallway. They turn a corner and we cut to them entering the hospital lobby; they exit the front door and we cut to them coming out into the parking lot. This is a fairly common sequence of shots. Here's the secret: the lounge, the hallway, the lobby and the parking lot might well be all in different buildings, even in different countries — this is called location stitching.

FAKING IT WITH REDRESSING

The opposite is sometimes true, especially on low-budget productions: sometimes we make one location look like several different places. Maybe the script calls for us to meet three couples as they prepare for their vacation together. We need a scene of one couple at their apartment in New York; we need to see another couple at home in Michigan and the third couple as they pack in Kansas. On a super low budget it wouldn't make sense to find three different houses for these short scenes.

Figure 4.14. (left) The master for this scene. (middle) This shot *might* be cuttable, but it would be an awkward cut. (right) This medium would definitely cut well with the master shot and be a smooth edit.

 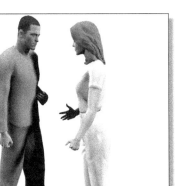

Instead we just make one bedroom the New York apartment, another bedroom the Michigan home and then we can redress that same bedroom as the house in Kansas. Redressing means changing the furniture and decorations to make it look like a different room.

CHEATING ANGLES

Sometimes when we want to get the answering shot/reverse angle on a scene, the background just isn't right. In cases like these, it is possible to cheat the angle. This can be done by moving the camera to a different angle but positioning the actor so that they appear in the frame exactly as they would if you were shooting the actual answering shot in the previous position. Since the audience hasn't seen the actor's actual background before, they won't know the difference; or, in some cases, the background of the entire scene is neutral enough (for example, a brick wall) that it doesn't matter. Be sure to adjust the lighting so that it appears as it should in the actual answering shot.

Types of Continuity

As we mentioned, there are several types of continuity. The script supervisor keeps an eye on all of these, but it is really the responsibility of each department to make sure continuity is kept consistent: clothes and jewelry are up to wardrobe, screen direction is up to the cinematographer and director, the prop master controls all props, and so on.

WARDROBE

Mistakes in wardrobe, jewlery, watches, hats, hair styles, and makeup are the ones most likely to be noticed by the viewer. Other types of continuity may not be so recognizable but they have a jarring, discomforting effect on the audience, even if they don't know why.

SCREEN DIRECTION

Wrong screen direction is something that the viewer may not directly notice but it is confusing and for a moment takes their mind off the story and forces them to reorient themselves mentally.

PROPS

Props are an obvious one: he is holding a wine glass in the wide shot, but his hands are empty in the medium shot. One example: in *Ocean's Eleven*, Linus and Rusty are talking in the casino. Rusty is eating a shrimp cocktail that changes from a cocktail glass to a plate and back again.

TIME

This goes beyond just time leaps on a clock visible in the shot (Figures 4.9 through 4.11); it also includes time of day — in the wide shot it is near sunset, but in the next shot, the characters are in midday daylight.

The Work of the Director

Director and Producer

The director and producer are a team. Even though there will inevitably be disagreements about the script, the budget, who to cast and about the editing, they must always be willing to work to overcome their differences for the sake of the project.

In theory, the producer is in charge of a production. In actual practice, it is often the director who has the last word on artistic matters and the producer who has the final say on all things concerning the budget. In some cases, the director and the producer will be the same person. This is possible, but it can be dangerous. Trying to do both will be overtaxing and exhausting, and can easily lead to both jobs being done poorly. The same applies to a director who also wrote the script. In that case, it is very helpful to have someone you trust to be able to give you feedback and even pushback on the script, casting and other important matters.

> Filmmaking is all about appreciating the talents of the people you surround yourself with and knowing you could never have made any of these films by yourself.
>
> Steven Spielberg

THE DIRECTOR'S JOBS

First let's talk about the responsibilities of the director. Here are some of the many things they do:

- Overall artistic direction of the project; primarily "bringing the script to life."
- Makes final casting decisions.
- On the set, the director is artistically in charge; however, the assistant director (AD) has primary responsibility for the schedule and actors' schedules, subject to what the director needs.
- "Calls the shots" — decides the shots and coverage for every scene in the film.
- Collaborates with the cinematographer, production designer, and other creative leaders on the project and gives them guidance.
- Keeps the production on schedule and within budget, in collaboration with the AD and Line Producer.
- Works with the actors individually, and as a group to keep everyone "making the same movie."
- After shooting, works with the editor, composer and VFX team (if there is one) to shape the final project.

THE STAGES OF FILMMAKING

The director is involved in all phases of the filmmaking process:

- Development
 - Working with the producers.
 - Collaboration with the writers. In some cases, the script is finished before a director is brought on board.
- Pre-production
 - Working with the production team.
 - Collaboration with the Production Designer, Wardrobe and Makeup.
 - Analyzing the script and forming ideas about how each scene will be approached and how the overall flow of the story needs to work out.
- Shooting
 - Collaboration with the Director of Photography and the entire creative team.
- Post-production
 - Working with the editor and composer.
 - Working with the special effects team, if there is one.
 - Working with marketing.

Getting Started

Directing a movie, or even a short film or commercial can seem daunting, even overwhelming. How do you start? Where do you begin? In short — with the script.

The screenplay, the script, is the basis of everything that happens in a movie — that's why it is so important to get the script right before you even begin production. When we say the script is the basis for everything, we mean that literally. It is so much more than just "what the actors will say." The script is also what the cinematographer will read to understand how to photograph the film; it's what the production designer studies to think about the design; the prop person will use it as a guide, the AD will use it to make the schedule, the effects people will learn where they fit it, and so on.

For the director, the script is their bible, it is a guide that everyone shares. When beginning a production, the director will read the script again and again, making notes, daydreaming, perhaps screening similar movies along with the cinematographer and production designer and discussing them — an old tradition in the film business.

The director might also put together an idea book: little sketches, pictures torn from magazines, notes, printouts, etc. This is a good process for the director's thinking, but it can also be a great communications tool when working with the cinematographer, production designer, wardrobe and makeup.

UNDERSTANDING THE SCRIPT

It's not enough just to read the script, or even just make plans for how you want to shoot the scenes — you have to understand the story and the script *in depth*. This means you have to understand how the whole story progresses and comes together; what the important story points are and how they fit into the overall flow. Most of all, you need to have a deep knowledge of the intentions of each scene — what are the characters trying to accomplish? What is going on inside their heads? How do these change during the course of a scene?

You'll need to read the script again and again, analyzing and making notes. This applies even if you wrote the script. A lot of times, you are going by instinct when you write a script and you may not have taken a step back to look at the script as the director, not as the writer. The important thing is that not only do you need to have a thorough comprehension of the scripts, you'll need to be able to communicate that understanding to the actors, the DP and others on your team.

TABLE READ

Next comes a *table read*. The actors gather together and the director, along with the AD, listen as the actors read through the script. It's a great way for people to get to know each other, hear others say the dialog and start to form their ideas about how they will portray the characters. It's a good time for the director to give some overall guidance but since it's public, probably not a good time to give individual actors specific direction — that's probably better done privately.

REHEARSAL

Often on movies, we don't get a real rehearsal period — sad but true. Most directors and actors would love to rehearse extensively but often the pressure of budget and time don't allow it. More often the rehearsal comes on the set, right before the camera rolls. This is not as bad as it sounds, it is very immediate, and helpful and most of the time, it's how movies get made. But if you can have rehearsals, definitely do it. They are not just for the actors either, the director is likely to learn more about the characters, the story and how to work with each actor. New ideas almost always emerge in rehearsal; also, bad ideas tend to melt away.

PAGE TURN

Similar to the table read, the *page turn* is for the crew, not for the actors. Led by the Assistant Director (the director sits in), all the department heads — cinematographer, gaffer, grip, production designer, props, makeup, wardrobe, stunts, mechanical effects (the ones done on the set) and others — go through the script page by page and make sure the specific requirements of each scene are under control: lighting, props, wardrobe, sets, special effects, transportation, etc. This is also a great opportunity for the director to communicate to them the vision and style they have in mind for the film. For department heads, it is also about making sure the right equipment and crew are on hand when they are needed.

You gain actors' trust sometimes through the rehearsal process, through interactions with them, by getting to know them, listening to their opinions. It's a little like being a therapist or a friend. Then once an actor trusts you, you can give criticism in a positive way, to shape the performance. If you don't have that trust relationship, it can be detrimental. On the other hand, I've worked with actors like Meryl Streep who are far more experienced than I am. In that case, it's about working together to figure out who the 'character' is, but then trusting the actor's instincts to be able to deliver that character on screen.

Susan Seidelman
(*Desperately Seeking Susan*)

Director's Pre-Production

Pre-production is a busy time for the director: possibly fine-tuning the script, creative meetings with the DP, production designer and others. The AD will have questions as they prepare the strip board and schedule; the producer will undoubtedly want to talk about the budget — they always do. But there are more essential duties in pre-production: casting actors and selecting locations. These are activities that simply cannot go forward without the director.

CASTING

Casting is one of the most essential parts of directing a movie. On small productions, the director may do all the casting, assisted by the AD and maybe a PA or two. On larger productions, this would be a very time-consuming and exhausting task, especially at a crucial time when the director might be working out production details or working with the screenwriter. In these cases, a *casting director* is employed. The casting director will generally already know a great many actors and have hundreds of headshots and resumes. They will also likely have contacts with agents, agencies and services that help actors publicize themselves.

One key resource that a casting director will usually draw on is *Breakdown Services*. This is a company that will send your casting breakdowns (descriptions of the roles and the kinds of actors you are looking for) to hundreds of agents and agencies. Online casting services are usually free for the production and are very useful. Don't forget to be specific about where and when the filming will take place; no use getting headshots from Florida if you're shooting in Alaska and don't have a budget to fly people around.

The casting director (usually along with an assistant) will then go through the submissions and narrow it down to a smaller selection of highly likely choices. These choices are then called in for a first audition, which is shot on video.

The casting director shows the selected videos to the director, who narrows the choices further, down to a few top picks for each role. The actors selected are then contacted for a *call-back* (a second audition), this time with the director present. If the director can't decide by this time, a second call-back is needed. Sure the director has to do what is necessary to find the right actors, but keep in mind that these are people with real lives — don't waste their time with audition after audition unless it is really necessary. A good casting director can be an invaluable aid to your production — even if you've already booked Leonardo as your lead!

LOCATION SCOUT

There are two types of location scouts. The first is just the process of looking at locations to see which ones best suit the movie and the budget. If you can afford it, the first part of this process will be done by a *location scout*, who may be an outside consultant (there are many professional location scouts throughout the country and in other countries) or may be someone from the crew.

The location scout may do research on the web, in magazines or with state and city film commissions; most of which are extremely helpful and have lots of resources and places to show you. As a last resort, just getting in the car and driving around may be the way to go. At the location, the scout will take lots of photos or video, being sure to photograph in all directions and get pictures both inside and outside. Don't make yourself look foolish by showing a picture of a room and saying "and there's this great fireplace on the other side of the room." Have a photo or video of it!

Once the director reviews these images, they will decide which ones to visit in person. The director, AD, DP and production designer may all participate in these visits, but absolutely the director has to be there. By the way, *location manager* is a different job, which we'll talk about later. Sometimes the two jobs are done by the same person.

COLLABORATIONS

In pre-production, the director will be working closely with several key people. Often the *production designer* is the first person hired as their work often needs lots of lead time, even if you are shooting entirely on location. This is also the time where a lot of the visual world building is done, not just selecting locations, but also making decisions about wardrobe, props, makeup, color themes and so on. Even the smallest details may be worthy of the director's yea or nay — the wardrobe person might bring in four or five watches and ask "which one do you see the countess wearing?" Props might ask, "do you think she would have this kind of clock in her room?" The director doesn't need to weigh in on every single detail, just the ones that are really important to the visual storytelling.

The most important job of the director is casting. If you can cast your film in an interesting way, then you're 50 percent there.

Susan Seidelman
(*Desperately Seeking Susan, Smithereens*)

A Director Prepares

Directors must arrive on the set prepared — it is one of their most important duties. How does a director prepare for a day's shooting? First of all, they need to have studied the script inside and out — to truly understand the intent and purpose of every scene and how every character contributes to the intention of that part of the story. Most directors make extensive notes in their scripts about *blocking* (the movements of the actors), camera angles, notes to actors and what they are trying to do in every scene.

THE SHOT LIST

There is one piece of preparation that a director absolutely must do: a *shot list*. A director who comes to the set without a shot list is simply not doing their job and is arriving unprepared. A shot list is simple, it's just a list of what shots the director wants for each scene they plan to shoot that day (Figure 5.1). A copy will usually be given to the AD and possibly also the DP. Directors vary in how closely they stick to a shot list, but it is still absolutely required that a director have one ready at the start of the day. They don't necessarily have to be in the order of when you want to shoot them, although that is helpful. As shots are completed, the director (or the AD) crosses them off — this is incredibly important to check before you call wrap. Thinking on the drive home that "oops we didn't get that shot," is a terrible feeling and bad filmmaking. If you are coming back to the same set the next day, it's not fatal, but often that location is wrapped and no longer available, the same actors are not scheduled for the next day and so on. For the director to be certain that she or he got all of the shots needed for that day is absolutely critical. Figure 5.1 is an example of part of a shot list. The actual list for a shoot day would be much longer.

SETUPS

How do you measure a shoot day? How do you know if you're doing OK or falling behind? Of course, the main thing is to get all the shots scheduled for that day, but there is another measure called *setups*. A *setup* is every time the camera is moved to a different spot or the lens is changed. Shooting the master is a setup, but shooting the over-the-shoulder and a close-up are each individual setups. You might occasionally hear people say, "it was a huge day, we did 60 setups." On big-budget films, they do fewer setups, but do dozens of takes of each one; on smaller films you have to constantly fight to stay on schedule.

SKETCHES

Sometimes directors will add little sketches to the script, simple line drawings, of shots and the framing of particular shots. If you want, you can make full storyboards, but most often, simple little sketches are all you need. Alfred Hitchcock was an accomplished artist (he started in the business as an art director) but his shot sketches were no more than primitive stick figures — that's all he needed for himself and his cinematographer — just that the shot will show this and this and the camera will be about this high and on this side. Since he trusted his director of photography and he knew how much each lens would see, he rarely ever looked through the camera viewfinder and yet he is known for his precise and expressive mastery of the frame.

```
SHOT LIST - Shoot Day 5

Scene 27:
        Establishing shot of exterior

        Scene Master

        Two shot of them on sofa

        OTS on her
        OTS on him

        CU her
        CU him

        Reverse of them talking on sofa.

Scene 7:
        Tracking shot of her walking down the hall - leading her.
        Tracking shot of her walking down the hall - following her.

        Wide shot of her walking and entering door, pan to follow her.
        Medium of her opening door and going in.
        CU of her hand on doorknob.
```

Figure 5.1. A sample *shot list.*

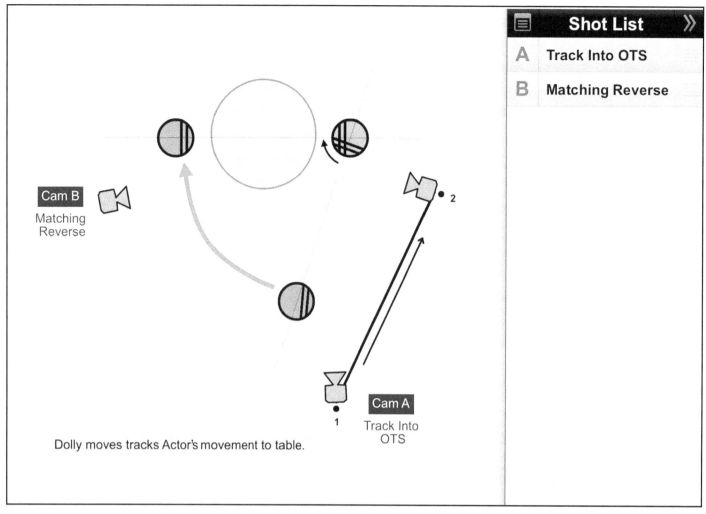

Shot List

A Track Into OTS

B Matching Reverse

Cam B
Matching
Reverse

Cam A
Track Into
OTS

Dolly moves tracks Actor's movement to table.

Figure 5.2. An overhead plan for a scene. This one was prepared with software (*Shot Designer*) made for this purpose, but most often they are hand sketched by the director.

OVERHEADS

Some directors prepare *overheads*, which are diagrams of the set that show where the camera will be placed for different shots (Figure 5.2). These can be very helpful as you think about how to stage a scene, but you will find that often when you are actually on the set shooting the scene you will deviate significantly from these plans. That is perfectly OK, the storyboards or overheads are planning devices, not rigid blueprints that absolutely must be obeyed. When you are really there on the set looking through the camera and seeing the real actors adding their own energy and movement ideas, it is quite natural to adjust your plans — in most cases it will be something even better than what you had envisioned in your imagination.

STORYBOARDS

Storyboards can be a great way to think through your ideas for a scene and very helpful in explaining your ideas to the production designer, DP and AD. Some beginning film-makers think that storyboards are an absolute necessity — they aren't. For most simple scenes, storyboards are not really needed, but if it is a complex action or stunt scene, or one that requires special effects or coordination of vehicles or movement, then storyboards are important to make sure that every department knows what is going to happen.

Although they are not a necessity, they might very well help you in thinking through a scene and how you want to shoot it. This can be done in the relative quiet of pre-production, without the pressure and time limits you'll be facing on the set. Sketches, overheads, storyboards — do whatever you can to be sure you are prepared for each day of shooting. A director who shows up not prepared is a director who is not doing their job!

Working With Actors

Working with actors can be like walking a tightrope: the director needs to guide the overall production, but it is very easy to create friction if an actor thinks you are trying to push them around artistically. One thing you will almost always want to avoid is "giving them a line reading."

"Giving a line reading" is when the director acts out the dialog and tells the actor "say it like this." Professional actors usually find it insulting. But don't think that you can't have some input with how an actor does the dialog — you just have to find a diplomatic and collaborative way of communicating your ideas. This can really tax your people skills and your diplomacy — but that is what makes a director a director. A good director creates an environment that gives the actor the encouragement to do well.

INTENTIONS OF THE STORY

Actually, specific line readings are the least important thing a director can do with actors: there are far more important jobs that need to be done. First and foremost is clarifying the intentions of the script and each scene. What is the essence of this story? What is it trying to say? What is each character's part in telling that story? That is the guidance the director owes to the actors.

INTENTIONS OF THE SCENE

When it comes to each scene, this is particularly important. It is up to the director to absolutely clarify what the scene is about and what the story needs to accomplish within that scene and how each actor's character is a part of what that scene needs to accomplish. An actor might have extraordinary insight into their own character and how a particular scene should play out, but it is important that the director also give the actors a sense of how their character and scenes fit into the overall story and what is needed to make sure that all the performances gel together into a unified whole.

ACTION, ATTITUDE, ACTIVITY

There is an old saying in actors' circles: it all comes down to the three A's; *Action*, *Attitude* and *Activity*.

- *Action* is what the character is actually doing: trying to get another character to reveal the password or trying to intimidate someone. Action is the story purpose of the scene. It is not physical action, it is what each character is *really* trying to do: uncover a mystery, spread a rumor about an enemy, save the life of the hostage. Most often, this is what the director needs to deeply understand and to help the actors understand. It is a big part of understanding the intentions of the scene.

- *Attitude* is how the character feels about things: about themselves, about the other characters, about what is happening in the scene.

- *Activity* is what they are doing physically: talking on the phone, shining their shoes, mixing a drink, or rowing a canoe.

GIVE THEM A VERB

Many actors think of each scene in terms of an *action verb* — what they are trying to do, their action in the scene. Here we are using the term action as what the character is trying to accomplish. What do we mean by an action verb?

- To demand.
- To convince.
- To incite.
- To challenge.
- To pry.
- To charm.

These are all things a character is trying to do — the things that motivate their actions in a scene. Often they are not on the surface, they are hidden or what we call "between the lines." Often, this is the only guidance an actor needs.

THE CONFLICT

If two characters in a scene have two different verbs — then you already have conflict, which is the basis of drama and comedy.

The director's job is to know what emotional statement he wants a character to convey in his scene or his line, and to exercise taste and judgment in helping the actor give his best possible performance. By knowing the actor's personality and gauging their strengths and weaknesses, a director can help him to overcome specific problems and realize their potential.

But I think this aspect of directing is generally overemphasized. The director's taste and imagination play a much more crucial role in the making of a film. Is it meaningful? Is it believable? Is it interesting? Those are the questions that have to be answered several hundred times a day.

Stanley Kubrick
(*Full Metal Jacket, The Shining, Paths of Glory, A Clockwork Orange*)

Performers are so vulnerable. If they're frightened of humiliation, their work will be crap. I try to make an environment where it's warm, where it's OK to fail — a kind of home, I suppose.

Jane Campion
(*The Piano, The Portrait of a Lady*)

Blocking the Actors

Blocking means giving the actors instructions on where to stand, sit, walk, open a door and so on — all of their physical actions. It is a very important part of the director's job. It makes a big difference in how the scene plays out on-screen. The director blocks all of the key actors, but the Assistant Director usually handles blocking for the extras and atmosphere performers.

BLOCKING FOR THE CAMERA

Of course, it's not just the actors who might move in a scene. Blocking the camera moves is important also. You will need to be very specific about where you want the camera for each part of the scene, whether you want movement or not and the timing of each movement. Sometimes directors leave it up to a trusted DP to work these out, but most often it is the director who makes these decisions.

AVOID FLAT SPACE

Flat space is when the actors just stay at the same medium distance from the camera for the whole scene. While this might be OK for some scenes, if every scene in your film is like that, it is boring; more importantly, it is failing to create a three-dimensional world for the audience. In other words, if you do every shot in flat space, you are missing out on some great opportunities that filmmaking offers you.

BLOCKING AND REHEARSAL

When you are on the set, the first thing a director will do is block the scene. The director will walk through the scene with the actors and show them step by step where they will be in the scene. For example: "You will enter through that door, then walk over here. When the phone rings, sit at the desk and pick up the phone."

The blocking is important for the actors to know obviously, but there is more to it than that. Blocking is also important for the DP, the gaffer, the first AC (focus puller), the dolly grip and the boom operator. All of these people need to know what is going to happen in a scene.

For the DP and gaffer, what happens in the scene and where the actors will be strongly affects the lighting of the scene. For the focus puller, they need to know where to focus the lens — obviously it is a high priority that the actors be in focus, nobody cares if the back wall is in focus, it is the actors that matter.

This part of the day is called the *blocking rehearsal*. The crucial thing to remember is that the blocking rehearsal is solely for the purpose of getting everybody on the same page, making sure everyone knows what is going to happen. It is important that it not turn into an acting rehearsal — there will be time for that later. Actors love to rehearse their scenes (they want to keep making their performance and the scene better and better), the director and AD need to work together to keep things on track — just do the blocking and then let the crew do their work while the actors go off to makeup and wardrobe.

Once the blocking rehearsal is complete, the AD turns the set over to the DP and the lighting crew. All actors should move off the set, everyone else gets out of the way and the DP walks through the set with the gaffer and key grip and lays out the plans for lighting the scene. Once that is done, the gaffer works with her electricians and the grips to get the lighting done.

When the DP informs the AD that the lighting is ready, the actors and director are called back to the set. The AD calls "first team in." Now is the time for the *acting rehearsal*. The director takes as long as she needs to rehearse with the actors and get the scene ready to shoot. The crew have done their jobs and at this time it is important for them to be very quiet and stay in the background so as not to disrupt the rehearsal or distract the actors. When they see the actors really doing the scene at full energy, the DP may decide that a few small *tweaks* to the lighting are needed. Hopefully none will be needed, but if they are, this is the time. Once the director decides everything is ready, the actual shooting begins.

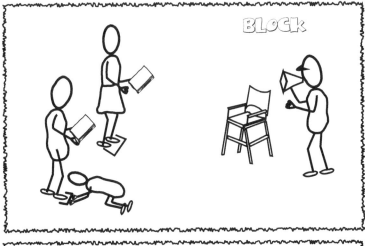

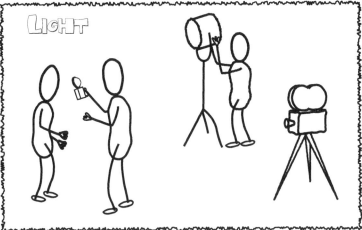

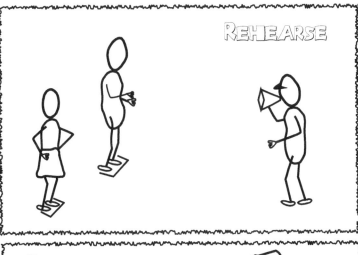

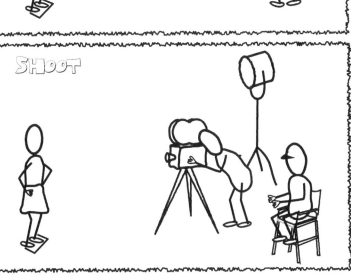

Block, Light, Rehearse, Shoot

Block, Light, Rehearse, Shoot. This is not just a suggestion, this is how it's done!

- Block: The director tells the actors what their movements will be in the scene as the DP, AD, and others observe.

- Light: The DP takes control of the set and with the gaffer and grip lights the scene while the camera assistants position and prepare the camera.

- Rehearse: This is where the director and actors really work out the scene. No one should interrupt them for technical stuff, this is all about the actors.

- Shoot: When the director decides the scene is ready, the AD sets things in motion and shooting starts.

Professionals do it this way for a reason: this is the way that works!

Figure 5.3. Block, Light, Rehearse, Shoot.

The Master Shot For the Scene

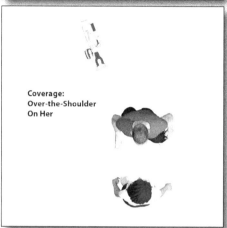

Coverage: Over-the-Shoulder On Her

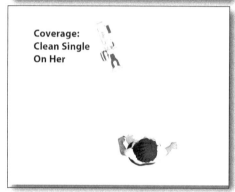

Coverage: Clean Single On Her

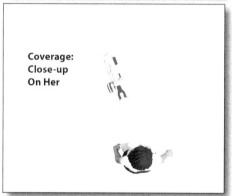

Coverage: Close-up On Her

Figure 5.4. (top) The *master shot* — the whole scene from beginning to end.

Figure 5.5. (second from top) An *over-the-shoulder* on her.

Figure 5.6. (third from top) A *loose close-up* on her. The other actor may need to move aside to get the camera in position.

Figure 5.7. (bottom) A *tight CU* on her. If the other actor can't be in position, give her a target for her eyeline.

Action, Cut, Circle That

There is a well-established and time-honored method for the procedures of shooting a scene. Once everything is ready to shoot: the camera, the lighting, the actors, it goes like this:

- The Assistant Director says "roll sound" and the sound recordist starts the recorder.
- The sound person says "speed," meaning it is recording audio.
- The First AD says "roll camera" and the AC or operator turns on the camera.
- The first AC says "speed," meaning the camera is rolling.
- The director says "action" and the actors do the scene.
- When the director feels the shot is complete, she says "cut," and the actors, camera and sound recorder stop. It is important that nobody says cut except the director — this is an old tradition. Sometimes, the actors and camera operator might think the scene is over, but the director feels that something is still happening that works for the film.

The only exception to this rule is that some directors ask the DP or camera operator to stop the shot when they see something that means the shot is worthless anyway, such as a stranger walking into the background of the scene. This is something that needs to be worked out in advance between the director and crew: some directors work this way and some don't.

Directors used to say "Cut. Print." This is a film term. It means that they should print the take. When shooting on film, not every take is printed in the *dailies*. The dailies are prints of what has been shot each day — they are usually viewed the following day after being sent back from the film lab. In video, you can view things whenever you wish, of course.

Now when shooting on video, it is more likely the director will say "Cut, circle that." This indicates that the script supervisor should circle the number of the take, meaning that it was a good take and everything worked. You will still have the not so good takes on the media, but at least the editor will know which take the director prefers. Since it may not always be important to even know which takes are circled, then more often nowadays, it's something like "Cut, loved it. Moving on."

The Shooting Methods

There are many different ways to shoot a scene, but some basic methods are used most often. The following summaries are some of the most fundamental and frequently used techniques for shooting a scene.

THE MASTER SCENE METHOD

Of the various methods of shooting a scene, by far the most commonly used, especially for dialog scenes, is the *Master Scene Method* (Figures 5.4 through 5.7). In principle, it's quite simple: first you shoot the entire scene as one shot from beginning to end — this is the *master*. Once you are happy with this master, you move on to the *coverage*. The master does not have to be a big wide shot; it usually is. Nor does it have to be static, a *moving master* is fine too. The important thing about the master is that it is the entire scene from beginning to end.

COVERAGE

The *coverage* consists of the *over-the-shoulders*, the *medium shots* and *close-ups* that will be used to complete the scene. Think of the master as a framework for the whole scene — the coverage are the pieces that fit into that framework to make it all work together. This is why you should always shoot the master first. It establishes the continuity for the scene — everything you shoot after has to match the continuity that was established in the master.

If for example, he says "I quit" and then sits down in the master, then in all of the other coverage he has to do it the same way. The actor can't all of a sudden sit down and *then* say "I quit." It won't match. Professional actors are very good at this and know that it's part of the job. If you are working with non-professionals, you will need to be extra alert to make sure everything matches. If it doesn't match, editing the scene will become extremely difficult. Good ideas when shooting with the master scene method:

- Always shoot the master first. If you try to shoot coverage first and the master later, it will very likely cause problems in continuity.
- Get the whole scene from beginning to end in every shot you do.
- If characters enter, start with a *clean frame* and have them enter.

- If characters leave, make sure they exit entirely, leaving a *clean frame*. Continue to shoot for a beat after that.
- You might want to use transitional devices to get into or out of the scene. Just as an example, a typical (if somewhat cliched) transition is to end the scene by panning over the fireplace or window or whatever.
- Shoot all the shots on one side before moving to the other side of the scene.

If you know you are going to use mostly the coverage when you edit, you may be able to live with some minor mistakes in a master. If you think you might want to use the master as a self-contained shot, then you may need to do as many "takes" as needed to get it right. In other words, for a long master, you don't need to "beat it to death."

OVERLAPPING OR TRIPLE-TAKE METHOD

The *overlapping* method is sometimes called the *triple-take* method (Figure 5.11). It is not used as much as other ways of shooting a scene. Let's take an example: a lecturer walks into a room, sets his notes on the lectern, then pulls up a chair and sits down. This is where the overlapping part comes in. You could get a wide shot of him coming in, then ask him to freeze while you set up for a closer shot of him putting the notes on the lectern, then have him freeze again while you set up another shot of him pulling up the chair.

What you will discover is that the shots probably won't cut together smoothly. The chance of finding a good, clean cutting point is a long shot. It is the overlapping that helps you find smooth cut points. Here is what will work much better: you get a wide shot of him walking in and let him take the action all the way through to putting the notes on the lectern. Then set up a different angle and ask the actor to back up a few steps. Once you roll the camera, the actor comes up to the lectern again (repeating the last part of his walk). You then shoot the action all the way through to pulling up the chair.

Again you halt to set up a different angle, and have the actor back up from the lectern, and repeat the action of putting down the notes and then carrying it on through to the end of the scene. All this overlapping will enable you to cut the action together smoothly with good continuity cuts. The most important principle to take from this is to *always overlap all action*, no matter what shooting method you are using. Giving the editor some extra overlap at the beginning or end of any shot will prevent many potential problems when editing the scene. Again, it is important to remember that this is one of our primary responsibilities — making sure all the footage is *cuttable*.

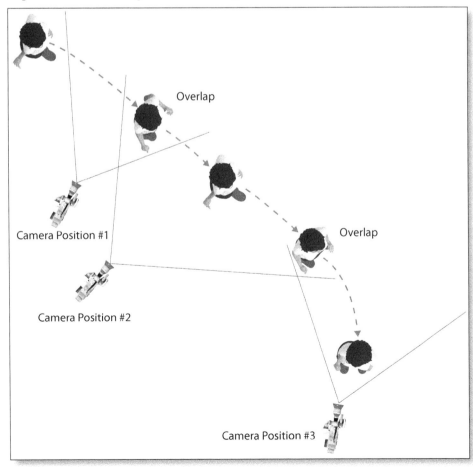

Camera Position #1

Overlap

Camera Position #2

Overlap

Camera Position #3

Coverage:
Over-the-Shoulder
On Him

Coverage:
Medium Shot
On Him

Coverage:
Close-up
On Him

Figure 5.8. (top) The *turnaround* — where we get the other side of the *coverage*. Some people call it the *reverse*, but *turnaround* is the correct term. This one is an *OTS* on him.

Figure 5.9. (middle) A *medium* on him. As with the coverage of her, if the actor needs to move aside to leave room for the camera, he will need a target to keep his eyeline correct. A paper cup on the end of a grip arm is sometimes used for this.

Figure 5.10. (bottom) The tight *CU* on him.

Figure 5.11. (left) The *overlapping* or *triple-take* method is used to get coverage of a continuous action or movement when we don't want to or can't cover it as a dolly shot, handheld, or panning shot. The most important part is to *overlap* the action. Make sure the actor goes beyond the end of the shot and starts the next shot several steps back from where you actually want the shot to begin — this creates the overlap that makes it immensely easier for the editor to match the action.

With this and other shooting methods, always make sure the actor makes a *clean entrance* to the frame and then makes a *clean exit* to leave the frame before you call cut.

Figure 5.12. There are many ways to shoot a *walk and talk*. Obviously, you are unlikely to shoot all these angles, but it can be very valuable to shoot it two or three different ways for editing.

Walk and Talk

Leading them Following them

You can shoot from any angle,
the camera moves with them

IN-ONE

Of all the methods of shooting a scene, by far the simplest is the *In-one*. This just means the entire scene in one continuous shot. A scene might be simple as "she picks up the phone and talks" or "He slams the door and storms out into the rain," in which case a single shot is probably plenty. *In-ones* can involve camera or actor movement, but in general, when most people say *In-one* or *Oner*, they are usually thinking of a fairly simple scene that just doesn't need a lot of coverage.

THE DEVELOPING MASTER

The *Developing Master* is a type of *In-One* or in the French term *plan scène* or *plan séquence*, but it's generally longer and more involved than a simple single shot. *Developing Masters* often involve a good deal of movement by the actors and the camera. Frequently, actors move into the foreground, into the background or even walk toward the camera into a close-up; this is a favorite technique of Spielberg, for example. It's important to avoid *flat space* in scenes like this. *Flat space* is when the actors stay the same distance from the camera the whole time. Scenes of this type are a great opportunity to exploit the possibilities of depth: the foreground, midground, and background. You can think of the developing master as a series of key frames connected by camera movement, thinking in reverse, thinking of the last frame first and working backwards to the first.

Some *Developing Masters* can be vastly more complicated: such as the famous four-minute opening shot of *Touch of Evil* or the long Steadicam shot of entering the Copacabana in *Goodfellas*. Take a look at the first four minutes of *Touch of Evil* — it's all one continuous shot, but it is no ordinary shot — it is mysterious, evolving, introducing new characters and setting up the basic backstory. Not every shot can be that great, in fact, not every shot needs to be that intense — a whole movie made of shots like that would be exhausting to watch. A caution, however: when these shots work, they can be great, but if they don't work — for example, if you find in editing that the scene drags on much too slowly — your choices are limited. If all you did was several takes of the long in-one, you really don't have much choice in editing. Play it safe — always shoot some coverage and cutaways just in case!

WALK AND TALK

Another variation is the *walk and talk* (Figure 5.12). It's pretty easy — the camera just follows along and two or more people walk and talk. The camera can be leading them, alongside them, or following them. It's wise to shoot several angles. If you only shoot one angle (such as leading them), then you are stuck with using that take from start to finish, no matter what problems may show up in the editing room — you have nothing to cut to combine two or more takes.

FREEFORM METHOD

Many scenes theses days (and even entire movies or TV shows) are shot in what is commonly called *documentary style* — the camera is handheld, loose, and the actor's movements don't seem pre-planned. It seems like documentary style and many people call it that, but it is not really. When shooting a real documentary, we can almost never do second takes, or have them repeat an action. Our aim in shooting fiction scenes like this is to make it

> If it seems a trifle slow, if it feels a trifle slow on the set, it'll be twice as slow in the projection room.
>
> Robert Wise
> (*West Side Story*, *The Sand Pebbles*, editor of *Citizen Kane*)

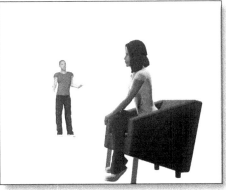

Figure 5.13. (left) The opening shot in a typical *developing master*. It makes use of *deep focus* to include close foreground and deep background.

Figure 5.14. (right) The shot as it appears on camera.

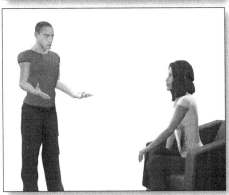

Figure 5.15. (left) He moves forward and the camera moves slightly left to adjust to a new frame — a two shot of both people.

Figure 5.16. (right) The resulting frame.

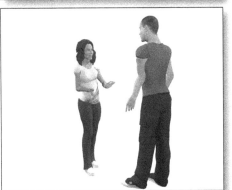

Figure 5.17. (left) He moves forward and the camera moves slightly left to adjust to a new frame — a two shot of both people.

Figure 5.18. (right) The resulting frame.

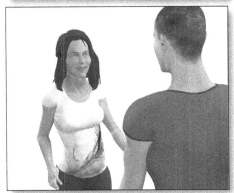

Figure 5.19. (left) He moves to behind her, she turns and the camera dollys in for an *over-the-shoulder*.

Figure 5.20. (right) The *OTS*.

Figure 5.21. (left) She turns away from him and the camera adjusts to the right to create the final frame featuring her in the foreground, him in midground.

Figure 5.22. (right) The final frame of the scene — all done as one continuous shot.

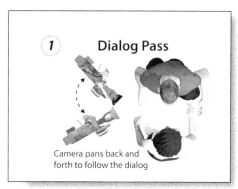

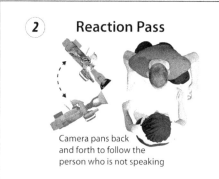

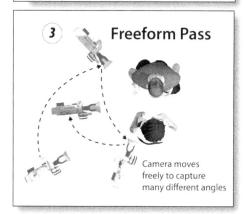

Figure 5.23. (top) The *Dialog Pass*—the camera operator pans back and forth to the actor who is speaking.

Figure 5.24. (middle) The *Reaction Pass*—the camera pans to the person who is not speaking. This gives the editor plenty to work with and most importantly, it gives you reaction shots, which you don't get if the camera only follows the dialog.

Figure 5.25. (bottom) In the *Freeform Pass*, the camera operator improvises, moving freely around and into the scene—this gives the editor many options.

seem like a documentary. In most cases, scenes like this are shot several times with the actors repeating the scene for several takes. Since the camera is handheld, the camera operator typically does their best to follow the dialog: they pan the camera back and forth to always be on the person who is speaking. This can sometimes be a disaster for the editor. Imagine that you shoot a scene three times like this. You end up with three takes that are almost the same and the camera is only on the actor who is talking. Since there are so many things that can go wrong — muffed dialog, the camera operator misses a pan, the camera assistant doesn't quite nail the focus, you can end up doing take after take after take, and even then maybe still not getting exactly the scene you want.

No matter how many takes you do, it is very unlikely that you will able to edit them together if you want to take some piece of one take and cut it together with pieces from another take. An even bigger problem is that you have no *reaction shots*. These are shots where we are seeing the person who is listening — they are an important part of filmmaking. Without reaction shots, we are not seeing the whole scene; we're not giving the actors a chance to see what they are thinking, how they are perceiving what is going on in the scene. Reaction shots are important no matter what style of shooting you are doing — in the Master Scene Method, it's one of the reasons we shoot the entire scene for every angle, not just the moments when someone is talking.

Figures 5.23, 5.24 and 5.25 illustrate a method that works well for providing the editor with lots of cuttable material and is also very efficient in shooting — we call it the *freeform method*:

- On the first take, follow the dialog. Do your best to stay with the actor who is speaking. This is the *dialog pass*. Don't worry if you don't get a perfect take — that's the beauty of this method, you don't need a flawless take because you'll have the ability to cut the scene freely.

- On the next take, pan back and forth to stay with the person who is *not* talking. This will give you lots of good reaction shots. It will also give the editor lots of things to cut away to. This is the *reaction pass*.

- For the third take improvise: follow the dialog sometimes, go to the nonspeaking actor sometimes, occasionally back up to get a wide shot or an over-the-shoulder — whatever seems appropriate. This is the *freeform pass*.

All these together will give you a scene you can cut together smoothly and give the editor lots of flexibility to cut the scene in various ways and to tighten up parts that seem to be dragging, to cover up blown lines or occasional bad focus.

MONTAGE

There is a special form of editing used in dramatic narrative filmmaking that does not aim for continuity at all; this is called *montage*. A montage is simply a series of shots related by theme. Say the theme is "Springtime in the city" — you might have a series of shots of the flowers blooming, gentle rain showers, the sun breaking through the clouds, that sort of thing. Or "Paris in the rain" — the opening montage of *Midnight in Paris* is an excellent example of this.

Some kinds of montage advance the story but without linear continuity. For example, *Rocky* prepares for the big fight: we see him working out, punching the bag, running on the streets of Philly, then finally running up the stairs to triumph. It is not real-time continuity but we see the story develop. It's a series of related shots, not scenes with linear continuity.

INVISIBLE TECHNIQUE

All of these methods — *Master Scene, In-One, Walk and Talk, Overlapping, Freeform* — share one common goal: to be invisible. We don't want the viewers to be aware they are a movie because this would distract them from the story. It's called *invisible technique* and it is fundamental to filmmaking.

Cinematography

The Camera Department

DIRECTOR OF PHOTOGRAPHY

The *DP* (*director of photography*, also called the *cinematographer*) is the person in charge of photography on the set. They supervise the lighting of the scene and set up the shots that the director asks for. Outside the US, it's usually abbreviated as *DoP*.

FIRST AC

The *First AC* is the head of the camera department. The DP is the big boss, of course, but in terms of running the day-to-day operations and doing things such as signing time sheets, the First AC is in charge. There is no way the Director of Photography wants or needs to spend time figuring out where to park the camera truck or checking if the batteries are being charged; that's up to the First AC and her or his crew.

First AC is also called *Focus Puller*. The First pulls focus on the shot, sets the aperture of the lens, checks that everything is working properly and generally manages everything to do with the camera. An old rule of thumb is that the First AC is never more than two arm lengths away from the camera; for bathroom breaks, the Second AC covers at the camera.

SECOND AC

The *Second AC* helps the First "build" the camera at the start of the day, brings new lenses when needed, takes the memory cards to the DIT when they are full and generally helps out wherever needed. The Second also helps the First measure focus by holding the other end of the measuring tape, then lays down focus markers (tape or otherwise) for the actors.

CLAPPER-LOADER

On film jobs, the Third AC was generally called the *Loader* or *Clapper/Loader* — they loaded and unloaded the film magazines; a huge responsibility. On digital shoots, they deal with the media: whether it is *CF* (*Compact Flash*) cards, *SD* (*Secure Digital*) or hard drives. Of course, they assist the First and Second ACs with whatever is necessary. The *clapper* part of the job means they operate the slate, clapping it at the start of a take to make syncing sound possible.

DMT

As independent productions almost never use film anymore, the Loader has been replaced by the *Digital Management Technician* (*DMT*), who takes the filled camera media from the Second AC and downloads them to hard drives, checks them to be sure all is OK and then gets the media back to the Second. The DMT is sometimes called *Data Wrangler*.

DIT

The *Digital Imaging Technician* (DIT) is a crucial and highly skilled position on the camera crew. Just downloading some Compact Flash cards does NOT make you a DIT (that's what the DMT does). The DIT may monitor the camera signal on the waveform/vectorscope, create LUTs and Look Files or check the integrity of camera files for proper exposure (guarding against clipping and noise), color balance, file corruption and so on. Some DITs also do basic color grading and work with the DP to achieve a "look." They might also transcode files so that the director/producer can view dailies and prepare the files in the proper format for the editors, VFX and other post-production people. Of course, many times the jobs of the DMT and DIT are combined.

OPERATOR

The DP does not always necessarily operate the camera. Especially on bigger productions there is usually a separate person whose only job is to operate. If more than one camera is in use (B-camera, C-camera, etc), those will have operators as well. The DP still handles the lighting, sets the exposure and controls the camera look. In the UK, the operator works more closely with the director than is usual in the US.

SECOND UNIT

Second unit handles shots that don't involve the main actors and thus don't need the director and DP to be there. Action shots, explosions, chase scenes, establishing shots and aerial footage are almost always handled by second unit, which will have its own DP, ACs, DIT and so on. On some very big second unit shoots, there will be nearly a full crew: gaffer, grip, audio, etc.

Shooting Digital

Everything is *high def* (*HD*) these days; "standard def" or "SD" (like TV was up until a few years ago) is as dead as disco. But there are different varieties of high def; the ones you need to be aware of are *HD* and *UHD* (*ultra high def*). HD is usually considered to be 1920x1080 pixels. *UHD* (often called *4K*) has several variations but it's usually 3840×2160 pixels. Resolution is measured by counting the pixels horizontally: 4K means there are somewhere around 4000 pixels across, 2K is 2000 pixels.

ASPECT RATIO

Aspect ratio is the "shape" of the frame — how wide and how tall it is as a ratio (Figure 6.1). If you see an old black-and-white movie, it will probably be 4:3 — four units wide by three units high, more square than we are used to seeing now (Figure 6.2). Both *HD* (*High Definition*) and *UHD* (*Ultra High Definition*) can be shot and displayed in a variety of aspect ratios but 16x9 is the most widely used standard.

FRAME RATE

In the beginning, movie cameras didn't have motors, they were hand cranked, which means that there was some variation in the *frames per second* (*FPS*). When sound recording was introduced, it was very important to keep the rate uniform and universal in order to synchronize the image and the sound, so 24 FPS was chosen to be the universal frame rate. Even today, movies are shot at 24 FPS. Until a few years ago, most video cameras shot only at 30 FPS and TV was the same. Doesn't sound like much of a difference, does it? Actually, it makes a big difference. Shooting at 30 FPS will give you what is called the "soap opera look." It definitely looks like TV, not cinema, which isn't often desirable. If your camera has a selection, you will normally want to set it to 24 FPS for a "film look."

Camera Terms

STATIC SHOT

Nobody calls it this, but that's what it is. It's a simple shot where the camera doesn't move and the frame doesn't change.

PAN

A pan (short for panoramic) is when a camera turns to the left or right. Turns, not moves; the camera stays where it is but just rotates to one side or the other.

TILT

A tilt is when the camera stays where it is but tilts up or down. Many people say "pan up" or "pan down." Sure, it's not technically correct to say that, but don't feel like you have to correct them just so you look like a smartie. If everybody knows what they mean, what does it matter?

ZOOM

A zoom is when the *focal length* of the lens changes from wide to narrow or narrow to wide. Most cameras now have zoom lenses. Years ago, zoom lenses were avoided as they were never quite as good as a fixed focus lens (one that cannot zoom in or out), but zooms have greatly improved since then.

DOLLY IN / TRACK IN / MOVE IN

This is when the camera moves toward or away from the subject. It might be handheld (called *move in*) on a *dolly* or some kind of a mobile camera support such as a *Steadicam*, or one of the many handheld stabilizers (Figure 6.57).

DOLLY LEFT / DOLLY RIGHT

When the camera moves left or right in relation to the subject; also called *track left* or *track right*. This is in no way restricted, you can combine a track in with a track left and move in at an angle, for example.

BOOM

The boom is the arm on a dolly that holds the camera; it can "boom" up or down so the terminology is simple: *boom up* or *boom down*.

DUTCH TILT

Most of the time, it's important to keep the camera perfectly level, but in some cases, it might be tilted left or right for effect. The most famous example of this is the movie *The Third Man*, where Dutch tilts are used extensively (Figure 6.2).

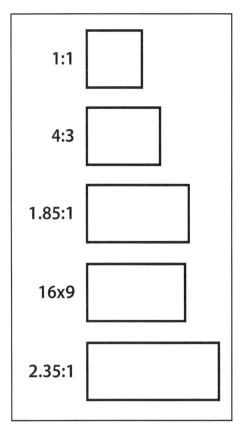

Figure 6.1. Various *aspect ratios*. For HD and UHD video, 16x9 is the most commonly used, but you can use others if you want.

Figure 6.2. (below) Dutch tilt in the classic film *The Third Man*.

Figure 6.3. (top) A scene shot with a wide angle lens. Wide lenses *expand* the sense of space.

Figure 6.4. (above) The same scene shot from the same camera position with a long focal length lens. It is important to note that the camera has not moved, neither have the actors. Long lenses *compress* space; they also have less depth-of-field.

Figure 6.5. (below) The *iris* (*aperture*) wide open — a lower f/stop number. This is a *prime* lens — it has a fixed focal length — in other words, it's not a zoom lens.

Figure 6.6. (below, bottom) The iris closed down to a higher f/number. This will let in less light. This will also increase your depth-of-field in the shot.

Focal Length

We talk about lenses in terms of its *focal length*. This is a measure of its *angle of view* — which just means whether the lens gives you a wide angle view of the scene or a narrow angle view (Figures 6.3, 6.4 and 6.7). A short focal length (a lower number in millimeters) is a wide angle, a long focal length (a higher number in millimeters) gives a narrow angle view of the lens. Long focal length lenses are sometimes called telephoto. Think of them like a telescope or a pair of binoculars — the reason they only give you a narrow angle of view is because they are magnifying the scene, just like a telescope would. On a 35mm film camera, an 18mm lens would be a very wide angle while a 250mm would be a very long focal length lens. It is important to understand that angle of view for a particular lens varies depending on what format you are shooting.

For example, a 25mm lens is fairly wide angle when shooting with a 35mm camera, but if you put the same lenses on a 16mm camera, it becomes a medium (or "normal") lens; in other words it will look the same as a 50mm lens would look on a 35mm camera. If you put the same lens on a smaller camera, it would be telephoto: a very long focal length lens.

THE PERSONALITY OF A LENS

There is another very important aspect of lens focal length: how they show space. Look at the illustrations in Figures 6.3 and 6.4. Neither the actors or the camera have moved between these two shots, only the lens has changed.

Notice that with the wide angle lens the two actors appear to be standing several feet apart, one in front of the other. In the shot done with a long focal length lens, the two actors appear to be only inches apart.

Long focal length lenses *compress* space. Wide focal length lenses *expand* space. This is an enormously important storytelling tool. It is very important for directors as well as cinematographers to understand these aspects of lenses.

Iris/Aperture

It is very important that we control how much light gets to the film or video sensor. Here's the key point: a particular type of film or a particular video sensor needs exactly the right amount of light in order to give us a good image. Let's talk about it in film for a moment; however, the same principles apply to video.

THE BUCKET

Think of the video sensor like a bucket: we need to exactly fill up that bucket to the rim. Too little water and it's not filled. Too much water and it overflows. Cameras are same: it needs exactly the right amount of light in order to give a good image. Too much light and it will be overexposed: washed out, blown out — terrible. Too little light and it will be dark and murky.

Giving that piece of film exactly the right amount of light is one of our most important jobs. Sounds trivial but it's really important for getting a good, professional looking image. Of course, there are exceptions — you might want a scene darkly lit for artistic effect, for example. What we are talking about here is getting the ideal good image, which is what we are trying to do most of the time.

THE APERTURE/IRIS

The *aperture* (sometimes called the iris) is simply a light valve (Figures 6.5 and 6.6). It is a circular opening inside the lens that has the ability to open and close. When we *open up* to a wide opening, it lets more light through. The camera is set up to produce the best picture if it receives a certain amount of light. When the scene is very brightly lit and there is too much light, we can *close down* the iris. If there isn't much light in the scene, we *open up* the iris to let more light in.

F/STOP

We measure how closed or open the iris is in terms of *f/stops*. A low f/stop means the iris is *more wide open* and lets more light in. A larger f/stop means the iris is more *closed down* and letting in less light. F/stops are a power of 2, meaning that one stop more open doubles the amount of light and one stop less reduces it by one half. Cutting the number in half *reduces* its speed by *one stop*. This applies to light as well; a stop is a *power of 2* — one stop more means you are doubling the light, one stop less means cutting it in half. Think of it this way: the camera always wants to have the exact same amount of light — if there is more light than that in the scene, you need to let less of it in, and vice versa.

Focus and Depth-of-Field

Many things are important in getting good cinematography, but two things are absolutely fundamental: exposure and focus. You can do the most beautiful and exciting shot ever: wonderful lighting, great camera movement, good use of the lens, everything perfect. But if that shot is not in focus and properly exposed — it's garbage. When a shot is *in focus*, the main subject is sharp and clear. When a shot is out of focus (commonly called *soft*) then the subject is fuzzy and indistinct (Figures 6.10 and 6.11).

CRITICAL FOCUS

The lens is always focused on exactly one point out in the scene. However, things in front of and behind that point also may *appear* to be in focus. The exact point the lens is focused on is called *critical focus*. The things in front of and behind this point that appear to be in focus are called *apparent focus*. If a lot of things are in focus back-to-front, we say that the shot has a lot of *depth-of-field*. If only things right at the point of focus are sharp, then we say the shot has very narrow depth-of-field. Depth-of-field (DOF) can be controlled in several ways.

The easiest way is with the aperture. If we close down to a smaller aperture, this *increases* the depth-of-field. If we shoot with the lens wide open (at f/1.4 for example) then we reduce the depth-of-field to its smallest. Two other factors change the depth-of-field: long focal length lenses have less depth-of-field and moving the camera closer to the subject also reduces the DOF.

STORYTELLING WITH FOCUS

Obviously, if you close the lens down to a very small f/stop, then you need more light to get a good image. This is the strategy used on a film that is famous for its *deep focus* (lots of depth-of-field), *Citizen Kane* (Figure 6.7). On the other hand, narrow depth-of-field, where only the actor is in focus and all else is slightly out-of-focus, draws the viewer's attention to the subject. Focus and depth-of-field are critical storytelling tools!

RACK FOCUS / FOCUS PULL

A rack focus is the practice of changing the focus of the lens during a shot. The term can refer to small or large changes of focus which play with the depth of field.

SHALLOW FOCUS

Shallow focus is a technique using very narrow depth-of-field. In shallow focus one layer of the image is in focus while the rest is out of focus. Shallow focus can be used to emphasize a certain part of the frame and all attention to it. It is most often used to focus attention on one actor by keeping the rest of the frame more or less out of focus.

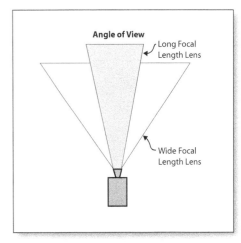

Figure 6.8. (above) The *focal length* of a lens determines how wide its angle of view will be. A lower number focal length (such as 10mm) will be a wide angle lens and a higher number focal length (like 100mm) will be a narrow angle lens, sometimes called a "telephoto lens."

Figure 6.9. (below) The *depth-of-field* (DOF) is how much of the scene is in focus. Two things determine depth-of-field: the focal length of the lens and the f/stop. Wider lenses have more depth-of-field and long focal length lenses have less depth-of-field. Lower f/stops (like f/2) have less DOF and higher f/stops (such as f/11) have less DOF. With the lens wide open (low f/stop number), only the King in the middle is in focus, the rest of the cards are out of focus.

Figure 6.10. (below, bottom) With the lens stopped down to a higher f/stop, all of the cards are in focus (although the King in front is slightly soft).

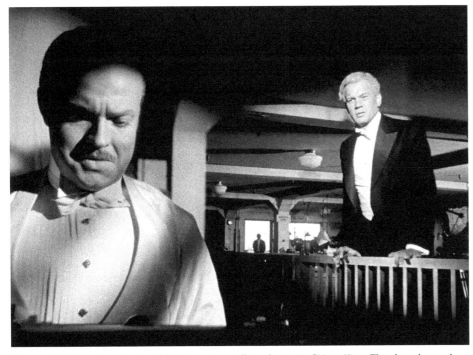

Figure 6.7. Very deep depth-of-field as a storytelling device in *Citizen Kane*. The shot shows three levels of story at the same time: Kane in front typing, his friend horrified at what he is doing and his business manager in the background, trying to stay out of the situation.

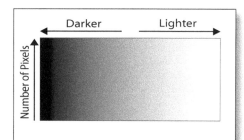

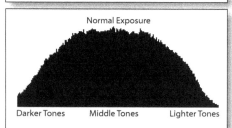

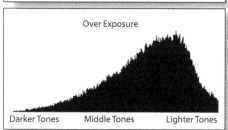

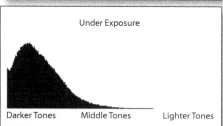

Figure 6.11. (top) Diagram of what a histogram tells you.

Figure 6.12. (second from top) A typical normal exposure on the histogram.

Figure 6.13. (third from top) Overexposed.

Figure 6.14. (above, bottom) An underexposed frame.

Exposure

Exposure is critical; it is one of the two fundamentals — focus is the other one. If your shots are not correctly exposed, there is no way you can ever get a good, professional looking image. Contrary to the myth, it cannot be "fixed" in post. True, some minor adjustments can be made, but if the exposure in a shot is really off, then "fixing" it will only result in an image that is grainy, flat and ugly. Whether you are shooting film or video, however, you are only going to get a good image if your exposure is correct.

It is important to think of exposure as more than just "it's too bright," or "it's too dark." It is much more than that. Exposure for film and video is essentially the same, but for simplicity we'll first talk about it in terms of video. What do we need to know in order to set the lens aperture at exactly the right setting? Remember this is film — there is no monitor to refer to. There are some things we need to know:

- What is the *speed* of the camera?
- What is the *shutter speed*?
- How *fast* is the lens?

Speed — ISO

Let's take it one at a time. What is "speed"? Every type of film and every video camera has a speed rating, which is called ISO. This is a measure of how sensitive it is to light. For film it is set as it is manufactured; on video cameras it is adjustable. A very *high ISO* will be able to get a good image even in very dim light. A *low ISO* needs lots of light to get a good shot. But there is catch — the higher the ISO, the more noise there will be in the shot; lower ISO leads to less noise, so always use the lowest ISO setting that still gives you the f/stop (and thus depth-of-field) you are going for.

Lens Speed

The widest the aperture will open up is important too. If the aperture is wide open, this is the setting that lets in the most light — in other words the setting we would use in the dimmest, darkest situations. The widest aperture a lens will do is how "fast" the lens is. We say "it's an f/2 lens," or "that's an f/4 zoom."

One other thing should be mentioned while we are talking about day exteriors. Often we just have more light than we want; for example, we just might not have any day exterior film stock available. In this case we often use *Neutral Density Filters (ND)* — these are light or dark grey filters which have no color bias at all; their only job is to reduce the amount of light. Don't forget that the aperture setting affects your depth-of-field — a higher f/stop (such as f/11) will give you more depth-of-field (more of the frame is in focus) and a smaller f/stop (such as f/2.8) will result in less depth-of-field.

DON'T BLOW OUT THE HIGHLIGHTS, DON'T GET INTO NOISE

The important thing about exposure is that you don't want to overexpose, which "blows out" the highlights (something which cannot be fixed in post), and don't underexpose, which creates video "noise" (some call it grain, but it's really just noise).

DON'T TRUST THE LCD SCREEN

The viewing screen on your camera is a handy guide to exposure, but don't trust it too much. Another thing to watch is that in dark shooting situations it is tempting to turn the brightness up on the viewing screen, but this means it might influence your exposure decisions, which is dangerous. Don't completely trust it for focus either — when the image is very small, everything looks like it's in focus. Try to use the biggest monitor you can.

HISTOGRAM

A very reliable guide is the histogram, which nearly all cameras have these days. The histogram shows you how much of the picture is in the dark areas, the light areas and in between. Figure 6.12 shows the basic concept of a histogram — it shows how many pixels are darker, all the way to pure black, and how many pixels are lighter, all the way to pure white. Figures 6.13 through 6.15 show examples of a typical normal exposure, an overexposed picture and an underexposed one. Remember that over exposure will lead to part of the picture burning out and under exposure results in more video noise.

ZEBRAS

Some cameras will show you zebras in the viewfinder. Zebra stripes will appear on the part of the picture that is exposed over a certain level and will help you judge your exposure. Figure 6.16 shows normal exposure with zebras — only the highlights have zebras over them; Figure 6.17 is a very overexposed frame which will have lots of detail burned out.

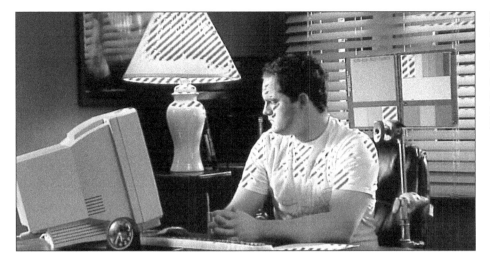

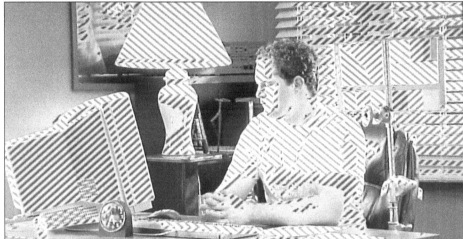

Figure 6.15. (left, top) A normally exposed frame. Zebras appear only over things in the scene that we want to be *highlights*.

Figure 6.16. (left, bottom) The same shot very overexposed — zebras appear on parts of the scene that are in the middle of the scale, which means that they will *burn out*, which always looks bad.

Color Balance

We can't show color balance here, but there are examples on the website. Humans perceive most normal lighting as "white" but in fact it's not. *Daylight* is more on the blue side. Indoor *tungsten* light (ordinary light bulbs) is reddish-orange. *Fluorescent* lights, such as you might find in office buildings, warehouses, schools, and so on, are very green, as are many LED household lights. We don't see this because our eye/brain *adapts* and fools us into thinking it is white light. Cameras are not so easily fooled so we have to make adjustments for different kinds of light. Keep in mind that for some scenes, you might not want technically "correct" color balance. For example, you might want romantic scenes to be slightly warmer, alien attack scenes to be bluer, or you might want to go for a *Fight Club* style green overcast.

VIDEO WHITE BALANCE

Video cameras can automatically adjust their color balance to adapt to the kind of light you are using on your scene. It is called white balance, but some refer to it as color neutral balance. It's very simple: you point the camera at something neutral in color, something pure white or pure grey, and push the color balance button.

The camera analyses the light and if it is off in any direction, such as too red or too green, it changes the camera electronically to make the camera "see" the light as neutral. Here is the important point and the one people most often forget: you must shoot the neutral white or grey object under the same light you will be using on the scene.

Also, if you are planning to use colored gels on your scene, then make sure you take them off before you white balance the camera. For example, if you are going to use a deep blue gel on your scene and you color balance the camera with that blue gel on — white balancing the camera will just remove the blue, thus defeating your purpose. Most people use something white, but it's hard to know if it's really neutral white. It is better to use something you know is truly neutral, such as a *Neutral Grey Card*, available at any photo shop. A neutral grey card or other type of more professional color balance chart is an essential tool for cinematographers. See *Cinematography: Theory and Practice* or *Motion Picture and Video Lighting* (both by the same author as this book and both from Focal Press) for more details on professional color charts.

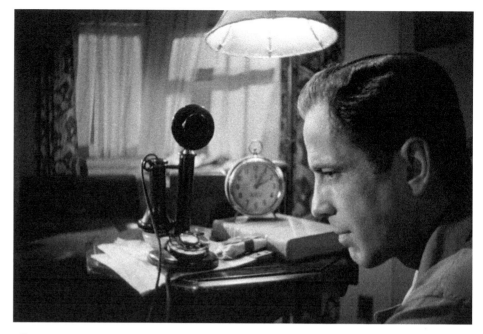

Composition

Composition is an intense subject and we can only touch on the high points here. For a more in-depth discussion, see the chapter *Visual Language* in **Cinematography: Theory and Practice** by Blain Brown or **Picture Composition for Film and Television** by Peter Ward. In general, we are trying to get the composition of the frame to present the subject in an organized way: one the eye can perceive in a meaningful way. We want to not just see the subject, we want the composition to tell us something about what we are seeing, we want it to be part of the storytelling. In most cases we are looking for some kind of visual balance, although in some cases we might want an unbalanced frame for artistic purposes. Figure 6.18 shows examples of a disorganized, unbalanced frame and an organized, balanced composition.

THE RULE OF THIRDS

A very rough rule of thumb for these things is called the *Rule of Thirds* (Figure 6.19). Divide the frame into three parts vertically and horizontally. If major elements of the frame comfortably fit on these lines and intersections, most likely you will have a basic decent composition. This is a very rough guideline, but it's a good starting point.

Disorganized composition. No order, no balance.

Organized composition: order and balance.

Figure 6.18. (top) Composition is about balance and order. This doesn't mean that every shot has to be perfectly centered and balanced, but it is something to keep in mind when setting up your shots, and when the director is blocking the actions of the actors.

Figure 6.19. (bottom) The *Rule of Thirds* can be a helpful guideline in composition.

Point-of-View

We use the term point-of-view (POV) in a couple of different ways in filmmaking. The most commonly used one is the POV of the camera. If the camera is seeing what the character would see in a scene, we say "it's her POV." If the camera is more or less distant from the scene, we say it is an objective POV — it's not the point-of-view of any particular person. It's like in writing in the *third person*, such as "Look at them over there." If the camera gets closer and gets into the scene, it becomes more subjective. For example, an over-the-shoulder shot is more subjective, but it's not exactly what the character in the foreground is seeing; it's like writing in the *second person* "I see what you mean." If the camera is seeing the scene exactly as one of the characters might see it, then it is a completely subjective POV. It's like speaking in the first person "I am seeing this."

A true subjective shot has certain conventions: it is always done handheld, this helps create the feeling that it is really how a person sees. It should also be at the same eye level as the character. For a typical person, this means handheld camera on the shoulder is just about right. If you are doing the subjective POV of a dog (like in Figure 6.22), then the camera needs to be much lower — at the same eye level as the canine actor. This doesn't mean that all handheld shots are subjective POV. Doing entire scenes or even entire movies handheld has become a frequently used device. Many TV shows arc shot as pseudo documentary. Handheld camera helps convey the feeling that it is shot by a documentary crew.

This kind of loose, handheld feel may not be explicitly intended to imply that it is documentary, but it is more informal and gives a more realistic, "you are there," kind of feeling to the scene. Remember that the camera is in some ways a character in the scene — some shots are better with an objective POV and some with a more subjective point-of-view. Think about what is best for your scene before you decide how to shoot it.

Figure 6.20. (below, left) A purely *objective* point-of-view.

Figure 6.21. (below, right) The dog's *POV* of the man. This is a true *subjective* POV.

Figure 6.22. (bottom, left) The man's *POV* of the dog; also a subjective point-of-view shot.

Figure 6.23. (bottom, right) An *over-the-shoulder* shot is more *subjective* but not purely so. It includes both of them but it is very close to the subjective POV of the man.

The Shots: Building Blocks of a Scene

It is useful to think of "building" a scene. Since we make scenes one shot at a time, we can consider that we are assembling the elements that will make the scene. If we think of a language of cinema, these shots are the vocabulary; how we edit them together would be the syntax of this language. These are the visual aspects of the language of film; there are, of course, other properties of this language that relate more to plot structure and narrative, but here we are concerned only with the visual side of this subject. In terminology, there are two general types of shots: *framing shots* (defined by how much is included) and *function shots* — defined by what purpose they serve in editing. In a by no means exhaustive list, they are:

Framing Shots

- Wide shot (or long shot)
- Full shot
- Cowboy
- Two shot
- Medium
- Close-ups
- Clean single
- Dirty single
- ECU
- Over-the-shoulder

Function Shots

- Establishing shots
- Cutaway
- Insert
- Connecting Shot
- Transitional Shot
- Reaction Shot

With a few exceptions, most of these shots apply to people, but the terminology carries over to any subject. As they appear in the script, they are called *stage directions*. Let's look at them individually. As with many film terms, the definitions are somewhat loose and different people have slight variations in how they apply them, particularly as you travel from city to city or work in another country; they are just general guidelines. It is only when you are lining it up through the lens that the exact frame can be decided on.

As they appear in the script, stage directions are completely non-binding — it is entirely up to the director to decide what shots will be used to put the scene together. The screenwriter really has no say over what shots will be used, but they are helpful in visualizing the story as you read the script — especially if you are giving the script to people in order to secure financing for the project or to actors so they can decide if they want to be involved. These shots are the basic vocabulary we deal with — both in terms of editing and also in terms of the director communicating to the DP what it is they are trying to do. These basic elements and how they are combined in editorial continuity are the grammar of cinema.

An important function of choosing the shot is deciding what it is you want the audience to pay attention to; what you want them to mentally focus on or take in. An essential part of choosing the shot you want is what you want the frame to be: what you want to include but also what you don't want them to see.

WIDE SHOT

The wide shot is any frame that encompasses the entire scene. This makes it all relative to the subject. For example, if the script designates "Wide shot — the English Countryside" we are clearly talking about a big panoramic scene done with a short focal length lens taking in all the eye can see. On the other hand, if the description is "Wide shot — Leo's room" this is clearly a much smaller shot but it still encompasses all or most of the room.

ESTABLISHING SHOTS

The establishing shot is normally a wide shot (Figures 6.24 and 6.25). It is the opening shot of a scene that tells us where we are. The scene heading in the script might be "Ext. Helen's office – Day." This might consist of a wide shot of an office building, so when we

Figure 6.24. (left) An establishing shot from *Manhattan*. It shows us the location, but also the time, tone and mood of the scene. This is a *wide shot* also called a *long shot*.

Figure 6.25. (above) An establishing shot from *Metropolis*—it shows us the world of the future where the story takes place. Also a wide shot.

cut to a shot of Helen at her desk, we know where we are: in her office building. We've seen that it is a big, modern building, very upscale and expensive and that it is located in midtown Manhattan, and the bustling activity of streets indicates it's another hectic work-day in New York. The establishing shot has given us a good deal of information.

Establishing the Geography

A phrase that is often used is that we have to "establish the geography." In other words, we have to give the audience some idea of where they are, what kind of place it is, where objects and people are in relation to each other. Other aspects of this were discussed earlier in this chapter.

Establishing the geography is helpful to viewers to let them know the "lay of the land" within a scene. It helps them orient themselves and prevents confusion that might divert their attention from the story. There are times when you want to keep the layout a mystery, of course. As we will see throughout the discussion of film grammar and editing, one of the primary purposes is to not confuse the audience. There will be times of course where you *will* want to confuse them, but if you don't give them information and they have to spend time trying to figure something out, however subconsciously, you have taken their minds away from the characters and the story. Figure 6.24 is an example of an establishing shot that has value in ways beyond just showing the geography — it can also establish tone, mood, and time of day.

An establishing shot, such as our office building example, might also include a tilt up to an upper floor. This indicates to viewers that we are not just seeing an office building, but that we are going inside. Shots of this type are sometimes considered old-fashioned and prosaic, but they can still be effective. Even though they give us a good deal of information, they are still a complete stop in the dramatic action.

Many filmmakers consider it more effective if the establishing shot can be combined with a piece of the story. One example: say we are looking down that same bustling street and our character Helen comes into view, rushing frantically and holding a big stack of documents; we pan or dolly with her as she runs into the lobby and dashes to catch a departing elevator. The same information has been conveyed, but we have told a piece of the story as well. Something is up with Helen; all those documents are obviously something important that has put her under a great deal of stress. Of course, in the story, Helen may already be in her office. One of the classic solutions has been to combine a bit of foreground action with the establishing shot. For example, we start with a medium shot of a sidewalk newsstand. An anonymous man buys a paper and we can read the headline "Scandal Disclosed," and we then tilt to the building. What we have done here is keep the audience in the story and combined it with showing the building and the context.

CHARACTER SHOTS

There are a number of terms for different shots of a single character. Most movies and short films are about people, so shots of people are one of the fundamental building blocks of cinema.

FULL SHOT

Full shot indicates that we see the character from head to toe (Figure 6.29). It can refer to objects as well: a full shot of a car includes all of the car. A variation is the *cowboy* (Figure 6.30), which is from the top of the head to mid-thigh.

TWO SHOT

The *two shot* is any frame that includes two characters (Figure 6.36). The interaction between two characters in a scene is one of the most fundamental pieces of storytelling; thus, the two shot is one you will use frequently. The two characters don't have to be

Figure 6.26. (top) A *two shot* from *Casablanca*. A shot like this could also serve as the *master*, if you are going to do more coverage of the scene (which you always should).

Figure 6.27. (middle) An *over-the-shoulder*.

Figure 6.28. (bottom) A *fifty-fifty* from *Casablanca*.

Opposite page:

Figure 6.29. (top, left). A *full shot*.

Figure 6.30. (top, middle). A *cowboy shot*.

Figure 6.31. (top, right). *Medium*.

Figure 6.32. (second row, left). *Medium CU*.

Figure 6.33. (second row, middle). *Close-up*.

Figure 6.34. (second row, right). A *choker*, also known as a Big Head Close-up.

Figure 6.35. (third row, left). An *ECU* (*extreme close-up*). Sometimes called a *Sergio Leone*.

Figure 6.36. (third row, middle). Any shot with two people is called a *two-shot*.

Figure 6.37. (third row, right). A *three-shot*.

Figure 6.38. (bottom row, left). A *50-50* (*fifty-fifty*) is two people from the side.

Figure 6.39. (bottom row, middle). An *over-the-shoulder* (OTS).

Figure 6.40. (bottom row, right). The *answering shot* for the OTS in 6.39. Every shot you do in coverage should have an answering shot.

arranged symmetrically in the frame. They might be facing each other, both facing forward, both facing away from the camera, and so on, but the methods you use for dealing with this type of scene will be the same in any case.

MEDIUM SHOT

The *medium shot*, like the wide shot, is relative to the subject. Obviously, it is closer than a full shot. Medium shots might be people at a table in a restaurant, or someone buying a soda, shown from the waist up. By being closer in to the action, we can see people's expressions, details of how they are dressed, and so on. We thus become more involved in what they are saying and doing (Figure 6.31).

CLOSE-UPS

Close-ups are one of the most important shots in the vocabulary. There are a number of variations: a *medium close-up* (Figure 6.32) would typically be considered as something like from top of head to waist or something in that area. A *close-up* (*CU*) would generally be from the top of the head to somewhere just below the shirt pockets. If the shot is cut just above the shirt pocket area, it is often called a *head and shoulders*. A *choker* would be from the top of the head down to just below the chin (Figure 6.34). An *extreme close-up* or *ECU* might include the eyes and mouth only; this is sometimes called a *Sergio Leone* after the Italian director who used it frequently. Terminology for close-ups includes:

- *Medium CU*: Mid-chest up.
- *Choker*: From the throat up.
- *Big Head CU* or *tight CU*: Framed from just under the chin and giving a bit of "haircut." That is cutting off just a little bit of the head.

Over-the-Shoulder, Clean Single and Dirty Single

The over the shoulder shot is a camera angle that frames itself from behind a person who is looking at the subject of the shot. The over the shoulder shot abbreviation is "OTS." Other names: Sometimes this shot is called the "Dirty single." A "clean shot" means there's nothing in the frame but the subject. A "dirty single" is the view of something else in the frame other than the main subject.

ANSWERING SHOT

If you shoot a close-up of one actor in a scene, you should always get the same shot (same lens, distance and shot size) for the other actor — it is called the *answering shot*.

50-50

A *50–50* is a shot with two actors facing each other so we see them in profile (Figures 6.28 and 6.38). It's a perfectly usable kind of shot, but be careful not to use it as an excuse for not getting proper coverage with over-the-shoulders and close-ups.

CUTAWAYS — ALWAYS SHOOT SOME!

A *cutaway* is any shot of some thing or person in the scene other than the main characters we are covering that is still related to the scene. The definition of a cutaway is that it is something we did not see previously in the scene, particularly in the master or any wide shots. Examples would be a cutaway to a view out the window or to the cat sleeping on the floor. Cutaways may emphasize some action in the scene, provide additional information, or be something that the character looks at or points to. If it is a shot of an entirely different location or something unrelated to the scene, then it is not a cutaway, it is a different scene. An important use of cutaways is as safeties for the editor. If the editor is somehow having trouble cutting the scene, a cutaway to something else can be used to solve the problem. A good rule of thumb is in almost every scene you shoot, get some cutaways, even if they are not called for in the script or essential to the scene — a cutaway might save the scene in editing.

REACTION SHOTS

A specific type of close-up or medium is the *reaction* shot. Something happens or a character says something and we cut to another person reacting to what happened or what was said; it can be the other person in the dialog or someone elsewhere in the scene. Generally, the term refers to a facial expression or body language, not dialog. A reaction shot is a good way to get a safety *cutaway* for the editor. Sometimes the term just refers to the other side of the dialog, which is part of our normal coverage — it's only a reaction shot if the actor isn't talking. Reaction shots are very important and many beginning filmmakers fail to shoot enough of them. Reaction shots may not seem important when you are shooting the scene, but they are invaluable in editing.

Typical Character Shots

There is a fairly standard repertoire of shots that are commonly used in film. You are not limited to these shots; not by any means. It's just that these are the most common ones that have names. There are some variations in the names from place to place, but overall they are fairly consistent.

Full shot or *head-to-toe* or *five T's*.

Cowboy. Outside the US, sometimes called the *American shot*.

Medium. Also, any shot that shows a person alone is a "single."

Three T's or *Medium CU*.

Close-up (*CU*).

Choker — tight close-up.

Extreme close-up (*ECU*) or "Sergio Leone." It's OK to give them a "haircut."

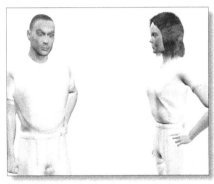

Two-shot. Any shot of two people is a two-shot.

Three-shot. 'nuff said.

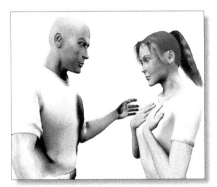

A *50-50*. A useful shot, but don't use it as a substitute for getting proper coverage.

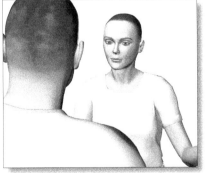

An *over-the-shoulder* (*OTS*). A very important shot in filmmaking.

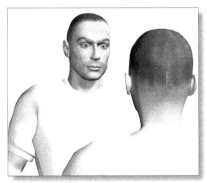

The *answering shot* for the OTS at left.

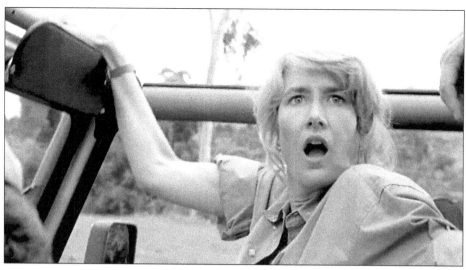

Figure 6.41. (top) Bond fighting on top of a train.

Figure 6.42. (second from top) *Close-up* of Moneypenny aiming.

Figure 6.43. (third from top) Her *optical POV* of the fight through the telescopic site on her weapon.

Figure 6.44. (above, bottom). The *connecting shot* that ties it all together.

Figure 6.45. (right) A *reaction shot* from *Jurassic Park*.

Figure 6.46. (below, top) He picks up the cardboard tube and looks at it.

Figure 6.47. (below, bottom) An *insert shot*—his *POV* of the label.

Inserts

An *insert* is an isolated, self-contained piece of a larger scene. To be an insert instead of a cutaway, it has to be something we saw in the wider shots. Example: she is reading a book. We could just shoot the book over her shoulder, but it is usually hard to read from that distance. A closer shot will make it easy to read. Unlike cutaways, many inserts will not be of any help to the editor. The reason for this is that since an insert is a closer shot of the larger scene, its continuity must match the overall action. For example, if we see a wide shot of the cowboy going for his gun, a tight insert of the gun coming out the holster must match the action and timing of the wider shot; this means it can be used only in one place in the scene and won't help the editor if they need to solve a problem elsewhere in the scene. Inserts tend to fit into a few general categories:

- *Informational inserts*: a shot of a clock on the wall is a practical insert, as is reading the headlines on the newspaper or the name of the file being pulled from the drawer. These are mostly about giving the audience some essential piece of information we want them to know (Figure 6.47).
- *Emphasis inserts*: the tires skid to a halt, the coffee cup jolts as he pounds the table, the windows rattle in the wind. Emphasis inserts are normally closely connected to the main action but not absolutely essential to it.
- *Atmosphere inserts*: these are little touches that contribute to the mood, pacing, or tone of a scene.

CONNECTING SHOTS

Most scenes involving two people can be adequately edited with singles of each person; whether they are talking to each other or one is viewing the other from a distance, such as a shot of a sniper taking aim at someone. This is sometimes called *separation*. A *connecting shot* is one that shows both of the characters in one shot; often it is in the form of an over-the-shoulder or wide angle that includes both of them.

TRANSITIONAL SHOTS

Some shots are not parts of a scene themselves but instead serve to connect two scenes together. We can think of these as transitional shots. They might come at the end of a scene, at the beginning, or between scenes. Some are simple cutaways: a scene ends, cut to a shot of a sunset and then into the next scene. There are many other types of transitional shots as well, they are a sort of visual code to viewers that the scene is ending. Scenes of the city or landscape are frequently used as transitional devices as they also add to the mood or pace and are generically visual — meaning they don't need to make a specific point in order to be interesting.

Framing People

Certain guidelines apply to framing up people in your scene. The most important of these are called *headroom* and *nose room*.

HEADROOM

Above are some examples of headroom: not enough (Figure 6.48), way too much (Figure 6.49), and just right (Figure 6.50). Too much headroom is one of the most common signs of poor camera operating. It's a natural human impulse to put the head in the center of frame; watch out for this when you're operating the camera.

NOSE ROOM

Nose room is also called looking room. It is the room in front of a person's face as they look to either side. Below are some examples:

Figure 6.48. (above, left): Not enough head room.

Figure 6.49. (above, center: Too much head room.

Figure 6.50. (above, right): Goldilocks! Just right.

Figure 6.51. (far left): Not enough nose room.

Figure 6.52. (left): Good nose room.

On the left is an example of not enough nose room (Figure 6.51). See how he seems jammed up against the edge of the frame? On the right is an example of better nose room (Figure 6.52). It gives him some comfortable room in front of his face.

THINGS TO AVOID

- Don't let something grow out of their head — such as a light pole, a cactus or anything else that is distracting.
- Don't cut them off at the knees.
- Don't have too much headroom (see next section).
- Avoid having the subject dead center — unless that is the effect you're going for.
- Fill the frame — don't leave too much dead air.

FOREGROUND, MIDGROUND, BACKGROUND

One of our challenges in filmmaking is to recreate the three-dimensional real world in a two-dimensional frame. Shots that have depth and dimension will help with this. If your shot doesn't have depth and dimension, it is *flat space* — more of a two-dimensional scene.

AVOIDING FLAT SPACE

Flat space is when all of the key elements (mostly the actors) just stay the same distance from the camera for the whole scene — no depth or dimension. Avoiding flat space is about how things are arranged in the scene, but it's also about camera placement and use of lenses. Remember that long lenses compress space and make it flatter and wider lenses expand space and make it more in depth.

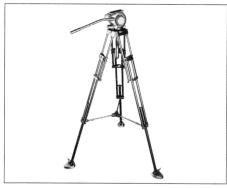

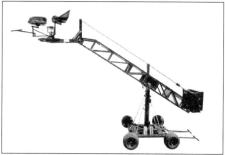

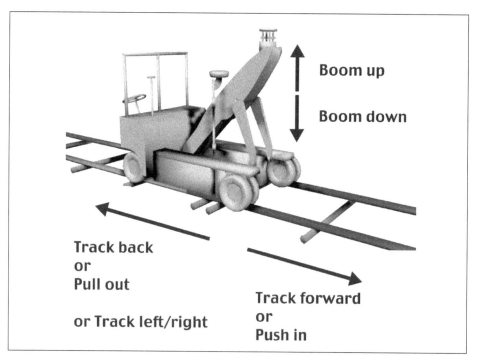

Boom up

Boom down

**Track back
or
Pull out**

or Track left/right

**Track forward
or
Push in**

Figure 6.53. (top) A tripod with a fluid head.

Figure 6.54. (second from top) A jib arm. Jibs come in many different sizes.

Figure 6.55. (third from top) A camera slider from CAME-TV.

Figure 6.56. (above) A crane with seats for the operator and camera assistant.

Figure 6.57. (right) A dolly and the names of various moves it can execute.

Camera Support

Camera support is the general term for things that hold the camera where we want it to be.

TRIPOD (STICKS)

A *tripod* (often called *sticks*) is the oldest method of holding the camera steady (Figure 6.53). You will also need a *fluid head* to make sure all your camera moves are smooth and steady. Some type of camera head is needed for most of the camera support methods.

DOLLY

A *dolly* (Figure 6.57) is the most commonly used type of camera support. It is as steady as a tripod but can freely move in any direction and also *boom* the camera up and down.

HANDHELD

Handheld cameras can bring a feeling of realism and a pace to the scene. They are used for POV shots and for that "documentary" feel.

SLIDER

A *slider* enables you to shift the camera from left to right with fluidity and stability. You can move in and out with the slider and always appear controlled (Figure 6.55).

STEADICAM

A *Steadicam* (or one of the several types of gear that do the same thing as a Steadicam) lets you have the access and fluidity of handheld, but the stability of the slider or tripod (Figure 6.59).

GIMBAL

A *gimbal* is a support that allows the rotation of the camera in several directions (Figure 6.60). The gimbal is something to use if you don't have the room or access to a Steadicam setup.

CRANE

If you want to emphasize scope and scale, consider mounting your camera on a *crane* (Figure 6.56). A crane is not cheap to rent and you need professional grips to operate it, but a crane shot can add size and scope to the scene.

JIB

Cranes are built to support the camera, an operator and a camera assistant. If you don't need that, a *jib* works like a crane, but is smaller and can be controlled mechanically or by one person (Figure 6.54). The jib allows you to go smoothly high or low and swing left or right. Most often, you will need a remotely controlled camera head to point it in the right direction.

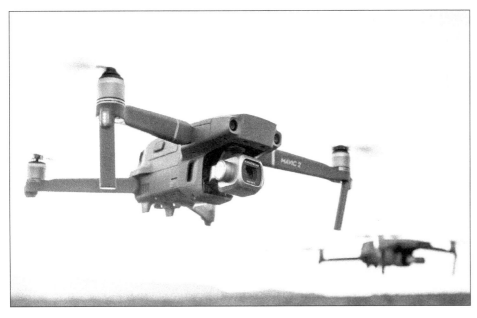

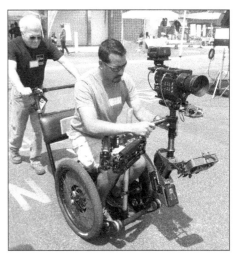

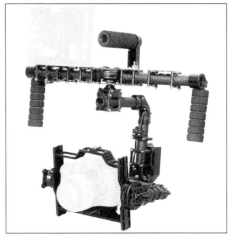

DRONE

Drones (Figure 6.58) have become extremely popular as a way to get camera angles and moves that wouldn't be possible any other way (you can't fly a helicopter indoors, for example). They also have the advantage of being relatively cheap to rent or buy.

Camera Angles

Camera angles are an important tool because they can help convey different emotions and open the audience up to a different viewpoint.

EYE LEVEL

This is the "default" placement for the camera most of the time — at the actor's eye level. Sometimes the impulse is just to set the camera up at a level convenient to the operator's eye level, but it is the character in frame that matters.

LOW ANGLE

Shots from a *low angle* give power to the objects in the frame. These provide scope and scale, dominance.

HIGH ANGLE

When the camera looks down on the scene. It can make someone feel insignificant or can lay out the pathway for what lies ahead — commonly seen in film noir.

HIP LEVEL

A *hip level* shot is a camera angle that focuses on the characters from the waist up. This shot was popular in Westerns as it could feature the gunslinger's sidearm in the foreground.

LOW ANGLE

Let's get low with the ground level shot. Here maybe you're following ants in your reality show or your Pixar movie. This shot takes you close to the earth for a falling boot or to give scale to the horizon.

DUTCH ANGLE

Most of the time, we want the camera to be absolutely level. Checking the level is an important part of the AC's job for every setup. If we lean the camera to the left or right, this is called Dutch Tilt. Be sure that it is tilted enough so it doesn't just seem like a mistake.

BIRD'S EYE VIEW

Also called an *overhead* or a *God's Eye* shot, this is any shot from a very high angle or even directly over the subjects.

AERIAL SHOT

Aerial shots from a drone or helicopter can have a large view, a sweeping panorama and graceful sweeping moves.

Figure 6.58. (left) A *drone* with HD camera. (Courtesy DJI, Inc.).

Figure 6.59. (top) A *Steadicam*. In this case it's rigged on a wheelchair type dolly with large wheels for very smooth moves.

Figure 6.60. (above) A *three-axis gimbal*. (Courtesy CAME-TV).

Camera Movements

Moving the camera is a key tool that can be used for many purposes: to change the framing of the shot, add energy to the scene or to convey some subtle emotional undercurrent.

STATIC / FIXED SHOT

The camera does not move. This is the default for tripods as you can't really move the sticks unless it is mounted on something that moves.

PAN

The camera rotates from side to side so that it aims more to the left or right. The camera does not change its location.

TILT

The camera rotates to upward or downward without moving where the camera is. Directors often say "pan up," and newbies take great delight in correcting them. Don't be that way; you know what they mean, just do it.

SWISH PAN / WHIP PAN

A whip pan is a type of pan shot in which the camera pans so quickly that the picture blurs into indistinct streaks. A swish pan can be used to meld two scenes together so it seems like you're just panning, when it fact it is two entirely different shots.

TRACKING MOVE

The camera moves and follows a subject, left or right, forward or backward.

CRAB MOVE

A version of tracking, trucking and dollying. This is side-to-side movement at a constant distance from the action at hand.

ARC MOVE/CIRCLE MOVE

An arc move is a camera move around the subject, somewhat like a tracking shot, where the camera moves in a rough semi-circle around the subject. Michael Bay loves these shots.

ROLLING SHOT

Anytime the camera is mounted on a vehicle, camera car or truck, it is a rolling shot. On bigger budgets, remotely controlled cranes mounted on the top of cars are very popular.

ZOOM

Zooms were popular in the seventies but are out of favor now for one simple reason — they call attention to themselves and take the viewer out of the story for a moment. They remind the audience they are watching a movie — not usually what you want.

The Prime Directive

If the shot is not in focus and properly exposed, then it doesn't matter how artful your lighting is or how "cool" your camera moves are — it's garbage. Above all else, the DP is responsible for getting usable images, and of course, the art as well. Also critical is making sure the camera is level; your first AC should check this, of course, but it is still ultimately the responsibility of the cinematographer. To be more specific, the parts that you want to be in focus should be in focus. Remember that focus is an important storytelling tool — it can be used to draw the viewer's attention to elements in the frame.

DON'T JUST DO ALL CLOSE-UPS OR ALL WIDE SHOTS

Variety is important in your shot selection. A movie that consists of all wide shots or only close-ups will be visually boring and, more importantly, you are giving up one of your most important tools for visual storytelling. You have a lot of ways of engaging the audience, don't give them up unless you have a very strong reason for doing it.

Managing Your Media

Digital cameras generally fall into two categories: the high-end pro cameras that record to a hard drive and cameras that record to an *SD* (*Secure Digital*) or *CF* (*Compact Flash*) card. All of these are referred to as *media* (Figure 6.61).

The important thing to remember about media that comes out of the cameras is that this is your movie. All of the time, effort, money and sweat that went into shooting the movie is now entirely contained on those little cards — it doesn't exist anywhere else. Damage that card or accidently erase it and it's never coming back. Needless to say — proper handling of your media is critical.

Figure 6.61. A *Secure Digital* (*SD*) card, used in many video cameras.

DON'T DRAG AND DROP!

A standard method of transferring computer files (and all digital camera video is a computer file) is to "drag and drop." However, this is a dangerous way to capture your footage because it doesn't usually involve error checking. If possible, it's better to use software specifically designed for this, such as *Shotput Pro*.

THREE BACKUPS

It is impossible to overstate the importance of backups. Keep in mind that those files are your whole movie — all the time, money and effort that was put into making the film only exists in those files — back them up! A single backup is never considered to be enough, professionally, three backups are the minimum and for many projects there are more. On a large professional project, the original hard drives or memory cards are often not erased until the clone copies have been verified by the insurance company. As this obviously involves a lot more hard drives or cards, it isn't feasible on most productions.

Figure 6.62. Types of toe marks for the actors. Which one is used is up to the preference of the camera assistant.

Marking

Both the actors and the camera need marks to tell them where to be in various parts of the scene (Figures 6.62 and 6.63). For the actors, "hitting their marks" is an important part of the job. A big part of this is that the First AC knows where to focus on them for sure only when they are on their marks. The same applies to the camera movements.

MARKING DURING BLOCKING REHEARSAL

One of the most important factors in keeping the action sharp is to make focus marks. These serve two purposes: first they give the actors a reference for where they need to be and second, they give the focus puller definite places to focus on — assuming the actors "hit their marks."

MARKING TAPE

There are several ways of making marks but the most frequently used is marking tape. You can always tell who is the second AC on a film set — they will have several colors of 1/2" paper tape hanging from their belt. Different colors are used for different actors so they can tell which marks are theirs. T-marks are the most commonly used, but some ACs use toe marks made from a "V" of tape or box marks for both feet (Figure 6.62).

FOCUS MARKS ON THE DIAL

All follow-focus rigs have a marking dial made of white plastic that can be marked with an erasable pen. Usually, each mark on the dial will correspond with an actor's mark on the floor, but sometimes, ACs will make marks for references such as the door, the edge of the table, etc.

INVISIBLE MARKS

Marking becomes more difficult if it's a full shot that includes the floor. In this case, normal marks would be visible in the frame. Some ingenuity is needed to make marks in situations such as this: a twig, a spit mark, a crack in the pavement or any other reference can be used. Sometimes a very small piece of black tape won't be seen on camera. It's more difficult for the actor and the focus puller, but it's better than nothing.

DOLLY MARKS

If there's a dolly move, it will be necessary to make *dolly marks* as well — there's no point in measuring the distance to the actors if the dolly ends up in a different place on every take! Generally, a piece of white tape is placed on the floor even with the back axle of the dolly; this is what will be easiest for the dolly grip to see. Chalk is also used for this.

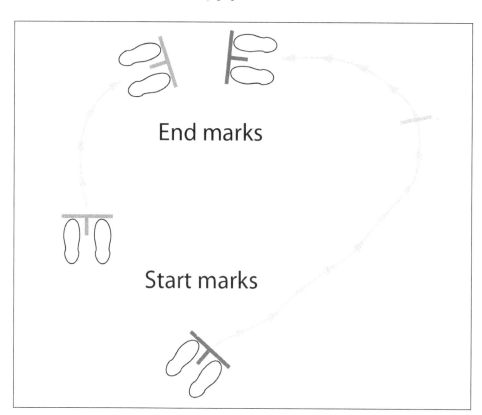

Figure 6.63. T-marks used for the actor's blocking so that focus is consistent. It's an old Hollywood saying that the key to acting is to "know your lines and hit your marks."

Pulling Focus

Accurate focus depends on accurate measuring. All professional cameras have a mark somewhere that shows the *plane-of-focus* — the exact place the lens needs to focus to. This mark is a small circle with a line through it.

SOME FOCUS PRACTICES:

- Take the time necessary to make accurate marks during blocking rehearsal: both for the actors and on the *follow focus dial*. The DP and AD should be on your side if the director gets fancy and doesn't want to take the time. Remind them that taking a moment to get proper focus marks will make shooting the scene go faster and be less frustrating due to fewer blown takes. The DP and operator should always back up the first AC when they need a moment — it never takes as long as the director thinks it's going to.

- Be ready in case actors miss their marks. Make your own "reference" marks either physically or mentally. For example, you may know that the edge of the carpet is six inches from the actor's mark and you can reference that if they land somewhere between their mark and the edge of the carpet.

- Do *eye marks* if necessary. The operator can visually focus on something in the scene, then the AC marks it on the dial. To do this, zoom in all the way and have the iris wide open, thus reducing depth-of-field for critical focus. With a very wide lens (or wide zoom) and the iris closed down, almost everything "looks" like it's in focus; don't be deceived.

- Get a feel for how the actors move: a common problem is that in blocking rehearsals, the actors are at half energy at most. When they get into the actual scene (especially if it's very emotional, physical or violent) their movements will usually be bigger and frequently they go past their marks. Anticipate and be ready for this.

- If there is a camera move, don't forget to set marks for the dolly as well as marks on the focus dial. These marks will be used by the dolly grip so that is who should set them. Most often the rear axle of the dolly is the place used to line up to marks as that is going to be easily visible to the dolly grip. On a studio floor, tape is OK (don't forget to clean it up after the shot) but chalk may be easier to deal with. Outdoors, some grips use lawn darts to set dolly marks.

- The eyes have it. Always measure focus to the actor's eyes. When pulling the tape measure, always to the plane of their eyes (this is one reason ACs use a fiberglass tape instead of a steel one). If holding up a flashlight or focus target, keep it next to their eyes. In extreme close-up, it is disturbing to see the nose in focus and the eyes soft. In very extreme close-up, it's wrong to see the eyelashes in focus but the eyes out of focus. Nobody said focus pulling was easy!

For critical focus, zoom in all the way, focus, then zoom back to your framing.

Figure 6.64. (above, top). Lighting the green-screen evenly is important.

Figure 6.65. (above, middle). The background plate — this is what will appear behind the foreground scene.

Figure 6.66. (above, bottom). The final composited image.

Figure 6.67. (right). The whole setup. Note the black Xs on the greenscreen. These are *tracking marks*; they will help the *compositor* align the foreground and background. They are especially important if there is any camera movement on either the foreground or background plate.

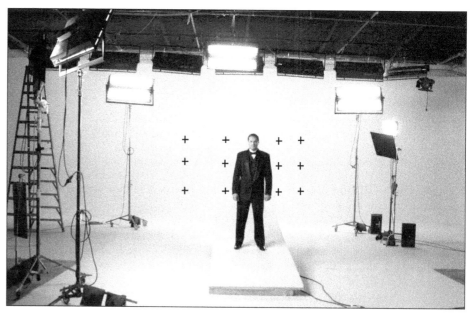

Shooting Greenscreen

Shooting *composites* (where two or more shots are combined into one shot) has become a major component of filmmaking at all levels. It is usually called *greenscreen* for the color of the background most frequently used. It consists of shooting a *background plate*, which will be the background of the shot — it might be the forest of Endor, or a Martian desert or an alley (Figure 6.65). The *foreground plate* is what you want to appear on that background — it's usually the actors, but it could be anything (Figure 6.67). This foreground plate is shot in front of a color backdrop (usually green) and then computer software makes the green "disappear," it becomes transparent, so wherever there was green you can now see the background plate and the two shots are now merged together.

Any color can be used as the background color, but the important thing is that whatever the backdrop color is (technically called the *matte color*) must *not* appear in the foreground scene. If, for example, someone is wearing a green hat in front of the green backdrop, in the final composite, part of their head will disappear. Lighting for the greenscreen should be as even as possible and should match the exposure of the foreground (actors). Lighting for the foreground should be whatever is appropriate for the scene. For example, if the actor is supposed to be walking through the jungle, then flat, even lighting on the actor would look very strange.

BACKGROUND PLATES

The *background plate* is often shot first as this makes it easier to match the lighting, camera angle and lens of the foreground plate (Figure 6.64). Most often the background is a static shot as any camera movement would make matching the foreground much trickier, although it is possible with more advanced technology. A *moving plate* is used for traveling shots in a car or train, for example.

THE FOREGROUND PLATE

Shooting the foreground can be a technical challenge but the basic rules are simple:
- Light the backdrop evenly.
- Match the exposure of the foreground and the backdrop.
- Match the camera angle and perspective (lens). For example, if the background is shot from a very low angle, it will look odd if the foreground is shot from a high angle. It also may not work if the background was shot with a very long lens and the foreground is shot with a very wide lens.

TRACKING MARKS ARE IMPORTANT

If the camera moves at all while shooting the foreground plate, remember that the background will also have to move in the same way. It is difficult to make the background move in sync if there is no way to judge exactly how much and how fast to move it in the post-production process. The way this is done is with *tracking marks* (Figure 6.67). Usually these are made with black x-marks of paper tape on the green background. They are important — don't forget to add them!

Lighting and Grip

Figure 7.1. An LED light panel.

Why Lighting Matters

A few years ago, a major manufacturer of professional video equipment announced a new High Def camera and said in their ads that "this camera is so sensitive that you don't need lighting." The reaction from the cinematography community was angry and intense. The reason is simple: if exposure were the only thing that mattered, then that might be true. A faster, more sensitive camera would make a difference. The real issue is that getting exposure is only one of the jobs that lighting does for us. What we really need lighting to do is:

- Create a mood.
- Help us tell the story visually.
- Shape the scene visually and emotionally.
- Underscore the emotional values of the scene.
- Direct the viewer's attention or in some case hide things.
- Help us shape the composition of the frame.
- Create beauty, or horror, or disharmony, or anything.

Sure, exposure is important and lighting helps us with that, but frankly, getting enough light for exposure usually isn't that hard. Doing lighting that sets the mood and helps us with the visual story takes a little more doing and a lot more thinking. If you only think about lighting as "do we have enough light to shoot the scene?" then you are missing 90% of what lighting can do for you as a visual storyteller.

THE MOST IMPORTANT THING ABOUT LIGHTING

There is one lighting basic that is so fundamental that it must be singled out: avoid flat front lighting! What this means is that whenever possible, try to light a scene from the sides and back: your lighting will be more interesting, create more depth and dimension and will go a long way toward setting the mood and helping tell the story. Of course, there are exceptions, but not many. As with any general principle, there are times when lighting from the front is the right thing to do, but as a general concept, avoiding flat, front lighting is absolutely fundamental (Figure 7.10).

EXPOSURE

A shot that is not properly exposed will never be as good as it could have been. While exposure is set at the camera, not having enough light on the scene just makes it more difficult to get it right.

CREATE A MOOD

One of the most important things lighting can do for us is create a mood: bright and sunny, dark and mysterious, evil shadows and so on. It is a powerful tool for the filmmaker.

DIRECT ATTENTION

Lighting can emphasize certain elements of the scene. A shot where everything is lit the same will not help direct the viewer's attention to one area or another. As with focus, you can use it to draw the eye toward the part of the scene you want them to notice — usually the actors or some other important object.

GIVE INFORMATION

We can use light and shadows to hide or reveal people or objects in the scene. This is frequently used in horror films, of course, when the evil being appears suddenly from the shadows.

THE LIGHTING PROCESS

Don't just "start lighting." This usually leads to many false starts and wasted time. You have to have a process. The most important element is the scene itself: the blocking, the mood, the atmosphere, the time of day.

You've read the script and interpreted it visually. Once you've seen the blocking rehearsal you should have ideas on how to light the scene. Most often, people start with the key light on the scene and then add to it as the scene dictates. Sometimes it makes more sense to start with some big lights punching through the window or an overall ambient. Which way you start will depend on the situation — the set or location, the number of lights you have, how much power is available, etc. For more on the process and techniques of lighting see **Motion Picture and Video Lighting**, third edition, also by Blain Brown.

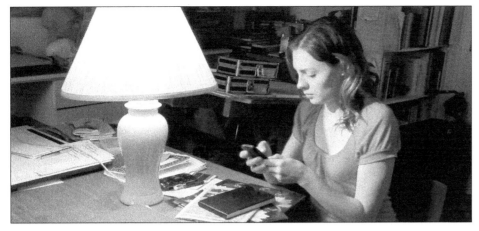

Types of Lights

Professional lighting equipment is great and easy to use. In many cases, you just won't have pro equipment available. On some jobs we end up making our own lighting units or using things from the hardware store. Lighting units come in a couple of basic types: Fresnels, LED, open-face and fluorescent.

FRESNELS

Fresnels are lights that have a lens. It's a special type of "stepped" lens but it is basically just a simple lens like a magnifying glass (Figure 7.2). All Fresnels have a "spot/flood" knob that allows you to make the beam narrow and intense or wider and more spread out (less light intensity).

OPEN FACE

Open face lights don't have a lens. They are basically a bulb holder, a reflector and a housing, nothing more. They do have some ability to spot-flood. They are useful because they are more efficient than a Fresnel, just because the lens absorbs some of the light. Open face lights are not as "refined" as Fresnels; one would rarely shine an open face light directly on an actor, but they are great for times when you just need raw power, such as when you are bouncing a light off a *reflector* or punching the light through some heavy *diffusion* — two ways to make a light *softer*.

LEDS

LED lights are the hot new thing in lighting for many reasons: they use a lot less power, they don't create as much heat and many of them have both built-in dimmers and color control. The fact that they need less power is important. It means that frequently you don't need a generator or heavy cable. This can be a huge cost and time saver. Being able to change the color with a dial also means saving on color gels.

FLUORESCENT

Pioneered by the company *Kino Flo*, movie lights based on ordinary fluorescent are extremely popular in film lighting. They are very efficient, which means you get a lot of light with very little electricity. For example, you can plug several of these lights into one household circuit, where with ordinary tungsten lights (Fresnels and open face) only one 2,000 watt light will go into a normal household circuit. Any more than that will cause the fuse or circuit breaker to blow.

PRACTICALS

Some scenes can also be lit with the existing household desk lamps and floor lamps that are already in the scene. Don't be afraid to move them around and experiment with the lamps until you get what you want. Ordinary lamps that actually work are called *practicals*.

Lighting this way has become much more popular in recent years due to several factors: cameras that can get a good image with much, much less light, more powerful practical bulbs, color correct sources (LEDs, Kino Flos), faster lenses and most importantly, the desire for a more naturalistic look and feel to a scene. *Birdman* is a prominent example; with one or two exceptions, it was lit entirely with practical lamps in the scene: hallway fluorescents, hanging lamps, wall sconces, table lamps and so on.

Figure 7.2. (above) A tungsten *Fresnel* light; in this case a 300 watt *Tweenie*. (Photo courtesy of Arri Lighting).

Figure 7.3. (left) An example of *carrying a lamp*. It looks like she is being lit by the table lamp but her lighting is actually a *Tweenie* just out of frame on the left.

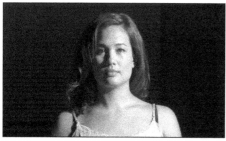

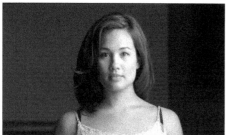

Figure 7.4. (top) *Hard light* creates sharp well-defined shadows on her face.

Figure 7.5. (above) *Soft light* doesn't create sharp shadows. It also wraps around her face for a softer, more pleasing look. Soft light is not the solution in all cases; classic films from the 30s, 40s, and 50s used hard light beautifully, but soft light is used much more often these days as it is tends to make the actors look good.

Hard vs. Soft

There are really only two types of light when you really boil it down to the basics: *hard light* and *soft light*. Of course there are all sorts of subtle gradations in between hard and soft, but in the end there are just these two types.

HARD LIGHT

Hard light is also called *specular* light. It is light that casts a clear, sharp shadow. It does this because the light rays are traveling almost parallel. What creates a beam of light with the rays pretty much parallel? The smaller the source, the harder the light will be. Outside on a clear sunny day, look at your shadow: it will be sharp and clean. Even though the sun is a large star, it is so far away that it appears as a small object in the sky — which makes it a fairly hard light. A Fresnel light by itself will also be a hard light.

SOFT LIGHT

Soft light is the opposite, it is light that casts only a fuzzy, indistinct shadow; sometimes no shadow at all. What makes light soft? A very large source. Go outside on an overcast day with heavy clouds — you will have little or no shadow at all. This is because instead of a small hard source (just the sun) the entire sky is now the light source — it's enormous.

How do we make soft light on the set? There are two ways. One is we bounce a light off a large white object. Typically we use things like *foamcore* (a lightweight artist board often used for temporary signs or mounting photographs). The bigger the *bounce board* is, the softer the light will be. We can use almost anything light colored as a bounce: a white wall, an umbrella, a piece of white styrofoam building insulation (also called *bead board*).

Another way is to shine the light through *diffusion*. In the past, photographers used things like thick white tracing paper or white shower curtains as diffusion. Nowadays, there are many types of diffusion available in wide rolls and sheets. It is amazing for its ability to withstand the intense heat of being put right in front of a powerful light: tracing paper can catch fire and shower curtain can melt.

Many types of diffusion material are available in varying grades of thickness. A popular *light* diffusion is *opal*; it is so thin you can almost see through it. This doesn't make the light very soft, but sometimes we want a very subtle effect. Heavier diffusion is much thicker, it makes the light much softer. About the heaviest, softest diffusion we normally use on the set is a cotton cloth called *muslin*. It's like a very heavy, coarse bedsheet.

Figure 7.6. What makes a light soft is purely a matter of the size of the source. (top) A small light hitting a large object will not wrap around the object. (middle) A large light on a smaller object will wrap around, thus softening the shadows. (bottom) Since there is a limit to how big a light can be, we often use diffusion to make the light source appear bigger.

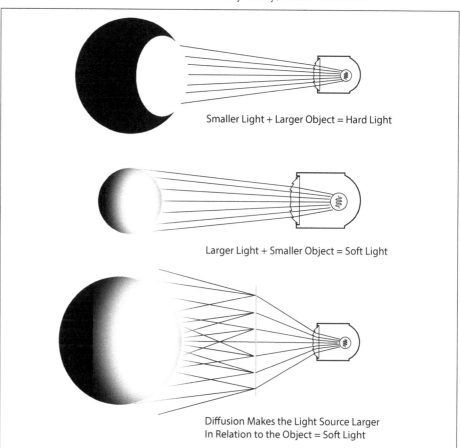

Smaller Light + Larger Object = Hard Light

Larger Light + Smaller Object = Soft Light

Diffusion Makes the Light Source Larger
In Relation to the Object = Soft Light

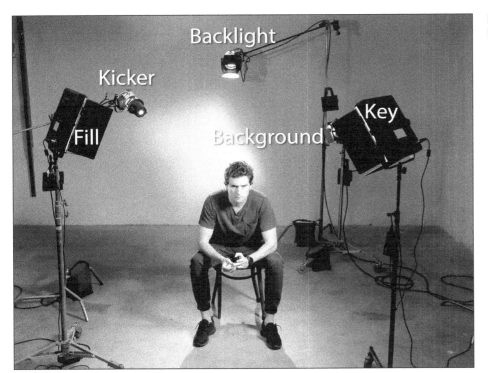

Lighting Terms and Concepts

There are a few terms that are essential when working with film lighting.

KEY LIGHT

The main light on a subject is called the *key light*. It is not necessarily the biggest light on the set, it is just the primary light on the particular subject (usually an actor). The key light will usually create shadows on the actor. First of all, there is nothing wrong with shadows! They can be an important part of the image. However, sometimes the shadows are darker than we want, we say that the scene is too *contrasty*. It all depends on the mood of the scene: sometimes we want deep shadows, sometimes we don't.

FILL LIGHT

If we want to lighten the shadows, we can use *fill light*. It does exactly what it says, it *fills in* the shadows. Don't get carried away with fill light or your scene will end up bland and flat.

BACKLIGHT

Backlight is a light from behind the actor. It is also sometimes called a *hair light* or a *shoulder light*. It almost always makes people look better. A backlight is a standard part of portrait or close-up lighting, where the whole aim is to make people look as good as possible.

KICKER

A *kicker* is a light from behind the actor that sort of skims along the cheek. It is different from a backlight in that it is on one side or the other. Most often you will see it on the side opposite the key light; it helps define the face even if the shadow side is fairly dark.

AMBIENT

Ambient light is overall light that is just sort of "there," meaning it has no apparent source and is usually very soft. Imagine a large office space lit with dozens of overhead fluorescent fixtures: this will be ambient light. It is soft but it is also shapeless and bland. The most common function of ambient light is to just sort of build an overall base exposure.

EYELIGHT

Eyelight is a very small light right next to the camera that has only one function — to give a little catchlight (highlight or twinkle) in the eye.

AVAILABLE LIGHT

Frequently, we use *available* light. This is simply whatever light there already is at the location we are using: daylight, fluorescent, ordinary house lights, street lights, whatever. Sometimes we supplement it with a few things to make it more expressive or fix a few small problems, but often, we just use what is there.

Figure 7.8. (top) Lighting from the down-stage side produces flat, uninteresting light, because the light is too close to the camera.

Figure 7.9. (above) Lighting from the upstage side creates pleasant shadows and a more three-dimensional image.

Basic Principles

LET THE SET AND THE SCENE MOTIVATE YOUR LIGHTING

Don't just go to a set and start putting up lights. Your understanding of the scene comes from the script, discussions with the director and seeing the blocking rehearsal. Only when you understand the mood, intentions and blocking of the scene can you really know how you should light a scene.

Light From the Upstage Side

The best way to avoid flat front lighting is to light from the upstage side. This means that lights are not close to the camera. Often they are actually on the other side of the actors — *upstage* (Figures 7.8 and 7.9).

BACK CROSS KEYS

Dialog scenes make up a very large part of every movie. By far the most commonly used methods for lighting these scenes is *back-cross keys* (Figures 7.11 and 7.12). Not only does it make for good lighting, it is also fairly quick and easy. It is extremely simple in practice: one key light for each actor — that's really the heart of it. There may be some additions as well: backlights, a fill light and perhaps kickers. As for the two key lights, the most important aspect is that they be on the *upstage side* — the side of the actors that is away from the camera.

LESS IS MORE

Over-lighting a set is something to watch out for. Not only can it result in lighting that is overdone, confusing and messy, it also takes more time and money. Many cinematographers say that the one thing that changes as you learn and grow as a lighting person is that you end up using a lot fewer lights in a scene.

Don't Be Afraid of the Dark

Shadows are an important part of lighting. Putting light evenly everywhere on the scene is boring and uninteresting. Shadows help create variation and make the parts that are lit more prominent — you can direct attention to the areas you want to feature. Also, they are more natural; places in real life that are uniformly and evenly lit are usually not visually interesting: warehouses, big box stores, etc.

Lighting Methods

There are many ways to light a scene, but a few methods are the basis for most lighting. Of course, each scene is different and you might end up using a combination of these fundamental techniques.

CLASSICAL HARD LIGHT

Up until the late sixties, sets were pretty much always lit with hard lights and the methods were pretty much standard: individual hard lights were used for every actor and every part of the set. This was easy because the blocking of the actors was very precise and the DP knew where they would be for every part of the scene.

AMBIENT AND EXISTING LIGHT

Ambient means either a sort of overall light that goes everywhere, or just the existing light in a location. Overall ambient is usually created by aiming lights at the ceiling for a soft bounce or by covering the set with a cloth material such as muslin or silk and shooting lights down through it. Frequently, this overall ambient is supplemented with other lights to keep it from being too bland.

THROUGH THE WINDOWS

There are many DPs who say "always light through the windows." Of course, this is not always possible, but there are good reasons to bring your light in through the windows. It is more naturalistic, it creates its own variations and it also means few, if any, lights, stands and cables on the set, making camera movement easier. Even if you bring your main lighting through the windows, it may still be useful to add a few accents/background lights on the set and often you will want to bring in a few additional lights for the close-ups. Often you will also want to add an *eyelight* for the actors. An eyelight might be something small like an inkie, but the danger is that this will add too much fill to the face. A better technique is to bounce a small light onto a white reflector near the camera; it is always a good idea to have this light on a *dimmer/hand squeezer* for adjustments.

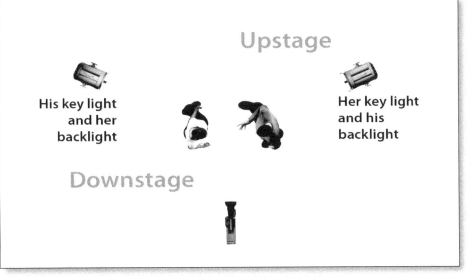

Figure 7.10. (top) Flat front lighting is boring and adds little to the scene. It also looks unrealistic.

Figure 7.11. (middle) Lighting from the upstage side adds shadows and depth to the scene. It also looks more realistic.

Figure 7.12. (bottom) Diagram of upstage lighting.

Natural Light and Windows

Windows are an important element in film lighting and they can be used in a number of different ways, whether you are on a set in a studio or at an interior location.

What Makes Window Light So Beautiful?

Window light can be very beautiful, because it is soft and even. What makes it soft is that it is bouncing from all directions from outside the window: from the sky, nearby buildings, even the ground.

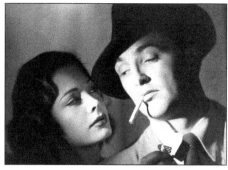

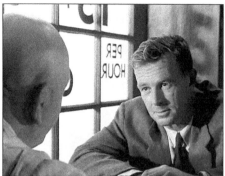

Figure 7.13. (top) Classical hard lighting as used in the film noir tradition.

Figure 7.14. (second from top) Window lighting in Kubrick's *The Killing*.

Figure 7.15. (third from the top) Lighting only the actor results in a scene with no depth; it's not three-dimensional. Of course, there are times when you want the background to be dark and shadowy.

Figure 7.16. (bottom) By carefully adding accents and pools of light to the background, the scene becomes three-dimensional, it has depth and looks more realistic.

THE WINDOW PROBLEM

One issue with windows occurs when an actor is placed in front of a window. Since what we see through a window is almost always much *hotter* (brighter) than the foreground, there are two bad choices: either expose for the actor and let the background *burn out* (overexpose) badly or expose for the background and let the actor be badly underexposed. There are ways to solve the problem: you can put a lot more light on the actor or you can control the light from the window with *ND (Neutral Density)* gel or by partially or entirely closing the blinds, if there are any.

GODFATHER LIGHTING

Named for the way Gordon Willis lit *The Godfather*, this method is soft overhead light. One caution, if you are going for the dark, mysterious look of that movie, you need to keep the soft overhead light off of the walls. In the Godfather films, Willis famously let the eyes of Don Corleone stay dark, suggesting that we can't know what he is really thinking. Unless this is the effect you are going for, you might want to add an *eyelight*, which is a small light or reflector that just creates a small *catchlight* in the eyes, without giving the face too much fill, which would spoil the effect you're going for.

DEPTH AND SEPARATION

When we watch a video, we are looking at a flat surface — our job is to give it depth and shape and perspective, to bring it alive as a real world as much as possible. Lighting plays a huge role in this. This is a big part of why "flat" lighting is so frequently the enemy. Flat lighting is light that comes from very near the camera, like the flash mounted on a consumer still camera: it is on axis with the lens. As a result, it just flatly illuminates the subject evenly. It erases the natural three-dimensional quality of the subject.

By *separation*, we mean making the main subjects "stand out" from the background. A frequently used method for doing this is a backlight. Another way to do it is to make the area behind the main subjects significantly darker or brighter than the subject. We try to create a foreground, midground, and background in a shot; separation is a part of this.

Backlight For Depth

One technique that helps with depth and separation is the *backlight*, which is any light that comes from the back of the subject. Backlight is a useful technique in almost any scene.

Controlling Light

Just putting lights on the set isn't enough — you have to shape and control the light. This is mostly done by subtraction — toning it down where it's too hot, casting shadows, keeping light off something you want to keep dark and so on.

Spot and Flood

Most kinds of lights can be *spotted* and *flooded* — meaning the beam of light can be concentrated into a smaller area or flooded out to cover a larger area but the most common use of the flood/spot control is to make the light a little hotter (spot) or a little dimmer (flood). This allows for fine tuning of the intensity.

Flags and Nets

Flags (also called *solids*) are made of opaque black and are used to cast shadows and keep light off of anything you want darker. The basic sizes are 18"x24", 24"x36" and 4x4s (four-by-fours) which are four feet wide and four feet tall. *Nets* are made of *scrim* — an open weave material that reduces the amount of light but doesn't change its quality.

Barn Doors, Scrims and Snoots

Lights have *barn doors*, which can be folded in or out and cut down the edges of the light. *Scrims* are just window screen material that reduces the amount of light. A *single scrim* (green edge) reduces the light by one-half stop and a *double scrim* (red edge) reduces it by a full stop (one half the amount of light). *Snoots* are similar to barn doors in the way they cut the spread of the light down as much as you want, but they are round and fixed, not flexible like barndoors. Snoots come in a variety of sizes from a wide to narrow beam.

Bounce and Reflectors

Sometimes you need just a little extra light on something, such as for the fill side of a face. It is often easier to use a *bounce board* instead of adding another light. A bounce is basically anything reflective but most often it is a piece of white *foamcore*, which is easily cut to any size you want. Larger bounces are cloth material that can be stretched on frames that come in sizes from six by six feet up to 20x20 feet and sometimes even larger.

THE AMAZING C-STAND

The *C-stand* (or *grip stand*) is one of the most ingenious devices ever invented for film work. It's like a light stand but with a *grip head* on top that can hold a wide variety of objects. Most often a *grip arm* is held by the head and the arm also has a grip head on it. This is used to hold nets and flags but also many other different kinds of objects. Unlike a light stand, the legs have different heights: high, middle and low.

There are a few rules for safe and proper use of a C-stand: always put the weight over the high leg, always put a *sand bag* on the high leg but the most important rule of all is the *right hand rule*.

Right Hand Rule

The reason for this method is that when a weight is pulling down on the grip arm, you want it to tend to be tightening the grip head, not trying to loosen it. The simple way to remember this is as you stand facing the grip stand, the grip knob is on the right.

How To Set a Light

When bringing a light to the set, it is important to bring the whole rig: the light, the barn doors and the scrim. The barn doors should always stay with the light, even if they're not being used. Same with the scrim bag — it should always be with the light, even if it's hanging the grid. If you take a scrim out of a light, do not just lay it on the floor — put it back in the scrim bag!

Don't Clothesline the Cable!

Another important rule is to never *clothesline* the cable, which is what we call it when the wire attached to the light isn't hanging straight down but is stretched out so that someone might trip over it. If someone does, they might get injured or hurt someone else and also the light might be damaged or destroyed.

Getting Power

The number one thing to remember about electricity is that it wants to kill you! Be careful! If you're not absolutely sure you know what you're doing — don't do it! Power for your lighting (and also monitors, battery chargers, hair dryers and the all-important coffee pot can come from several different sources. On big projects, it is usually supplied by portable generators (some of them up to 2000 amps). On smaller projects, it is often just a matter of plugging lights into the wall sockets. This used to be challenging but if you're using LED lights (or even Kino Flo lights) then it's easy, as these types of units provide plenty of light while using very little electricity. For much more information on electricity, distribution and other lighting topics, see ***Motion Picture and Video Lighting*** by Blain Brown.

Wall Plugging

In the US, most household electrical circuits in a building are 15 amps or 20 amps. For comparison, a *2K Junior* (2000 watt light) is 16 amps, a 1000 watt light (*Baby* or *1K*) is 8 amps, while an LED light might only be 2 or 3 amps. If you are on location and you plan on wall plugging several lights, be sure to check the breaker (fuse) box to see how much total power is available.

Just because a wall outlet is in a different room does not necessarily mean that it's on a separate circuit — in most cases, several wall outlets will be connected to each circuit. A good plan is to make a *circuit map* of the location — plug something in to each outlet and then turn the breakers off one at a time — an assistant with a walkie-talkie is very helpful for this. Also, try not to plug anything in to the refrigerator or air conditioning circuits. They might be OK at first, but when they turn on, they will blow the circuit. However, in many cases, the audio people will ask that they be turned off while shooting anyway.

Running Power

Once you have your power source, you have to get it to the lights and other things that need it. The more electricity that is running though a cable, the bigger it has to be — bigger in the sense of more copper. If you try to run too much power through a small cable, it will overheat and possibly melt and cause a fire.

On professional sets the smallest type of cable we use is called *12/3*, which means number 12 wire with three conductors (hot, neutral and ground). These are also called *singles* or *stingers*. If we're using a large amount of power (which we frequently do), we use much heavier cables, such as *Bates* cables, or *#2 banded distro* (or *distribution*) cables (three or four separate #2 cables).

Figure 7.17. (top) The *right hand rule*. When you face the C-stand, the knobs are on the right. This means they will tend to tighten, not loosen, under the weight.

Figure 7.18. (middle) A flag set properly — the arm is up and out of the way, the sandbag is on the high leg and under the load and the right hand rule is observed.

Figure 7.19. (bottom) Everything about this is wrong — the arm is right where it could poke someone's eye out, there is no sandbag and the right hand rule is not observed.

Figure 7.20. Wooden clothes pins, also called C-47s, are essential for lighting. They are used to hold gels and diffusion on the hot lights. Because they are wood, they are less likely to burn you when you grab them. On the left is a regular C-47; on the right is C-74 — a clothes pin when has been reversed so it can be used to grab hot scrims from the tight space in the front slot of the light.

Even if you're using the heaviest professional power cables you still need to guard against overloading the lines. The simplest check is to put your hand on the wire or the connectors (not touching the copper conductors, of course) — they should be warm but not hot. If they are hot, then you've got a problem — check how much load is on each line and if it's too much, turn the light off or switch it to another line.

Always remember — electricity wants to kill you. If you are doing anything that requires a generator or any large power source, only hire experienced *lighting technicians* (sometimes called *electrics* in the film business) to work on your project.

Expendables

Some supplies used in lighting a grip get used up during the course of the production; these are called *expendables*. They include tape, clothes pins, gels and diffusion, and so on. The production company supplies these based on lists given to them by the gaffer and key grip. For big productions, the expendables order can be very large, but here's a typical list for a small independent production.

Electric Department Expendables

- Clothes pins. Also called C47s, they are used for attaching gel to a light.
- Gaffer tape — black.
- Gaffer tape — white.
- 2" paper tape — black.
- 2" paper tape — white.
- Sharpies.
- Dulling spray.
- Sash cord — #8.
- Trick line (mason's line — black).

Other items the lighting crew might need include zip ties, and drywall screws. The electricians might have a few items with them, like electrical tape, but they should not be expected to supply them for your project.

Lighting Order

Lighting orders vary greatly depending on the size of the production, whether or not there are night exteriors, large sets, and, of course, the budget. On the website, you will find typical lighting orders for small, medium and large productions. Here's a typical sample of a lighting order for a small project with interiors only.

Power

1 — Generator 450 amp

Lights

4 — LED panels
1 — 5K Fresnel
4 — Mightie Mole open face 2K with barn door, scrims, stands
4 — Baby Junior with barn doors, scrims, triple riser stands
4 — Baby Baby with barn doors, scrims, stands
4 — Tweenie with barn doors, scrims, stands
4 — Inkies with barn doors, scrims, snoot set
4 — 1K soft lights (worklights for craft service, makeup, etc.)

Distro

500' — Five wire banded feeder cable — Cam-Lok
10 — Cam-Lok tees
6 — 100'–100 amp Bates extensions
5 — Bates 100 amp to 60 amp splitters
8 — 50–60 amp Bates extensions
2 — 3-phase distribution boxes

3 — lunch boxes
3 — 60 amp Bates to 6 outlet Edison
25 — 50' single extension (stingers)
20 — 25' single extension (stingers)
2 — Flicker boxes (three channel)

Grip

15 — C-stands
30 — Sand bags
8 — Shot bags
6 — Cardellini clamps
6 — Mafer clamp
10 — full apple boxes
10 — 1/2 apple boxes
10 — 1/4 apple boxes
10 — pancakes
1 — box of wedges
2 — 4x4 silk
8 — 24x36 flags
4 — 24x36 single nets
4 — 24x36 double nets
6 — 18x24 flags
6 — highboys
4 — 1K offset arm
2 — 1K sidearm

Dolly

Fischer 11 with seats, side boards, etc.
2 — 12" risers
5 — pieces straight track
4 — pieces wide circle track (45°)

EXPENDABLES

Full CTB (Color Temperature Blue)
1/2 CTB
Fulll CTO
1/4 CTO (Color Temerature Orange)
Rosco Opal
Rosco 3026 (216)
Rosco 3027 (1/2 216)

5 — Bags wooden clothes pins
2 — Rolls 2" black gaffer tape
1 — Roll 2" white gaffer tape
2 — Rolls 2" black paper tape
1 — Roll 2" white paper tape
1 — Black wrap 24"
2 — Sash cord 200' #8
1 — Trick line (mason's line) — black 100'
1 — Can Krylon Dulling Spray
1 — Streaks n' Tips — black

Lighting Definitions

Ambient is light that is just sort of "there." It is soft light from above; a general sort of light that just fills the room.

Amps are a measure of how much electrical current is flowing (the total amount of electrons flowing through the system). Each type of light draws a certain number of amps. In film, we usually round them up for safety. For example, a 1K (1000 watt Baby) actually draws 8.3 amps but we round it up to 10 amps. These are called Paper Amps.

Baby: A 1000 watt light or a smaller version of a Fresnel light.

Back cross keys is a reliable method of lighting two people in a dialog scene. Both lights are on the upstage side of the actors; one light is a key light for Actor A and a backlight for Actor B. The second light is a keylight for Actor B and a backlight for Actor A.

Bates: These are the heavy cables with 3 pin connectors that run power to the set. A Bates connector can be 100 amps (the big one) or 60 amps (the smaller ones).

Bounce board is made of either foamcore or beadboard. It is used to reflect light and make it softer. The bigger the bounce board, the softer the light will be.

Cardellini is a type of clamp useful for grabbing onto pipe, lumber or almost anything. It is solid enough to hold a heavy light on its baby pin (5/8th")

CTB and **CTO**. *CTB* (*Color Temperature Blue*) to make a tungsten light the same color as daylight. *CTO* (*Color Temperature Orange*) to make daylight the same color as a tungsten light.

Diffusion is opaque white material we use in front of a light to make it softer. Flag is a rectangular black cloth on a frame, used to make shadows. They come in sizes: 18"x24", 24"x36" (two by three) and 4'x4' (*four by four*). Some *four by fours* open up with an extra flap to make a 4'x8' — this is called a *four by floppy*.

Flat front lighting (where the light is near the camera) is almost always dull and boring: no shadows, no depth, no dimension.

Fluorescent lights: (the type of lights found in most offices, classrooms and industrial buildings) are usually very green and have a discontinuous spectrum, making it not very good for film or video shooting. It is important to shoot a grey card (with film) or white balance the camera (on video).

Fresnel: The "steppy" lens on front of many movie lights. A light with no lens is called an "open face."

Junior: A 2000 watt Fresnel light.

Kelvin scale: Degrees Kelvin (K) is a measure of the color temperature of a light source. Warmer lights (more reddish) have lower Kelvin temperature. Sources that are more blue have higher numbers. For example, a tungsten bulb (reddish-yellow) like we use in our motion picture lights, is 3200K. Daylight (more blue) averages 5600K. With video, you must color balance the camera to the type of light you will be shooting under.

LED: Light Emitting Diode.

Lunchbox: A box that distributes electricity. It takes a 100 Amp Bates input and has five outputs of 20 amp circuits each.

Mafer: Type of clamp that will go onto something as large as 2"x4" lumber and has a baby pin.

Pigeon is a baby plate screwed onto a pancake. Good for getting a light very low to the ground.

Primary colors in lighting are Red, Green, Blue (RGB). **Secondary colors** in lighting are Cyan, Yellow, Magenta (CYM).

Scrims are metal screens we put in front of the lights to reduce the brightness. They do <u>not</u> make the light softer. A single scrim (Green) reduces the output of the light by ½ stop. A double scrim (Red) reduces the light by one stop. **Nets** are the same except they are made from cloth netting (bobbinette).

Stinger: A heavy-duty extension cord. It can take 20 amps.

Tungsten light is 3200K — it's what we get from our tungsten movie lights.

The Art Department

The Art Department

The *art department is* the team that handles anything physical on the set or location that appears on camera. This covers sets, location set dressing, props, makeup, wardrobe and mechanical effects (EFX) such as rain, snow, fog, etc.

PRODUCTION DESIGNER

One of the great joys of filmmaking is building a world — creating a visual and story world that the characters and the audience is going to exist in. It is the job of the director, the *production designer*, the cinematographer, and the whole art department.

The *production designer* is responsible for the visual appearance of the film. To achieve the overall look, they will coordinate with the director, cinematographer, art department, costume department, makeup department, and more. They not only collaborate closely with the director to bring his or her vision to life, they also work with the producer to calculate the needed budget. Unlike other departments, the production designer is usually given a certain amount to spend and they use it as they see fit, for personnel, sets, props, set dressing and so on. They will *break down* the script to estimate the cost needed to bring the story to the screen. If sets are being built, the production designer will give sketches and outlines to the *art director*, who in turn delivers the plans to the construction department.

As the head of the art department, the production designer is in charge of making sure each shooting location or built set is prepared, and in tune with the vision of the film (and on budget). Film is a medium of visual storytelling, and so the visuals in front of the camera matter enormously to the success of the project. The locations, sets, costumes, makeup, etc. all work together to build a world on screen — the world where the story plays out, the world the actors live in. The production designer's job starts during pre-production collaborating with the director and producer of the project. The production designer takes the writer's script, the director's vision, and the producer's plan, and synthesizes them into a visual story.

During pre-production, the art team formulates ideas and plans for the visual context that will be used for the film. This includes deciding on colors, themes, compositions, and other visual elements that work best to evoke the tone, emotions, and themes of each scene and the film as a whole.

Once the desired look and feel of the movie has been decided, it is up to the production designer to make it happen. This begins with research. Production designers help identify which places and assets will be needed to create the right atmosphere for each scene. No matter what the time period or place where the story is set, the production designer needs to ensure that every detail is considered when creating a believable set or location.

Another big responsibility left in the hands of the production designer is the budget. Production designers must keep the whole film and the whole budget in mind at all times. Unlike other parts of the film team, the art department is usually given an overall budget that the production designer and art director spend as they see fit — keeping all the receipts, of course!

After all the design sketches and discussions with the directors, the art team is finally ready to turn all those drawings and ideas into reality. Since the art department is usually the largest on any film set, the production manager needs good management and people skills to make sure everyone is on the same page. This includes working with set designers, graphic artists, wardrobe supervisors, set decorators, prop masters, and makeup artists. A production designer is often called upon to come up with quick, effective solutions on set, all while making sure the whole team stays motivated, creative, and productive.

ART DIRECTOR

The *art director* reports directly to the production designer. They oversee the artists and designers who help create the overall look of the film. It is their job to supervise the planning and practical design of sets and set pieces. On large-budget projects, there may be several art directors. On smaller projects, the job of the production designer and art director are typically combined. The art director will manage the creation, dressing, and striking of all sets and locations. On smaller projects, the head of the art department is often called the art director and there is no one with the title of production designer; it's really up to them what title they'd like to have in the credits.

SET CONSTRUCTION, SCENIC ARTISTS

If you are building sets, then a construction crew will be needed to build it. All painting is done by scenic artists who are far more than just "set painters." Professional scenic artists are highly skilled at creating illusions such as brick and stone, backdrops like a forest, a cityscape, or outer space.

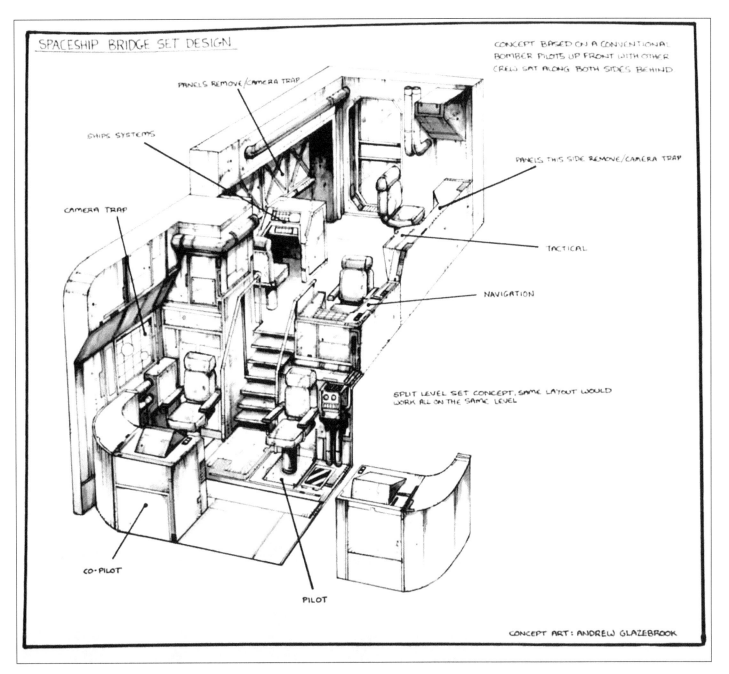

Image labels:
SPACESHIP BRIDGE SET DESIGN

CONCEPT BASED ON A CONVENTIONAL BOMBER PILOTS UP FRONT WITH OTHER CREW SAT ALONG BOTH SIDES BEHIND

PANELS REMOVE/CAMERA TRAP

SHIPS SYSTEMS

PANELS THIS SIDE REMOVE/CAMERA TRAP

CAMERA TRAP

TACTICAL

NAVIGATION

SPLIT LEVEL SET CONCEPT, SAME LAYOUT WOULD WORK ALL ON THE SAME LEVEL

CO-PILOT

PILOT

CONCEPT ART: ANDREW GLAZEBROOK

Figure 8.1. Concept design for a science fiction film. (Courtesy Andrew Glazebrook).

SET DECORATOR

The *set decorator* is responsible for decorating a film set. This includes furniture, drapes, fixtures, paintings, and overall decor. They are also responsible for dressing props, which includes everything from cars to furniture, to household items. Set decorators might also act as the buyers — within a given budget they buy, rent or borrow whatever is needed and make sure it's in the right place at the right time. The art department will usually have their own truck for transporting items and having them available on location.

SET DRESSER

Set dressers (sometimes called the *swing gang*) place and remove all set dressing. They are responsible for practically everything on the set: furniture, rugs, drapes, lamps, decor, doorknobs, etc. The term swing gang is most often used to refer to the *on-set dressers*, those making any last minute changes prior to cameras rolling. Any parts of the set that are not permanent are referred to as the swing set. These are items that can be moved around on set or easily removed if they don't work for the overall look of the shot. Set decorating and set dressing is just as important if you're working on a location as it is on a studio set. Some of them might need to be present during shooting if sets need to be *redressed* — for example a set might look one way at the start of the film but very different after the story has progressed.

Scene #	Location Name	Int/Ext	D/N	Set Dressing	Key Props	Notes
1	Samy's House	I	D	Art student materials drawing board, art posters, photos of great paintings	T-square, drawing pens, cell phone	Poor art student grungy.
11	Samy's House	I	D			
23	Samy's House	I	N		Coffee pot, coffee cups, bottle of brandy	
24	Samy's House	E	N	Venetian blinds for windows		
34	School Library	I	D	Card catalog		
37	School Library	I	D	Reading lamp, ND books	Art text book, sketch book, drawing pens, art photos, reading glasses	Typical small college library.
38	School Library	I	D			
7	Sosi's apartment	E	D	Decorative doorbell	Car keys, cell phone, backpack	
21	Sosi's apartment	I	D	ND books, tea cups, take-out food containers, unwashed plates and utensils	Cell phone, backpack, laptop computer, charger	Student apartment: homemade bookshelves, band posters.
22	Sosi's apartment	I	D			
67	Sosi's apartment	I	D			
55	Street corner	E	D	Street trash can, mail box	Letter for mailing, cardboard coffee cup	She mails the letters.
41	City park	E	D	Park bench	Kite and string, laptop computer,	Ice cream cart must be fully stocked to serve the key actors and also

Figure 8.2. An art department location breakdown list. A fillable version of this form is available on the website. Typically, there will be several scenes in any one place, otherwise, it's hardly worth going there. If there is only one scene at a particular place, the First AD is likely to ask "couldn't we do this scene at one of our other locations." It is also typical to fake it. For example, the second bedroom at Samy's apartment could dressed to make it work as Daniel's office, thus saving a time-consuming company move. Company moves in the middle of the day (where the whole crew packs up and goes somewhere else) should be avoided if at all possible.

PROPS

The *prop master* has many important responsibilities on a film project. So what is the difference between set dressing and a prop? It's only a prop if an actor picks it up and uses it in some way. This includes food, dishes, swords, or specific items like a cell phone or light saber. The distinction between set dressing and props is important because anytime an actor uses or moves something, it usually has to be *reset* for every take, meaning that it has to be returned to its original position and condition; glasses need to be refilled, newspapers need to folded back up, a vase that was smashed has to be swept up and replaced with a new one for the actor to smash again in the next take, and so on. The prop buyer might not come to the set, but on smaller productions, the person who obtains the props will usually be on the set at all times, providing what is needed, bringing replacements if something is broken, resetting the props that got moved during a scene, resetting any clocks that appear in the scene, and generally overseeing anything to do with props.

ARMORER AND PYRO

All guns are handled by a prop specialist called an armorer. Any explosions are managed by pyrotechnicians (pyro) who much have a federal license, which is not easy to come by. Don't even think about trying to handle guns or explosions by yourself. If something goes wrong you might hurt somebody and end up in big trouble — leave it to professionals.

Finding the Look of a Film

The look of a film comes out of the content of the story and the director's concepts of how to tell that story. It is the job of the production designer to pre-visualize the world of the film, to translate the script into visual images that will become the actual sets and dressed locations. Details will come out of concepts. To get started you will need a working metaphor, a specific psychological, atmospheric, and emotional image of what you want this world to be. The look of the film is not in an imposed or personal attitude toward visual style — the story will lead you there.

A useful technique for production design is to create a *mood board* or a *look book* to develop the visual ideas you're working on. It's not only a valuable aid to your own thinking, it's also an effective tool for communicating your ideas to the director and the DP. You don't need to have advanced artistic skills to create look books, mood boards and set sketches. To do this, you can find fitting images and place them together on a piece of foam core art board to show the director and set designer exactly what you want.

A SENSE OF PLACE

The design of a film should create a sense of place — a real place that resonates with the audience as where these characters would actually exist. The atmospheric qualities of the sets, locations, and environments are essential in establishing a mood and projecting an emotional feeling about the world in which the story takes place. The director of photography works together with the production designer in terms of color, texture, perspective and using lighting to supplement the actual sets and locations. The production designer and the director of photography can work together to impart an emotionally evocative sense of atmosphere.

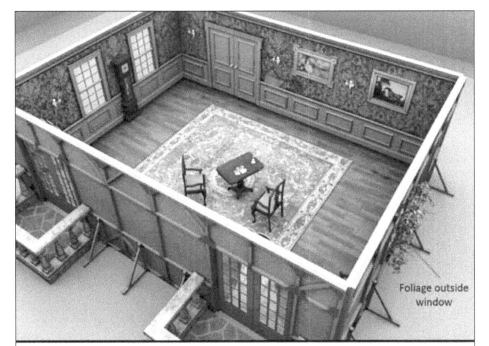

Foliage outside window

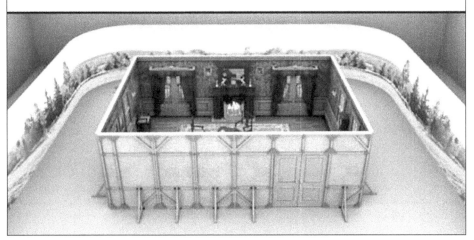

Figure 8.3. Set design by Andrew Glazebrook. These are computer generated, but most often set designs are hand drawn. For larger, more elaborate sets, actual blueprints might be produced by a drafter who works with the set designer. (Courtesy Andrew Glazebrook).

THE RIGHT DETAILS

A set (whether it's one you built or it's a borrowed or rented location) has to be dressed so that it's right for the scene and the characters who inhabit it. The big things are obvious (if it's a hermit's cave, you probably won't put modernist furniture in it), but it is often the little details that really allow a set to be an important part of the atmosphere and tone of the story. Things like:

- Posters on the wall — *My Little Pony* or *Metallica*?
- Flowers — fresh and artfully arranged, or dead on the window sill?
- Neat and tidy, or messy, dirty and disorganized?

WARDROBE

The wardrobe and makeup departments operate more or less independently but of course they coordinate with the production designer for the overall look of the film. On a bigger project you might have a *costume designer*, but even if you don't, the wardrobe people need to be sure that everything fits, and that it is kept clean and ready. They might also make minor repairs and usually have backup pieces standing by in case something gets ruined.

The *Costume Designer* is head of the department. She or he is responsible for the look, style and "feel" of everything worn by the actors, whether it is rented, borrowed, built or even if the actor brings their own clothes. They work with the director to make sure all wardrobe fits the visual concept of the picture, is appropriate for the time period and most importantly, that it communicates something about the character, their lifestyle, their mood and what their inner life is like.

The designer will need at least two days of prep for every day of shooting; more if you are doing a period piece or science fiction piece. On bigger projects, the prep time for

A person's clothes make up part of his character. I draw the character with his costume. I suggest it to the stylists with my drawings; the drawings translate some of my emotional impressions. For me, elegance happens when there is a correspondence between a person's personality and how she dresses herself.

Finally, don't forget that costumes, like dreams, are symbolic communication. Dreams teach us that a language for everything exists — for every object, every color worn, every clothing detail. Hence, costumes provide an aesthetic objectification that helps to tell the character's story.

Federico Fellini
(*8-1/2, La Strada, La Dolce Vita*)

Figure 8.4. A wardrobe continuity sheet.

Production Title: Trophy Wife
Role: Jennifer
Shoot Date: 3/11/19

Scene: 25, 26, 27
Played by: Jennifer Scott
Costume # 1

Photo

Sets

• Pentageles Office
• Sidewalk outside
• Limo

Description:

• Loose black pants-striped
• Fashion T-shirt
• Black sweater
• Pearl necklace
• Wedding Ring

wardrobe can be many months, especially for something where lots of period or unusual (such as futuristic or hobbit costumes) need to be designed and created.

One thing the wardrobe department needs to do is break down the script, just as other departments do. They have one additional element to contend with though: script days. Often the *Script Supervisor* will prepare a *Story Days Report* that outlines what happens when in the script. For example, a story might take place over one week. The report would list what scenes take place on Monday, what scenes take place on Tuesday, and so on. They would also specify whether the scenes are day, night or perhaps something particular like "early morning." This will be put together as a wardrobe "bible," which should be able to answer any questions that come up about who wears what, and when. The continuity book or costume bible on set consists of pages with information that relates to each garment that is part of the costume. The supervisor uses these to make sure that in the line-up everything is correctly ordered on the truck and then the *On-Set Dresser* ensures that this is kept updated on set. When the director is happy with a take, at the end of the scene, a photograph will be taken so all wardrobe can be matched for other scenes that take place before or after that require the same wardrobe.

WARDROBE SUPERVISOR

The *Wardrobe Supervisor* is an important member of the team. They make sure everything the designer is looking for is provided, in proper shape, cataloged and in the right place at the right time. If you visit the wardrobe room or trailer you will see that it is not just a bunch of clothes on racks. Each outfit is kept together on hangers with the shoes or hats in clothing bags. Each outfit is carefully tagged with the name of character, name of actor, what scenes it is for, what is included in the set and special instructions for cleaning, etc. For anything more than a small production, there may be *wardrobe assistants* as well. Period films that take place in the past present a particular challenge for wardrobe, and rentals are usually necessary, unless you have some talented costume builders working for you. Obviously, the same applies to stories that take place in the future.

ON-SET DRESSER

Someone from wardrobe needs to be on set at all times to attend to whatever comes up during shooting. They will have a number of items on their belt or in a bag: lint rollers, safety pins, clothing pins, etc. The *On-Set Dresser* (sometimes called *Standby Wardrobe*) along with hair and makeup, come in for touch-ups when the AD calls for *last looks*.

CONTINUITY

A continuing problem for wardrobe is when actors forget and wear something home and then fail to bring it back the next day. This happens most often when actors are wearing their own clothes for the picture. Another problem with this is that there are most likely not going to be backups for these clothes, meaning that something ripped or stained can become a continuity problem. Continuity photos are taken when each actor is dressed, and kept on a continuity form (Figure 8.4).

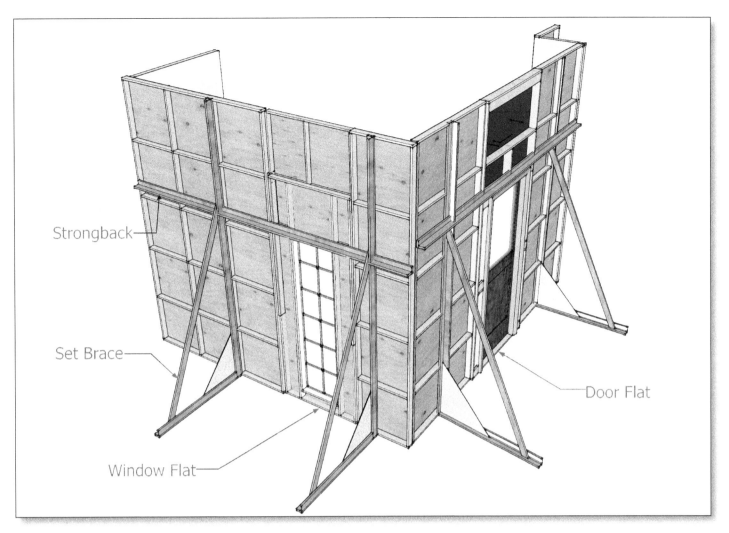

Strongback

Set Brace

Window Flat

Door Flat

Figure 8.5. Typical set built with 4x8 and 2x8 *flats*. *Set braces* and *strongbacks* keep it stable. In includes a *door flat* and a *window flat*. Above the window flat is a *plug* — a small piece to fill the gap.

WARDROBE RENTALS/PURCHASES

Start with your script. Figure out the number of wardrobe changes each character goes through. Add these together and you'll get a sense of the sets of wardrobe that are needed. Add multiples of outfits if you have stunts or blood effects, you will definitely need multiple backups for repeat takes. Uniforms, period costumes, and special items (helmets, kilts, samurai armor, etc.) will cost more. This will give you some idea of how much to budget for wardrobe purchases/rentals. Stunt people will need matching wardrobe.

Hardware

You'll need to rent racks to hang clothes on, clothing bags, hangers, a steamer, and possibly privacy screens so the actors can change. Just one of the many details that are easy to forget about when budgeting a project. You'll need to provide a budget for the wardrobe people to buy *expendables* — lint rollers, plastic bags, shoe polish, tape, safety pins, etc. On bigger productions not shot in a studio or at a single location, wardrobe might have their own truck or trailer.

Loss/Damage/Cleaning

Inevitably, something borrowed or rented will get destroyed or soiled and you'll have to pay for it. You can hold a wardrobe sale at the end to make back some money. You will need to allocate funds for cleaning. The range depends on the size of the wardrobe and whether we can use a free washer/dryer.

MAKEUP AND HAIR

The makeup and hair department has a similar structure to wardrobe. The makeup and hair key works with the director and production designer to determine the overall look of the characters, then decides what style of makeup and hair style is needed to express something about the character that helps tell the story, then the stylists execute that plan. As with props and set dressing, keeping track of continuity is important. Once an actor is in full makeup, photos are taken and kept on file. For the photos, the actors hold up their hands to show any fingernail polish, rings, watches, etc.

Building Sets

Even on small productions, you might need to build a set (Figure 8.5). If you don't have a studio, it might be in a garage, a warehouse that's not in use, or anywhere you can. If you can't afford set builders, it's not difficult to do it yourself. A basic component of all sets is called a *flat*. Flats are usually 4'x8' or 4'x10' (ten foot high flats make low angle shots easier). They are made with 1"x3" lumber and *skinned* with *luan*, which is a type of 1/4" plywood with a very smooth surface. With a coat of primer and a coat of paint, they can be made to look like just about anything you need: an apartment, an elevator, or inside a space station.

Joining them together has to be done carefully, so there is no visible joint or gap between them. You will need someone in back of the flats and someone in front to make sure the two surfaces are level with each other. Do it first with clamps, then when everything is set, you can use screws to secure them. If you can't get them perfectly level, a good trick is to put paper tape over the joint and paint that. You can use spackle to smooth it out, but that makes it more difficult to reuse the flats. Once a wall is built, a *strongback* (sometimes called *hog troughs*) is run across the whole wall and screwed in. A *strongback* is just two pieces of 1"x3" screwed and glued together at right angles. *Set braces* are also needed to keep the whole thing from falling over.

Besides the 4x flats, you might need some 1' or 2' wide flats to get the right layout of your set. You might also need *window flats* and *door flats*. Windows don't always need to have glass in them, especially if they are behind blinds or curtains. Whether or not you need real windows will be determined by the script and the director's preference. Some trim around the outside and some small strips of wood in the middle will completely *sell* the idea that it's a real window. It's all pretty simple and only very basic carpentry skills are needed.

Wild Walls

Especially if you are building a four wall set that is enclosed, you might want to have some *wild walls*. These are just parts of the set that can be quickly removed by taking out a couple of screws. For smaller sets, wild walls are essential for getting all the camera angles you need. They might also be important for lighting, laying dolly tracks, etc.

Smilex

If your windows don't have shade or curtains, you'll need something outside. *Drops* are painted canvas or transparent mylar with a scene painted on them: sky, cityscape, forest — just about anything you would want. They are, however, not cheap to rent. A more economical option is *smilex*, which is a film term for plants and vegetation. Part of this might be a *branchaloris*, which is a branch cut from a tree and suspended from a C-stand or the ceiling. If it's a night scene, you might be able to keep the curtains from looking "dead" by hanging Christmas lights or twinkle lights outside the window, (which is covered by a thin, translucent curtain), obviously for city scenes only. For less urban scenes, the gaffer can shoot a light though the branches or *smilex*, simulating either sunlight or moonlight. In either case, you might want to add a fan to make them move gently. It has to be a very quiet fan, otherwise it will be picked up on the audio.

Slating and Scripty

Scripty

The *script supervisor* (also called *continuity supervisor*) is a department of one. They have a very important job; many people think that the *scripty* (as the position is often called) just keeps *script notes* but actually the job is a lot bigger than that. It will help if we think of it in terms of who uses the notes that scripty produces. They have several functions:

- Reference notes so that continuity can be maintained within a scene or across several scenes, especially if they are being shot on different days (Figure 8.4). This is particularly important for wardrobe: if an actor has blood on their shirt in scene 27 and appears in the same shirt in scene 31 (which might not be shot till weeks later), it's up to scripty to remind everyone that not only is there blood on the shirt, but also where the stain is and also whether it would have dried by then. To do that, they need to keep track of the *story timeline*; in other words, scripty should be able to tell anyone who asks whether scene 31 occurs a few minutes after scene 27 or if it happens a week later in the story. To do this, some script supervisors prepare a report before shooting begins which briefly outlines the story timeline.

- Notes and a *lined script* (Figure 9.1) for the editor which indicate which parts of the scene a particular shot covers. Post-production will rely on these notes along with the camera notes, to find the footage they need and get it into the right order.

- An end of day report for the producers that lets them know what scenes were shot, what time the shoot day started and ended and most importantly, how many *pages* were shot. The number of script pages that have been completed is the primary measure of whether the production is on schedule or not. How many setups were shot also indicates how efficiently the shoot is being run. Big-budget productions might only shoot part of a page a day, because they have the luxury of a long schedule. Low-budget productions that have short schedules need to shoot many more setups per day; maybe 25 or more, in order to stay on schedule.

Scripty will almost always sit near the director and usually looks at the same monitor(s). They usually have a stopwatch in hand to time the shots (important for estimating how much *screen time* has been shot during the day). They will also be making lines in the script along with notes about continuity. The script notes shown here are generated using computer script supervisor software but they will give you an idea of how they appear even if done by hand. So, what's the difference between how many pages were shot and how much screen time was shot? An action scene might be just 1/8th of a page (scripts are always marked by the AD in 1/8ths of a page).

A minor function of scripty is to help actors if they occasionally have a little trouble remembering the lines. It's important to not jump in unless it's really important (such as if the actor says "Janice is the real killer," if in fact the script says it was James) or if the actor asks for it — many times the actors will deviate from the script but that may or may not be OK with the director; often the actors will come up with an even better interpretation of the intent of the scene.

Same thing applies to continuity. Some script supervisors are fanatical about always sticking to the strict traditional rules of continuity. They can sometimes make a real pest of themselves to the director and DP — some judgment and diplomacy is called for. Yes, continuity is important, but there is such a thing as too much continuity in some cases — it's an art form after all, not a computer game.

LINING A SCRIPT

- Wiggly lines indicate action that is off-camera — not in the shot.
- Draw the lines left to right in shooting order.
- Red is the standard color used for a lined script.
- Sometimes different colors are used to indicate different shots, i.e. blue ink for single shots, green ink for cutaways, etc.
- A horizontal line indicates the end of the take.
- If a shot continues to another page an arrow is placed below the line and continues onto the next page.
- Lined scripts are also called *Marked Up Scripts* or *MUS*.

A Sample Lined Script

The arrows indicate which takes cover which parts of the scene. A straight line means the dialog is shown on camera, a wiggly line means the dialog is off-screen. The arrow means it continues on the next page; a horizontal line means that is the end of the take. Numbers have been added to the lines of dialog for later reference in the script notes. This one is computer generated, but traditionally script supervisors do this by hand with different colored pens.

Figure 9.1. (below) A sample lined script. The original uses several coded colors, which we can't show here. The color version is on the website. (Courtesy Jonathan Barbato, digital script supervisor).

Figure 9.2. (following page) Sample script notes by Jonathan Barbato.

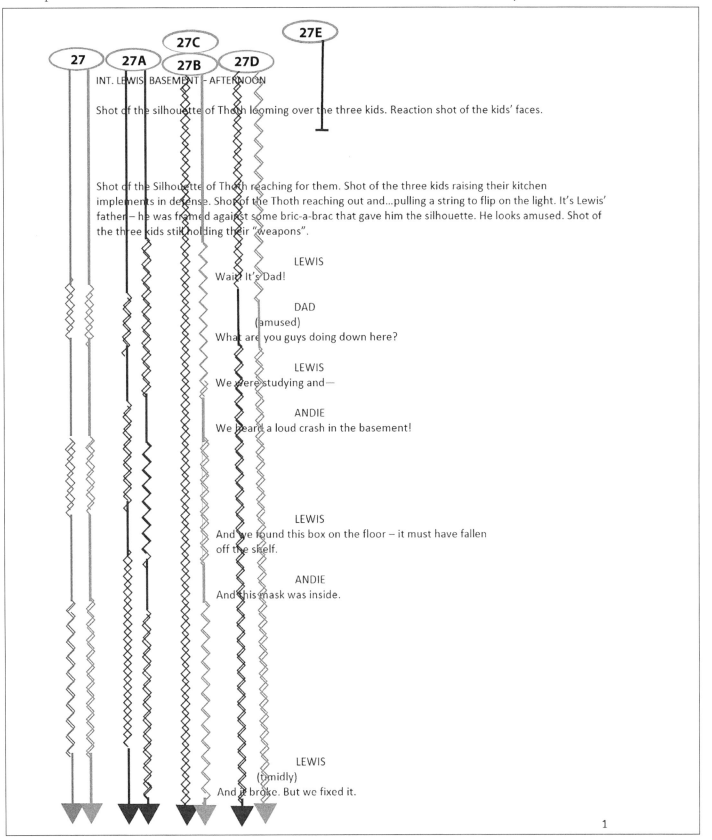

INT. LEWIS BASEMENT - AFTERNOON

Shot of the silhouette of Thoth looming over the three kids. Reaction shot of the kids' faces.

Shot of the Silhouette of Thoth reaching for them. Shot of the three kids raising their kitchen implements in defense. Shot of the Thoth reaching out and...pulling a string to flip on the light. It's Lewis' father – he was framed against some bric-a-brac that gave him the silhouette. He looks amused. Shot of the three kids still holding their "weapons".

LEWIS
Wait! It's Dad!

DAD
(amused)
What are you guys doing down here?

LEWIS
We were studying and—

ANDIE
We heard a loud crash in the basement!

LEWIS
And we found this box on the floor – it must have fallen off the shelf.

ANDIE
And this mask was inside.

LEWIS
(timidly)
And it broke. But we fixed it.

1

Sample Script Notes

Take	Print A	B	Time	Notes	Cam Roll A	B	fps	TC	Sound Roll
L6U1G				XICL Andie Danielle Lewis in basement hallway XOCR. A: WS B: CU. Lines # 45-46					
1			0:34	Dir OK w/ Lewis not leading.	25	15	29.97	17:02:52	5
2			0:35	Dir OK w/ Lewis not leading.	25	15	29.97	17:57:18	5
3			0:26	B: Cam voyeer from RS. INC. Dir OK w/ Lewis not leading.	25	15	29.97	17:10:07	5
4	H	NG	0:28	Dir OK w/ Lewis not leading.	25	15	29.97	17:11:21	5
6	P	P	0:35	Lewis takes lead at end.	25	15	29.97	17:13:30	5
6	NGA	NGA	0:28	Lewis takes lead at end. NGA pipes flushing	25	15	29.97	17:15:43	5
6	H	H	0:28	FS 17:18: 52 Lewis takes lead at end.	25	15	29.97	17:12:24	5

Day: **05** Date 8/30/2012 Setup: **15**
Lens: A: Z 0 B: Z 57

Take	Print A	B	Time	Notes	Cam Roll A	B	fps	TC	Sound Roll
L6U1				Andie Danielle Lewis XICL A: CS Lewis B: M2S A&D # 47-51					
1	NGP	NGP	0:58		22	12	29.97	9:41:02	5
2			0:23	not enough Straw on mask	22	12	29.97	9:44:30	5
3			0:27		22	12	29.97	9:46:50	5
4	H	H	0:28		22	12	29.97	9:48:30	5
5	H	H	0:22	FS: 9:51:07	22	12	29.97	9:49:58	5
5	P	P	0:22	FS: 9:51:07	22	12	29.97	9:52:00	5

Day: **05** Date 8/30/2012 Setup: **1**
Lens: A: Z 40 mm B: Z 35 mm

Take	Print A	B	Time	Notes	Cam Roll A	B	fps	TC	Sound Roll
L6U1A				Andie Danielle Lewis in basement. A: CS Lewis B: M2S A&D # 49-54 Mask is Dropped in A					
1	P	P	0:11		22	12	29.97	10:01:11	5
2			0:16		22	12	29.97	10:05:19	5
3	P	P	0:11	upto line # 55 on A Cam Lewis.	22	12	29.97	10:06:54	5
4	H	H	0:28	upto line # 55 on A Cam Lewis.	22	12	29.97	10:08:21	5
5	P	P	0:31	Lewis Line #44 variation " wow" upto line # 55 on A Cam Lewis.	22	12	29.97	10:09:56	5

Day: **05** Date 8/30/2012 Setup: **2**
Lens: A: Z 40 mm B: Z 30 mm

Take	Print A	B	Time	Notes	Cam Roll A	B	fps	TC	Sound Roll
L6U1B				Andie Danielle Lewis in basement. A: CS Lewis B: M2S A&D # 49-67 Mask is Dropped in A					
1			1:00	Lewis Line # 62 my dad will "get" mad.	22	12	29.97	10:15:00	5
2		P	1:10	Lewis Line #44 variation " wow" Good dialogue but D hands too low	22	12	29.97	10:19:27	5
3	H	H	5:40	Lewis Line #44 variation " wow"	22	12	29.97	10:22:30	5
4	P	P	5:40	Lewis Line #44 variation " wow" Line #67 Lewis not heard.	22	12	29.97	10:24:58	5

Day: **05** Date 8/30/2012 Setup: **3**
Lens: A: Z 40 mm B: Z 30 mm

Jonathan Barbato Digital Script Supervisor 781-718-6110 www.scriptonset.com

Script Notes Key

Lined Script Coloring	
Blue	Close Up
Red	Medium Shot
Green	Wide Shot

Abbreviation	Meaning
P	Print Take (great shot)
H	Hold Take (OK Shot)
XICR	Crosses in camera Right
XICL	Crosses in camera Left
XOCR	Crosses out camera Right
XICR	Crosses out camera Left
R	Right
CR	Camera Right
L	Left
CL	Camera Left
RH	Right Hand
LH	Left Hand
FS	Full shot
WS	Wide shot
EWS	Extreme wide shot
MS	Medium shot
Med. Shot	Medium shot
2-Shot	2-Shot
M2S	Medium 2 Shot
T2	Medium shot at chest
CU	Close up
MCU	Medium close up
ECU	Extreme close up
OTS	over the shoulder
OTRS	over right shoulder
OTLS	over left shoulder
O/H	over head
H/A	high angle
L/A	low angle
NG	No good
NGC	No good due to camera.
NGA	No good due to audio.
NGAct	No good due to acting.

Figure 9.3. Standard script note color codes and abbreviations.

End of Day Report

SCRIPT SUPERVISOR'S END OF THE DAY REPORT

Day of Photography: 5 of 6
Day of the Week: Thursday
Date: 8/30/12
Production Co.: Steadman Productions
Production: Think Big
Director: Wade Steadman

Crew Call: 7:30 AM
First Shot: 9:40 AM
Lunch: 2:06 PM
First Shot: 3:10 AM
Dinner: N/A
Wrap: 6:00 PM

Slate Numbers Shot:

L6U1, L6U1A, L6U1B, L6U1C, L6U1D, L6U1E, L6U1F, L6U7, L6U7A, L6U7B, L6U7C, L6U7D, L6U4, L6U7

Scenes Completed:

UNIT 6 LESSONS 1-3, UNIT 6 LESSONS 7-9

Totals:

	Today	Previous	Total	Total in Script	+/- Added Omitted	Adjusted Total in Script	Remaining
Slates							
Setups							
Completed Scenes							
Pages							
Time							

Added Scenes

Introduction to Unit 6

Comments / Reasons for Delay

PREVIOUS TOTALS UNKOWN AS SCRIPT SUPEVISOR WAS REPLACED AND THE PREVIOUS ONE DID NOT KEEP TOTALS. ALL THAT REMAINS ARE UNIT 6 LESSONS 4-6 TO COMPLETE.

Shots Still Owed:

UNIT 6, LESSONS 4,5,6

Jonathan Barbato
Script Supervisor
Script Supervisor

Jonathan Barbato Digital Script Supervisor 781-718-6110 www.scriptonset.com

Figure 9.4. An End of Day report. Courtesy Jonathan Barbato.

Anatomy of a Slate

Let's take a look at what goes on the slate.

- Production: The title of the production.
- Roll: The roll that you're currently shooting on. In digital, it's what memory card you're using.
- Scene: The scene number.
- Take: The current take number of the shot.
- Director: Name of the director.
- Camera: Name of the director of photography. Be sure to spell it correctly if you want to keep the job!
- Date: The month, day, and year of the shoot.
- Day or night/interior or exterior/MOS or sync sound.

With a digital slate, sometimes called a *smart slate* (Figure 9.6), there will also be timecode, which might be *jammed* from the audio recorder or might be *time of day* timecode. Smart phones and iPads have many slating apps available. Other data might include:

- Unit: A Unit, B Unit, EFX Unit, etc.
- Camera A, B, C, etc. With multiple cameras, it is common practice to individually slate each camera with just the information on the board, and then do *common sticks* — the same clapper which must be visible to all cameras.

Most assistants treat every memory card as a new roll number every time it is reformatted. This makes sense as it is really "new" media when it is formatted and this is how it will appear in the computer files as they are downloaded to send to the editor.

SLATE NUMBERS FOR COVERAGE

When shooting with the Master Scene method, there are going to be several very different shots: the master, the over-the-shoulder, the close-ups, and so on. These are all part of the same scene which has only one number in the script. How do we handle this? Just add a letter after the scene number to indicate coverage. For example, the master is just scene 27. For the coverage of the scene, letters are added for each *setup* (any time the shot changes).

- First over-the-shoulder: 27A
- Clean single: 27B
- Close-up: 27C and so on.

If you get to 27Z (and yes, it does happen), you start over with "AA." If you get to 27ZZ, you might want to consider that you are maybe over-shooting the scene! Remember from the chapter on scriptwriting that new added scenes in the script have a letter in front, so you might be slating "A27A" or "A27C."

"PU" DOESN'T MEAN IT STINKS

Usually, when doing a shot, you start from the beginning of a scene. For instance, an actor might have a long speech and they do it several times with the first part being perfect, but they mess up the second part again and again. The director might say to the actor "Let's pick it up from your line '...and furthermore.'" This is called a *pickup*. It is listed as *PU* on the slate. This is to help the editor, who might end up looking for the rest of the take.

A pickup can be any type of shot, master or coverage, where you are starting in the middle of the scene (different from previous takes where you started at the beginning as it is written in the script). You can pick it up only if you are sure you have coverage to cut to along the way.

Another use of the term is a *pickup day*. This is one or several days of shooting after the film is already in editing. The director and editor may realize that there are just a few shots here and there that they absolutely must have in order to make a good edit.

TAKES AND SERIES

Take numbers are easy: every time the camera cuts, it is a new take, even if you didn't complete the scene. The only time it is not a new take is if you roll the camera but it cuts before the *slate* is shot. Once the slate is shot, even if the actor only says the first few words and the director cuts, that is a *blown take* (or *false take*) and it needs a new take number. Sometimes (especially for very short shots), the director might want to do a number of takes without cutting the camera. This is slated as *series*.

Figure 9.5. This slate is for an *MOS* shot (no audio is being recorded). It is noted in the lower right hand corner, but more importantly the clapper sticks are not used and the assistant's fingers are held between the sticks to make it obvious to the editor that there is no audio recorder for this shot.

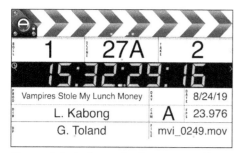

Figure 9.6. A timecode slate on an iPhone app, *Movie*Slate.*

Clapboards

Old-fashioned clapboards were black: they were designed to be written on with chalk. Now slates are white plastic and you write on them with an erasable marker. Be sure to use an *erasable* marker — a permanent marker can cause problems. If you do happen to make a mistake and use a permanent marker (like a Sharpie) you can save it: go over the marks with an erasable marker and wipe it off; this usually will save the board. If that doesn't help, sometimes Goof Off (a paint remover) will do it. Do NOT use acetone.

THE MOUSE

A mouse? Traditionally, it was a powder puff (obtained from the makeup department) taped to the back end of the erasable marker. Nowadays, there are special erasers that can be slipped onto the marker.

TIMECODE SLATES

Even better is a *timecode slate*. These slates have spaces to write the important information but they also have an LED display that shows the timecode of the video or audio. How does it know the timecode that is on the video camera or the audio recorder? You have to *jam it. Jamming* the slate is something the second AC and sound recordist will do at the start of the day and a few times throughout the day, as necessary.

Jamming is done by attaching the timecode slate by a wire to the video camera or the audio recorder. The slate can then stay in sync for several hours before it needs to be re-jammed. A smart slate can sense when it needs to be jammed and it will say "FEED ME" on the display. Whether you take the timecode from the audio recorder or the video camera is a matter of choice between the sound recordist and DP — ultimately it is up to the editor, who is the one who will have to make sense of it later. See the chapter *Audio* for more on this.

PLAYBACK TIMECODE ON MUSIC VIDEOS

On music videos, the timecode comes from the *playback audio* — which is the song recorded on tape with timecode added. The singer lip syncs to this playback audio and the timecode makes it possible to synchronize the video or film to the song later on.

A VERY COOL TRICK

Here's a very cool trick: instead of renting a timecode slate, you put the song into editing software along with blank video. You then display timecode on the blank video — most editing software can add this visible or "burned in" timecode. You then transfer this video onto an iPod, iPhone or even a laptop. Instant timecode slate!

Be sure it is close enough to be readable on the final video and be sure it is in focus so the editor can clearly see the numbers.

USE THE RIGHT MARKER

Slates used to be done with chalk, which was easy to erase. Now they are almost universally made of translucent Plexiglas and an erasable marker is used. Traditionally, a powder puff from the makeup department was taped to the end of the marker as an eraser — this was called a *mouse*. Nowadays, very handy little erasers are available to slip onto the end of a marker. Sometimes a PA might accidently use a permanent marker (such as a *Sharpie*) on the slate. Don't panic, it can be removed. Write over it with an erasable marker and then wipe it off. It works great! Also, be careful, some types of erasable markers are not really very erasable at all. Test a few types before you buy them. Camera assistants have definite preferences for the types that erase completely and don't mess up the slate board. They can also be cleaned with *Goof Off*. Do not use acetone, it will ruin the surface of the slate.

SCENE NUMBERS

Scene numbering is an important part of keeping track of things. It all starts with the script. Once a script is "locked" (a final shooting version is decided on), the AD divides it up into scenes and numbers them. These days, it is often done by the writer in the script-writing software, which makes it a lot easier. What is a scene? In other words, when does one scene end and another one begin? Several factors can determine this:

- Any time the location changes. This might be as simple as something like the characters being in the kitchen and then stepping out onto the patio.
- Change in time. It might be the same actors in the same room but they are talking during the day and then we seem them continuing the conversation at night.
- Major change in makeup or wardrobe. For example, if the actor needs to "transform" into a vampire, which might require hours of makeup.

Figure 9.7. Bad slating — moving the slate while clapping the sticks makes it unreadable by the editor and thus useless. Anything that makes the slate unreadable, such as being in the dark or glare, is a problem and is going to make the editor's job more difficult.

So why do changes necessitate a new scene number? You have to think of a script as much more than just "what the actors say." It is really a production document, like the blueprints of a building. The actors and director are going to read the script, but so is everyone else on the production. Everyone working on the film will make notes, create order lists, send memos and read the schedule based on the scene numbers. The editor will also follow the lined script during the editing process; along with the script notes.

The DP is going to read it to get ideas about the lighting, which means she might need different lights or even a different camera (like a highspeed camera) for certain scenes. The gaffer is going to use the script to decide what electrical equipment needs to be ordered for each scene. Same with the props department and art director — all their work is based on certain scene numbers: "we'll need a sofa for scene 25 and some champagne glasses for scene 54."

All of which means that it is important that the scene numbers in the scripts they receive never change. If a new scene was inserted and all of a sudden scene 25 becomes scene 26, that would be extremely confusing for everyone. New scenes get added to scripts all the time, sometimes scenes are deleted too. How do we make sure the existing scene numbers don't change? If a new scene is added after scene 25, it doesn't become scene 26; instead it is called A25. If another one is added, it is called B25, and so on. Deleted scenes are kept in the script but written as "Scene 55 — scene deleted."

SLATE LIKE A PRO

Slating is important and doing it right is something you should learn. The basic rules:

- Make sure the slate is well lit enough to be readable. Use a flashlight if necessary.
- Be sure it's in focus — a slate that can't be read is useless.
- If you are recording separate audio (in addition to audio recorded on the camera) you will need to slap the clapsticks.
- If no separate audio is being recorded, hold your fingers between the clapsticks. Also be sure to circle MOS that is on the slate. This is so the editor won't waste time looking for audio tracks that don't exist.
- Don't put the slate in until everyone is ready to shoot, or better, when the camera operator says "Slate in." This is because people are looking at the image for focus, composition, makeup and so on — don't block their view.
- Be standing by, ready to stick the slate in quickly.
- When the operator says "Slate" or "Stick it," say the information "Scene 27, take one." Then say "Marker" and bring the sticks down sharply.
- After you say the scene name on the first take, no need to say it again, just say "Take two," "Take three," etc.
- If you are close to the actor's face, don't do the sticks too loud. Instead say "Soft sticks" and slap the sticks with not too much force.

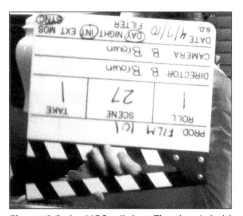

Figure 9.8. An *MOS tail slate.* The slate is held upside down to show the editor it is a tail slate. After doing this, quickly turn it right side up so the editor can read it without standing on their head.

- Make sure the slate isn't moving when you slate or it will be blurred (Figure 9.7). However, once you have slated, get the sticks out as quickly as possible. Don't take your time walking out — get out quickly, then settle so you're not making noise.
- If you are using a timecode slate, you will need to jam the timecode a few times a day. This is done by the sound recordist, as the reference timecode is generated by the audio recorder.

TAIL SLATES

Sometimes it is difficult to slate at the beginning of a shot or occasionally it just gets missed. In these cases, a *tail slate* is done at the end of the scene (Figure 9.8). Try to avoid them, as whoever is syncing up the audio is now going to have to find the end of the shot, read the information and the sync clapper, and then go back to the beginning. However, if you do a tail slate, three things are important:

- Hold the slate upside down.
- Say "tail slate" and then the other verbal slates (such as "scene 27A").
- Quickly turn the slate right side up so it is readable by the editor.
- Make a note of it in the camera report and script notes.

BUMPING A SLATE

In the film days, it was common to *bump* a slate. This was just shooting the slate information before the shot was ready — this might make sense for an MOS shot where the clapper is not important, for example. This also worked when shooting video with a tape-based camera, but those are now extinct. With file-based cameras (video cameras that record to flash memory or a hard drive), bumping slates doesn't work. Why not? Because in this system, every time you roll the camera, that is a separate computer file.

RESHOOTS

If a scene needs to be reshot, it will still have the same scene number in the script. To avoid confusion, it is common practice to put an "R" in front of the scene number. Without this, the editor could become very confused about which take to use.

VFX PLATES AND ROOM TONE

If you have *greenscreen* shots in your production, there will be two parts of the scene: the foreground plate (the part you shoot in front of the green screen) and the background plate (the stuff you shoot that will appear behind the actors when you use it to replace the green screen). These need to be slated as *Plate, Background,* or *VFX Plate.* Obviously you need to include the scene number, otherwise the editor may have no idea what the shot is to be used for. The other information stays the same. The same idea applies to *room tone.* When it is recorded only on separate audio, it is just verbally slated and entered in the sound notes, but if the video camera is used to record room tone, it needs a visual slate so that post can figure out why this shot of nothing even exists.

Audio Basics

Figure 10.1. (top) Three types of microphones. From top, a *shotgun mic*, a *short shotgun mic* and a *dynamic omnidirectional microphone*.

Figure 10.2. (bottom) An adapter from male XLR to 3.5mm (1/8″) TRS plug.

Double System vs. Single System Sound

Most digital cameras can record audio; however, only the higher end cameras will have professional audio inputs, which are XLR plugs in most cases (Figure 10.2). We'll talk about connectors in a bit, but for now it's important to know that XLR inputs are usually essential to getting the best audio. If you are recording directly into the camera, this is called *single system sound*.

All professional audio is recorded as *double system sound*, which means there is a separate recorder. Frequently, we record the audio onto a separate recorder but also feed the signal to the camera; this makes it much easier to *synchronize* the audio to video in post-production. If recording into the camera is your only option, then make sure you do the best you can with microphone choice, microphone placement, and keeping the set quiet. Whatever setup you use, test it before your shoot day!

LOCK IT UP!

One of the most important aspects of good audio is to not get any extraneous talk or noise that is not part of the scene on the audio recording. It's why we "lock up" the set and silence everyone and everything that might create noise during shooting.

WHY WE NEED CLEAN DIALOG

Frequently on location there are extraneous noises that we just can't get rid of; things like traffic, for example. For things like honking horns, helicopters and other background noise, some beginners get fed up with waiting for them to go away and try to convince themselves that "it's natural sound, it fits the scene."

Sorry, it doesn't work that way. Ironically, it frequently happens that crews go to a great deal of trouble to get rid of these kinds of sounds only to have the sound editor add them back in later to make the scene sound natural for that environment. It they are needed in the scene, why not just leave them in to begin with? First of all, sounds recorded on location are mixed in with the dialog, which means that you have no control over them later on. You can't dial the volume up or down on that background noise, move them to another track or anything else. Another issue is matching and continuity: if you shoot one side of the conversation and it has lots of traffic noise and then you shoot the other actor with the camera pointing in another direction and these close-ups have little or no traffic noise, the mismatch will be very noticeable and jarring in the final edit. The bottom line: get clean dialog with as little background noise as possible — always!

WHY WE DON'T LET DIALOG OVERLAP

If two actors are talking at the same time, it can make it extremely difficult for the audio editor. We generally ask the actors to not overlap their dialog. Of course, some great classic films such as those by Howard Hawks made overlapping dialog a feature, but it's very dangerous — proceed cautiously. It's always best to avoid overlapping dialog.

Sound Recordist Team

The person in charge of audio is the *Sound Recordist*, also called the *Mixer*. The equipment on the sound cart can be surprisingly technical and sophisticated at the pro level or might be something as simple as a handheld digital recorder or even an iPhone at the student level. There are three levels of audio recording:

- Recording directly into the camera. A separate microphone is needed if you want to have any chance at all of getting good audio. It can be a mic on a boom (so it can get as close as possible to the actors) or a lavalier lapel mic (wired or wireless).

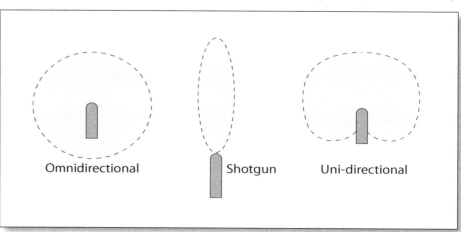

Figure 10.3. The pickup patterns of three types of microphones.

- Separate microphone which goes to a mixer and then is sent back to the camera.
- Audio from the mics is sent to a mixer and then recorded on an external recorder. This is called *double system* sound.

BOOM OPERATOR

The sound recordist may work alone, but ideally there should be a separate *Boom Operator*. Working the boom is a real art form in itself and takes a good deal of practice to get it right. On larger productions, there might also be a *cable puller*, which is also known as *audio utility*. In some cases, there might be more than one boom operator for complex scenes.

Microphones

There are many different types of microphones, *cardioid, dynamic, super-cardioid*, etc. For basic filmmaking you really don't need to know the technical details of all those, but there are some important things you need to know about mics. First, there is how directional the mic is and the second is whether or not it needs phantom power.

MIC ON THE CAMERA? NO!

It's tempting to just mount a microphone on the camera and be done with it. Sometimes this is the only practical way if you're working alone, but it is almost never a good idea. It means that the mic will not get close to the actors most of the time, and getting the mic close to the actor is how we get the best audio. As for using the mics that are built in to most DSLR cameras — don't even think about it; your audio will be terrible.

DIRECTIONAL MICS

Some microphones are *omnidirectional*, meaning that they pick up sound from every direction around them. Other mics are a little bit directional, meaning that they are much more sensitive to sound coming toward the front of the mic than anywhere else. When we're shooting video we're almost always looking for a mic to be directional, since the sounds coming from off the set are things we don't want to record; in fact we very much want to exclude those off-the-set sounds.

SHOTGUN MICS

Some mics are very directional; these are called *shotgun* mics. You can think of microphones like lenses: some are wide angle and some are like long focal length telephoto lenses — they only "see" a very narrow area in front of them. Generally, they fall into the categories of *short shotgun* and *long shotgun*. Long shotgun mics have a very narrow angle of acceptance, just like a very long lens on the camera.

THE SHOTGUN RULE

When selecting a mic for a shot, the general rule is: *The wider the shot, the longer the mic you want.* The reason for this is simple — if it's a big wide shot, then you won't be able to get the mic very close to the actors at all so you need a long shotgun mic. If the shot is a close-up of an actor, then you will be able to get the mic very close to them and a wider mic is appropriate. You also need to be careful with shotgun mics; keep in mind that they will not only hear what the actor is saying, they will also pick up anything that is coming from behind the actor and make it more prominent, just the way a long lens would do with background objects. What is coming from behind the actor might be extraneous noise like a fan, but it also might be a reflection, such as a hard surface wall or glass in a window, both of which will reflect sounds from elsewhere. The longer the mic, the more it will emphasize echo in a room, so you need to think about this when you're aiming the mic.

MIC MOUNTS

If a microphone is *hard mounted* to anything — the boom pole, the camera, a desk, there will inevitably be movement noise. To prevent this, special floating mounts are used on the boom pole; they use devices such as rubber bands to suspend the microphone and isolate it from any movement noise (Figure 10.4).

WIRELESS LAVS

You've seen wireless microphones at concerts, on the set we use a different type: *lavalieres* or *lavs*. They are usually attached or concealed in the actor's clothing, close to and point at their neck and mouth. They can create remarkably good audio that greatly eliminates outside noise. The disadvantages are that they can sometimes pick up outside radio interference and also that they can rub up against the actor's clothing and create a loud, raspy sound which spoils the dialog. For this reason, concealing a lav mic in an actor's clothing is a real art form when pro sound people do it. Just think it through carefully and experiment with good placements for the mics some time before you start shooting. Even in

Figure 10.4. (top) Two microphone shock mounts. They are designed to isolate the mic from knocks and vibrations that would record as audio.

Figure 10.5. (bottom) A foam cover (left) and a fuzzy (right) on two short shotgun mics.

Figure 10.6. XLR inputs and cables. XLR connectors are the standard for professional audio equipment.

the best circumstances, lav mics can be a problem so the best practice is to always have a separate mic on a boom also recording the actor's dialog. Actors sometimes change volume unexpectedly; one solution is to record the boom mic and wireless on separate tracks, with one track at 6dB lower than the other to protect against sudden loud sounds.

PHANTOM POWER

Dynamic mics can just be plugged in to the camera, to a mixer or a separate recorder. *Condenser* mics, on the other hand, require external power; usually +48 volts DC. This is called *phantom power*. Some cameras have phantom power available through the microphone inputs. It can usually be turned on or off. Mixers and some external recorders can also supply phantom power. Sometimes they will have a switch marked "48V Phantom" or something similar. In some cases, it will be in the menus.

MIC VS. LINE INPUT

A *microphone-level* signal describes the voltage generated by a microphone when it picks up sound, typically just a few thousandths of a volt. Microphone level is very weak and requires a pre-amplifier to bring it up to line level. A *line-level* signal is about one volt, or about 1,000 times as strong as a mic-level signal. The two signal types do not ordinarily use the same input.

Audio Basics

There are a few fundamental principles that you need to know in order to get good audio for your production.

RULE #1

There is one rule that matters more than anything else in recording audio. It's a very simple rule: *get the microphone as close as possible to the actor's mouth!* In professional situations you will generally see that the microphone is just inches outside the camera frame. You are always going to get the best audio if the mic is as close as it can get. Having a high quality *shotgun mic* does allow you to get usable audio from farther away, but it will never be as good as what you would get with a mic very close (Figure 10.7). This is why having a shotgun mic mounted on the camera is the laziest way to record audio — not only is it farther away than it needs to be, but it is also right on the camera and may pick up all sorts of extraneous camera and operator noises. Having a mic mounted on the camera may be necessary in some situations, but you should avoid it whenever possible.

RULE #2

Always record audio, even if you're sure you won't need it. In filmmaking, you never know. There are even instances where you will end up using the audio for another scene or in a different movie. Always roll sound, even if it's just audio on the camera.

SCRATCH TRACK

If there's no way around it and you have to anticipate doing looping, you should always record *scratch track* anyway. Scratch track (also called *guide track*) is audio that you know won't be usable but at least it will serve as a guide for ADR or other uses. It's a good practice to always record audio, even if you know it's an *MOS* scene (*mit out sound*).

WILD TRACK

Wild track is a variation of scratch track. It is audio that is recorded without any video. It might be sound effects, such as a telephone ring or it might be actor's dialog such as a missed line or a replacement line, such as "I've had it with these monkey-fighting snakes on this Monday-to-Friday airplane!" *Voice-overs* are also a type of wild track. They might be recorded on the set (or in a quiet room near the set) but preferably in an audio booth.

FOLEY

One reason to record wild track sound effects while you're on the set is to minimize the need for *foley* sounds later on. *Foley* is sound effects such as footsteps, punches, glass crashing, etc. that are added later on.

ROOM TONE

One example of wild track is *room tone*, which is just the sound of the room or set you are shooting on, without any dialog or extraneous sounds. You should <u>always</u> record room tone for every location you shoot at! Record at least 15 seconds of room tone. It is used by the editor to fill in blanks in the audio so that the background ambient noise matches from shot to shot. It's easy to forget. Not getting room tone is one of the biggest mistakes a filmmakers can make. Don't do it!

ADR IS EXPENSIVE

When it is difficult to get good audio or when you have been waiting ten minutes for the airplanes to clear so you can shoot, it is all too easy to give up and say "We'll ADR it." *ADR* stands for *Automatic Dialog Replacement* (also called *looping*). This is where the actors are called back after production has wrapped and go into a recording studio to repeat their lines in sync with the pictures — it is *very* expensive and never quite as good as the original dialog in terms of matching the actor's lip movements.

HEADPHONES

Headphones are important for the audio team; they need them to give good clear, neutral reproduction of the sound that is coming in from the microphones but they serve an additional function as well — as much as possible they should shut out the ambient sound so that the recordist can focus on what is actually being recorded. The boom operator needs headphones as well and this will be a feed that comes from the *mixer*.

HEADPHONES FOR THE DIRECTOR

It has become customary for the director to have headphones as well so that they can clearly hear the actors even if they are speaking very softly. They are fed from the mixer so it's up to the sound dept. to provide these for the director. The script supervisor will also need them so that he can clearly hear the actors. Most often, these headphones will be wireless, but wired is OK if you can't afford wireless. Also, keep in mind that a lot of great movies got made before directors had headphones.

BOOM OPERATING

Microphones are almost always mounted on a *boom* — which looks like a fishing pole and telescopes from short to long. The best ones are carbon fibre and super lightweight, but also very expensive. If you're doing sound all the time, it's worth the investment.

GET IT CLOSE

Since the purpose of the boom is to get the microphone into the best position for good audio, it's up to the boom operator to find the best positions to get the mic as close as possible to the actor who is speaking. They will also need to *cue* the mic (turn the boom slightly) as different actors speak.

KNOW YOUR LENSES

Experienced boom operators ask the camera operator what lens is being used for the shot: if it's a long lens, they know they can get close to the actor, if it's a wide lens, they know they have to leave more room.

GET FRAME LINES

The biggest mistake for a boom operator to make is to let the microphone dip into frame. It ruins the take and forces everyone to start over again. It takes practice but the main way to avoid it is to get a *frame line*. This is done with the camera operator — they look into the viewfinder and tell you when you are "in frame." Once you have the frame line, try to find a reference point: the top of a window frame, a picture on the wall — anything to help you hit that mark again and again.

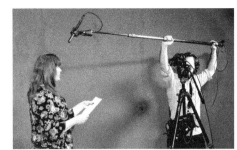

Figure 10.7. (top) A boom operator at work. It's important to get the boom mic as close to the actor's mouth as possible without getting into frame.

Figure 10.8. (above) A Rode shotgun mic and its *blimp*. Note that the blimp has a handle, in case the situation doesn't call for a boom. Handles like this always have a screw receptor for a boom mount. (Courtesy Rode Microphones).

Get room tone at <u>every</u> location and set you shoot at.

Figure 10.9. A Zoom F4 combination field mixer/recorder. "Field" meaning that it is battery powered. Always be sure you have plenty of extra batteries for all your audio gear. This unit has XLR inputs for microphones which can also accept a line input. A typical line input might be audio from an MP4 player or a music amplifier. On this particular unit, whether it provides phantom power or not is selected in the operations menu.

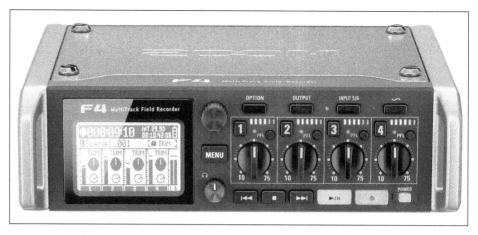

MAKE SURE IT'S POINTED IN THE RIGHT DIRECTION

You'll know you're watching a student film crew at work if the boom operator is holding the microphone far away from the actors even though the frame is tight and if they are not even aiming the mic at the actor's mouth.

Beware of "Straight On"

If you point a microphone straight and level at an actor, it might be good for getting their dialog, but it also might pick up any noise that's going on behind them — distant traffic, kids playing or even echoes off a hard surface wall. This is another reason why a mic mounted on the camera is such a terrible idea.

DEAD RATS AND BLIMPS — WIND NOISE

A big problem when recording outside is *wind noise*, which is created by the air rushing past the grill on the front surface of the mic. It can be quite loud and even with the slightest wind can make your audio completely unusable. Fortunately, there are some solutions to this problem. The most common solution is *foam cover* that slips over the microphone; another one of them is a fuzzy cover that goes over the microphone (Figure 10.5). These have fake fur on them which muffles the wind sounds. They can be effective, but for windier situations, something more is needed. For this, sound mixers use *blimps*, which are rigid enclosures (Figure 10.8). On a small production, you might not be able to afford these, but it's usually easy to get a foam cover for any mic.

Mixing Audio

Actors seldom speak in a monotone at the same volume all the time; if they did we probably wouldn't think they were very good actors. If their volume gets too low, it won't be a good recording because if we raise the level in post, we will also be raising the audio level of all the background noise, hiss, echoes and wind sounds. If they speak too loudly, the audio may get distorted and cause other recording problems. We need a way to instantly control the recording volume to deal with this. The person who does this is the key sound person who is also called the *mixer* — he or she is head of the audio department.

DO NOT USE AUTOMATIC VOLUME CONTROL

With auto volume control, every time the actor stops speaking the auto control will think it needs to raise the recording level and there will be horrible hissing and other problems. Some cameras are worse than others, but it is something you want to avoid. Most cameras have audio control on them, but it is very impractical for the camera operator to adjust volume in the middle of a shot and even more difficult for someone else to reach in and do it. Having some sort of *mixer* is important. These are not the same as a DJ mixer; the ones used in film are generally called *field mixers*, as they are most often run on batteries.

TYPES OF MIXERS

Mixers are usually separate from the recorder but not always. The *sound recordist* (who is also called the *mixer* or *production sound mixer*) needs to be able to easily manipulate the volume controls for individual channels as the scene progresses. The mixer itself will also need to have outputs to the audio recorder and for the headphones worn by the audio recordist, the boom operator and usually the director, the script supervisor and perhaps some producer. Figure 10.10 shows a typical cabling diagram for a lav mic on the actor (wireless) and a boom mic (wired). A more common situation might be a boom mic and two, three or more lav mics for actors. Plan ahead and be sure your mixer has enough inputs to accommodate how many mics you will be using.

SHOOTING TO PLAYBACK

Say you're given the job of producing *La La Land 8: The Revenge*. This means you will be recording song and dance numbers on location and in a sound stage. It has long been known that recording the actors actually singing on the set makes it nearly impossible to get good quality audio. To remedy this, the songs are recorded to *playback*. Shooting to playback means that the sound department has digital files of the actors singing the songs that were recorded under ideal conditions in a sound studio. The performers then lip-sync to the playback.

An audio player is wired to powered speakers on the set so the actors can hear the song and lip-sync along with it. The *sound recordist (mixer)* still records the live audio — some of the on-set ambiance of the actors might be blended into the final mix and there might be dialog before, during or after the songs; there might also be incidental sounds that need to be captured. This means that the audio recorder used by the mixer cannot also be used to do playback — a separate unit will be needed.

The actors will almost always ask for the music and lyrics to be played as loud as possible, especially on music video shoots, so you will need some fairly powerful speakers to use on the set — an iPhone without external speakers won't cut it. Most often, powered speakers, which have built-in amplifiers, are the choice for this job. Be sure to alert the gaffer that you will need AC power for your speakers. If it's a day exterior shoot, the gaffer may have been planning on only using reflectors to light the set and not intending to provide AC power on the set with a generator or other means, such as asking a local shop if they can plug in a line to run out the door to your set.

SOUND REPORTS

The sound recordist also keeps the *sound report*, which is a list of every shot and where it occurs on the audio tape — usually listed by timecode (Figure 10.13). A sound report is a written form that's filled out by production's sound mixer. The sound reports accompany the film rolls, memory cards or hard drives of the video and audio shot that day. Some recorders, such as the *Zoom F4* (Figure 10.9) will automatically generate a sound report that can be downloaded via USB.

Figure 10.10. Typical connections for audio recording. Bigger productions always record audio separately from the camera, but also recording to the camera in addition can make syncing the audio in post much easier. On smaller shoots, you may not have a mixer (meaning both the mixing equipment and the person called the mixer) but if you don't have these, it is essential to constantly monitor the audio with headphones to make sure it's within acceptable limits.

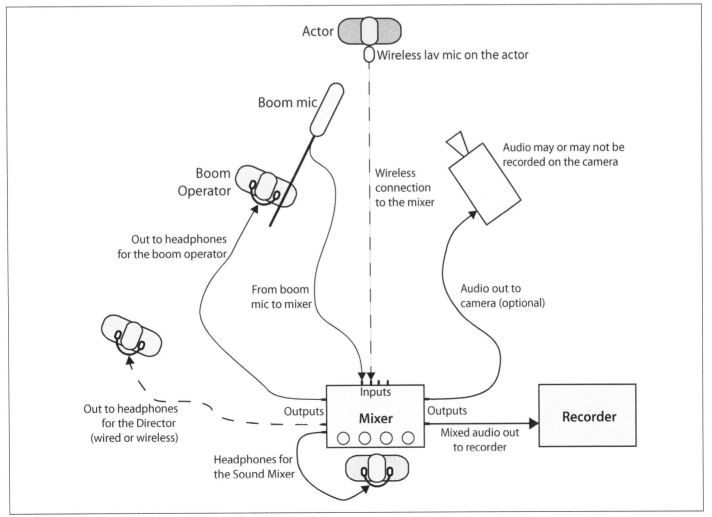

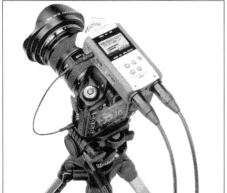

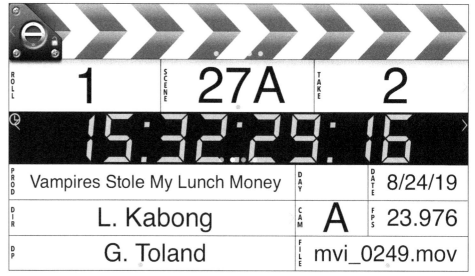

R O L L	**1**	S C E N E	**27A**	T A K E	**2**

15:32:29:16

P R O D	Vampires Stole My Lunch Money	D A Y		D A T E	8/24/19
D I R	L. Kabong	C A M	A	F P S	23.976
D P	G. Toland	F I L E			mvi_0249.mov

Figure 10.11. (top) The traditional clapper slate.

Figure 10.12. (above) A Zoom H4n recorder mounted to the top of the camera. It has XLR connectors on the bottom — these same inputs can also accept 1/4″ TRS plugs. A small cable runs from the output on the side of the recorder to the in audio input of the camera — this both makes a real-time backup of the audio and also makes synchronization of picture and sound much easier. (Photo courtesy Zoom, North America)

Figure 10.13. (right) Movie*Slate 8 is an app that performs nearly all of the features of a timecode slate.

Syncing

If you are using double system sound (where the audio is recorded on a device other than the camera), you have to *sync* (synchronize) the audio and video. Since the invention of "talkies" in 1929, this was done with a clapper slate (Figure 10.11). On film and video, it's easy to see the exact frame where the sticks come together. The distinct clap sound it makes is clear on the audio; then it's usually up to the assistant editor to laboriously go through each and every take, find the frame where the sticks come together, find the distinctive "clap" on the audio and match them up. It's a laborious and slow process. *Plural Eyes* is a popular software that does a good job of syncing audio and video. *Final Cut Pro X*, *DaVinci Resolve*, and *Premiere Pro* also have syncing capabilities; however all of these applications have some limitations, especially in more complex cases.

TIMECODE SLATE

A big improvement came with the *timecode slate*. So what is *timecode*? You can see it in Figure 10.13 — it's *hours:minutes:seconds:frames*. The beauty of it is this is that it means every frame of your video and audio has a unique identifier. This has tremendous utility in post-production; for one thing it makes syncing audio and video practically automatic. It also helps editors, sound editors, composers, and special effects creators keep track of everything throughout the post process.

Of course, timecode doesn't come from nowhere — it has to be generated. Professional audio recorders are capable of creating timecode, but they are very expensive. Separate timecode generators are also very expensive — until recently. Affordable and easy to use timecode generators are now available, notably from *Tentacle Sync*. Small, lightweight and easy to use, they make timecode available to indie filmmakers. Let's take a look at using timecode on the set using the *Tentacle Sync E* as an example (Figures 10.14 and 10.16).

First of all, you need to set the unit to the timecode you want to use. There are two ways of using timecode: *free run* and *record run*. Free run timecode is running all the time, even when the camera is not rolling. Most of the time, we use it as time-of-day timecode — meaning it matches the actual clock time of where you are shooting. Although it's not necessary, having the timecode match the time of day helps identify shots and makes things easier to keep track of. In the case of the Tentacle, setting the time is done by Bluetooth through their iPhone, iPad app, or Android device. Since smartphones and tables get their time from the internet, it is extremely accurate. The app also indicates the battery level of each device and whether or not it is connected.

Once all of your Tentacles are synced to the same timecode, it's time to *jam* it to the audio recorder and all of the cameras (Figure 10.14). *Jamming* just means transferring the timecode from the generator to the audio device or camera. Generally, this is handled by the audio department, as timecode originates either from their recorder or from a timecode generator that they supervise. Jamming is always done at the beginning of the shoot day, and then again after lunch. The reason for this is that even high-end pro equipment can drift over time, thus throwing sync off by a few frames or even more. Each time, the audio person will jam sync to the timecode slate (if there is one), and each of the cameras. The audio recorder is the origin so it doesn't need it. With pro equipment this would involve connecting and disconnecting cables for each device. Since Tentacle works with Bluetooth, the process is much simplified; however, the devices have to be fairly close together, but since they are so small and light, this is not a problem.

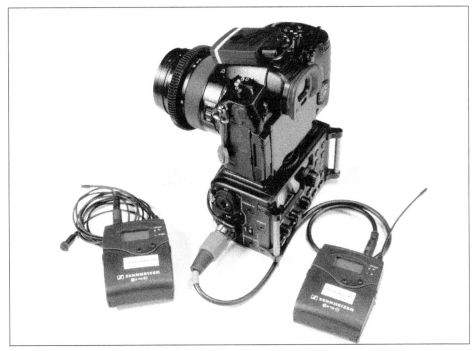

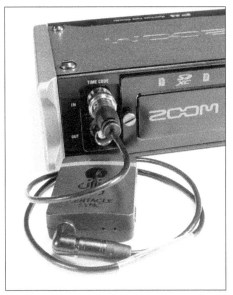

Figure 10.14. (above) A *Tentacle Sync E jamming* timecode to the *Timecode In* BNC connector on a *Zoom F4* recorder. After timecode is jammed, the Tentacle can be disconnected and used on a camera. For recorders and cameras that don't have a dedicated *timecode in* connector, you can record timecode to one of the audio tracks, as in Figure 10.16.

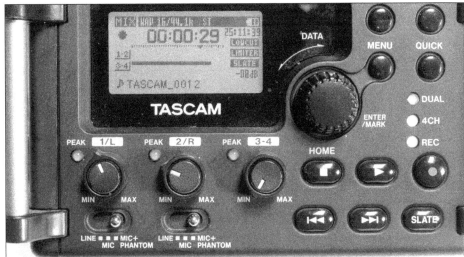

Figure 10.15. (left, top) A *Tascam DR60D* mounted under a DSLR. A wireless lavalier is plugged in to channel 2 and a *Tentacle Sync E* is velcroed to the top of the camera and feeds timecode into channel 3 of the Tascam.

Figure 10.16. (left, bottom) Timecode from the Tentacle timecode generator shows as a constant signal on channel 3 of this Tascam recorder. Note also the switches at the bottom to select Line, Mic, or Mic+Phantom Power.

Figure 10.17. (next page). A sound report form filled out each day by the *production sound mixer*. Just like with camera reports, it is all about helping the editors find and identify the material they receive from the set. Record keeping like this is important on any project bigger than a short film.

Pro equipment has dedicated timecode inputs; however, even cameras that cost up to seven or eight thousand dollars might not have them. Of course DSLRs and other prosumer cameras that might be in use on indie or student productions will certainly not have them. So what do we do? In this case, the Tentacle comes with a short cable that has a 3.5mm TRS connector at each end. DSLRs and many audio recorders have 3.5mm microphone inputs. Connecting the generator to the mic input sends timecode as an audio signal to one of the channels; you will see it as a constant level on the audio display, you will also hear it as high-pitched noise on that channel. Does this mean you have lost both audio channels on the camera? No, the Tentacle has a built-in microphone that transmits location sound to the other channel. Is it great audio? No, but it doesn't need to be — it's what we call *scratch track*, which is just audio recorded to be used for sync or other purposes later on. You should always record scratch track, no matter what your setup.

SOUND REPORT

Title/Prod:				Roll #		Sheet #

Mixer:	Phone:

Recorder/Mics:	Location:	Date/Day:

Fs/Bits:	Time Code:	Ref Level:	File Format:

Comments/Instructions:

Scene	Take	CR	Timecode	Notes

Abbreviations: HS—Head Slate SS—Second Sticks NS—No Slate IC—Incorrectly Called TS—Tail Slate
GS—Good for Sound NG—No Good for Sound BG—Background GT—Guide Track
FX—Sound F/X WT—Wild Track WL—Wild Line

The Work of the Editor

Why Do We Edit?

So, when do we need editing? When do we stop using one shot in a scene and go to another one? There are many different reasons for an edit: continuity, juxtaposition of two things to make a new, third meaning and so on. Sometimes we even edit in order to fool the audience; this effect is frequently used in horror films, thrillers and even comedy. There's another reason, which doesn't really fit into the world of high-minded cinematic philosophy but it's still very true: we edit when the audience starts to get bored with a particular shot.

Editing also helps the audience interpret and understand a scene. Imagine a scene of five people talking. If we just did a wide shot of all five of them as they talked on and on, not only would it be boring, but it would be a little hard to follow — it's the close-ups, the reaction shots, the over-the-shoulders that really help us get more involved with the individual characters and really follow the conversation. Often it is the editing that gives the scene a *point-of-view*, a particular take on the material that conveys meaning to the viewer.

WHAT THE EDITOR DOES

Director Martin Scorsese put it like this: "It's the editor who orchestrates the rhythm of the images, and that is the rhythm of the dialogue, and of course the rhythm of the music. For me, the editor is like a musician, and often a composer."

THE DIRECTOR/EDITOR COLLABORATION

The great editor Walter Murch (*Apocalypse Now*, *The Godfather Part II*) said "The director's method of working with the editor should be very similar to the way the director works with actors. In general, you don't give line readings to actors. It's similar with editors. With some exceptions, I would hesitate to tell an editor 'Take 10 frames off the end of that shot,' because how you interpret pace can be different. An editor can think, 'This shot looks like it's on for a long time, but it only looks that way because of things that happened earlier in the scene, so I'm going to accelerate those earlier things and that will allow this shot to hold on the screen longer.'"

On the other hand, editor Ann Coates (*Lawrence of Arabia*, *Chaplin*) said "I don't care if a director tells me to take 10 frames off — because I don't take 10 frames off. I take off what I think would be appropriate. Most directors have no idea what 10 frames looks like. If you work with Sidney Lumet, he knows what 10 frames are. Milos Forman does, too. But most directors, when they say 'take 10 frames off,' they're just kind of showing off to you. I've learned through the years you just do what you think is right. And they'll think that's great because they'll never count the frames." A big part of editing is diplomacy.

The Six Steps of Editing

You don't want to just jump in and "start editing." The editorial process has some well established stages that are logical in progression. Each step prepares you and the material for the next stage.

LOGGING

This is the first time the editor sees the film, and since it is shot out of sequence, it is out of context of the story. The editor views the rushes (dailies) and looks for fluidity of movement and nuances that will later be incorporated into the film.

FIRST ASSEMBLY

The editor considers all the visual and audio material collected on the shoot for each scene and then re-orders it in the way to tell the story best. Editing on a large project usually commences as soon as the film starts shooting. An editor will work on the daily footage and assemble scenes for the director to view. Often at this point the editor and director will decide that additional footage of key moments is necessary in order to make more editing choices available during the edit. First assembly is like a sketch of the finished scene.

ROUGH CUT

This is the editor's first pass at really editing the project. Sometimes the editor works alone and shows the day's or week's work to the director. Sometimes the editor and director work together, discussing every nuance. In the rough cut, the scenes are placed in order, and checked for continuity. This all-important step in the editing process allows for revisions and new ideas to be tried and tested. Make the edit points between the scenes very obvious in order to emphasise the 'roughness'. Failure to do so may result in the editor committing to an edit before it is ready.

Film is a dramatic construction in which the characters can be seen to think at even the subtlest level. This power is enhanced by two techniques that lie at the foundation of cinema itself: the close-up, which renders such subtlety visible; and the cut, the sudden switch from one image to another, which mimics the acrobatic nature of thought itself.

Walter Murch
(*Apocalypse Now*, *The English Patient*, *Cold Mountain*, *Jarhead*)

FIRST CUT

The first cut is the rough cut that is accepted by the editor, the director and the producer. Selection and sequence are basically fixed, although changes can still be made. Detailed fine cut starts out from its proportions, structures, rhythms and emphasizes them. Once your first cut is done, it's a good idea to step away for a few days so that when you go back, it is with a fresh idea and clear mind. It goes without saying that there is probably going to be a second, third, fourth cut and maybe more — it's all part of the process.

FINE CUT

The fine cut is usually not about the overall structure of the film, but the details of each and every cut. The fine cut emphasizes and strengthens the rhythms and structures identified in the first cut. It also hones the little details, the small editing flourishes that really make the film sing.

FINAL CUT

When the editor, director and producer agree on a *fine cut*, the sound designer, music composer and title designer come in to do their work. Sound effects and music are created and added to the final cut. Who gets the last say, the final cut, is up to the agreement between director and producers. Not many directors get to have the absolute last word on the version that will be shown to the public; that's usually up to the producer of the film.

What Is an Edit?

Almost every visual story we tell is made up of shots, sometimes a few, sometimes hundreds or even thousands. Editing is how we put these shots together so that they make sense and tell our story for us. However, don't think of editing as just "Putting them together." The fact is that the editing process is an enormously powerful part of the creative process. It has been said that a movie is "written" three times. One time by the screenplay author; a second time by the director and a third time by the editor. In many cases, there can be significant differences between these three versions — even, on occasion, when the writer, director and editor are the same person! As the final stage of the creative process of making a film, editing is where it all comes together. It is also where you finally have to make up your mind about some of the alternatives you've been keeping alive, not sure which way to go with it. At some point you have to decide, because the final edit has to be finished at some point.

You can think of the filmmaking process this way: when we shoot on the set, we are taking "reality" and cutting it up into a lot of different shots and camera angles. When we edit the film, we are taking this "disassembled" reality (we can call it deconstructed if you like) and "reconstructing" it. We can put those pieces back together in any number of different ways — all of which tell a slightly different story; sometimes a radically different story. We can change the ending, we can expand or contract time, we can show different viewpoints on the story — it's an almost magical power!

So back to basic definitions: what is an edit? An edit is the simple process of taking two shots and joining them together in some way. Editing is the process of arranging our shots in a specific order — usually with the clips that are trimmed down from original length.

POST-PRODUCTION

Editing is a part of post-production, but "post" is a lot more than just editing the video. It also includes editing the audio (an important part of the workflow) and also adding music, sound effects, visual effects, perhaps some animation or green screen, "sweetening" the audio, and so on. Post can be a big and complex process, so larger productions often have a *post-production supervisor* to oversee and coordinate all parts of the process.

CONTINUITY CUTTING

Continuity editing — also called *invisible editing* or classic editing; it is essentially the system that exists today. Understanding this system is crucial to understanding not only for editors, but also for directors, and continuity supervisors. Other members of the crew will benefit from understanding it also. It is especially crucial that the Director of Photography knows how it works, and how to shoot, so that the essential elements are delivered to the editor.

The *continuity* is the development and structuring of film segments and ideas so that the intended meaning is clear, and the transitions employed connect the film parts. In a more specific meaning, "continuity" refers to the matching of individual scenic elements from shot to shot so that details and actions, filmed at different times, will edit together without error. This process is referred to as *continuity editing*. To maintain continuity within sequences, the editor will often *cut on character action* so that the scene flows. Lapses in the

You get to contribute so significantly in the editing room because you shape the movie and the performances, you help the director bring all the hard work of those who made the film to fruition. You give their work rhythm and pace, and sometimes adjust the structure to make the film work – to make it start to flow up there on the screen. And then it's very rewarding after a year's work to see people react to what you've done in the theater.

Themal Schoonmaker
(*Goodfellas*, *Gangs of New York*, *The Wolf of Wall Street*)

For a writer, it's a word. For a composer or a musician, it's a note. For an editor and a filmmaker, it's the frames. Two frames added, or two frames less… it's the difference between a sour note and a sweet note. It's the difference between clunky, clumsy crap, and wonderful rhythm.

Quentin Tarantino
(*Pulp Fiction*, *Django Unchained*, *Once Upon a Time In Hollywood*)

flow of action can be avoided by transition and cutaway devices. This system is associated with the following other terms:

Establishing shot — Refers to the shot at the beginning of a scene that shows the viewer where (and sometimes when) the scene takes place.

Shot/answering shot — After an establishing shot, the shot-reverse shot refers to the close-ups used when two characters are in conversation. (Because we have already used an establishing shot, we now know where the characters are in relation to one another.)

Match-on-action — connects two shots cut together by having a character finish an action in the second shot begun in the first shot. For instance, if a character lights a match in the first shot, the same character will draw it up to a cigarette in the second.

Eyeline match — The directions that actors look affect the way we perceive their spatial relationships to one another. Eyeline matches are important for establishing who a character is talking to or what a character is looking at. For instance, if a character is talking to two people on either side of him or her, then the character will look to the left of the camera to connote that he or she is talking to the person in that direction.

The 180-degree rule — The rule that once a spatial relationship has been set with the establishing shot, no close-up will cross the imaginary line drawn between those two actors until a new line has been established. See *Coverage and Continuity* for more on this.

SHOT

Scenes are made up of *shots*. Each shot is a continuous piece of video — from when you start the camera until you turn it off (although of course we trim it down later on).

TAKE

If a shot doesn't work the first time, the director calls for it to be done again — every time the camera rolls on a particular shot, that is a *take*. If the camera moves to a new location after a take, then it is a new *setup*, which means it is also a shot, with a new shot number.

SCENE

A *scene* consists of continuous action in a single location at the same time. If the location or time changes, it is a new scene. Scenes are usually (but not always) made up of a number of shots. It's one of the reasons the *slug line* of every scene includes the location and time of day of the scene. If either of these change, it's a new scene. For example, if the action is in the same place but it's a different time (such as "Several hours later,") it's a new scene.

SEQUENCE

A *sequence* is a series of scenes that fit together in some way. For example, there might be "the swimming pool sequence" — more or less continuous action in a single location.

TRANSITIONS

Most of the time, when one scene ends and another begins, there will be a *straight cut*, meaning that one shot ends and another begins, but there are other ways to move from one scene to another. Films often begin with a *fade in*, where the screen is dark and then the shot gradually becomes visible. *Fade out/fade in* is also a way to transition between scenes. A *dissolve* is another example. In a dissolve, one scene fades out while the next scene simultaneously fades in.

Seven Elements of Editing

When we edit a project, we are most of the time aiming for basic continuity — in other words, putting together a story that makes sense and where no glaring holes or contradictions divert the viewer's attention. This focus on continuity began with the screenplay and is of prime importance to the director and DP when shooting the film and now it is up to the editor to put the footage together so it makes sense within the realm of continuity. So what are the elements we are looking for as we edit the footage together? There are many factors involved, but don't let them overwhelm you — in the end most of them are common sense and you'll know by looking at the footage what is right and what is wrong.

- Motivation
- Continuity
- Information
- Camera angle
- Composition
- Audio
- Continuity of motion

My job as an editor is to gently prod the attention of the audience to look at various parts of the frame. And I do that by manipulating how and where I cut and what succession of images I work with.

Walter Murch

The essence of cinema is editing.

Francis Ford Coppola
(The Godfather Trilogy, Apocalypse Now, The Conversation)

TYPES OF EDITS

There a number of different types of edits; they include:

- *Action edit* — also called a movement edit or continuity cut. This is the process of putting the shots together so that the action of the scene appears to be real time and continuous as if the viewer was watching a real scene.
- *Concept edit* — a cut or dissolve that puts two images together in a way that generates a new and different meaning. Two famous examples of concept edits are the fan that turns into a helicopter at the beginning of *Apocalypse Now*.
- *Screen position edit* — In a screen position edit, you draw the viewer's eye to a certain part of the screen. When you make the cut, you place what you want the viewer to see in the same part of the screen.
- *Form edit* — A form edit is a cut between two similar shapes, such as a cut from a Ferris wheel to a close-up of someone's eye.
- *Combination edit* — As you may have noticed, the fan to helicopter edit and the bone to spaceship mentioned above are both concept edits and form edits — these are combination edits.
- *Match Cut* — A famous example of match cutting comes from *2001: A Space Odyssey*. The classic cut comes towards the beginning of the film. After the apes have used a bone as a weapon for gathering food, an ape throws the bone into the air. As it falls, we match cut to a space ship carrying nuclear warheads. Both the bone and the ship are of similar shape and color, and both happen to be moving towards the bottom of the screen. The cut relates all of technology to the development of weaponry as it cuts out all of human history.
- *Montage* — A series of shots that are related in some way. Examples are the training sequence in Rocky that ends with him on the steps of the Philadelphia library, or the opening sequence of *Midnight In Paris* — which is a series of shots of Paris in the rain. Their purpose is to establish mood and theme.

Figure 11.1. Perhaps the most famous *match cut* of all from *2001: A Space Odyssey*. The ape discovers the bone as a weapon, throws it into the air and it cuts to a space station — the entire evolution of technology in two cuts.

MOTIVATIONS FOR A CUT

There are a few basic motivations for a cut:

- Where there is a change of time or location — a new scene.
- Continuity. Where the action is continuous but the scene is composed of more than one shot — editing maintains continuity.
- To keep things moving — looking at one shot for a long time can get boring.
- Pace.
- Where there is a need for "punctuation" for impact.

Let's look at these one at a time. The first is where there is a change of location or time. We know that this means it is a new scene: these are the main things the AD looks for as she "lines" the script to break it up into scenes. If a scene is taking place in a bank and then different characters are talking in a garage — there is no question but that is a different scene. Clearly the edit that transitions us from one scene to another has a job to do: it must make it clear that the location has changed and that a new scene has started. If the edit doesn't do these jobs, it will only lead to a very confused audience.

The second case is also very interesting: in many cases, we use an edit to add punctuation, emphasis or impact to a scene. This is where the editor has the opportunity to really change the tone of the scene in very interesting ways. That sudden close-up on the killer, the tight insert on the murder weapon, the cutaway to the gathering storm in the sky — all of these kinds of edits can dramatically alter the progress of the scene.

An editor is successful when the audience enjoys the story and forgets about the juxtapositions of the shots. If the audience is aware of the editing, the editor has failed.

Ken Dancyger

FINDING AN EDIT POINT

Like everything in film, every cut should have a reason. Don't just cut shots up and throw them together — there should be a reason for every clip or select and every cut you make: edits should be motivated and help tell the story. Whenever you put two shots together, you need to find the best *edit point* where they fit together.

Especially when you are editing any type of action, there are several considerations. First of all you need to *match the action*. For example, if one of the people talking is raising and lowering his hand to gesture, you will need to be sure the shots match from one clip to another. If you are just using clean singles of each actor, it's not as much of a problem, but let's say you are cutting back and forth between a two shot that includes both the actors and an over-the-shoulder shot that shows the actor who is gesturing. If his hand is in the air in the over-the-shoulder and you cut to the two shot and his hand is at his side, the two won't match — that would be a fairly serious continuity error.

With bigger kinds of action, it's pretty easy to see if the continuity is off, but this kind of action matching is important in subtle ways as well. Since people often turn their heads in various ways as they are talking, looking or doing any kind of activity, most editors pay very close attention to head position. Since it involves the head (the center of attention for most viewers), it is very important to match the position of the head as you cut from a wide shot to a medium, for example.

CUT ON ACTION

When editing, and to a certain extent while shooting a scene, we are always looking for a good *cutting point*, also called an *edit point*, as we just discussed. This is the moment when we can make the smoothest, most effective cut from one shot to another. Keep in mind that with all edits (except those at the beginning or end of a scene) we are dealing with two shots. We need to find the right moment. One of the oldest and most reliable rules of editing is to *cut on action*. What do we mean by this? If a character in the scene does something physical, that's often a good time to cut. A classic example is a scene where someone walks into a room and sits down at a desk.

ESTABLISHING THE GEOGRAPHY

The director will usually shoot a wide angle of the character entering the room and crossing to the desk — this *establishes the location* and also *establishes the geography* of the room, so the audience has a good idea of where the scene is and where things are within the scene. Once the character is sitting at the desk, then a wide shot isn't much good now. We really want to go to a *medium shot* or *close-up* at that point, because at this point it's not the whole room we're interested in, it's the guy sitting at the desk that we want to focus on.

Invisible Technique

If we cut from the wide shot to the medium while he's crossing the room or after he is sitting at the desk, there's a very good chance that the cut will be noticeable, which violates one of the most basic principles of filmmaking — everything we do should be *invisible*. This is something that applies not just to editing, but to cinematography, acting, camera movements and many other aspects of film — the basic concept is called *invisible technique*. If the audience is aware of the artificial nature of anything we do, it takes away from the basic illusion of cinema — the idea that we are watching real people doing real things.

So, what's our best chance of making sure the edit in this scene is invisible and that the edited scene flows smoothly? Cut on action! In the simple scene we described above, you'll find that the cut from wide shot to medium or close-up will almost always take place as he is sitting down, the most obvious physical action that comes between things we want to see in wide shot and the things we want to see closer up.

J AND L CUTS

It is sometimes a temptation to only use shots where the actor is speaking — this is a mistake. In a dialog scene, editors frequently cut to shots of other people in the scene reacting to what is being said. If you review clips of some of the truly memorable lines in films, you will be surprised at how often we don't actually see the actor say those immortal words — often the editor will cut away before the speech is finished or in some cases, not show the speaker at all.

There is a very basic reason for this: *reaction shots* are very important in filmmaking. *Reaction shots* are where we show a medium or close-up of the person listening to what is being said, or in some cases, reacting to what they see. This is also why we always shoot both sides of the dialog, including the parts where the actor isn't speaking — this is to ensure we get some good reaction footage. Editorially, it is also quite boring to have scene after scene where we just cut back and forth to the person who is speaking.

JUMP CUTS

A *jump cut* cuts from a frame in a clip to a later frame in the same clip — or to a clip that looks very similar. Most times, a jump cut will look like a mistake, as if a piece of a shot was missing, but it can be used in a stylistic way, where it can mean one of two things:

- Passing time
- Repetition over time

HIDDEN CUTS

Matching the two shots perfectly makes an invisible cut. Historically, the intent of the invisible cut was to hide the transition from the audience. Alfred Hitchcock used this in his film *Rope*; the same technique is used in *Birdman* and *1917*. Film cameras could not capture more than 10 minutes of video at once, so he had to trick to hide cuts during long scenes.

When well done, an invisible cut gives the impression that the entire scene is a single shot, increasing the sense of immersion for the audience. Using this technique, *Birdman* and *1917* are entire films that look as if they have been captured in a single take.

Walter Murch's Rule of Six

In legendary editor Walter Murch's book *In the Blink of an Eye*, he talks about the *Rule of Six*. "What I'm suggesting is a list of priorities. If you have to give up something, don't ever give up emotion before story. Don't give up story before rhythm, don't give up rhythm before eye-trace, don't give up eye-trace before planarity, and don't give up planarity before spatial continuity." The ideal cut is one that satisfies all the following six criteria at once.

EMOTION

How will this cut affect the audience emotionally at this particular moment in the film? Telling the emotion of the story is the single most important part when it comes to editing. When we make a cut we need to consider if that edit is true to the emotion of the story. Ask yourself does this cut add to that emotion or subtract from it? It is important to consider if the cut is distracting the audience from the emotion of the story.

"How do you want the audience to feel? If they are feeling what you want them to feel all the way through the film, you've done about as much as you can ever do. What they finally remember is not the editing, not the camerawork, not the performances, not even the story — it's how they felt."

STORY

Does the edit move the story forward in a meaningful way? Each cut you make needs to advance the story. Don't let the edit become bogged in subplot. If the scene isn't advancing the story, cut it. If the story isn't advancing, then it's confusing or worse — boring your audience.

RHYTHM

Is the cut at a point that makes rhythmic sense? Like music, editing must have a beat, a rhythm to it. Timing is everything. If the rhythm is off, your edit will look sloppy, a bad cut can be 'jarring' to an audience. Try to keep the cut tight and interesting.

"Now, in practice, you will find that those top three things on the list are extremely tightly connected. The forces that bind them together are like the bonds between the protons and neutrons in the nucleus of the atom. Those are, by far, the tightest bonds, and the forces connecting the lower three grow progressively weaker as you go down the list."

EYE-TRACE

How does the cut affect the location and movement of the audience's focus in that particular film? You should always be aware of where in the frame you want your audience to look, and cut accordingly. Match the movement from one side of the screen to the other, or for a transition, matching the frame, shape or symbol. When editing *Apocalypse Now*, Murch used the repetition of symbol, from a rotating ceiling fan to helicopters.

Break the screen into four quadrants, and try to keep the movement in one of those quadrants. For instance, if your character is reaching from the top left quadrant, and his eyes are focused to the right lower quadrant that is where your audience's focus will naturally move after the cut. Remember to edit on movement and to match the action, keeping the continuity as close as possible.

TWO-DIMENSIONAL PLACE ON SCREEN

Is the axis followed properly? Make sure your cuts follow the axis (180° line). This will keep the action along its correct path of motion and maintain the continuity. For a discussion of the 180° rule, see the chapter *Coverage and Continuity*. It's an important rule!

THREE-DIMENSIONAL SPACE

Is the cut true to established physical and spacial relationships? A great example of this is Stanley Kubrick's *The Shining*: scattered throughout are reverse-angle wide shots between characters, the freezer door opens from both sides of the frame (from one cut to the next), even the architecture of the set makes no sense with doorways to rooms that spatially would be somewhere mid-air above stairways. The manager's office (where Jack is interviewed) has a window with a view to outside despite being located in the middle of the hotel/set. The point is, stick to the 180° rule, and spatially your edit will work, unless you really want to mess with your audience's minds.

A film is, or should be, more like music than like fiction. It should be a progression of moods and feelings. The theme, what's behind the emotion, the meaning, all that comes later.

Stanley Kubrick

An edit should come just a moment before the viewer expects it. If they are anticipating the cut, it's already too late.

Walter Murch

Murch says that above all else emotion is the most vital element, beyond that the top three (emotion, story and rhythm) should really be at the forefront of the edit. "If you find you have to sacrifice any one of these six things to make a cut, sacrifice your way up, item by item, from the bottom."

ELLIPSIS AND CROSS-CUTTING

An ellipsis in writing is the three dots at the end of an uncompleted sentence. Like this... In filmmaking, it means that something is left out. Filmmaking is all about leaving things out. Suppose your story takes place over a month — you certainly wouldn't ask the audience to sit in the theater for a month; of course we have to leave things out. Many young filmmakers have a hard time doing this — they tend to think that if they don't show everything, the audience won't understand. Here's an example:

A man gets into a limo in front of the Empire State Building in New York City. In the next shot, we see the limo door open and he steps out to reveal that he's in front of City Hall in Philadelphia. Beginning filmmakers often feel compelled to see him saying to the driver "Take me to Philadelphia," and then have scenes of the limo going over the bridge and driving on the highway. You can do those scenes if they serve some other purpose, but they are not necessary to prevent any confusion in the audience. Viewers are capable of filling in lots of information between scenes and between shots in scenes. Don't be afraid to leave things out; the audience is a lot smarter than you might think.

CROSS-CUTTING

Also called *parallel editing*, *cross-cutting* is taking two scenes that occur in physically different places and cutting back and forth between them. A very simple example (and one of the earliest uses of this technique) is the cowboys riding into town. In one scene, we see the bad guys (with black hats) riding toward the town to shoot up the town. In the other scene, we see the good guys (with white hats) also riding into town to save the people. If we just let the scene of the bad guys riding in play out, and then went to the scene of the good guys coming in, it would be a bit boring — there would be very little tension. Cutting back and forth between the two groups of riders adds tension, suspense and a sense of action rising to a climax.

An important point that the director must remember while shooting these two scenes is that each group of cowboys has to be traveling in a different *screen direction*. If the bad guys are riding into town traveling toward screen left, then it is important that the group of good guys be traveling toward screen right whenever we see them. If both groups are traveling in the same direction, it will be confusing for the audience. It might seem like one group is traveling toward the town and the other group is running away.

Of course, this is an extremely simple use of cross-cutting; a richer and more complex example is the christening scene from *The Godfather*: the main scene is Don Corleone's niece being christened. At the same time this is happening we see other scenes in different locations in the city: they are all scenes of Corleone's enemies being assassinated. Set to a soaring aria, it is grand sweeping drama that is also chilling and horrifying. Each scene would be fine by itself (although a simple christening scene might be pretty dull) but it is the cross-cutting between them that turns it into a grand opera of gangsters.

Safety on the Set

Get Out Alive!

Make no mistake about it, film sets are inherently dangerous places. Not only should you be very aware of safety issues, you will also find that it is important to your career. Film professionals don't want someone around who ignores safety and puts everyone in danger; producers know that it puts them in legal liability. You'll find that in the professional film world, people take safety procedures seriously, and you want to fit into that culture. On a movie set, safety is everybody's business. It's no joke; this is for real. If somebody asks you to do something you consider unsafe for yourself or for others, politely remind them "Hey, it's only a movie."

THE PRIME DIRECTIVE

- Never run on the set! This one is carved in stone. You don't do it, no matter how much of a hurry you are in, or who is yelling at you.
- Never stand on top of a ladder.
- Don't operate any equipment if you are not familiar with it, or if you are not the person who is supposed to be doing it. Don't be afraid to say "I don't know this one," or to ask for help. People will respect your honesty and respect the fact that you chose to keep everyone safe.
- Don't touch anything electrical unless you are one of the electricians/lighting technicians working on the job.
- Never leave anything on top of a ladder. Or anywhere on a ladder. Ladders are not storage devices.
- Know where the fire exits are, and how to direct people toward them.
- Do you have a flashlight on you? You should, even if it's just one of those small key-ring flashlights.
- Know where the first aid kit is. There should always be a first aid kit on the set!
- Know where the fire extinguisher is. If there isn't one, mention it to the AD.
- No open toe shoes, no sandals or flip-flops.
- Use safety chains on all lights hung overhead.
- Don't carry dolly track or a light stand horizontally, tilt down so it's not aimed right at someone's face. Call "hot points," or "free dental work, coming through."

ALSO

- Consult the call sheet to know where the nearest hospital is, and what their phone number is.
- Learn CPR. It's a good thing to know. CPR rules have been recently updated; review them.
- Know what to do if someone is being electrocuted.

FIRST AID KIT AND FIRE EXTINGUISHER

Three items should be on every set:

- A first aid kit. A real one, not just a couple of band-aids.
- A fire extinguisher. For a large set or location, more than one.
- The phone number and address of the nearest emergency room.

FIRES, PYRO, AND FIREARMS

Fire is handled by the props department. They can set up fireplaces, barbecues and other types of basic fire. For campfires, they generally use propane with hidden feed lines and some type of burner that can be concealed in the logs. Why not just burn logs? Continuity. The size of the fire would constantly be changing as you cut from shot to shot. Of course, they always have several fire extinguishers close by.

Pyro means anything explosive, from large explosions down to squibs, which are the small charges attached to an actor or object to simulate a bullet hit. Anything pyro absolutely must be handled by a licensed pyrotechnician. These are people with a federal license who have passed extensive testing in the use of explosives.

CRANES AND JIB ARMS

Cranes, especially ones that the camera operator and assistant ride on, must <u>only</u> be operated by qualified grips. Don't get on or off of a crane until the key grip says so — the weight might not be balanced. Don't get a crane or jib arm anywhere near a power line.

Getting Started in the Business

Film School?

Yes, film school is a good idea, but it is by no means necessary. Lots of great filmmakers did not go to film school. On the other hand, lots of great filmmakers did go to film school. Don't think of film school as only a way to learn techniques; the networking is important, as is working with other students who have much the same aspirations as you. It can also be useful for figuring out what it is you want to do in filmmaking.

WORKING AS A PA

The classic way of getting started in the movie business (and to continue learning even if you went to film school) is to work as a PA. We talked about the duties of a PA in the chapter *The AD Team*. It can be tough work with long hours, but it's a great way to learn, make contacts, and become known as hardworking and reliable. Of course, all PAs want to work on the set, and they usually try to stand as close to the camera and the director as they can. Unless that is your assignment, don't do it. Crowding the camera is likely to get you sent away, or even fired. There is plenty to learn elsewhere on the set, even in the production office. No matter what your job, do it the best you can; be the first to arrive and the last to leave — that's how you get asked back for the next production.

Department PA

Some PAs work in departments: camera, art, grip, etc. If your aim is to work in any of the crafts, these are excellent assignments, and probably the best way to get your career started in the crafts. Keep in mind that no matter how brilliant you are, you're still going to have to pay the rent while working on getting financing for your first blockbuster. Being a technician is a great way to stay involved and make contacts.

Personal Assistant

In film credits, you've probably seen "Assistant to the director," or producer, or one of the key actors. It can involve anything and everything, and even more so than any other job on a movie, requires extreme diplomacy, and sensitivity to personal quirks and demands.

SHOOT A TRAILER

Many people work on getting financing for their first movie by shooting a *trailer*. This is not the same kind of trailer as you see in the coming attractions in a theater. It is a short compilation of scenes from your script. It acts as your calling card, and shows potential investors what kind of movie you intend to make, and most of all, showcases your skills as a writer and director.

The absolute number one mistake people make in putting together a trailer is being too ambitious. When presented with the reality that "you have enough money to make ten minutes of mediocre, amateurish footage or three minutes of absolutely thrilling professional film," you would be shocked at how often people choose the former.

MAKE A SHORT FILM, OR EVEN A WHOLE MOVIE

Of course, you don't need to be shooting scenes from a potential movie — a short film can serve to demonstrate your skills. Almost always, the film school thesis film is intended for this purpose. It can work: George Lucas (*Star Wars*) got his start by making an absolutely stunning silent film as his thesis. *Electronic Labyrinth: THX 1138 4EB* was so amazing that he almost immediately was offered financing to make it into a feature film (*THX 1138*) with Robert Duvall.

BUILD YOUR REEL

For directors, DPs, and editors, it's important to have a *reel* — examples of your work. These days, reels are usually shown online, but you might want to have a digital file on your iPad or tablet, maybe even a DVD/BluRay also ready to show. Five minutes is the absolute maximum time.

Don't show the mediocre stuff, only your best. Edit your reel brutally, taking out anything that smacks of amateurism. Leaving in that one bad scene is the most common mistake people make when showing their work. It's all about quality, not quantity! Remember, people are only going to watch the first two or three minutes anyway. There is no point in trying to impress them with how much work you have done.

WORK AS BACKGROUND/EXTRA

Being a known actor makes it much easier to get a job directing a film. Getting work as an actor is, as any actor will tell you, not so easy. But you can much more easily work as an extra or background player. Just keep your eyes and ears open, and learn what you can.

I don't think there is any one route to directing.... Other than that I think you just have to think 'by any means possible' and take any job you can that will get you experience. I also did a lot for free. I got paid virtually nothing for my first film, but it changed my life.

Mary Harron
(*I Shot Andy Warhol*, *American Psycho*)

Terminology

ABOVE THE LINE

Usually refers to that part of a film's budget that covers the costs associated with major creative talent: the stars, the director, the producers and writers.

ACTION

The scene description, character movement, and sounds as described in a screenplay. Sound effects and character names are all caps. For example:

> The sounds of TYPING rise above all the rest as Dave sits at the computer writing his essay. He stops to sigh. Looks at what he's written. Reaches over to the mouse. Highlights it all. And erases it.

"Action" is also what the director says to start the scene while shooting.

AERIAL SHOT

Use only when necessary. This suggests a shot be taken from a plane or helicopter (not a crane). For example, if a scene takes place on a tall building, you may want to have an aerial shot of the floor the action takes place on.

ANGLE or ANGLE ON

Description of a specific shot within a scene. Use sparingly and only for spec scripts. Directors don't pay much attention to specific shots described in the script.

BEAT

Many scripts will use the parenthetical (beat) to interrupt a line of dialog. A "beat" suggests the actor should pause a moment, in silence, before continuing the scene. "Beats" are often interchangeable with ellipses "..."

BELOW-THE-LINE

Everyone and everything who is not "above the line" — this includes the crew, production staff, assistant directors, effects, stunts, etc.

BEST BOY

For obvious reasons, this term is no longer used. The second grip or second electrician. Now the term *Assistant Chief Lighting Technician* is used for the second electric.

B.G. (BACKGROUND)

Used to describe anything going on behind the main action (the background as opposed to the main action or attention is focused in the foreground). Always use this term in lower case initials or written in full ("background").

CHARACTER

In a screenplay, the name appears in all caps the first time a character is introduced in the "Action." The character's name can then be written normally, in the action, the rest of the script.

CLOSE ON

CLOSE ON is a shot description that strongly suggests a close-up on some object, action, or person. Might also be written CLOSE-UP / C.U. or CLOSE SHOT

CONTINUOUS

Sometimes, instead of DAY or NIGHT at the end of a SLUG LINE/Location Description, you'll see CONTINUOUS. Continuous refers to action that moves from one location to another without any interruptions in time. For example, in an action movie, the hero may run from the airport terminal into a parking garage. The sequence may include cuts, but the audience would perceive the action as a continuous sequence of events from the terminal to the lobby to the street to the garage to the second floor to a car etc.

CONTINUITY

Continuity editing is the process of combining related shots into a sequence so as to maintain consistency of story across both time and physical location. In other words, it is about taking different shots done at different times of the day (because it takes time to shoot a scene) and making them seem like they are continuous action in real time.

Continuity also means making sure the props, wardrobe and other elements of the scene stay consistent throughout the scene. Acting continuity means that the actors do the dialog and action more-or-less the same for every take. Sometimes the director will ask for variations, but generally the actors must do the scene the same way for every take.

CONTRAZOOM

The *Hitchcock zoom*, also known as the contra-zoom or the *Vertigo* effect is an unsettling in-camera special effect that appears to undermine normal visual perception in a way that is difficult to describe. This effect was used by Alfred Hitchcock in his film *Vertigo*; also in the film *Jaws* and in *Goodfellas*. It rarely appears in a screenplay.

COVERAGE

Getting all the shots you need for editing is called coverage. If you don't have proper coverage of a scene, it may not cut together well. It is also about having enough shots and camera angles to make sure the scene is not boring. It's all about giving the editor everything they need to edit the scene to make it as good as it can be.

CRAWL

This is a term used for superimposed titles or text intended to move across/up/down/ diagonally on screen. For example, the text at the beginning of *Star Wars* "crawls" up into infinity.

CROSSFADE

This is like a "Fade to black then Fade to next scene." In other words, as one scene fades out, a moment of black interrupts before the next scene fades in. It is not to be confused with DISSOLVE, since CROSSFADE always involves a black or blank screen.

CUT TO

The most simple and common transition. Since this transition is implied by a change of scene, it may be used sparingly to help intensify character changes and emotional shifts. The transition describes a change of scene over the course of one frame.

DIALOG

What people are supposed to say according to the script.

DISSOLVE

A common transition. As one scene fades out, the next scene fades into place. This type of transition is generally used to convey some passage of time and is very commonly used in montages.

DOLLY

A mechanism on which a camera can be moved around a scene or location.

DSLR

Digital Single Lens Reflex camera. They are designed as still photography cameras but many of them are capable of HD and UHD video with excellent imagery. A mainstay of very low-budget filmmaking.

ESTABLISHING SHOT

A shot, usually from a distance, that shows us where we are. A shot that suggests location. Often used at the beginning of a film to suggest where the story takes place. For example, if our story takes place in New York, we might use a shot of the Manhattan skyline as an establishing shot.

EXT.

Exterior. This scene takes place out of doors. This is mostly for producers to figure out the probable cost of a film project.

EXTREMELY LONG SHOT (XLS)

Means the camera is placed a very long distance from the subject or action. Generally, this term would be left out of a screenplay and left to the director to decide. Use only when necessary.

FADE IN/FADE OUT

Pretty much the same as a dissolve. Starting in black and letting the scene appear slowly. A fade out starts in the scene and slowly becomes black.

FEATURE

A film (usually narrative) that is at least 85 minutes long although some features are as short as 70 minutes. A long documentary is sometimes called a "feature length documentary."

FLASH CUT

An extremely brief shot, sometimes as short as one frame, which is nearly subliminal in effect. Also a series of short staccato shots that create a rhythmic effect.

FLASHBACK

Sometimes used as a transition or at the start of slug line to denote a sequence that happened in the past. This can be followed by BACK TO PRESENT DAY if required or the writer can use PRESENT DAY as the time of day.

FREEZE FRAME

The picture stops moving, becoming a still photograph, and holds for a period of time.

HINGE OUT

Move where camera pans to follow the actor part of the way as they walk or drive, then lets them exit frame.

HOT SET

When shooting is not going on but the set needs to stay undisturbed so that the crew can come back and shoot there again. Nobody should go onto a Hot Set unless they are working there; nothing must be moved or touched. Hot Set tape is available to cordon it off and warn everyone.

INSERT

When a writer pictures a certain close-up at a certain moment in the film, he or she may use an insert shot. This describes a shot of some important detail in a scene that must be given the camera's full attention for a moment. Inserts are mainly used in reference to objects, a clock, or actions, putting a key in a car's ignition. For example: if there's a clock in the room, the writer might have reason for the audience to get a good glimpse of the clock and as such would use an insert shot to suggest the director get a closer shot of the clock at a particular point in the scene.

INT.

Interior. This scene takes place indoors. It is an important part of the slug line as it helps the director, DP, gaffer, grip and others plan for the shoot.

INTERCUT / INTERCUTTING

Some scripts may use the term INTERCUT: as a transition or INTERCUT BETWEEN. At this point, two scenes will be shown a few moments each, back and forth. For example, if Laura is stuck in her flaming house and the fire department is on the way, a screenplay may call for intercutting between the flames closing in on Laura and the firefighters riding across town to save her.

INTO FRAME

See also: INTO VIEW.

The audience can only see so much through the window of a movie screen. Use this term to suggest something or someone comes into the picture while the camera stays put. It's like a character or object coming from off stage in the theater. For example: Forrest Gump sits on the bench. OLD WOMAN INTO FRAME. She sits next to him.

INTO VIEW

The audience can only see so much through the window of a movie screen. Use this term to suggest something or someone comes into the picture while the camera pulls back (pans, etc) to reveal more of the scene.

IRIS OUT

Also written as: IRIS FADE OUT or IRIS FADE IN. When the dark edges of the frame form a circle that shrinks down to nothing. Was used in early silent films to indicate the end of a scene. Rarely used now except as a vintage touch.

JUMP CUT TO

A transition which denotes a linkage of shots in a scene in which the appearance of real continuous time has been interrupted by parts being left out. Transitions from one moment to the next within a scene appear jarring because they break the direct flow of time and space. This transition is usually used to show a very brief lapse of time.

LAP DISSOLVE

See also *Dissolve*.

A transition between scenes that is achieved by fading out one shot while the next one grows clearer.

LOCK IT UP

Called out by the AD and echoed by the PAs when the camera is about to roll. It means everyone must be silent and foot traffic or vehicle traffic held up while the camera is rolling. Be sure to release the lock when cut is called, otherwise the pedestrians and traffic will get so annoyed they will ignore you the next time.

MARKS

When actors move in the scene, marks are made on the floor so they will be in the same place for every take. This is not only for the blocking of the scene, but also so the camera assistant can make sure they are in focus.

MATCH CUT TO

A transition often used to compare two completely unrelated objects. It is film's version of metaphor. This involves cutting from one object of certain color, shape, and/or movement, to another object of similar color, shape, and/or movement. For example, a circular saw to a child's merry-go-round.

MATCH DISSOLVE TO

See also *Match Cut To. / Dissolve To.*

This contains similar qualities to the MATCH CUT. A match dissolve involves two objects of similar color, shape, and/or movement in transition from one scene to the next. For example: if Scene A is following (tracking) an arrow whizzing through the forest, one might match dissolve to a tracking shot, in Scene B of a bullet whizzing through the inner city.

MONTAGE

From the French term "to assemble." A series of images showing a theme, a contradiction, or the passage of time. This film style became common in Russia in the early years of cinema. Russians were the first to truly use editing to tell a story. Modern day examples can be seen in *Goodfellas* and the opening sequence of *Midnight In Paris* — a love letter to Paris in the rain, which is the theme of the whole movie.

MOS

Mit Out Sound. MOS is a scene where no audio is recorded. It needs to be written on the slate and in the script notes so that the editor will not waste time searching for audio track that does not exist. Also when slating an *MOS* shot, the AC should put their fingers under the clapper stick.

O.C. / O.S.

Off-Camera or Off-Screen. This is the abbreviation sometimes seen next to the CHARACTER'S name before certain bits of dialog. It means the writer specifically wants the voice to come from somewhere unseen.

PAN

Camera movement involving the camera turning on a stationary axis. Imagine standing in one spot on a cliff in Hawaii. You want to absorb the view so you, without moving your body or feet, turn your head from the left to the right. This is the same effect as a pan.

PARENTHETICAL

If an actor should deliver his or her lines in a particular way, a screenplay will contain a description in parentheses to illustrate the point. Parentheticals should be used in cases where a line of dialog should be read in some way contrary to logic. It should not be used for action description. For example:

 ZOLTAN
 (calmly)
 I know it sounds impossible.

POV

Point-of-View. The camera replaces the eyes (sometimes the ears) of a character, monster, machine, surveillance camera, etc. As a result, we get to see the world through the sensory devices of some creature. This can be used to bring out the personal aspects of a scene, or it can be used to build horror and suspense. An example of horror and suspense in POV can be seen in the opening shot of *Halloween*.

PULL BACK

The camera physically moves away from a subject, usually through a zoom or dolly action.

PULL FOCUS

The camera focus changes from one object or subject to another, to direct the viewer's attention from one part of the scene to another. For example:
PULL FOCUS TO INCLUDE POLICE CAR IN B/G (background).

PUSH IN

The camera physically moves towards a subject.

REVEAL

Something that was hidden comes into view, either by way of a camera move or something changing in the frame.

REVERSE ANGLE

Often used to reveal things for comic or dramatic effect. Could be described as a counter POV shot. Basically, the script suggests the camera come around 180 degrees to get a shot from the "other side" of the scene. For example, in the *There's Something About Mary* script, Tucker is playing a joke on Mary in her office in one scene that the writers didn't want to reveal right away. They use a REVERSE ANGLE to show that he's got two tongue depressors in his upper lip to represent teeth.

SCENE

An event that takes place entirely in one location or time. If we go outside from inside, it's a new scene. If we cut to five minutes later, it's a new scene. If both, it's a new scene. Scenes can range from one shot to infinity and are distinguished by slug lines.

SHOOTING SCRIPT

This is the truly final draft used on set by the production people, actors, and director to make the movie from the screenplay.

SHOT

One image. If there's a cut, you've changed shots. Shots can range from split seconds to several minutes. Shots are generally chosen by the director although the writer can use capital letters to suggest where the camera should be. When a writer absolutely must have a certain shot at a certain moment in a film, he has a few options each described in detail elsewhere in this list: *Insert, Angle On,* and *Close On.*

SLUG LINE

The text in all CAPS at the beginning of a scene that briefly describes the location and time of day. For example:
INT. JIMMY'S BEDROOM - NIGHT or
EXT. SCHOOL YARD - DAY

Note: sometimes slug lines are abbreviated to something as simple as "LATER" or "BEDROOM" to maintain the pace and flow of a sequence.

SMASH CUT TO:

An especially sharp transition. This style of cut is usually used to convey destruction or quick emotional changes. For example: If you were writing a horror movie but wanted to lighten the gore at the beginning, you might have:
EXT. FOREST - NIGHT

A races through the forest, but then trips and falls.
SMASH CUT TO:
EXT. HIGH SCHOOL YARD - DAY

SPEC SCRIPT / SCREENPLAY

If a writer finishes his/her own screenplay outside the studio system (it isn't an assignment) then sends it to the studios for consideration, it is a spec script.

SPLIT SCREEN

The screen is split into two, three, or more frames each with their own subject. Usually the events shown in each section of the split screen are simultaneous. Split screen can also be used to show flashbacks or other events. For example, two people are talking on the phone. They're in different locations, but you wish to show the reactions of both simultaneously.

STEADICAM

A camera built to remain stable while being moved, usually by human hands. Occasionally seen in scripts to suggest a handheld shot be used in a scene, although a Steadicam is smoother than a regular handheld shot and as such produces a different result.

STOCK SHOT

Footage of events in history, from other films, etc. Basically, anything that's already filmed and you intend to be edited into the movie. For example, the Austin Powers movies use stock footage for comic effect. Some old B films use stock footage to keep their budgets low.

STOP AND GO

A rehearsal done one step at a time. The director calls "action on rehearsal" and then stops the action where she wants to set a mark or give an instruction, then calls "action on rehearsal" again.

SUPER

Abbreviation for *superimpose*. The superimposition of one thing over another in the same shot. Sometimes titles are superimposed over scenes. Or a face can be superimposed over a stream-of-consciousness montage shot.

SWISH PAN

A quick snap of the camera from one object to another that blurs the frame and is often used as a transition. Sometimes called a FLASH PAN. Cuts are often hidden in swish pans, or they can be used to disorient or shock the audience.

TIGHT ON

A close-up of a person or thing used for dramatic effect. A tight frame encloses a subject with very little space surrounding it. Not in common use. Use only when necessary.

TRACKING SHOT (TRACK, TRACKING, TRAVELING)

A tracking shot involves a camera following a person or an object. As long as the camera isn't locked down in place by a tripod, for example, and is following (tracking) a subject, then it's a tracking shot. For good examples of tracking shots, watch the one take episode of The *X-Files*, or the first shots of *Touch of Evil*, and *The Player*.

TRAVELING SHOT

Shooting while a vehicle is moving. Also called a *rolling shot*.

TRAILER

This term has two meanings. The trailers you will see most often are in the coming attractions at the movie theater, in television commercials and on the web. The other meaning of trailer is a short promotional sales piece for a film project. These are put together by filmmakers who are pitching a project to investors or producers.

TRANSITION

These describe the style in which one scene becomes the next. Used appropriately, these can be used to convey shifts in character development and emotion. In other words, a *Cut To:* is not required at every scene change. Some major transitions include: *Dissolve To:*, *Match Cut To:*, *Jump Cut To:*, *Smash Cut To:*, *Wipe To:*, and *Fade To:*. Occasionally a writer will make up his own transition. In these cases, the transition is usually self-defined (such as *Bright White Flash To:* suggests whiteness will fill the screen for a brief moment as we pass into the next scene).

VFX

Visual effects, these days usually created in the computer.

V.O.

Voice-Over. This abbreviation often appears beside a character's name before their dialog. This means the character voices that dialog but his or her moving lips are not present in the scene. Voice-over is generally used for narration, such as *Full Metal Jacket* or *A Clockwork Orange*.

WIPE TO

A transition in which one scene "wipes away" to the next. Rarely used except in industrial films as it is self-conscious and a bit cutesy.

ZOOM

Performed with a variable focal length lens (a zoom) which is capable of changing the lens field-of-view from wide angle to telephoto in a smooth, continuous shot.

Resources

How To Read a Movie

"Reading" a movie means going beyond merely watching it. If you are going to learn from films, you need to analyze *why* and *how* each shot, each scene, works to make the whole movie great. The best way to start doing this is to go shot-by-shot, scene-by-scene.

First, look at each individual shot in a scene. Pause the video. Work out why this particular shot was chosen. What does it bring to the film? How does it help you understand the story? How does it contribute to the roller coaster effect of an engaging plot? How does it set you up for the next scene? How is information conveyed — do the characters just talk the information, or is it conveyed in some other form, such as visual elements in the scene, or by superimposed titles like "Summer, 1986." Take notes, do your own director's commentary, write it up, summarize your thoughts and organize them — the process will help you clarify your thinking and help it really "stick" in your head.

THE STORY

- Who is the main character?
- What is their need? What obstacles do they face? How do they overcome them?
- Who is the antagonist? What is their need? How do they operate?
- What is Plot Point One? What gets the story moving?
- Are there subplots? How do they add to the story?
- What is the resolution? How does the story get wrapped up?

THE FRAME

- What's in the shot? Look at everything you can see in the shot: people, clothes, setting, vehicles, background. Why are they there? What can you tell about them?
- What's not in the shot? Do you think anything has been deliberately left out or hidden, perhaps to add mystery, or to be revealed later?
- How close is the camera?
- What's the shot size? Is it a close-up, a medium, or a wide shot that just shows the setting? Or something else?
- Why did they use that particular kind of shot? What do you think was the director's intention in choosing that shot?
- What's the camera angle? Try and work out the camera position. Was it at the same level as the subject, or was it higher or lower?

 How does that affect what you think of the subject? Was it directly in front, at a slight angle, at the side, or behind? Why was it filmed from there?
- How are things arranged in the shot?

 Does the shot look natural, or is the composition obviously formal or symmetrical? Or is it unbalanced, crooked, and deliberately awkward?
- Does the film utilize effects like voice-overs, text, direct addresses to the camera, and other narrative devices? What is the effect of these devices?

MOVEMENT

- How do things move? What movement is there in the shot? Do things or people in the shot move? If so, are they moving towards or away from the camera, across the screen, up or down the screen? How does this make you feel about them?
- Does the camera move? If it does, what kind of movement is it? Is the movement steady or handheld? What do you think was the reason they chose to shoot this way? How does camera movement add to the feel and energy of the scene?

LIGHTING

- What colors are in the shot? Are they vivid or drab? How do they make you feel? What about the color balance of the light: is it warm, cold, or something else?
- How is the scene lit? Is the light bright and flat, or dramatic and shadowy? Do you think the scene was filmed with natural light or artificial lights? Can you figure out where the light sources were?
- Is the lighting naturalistic or stylized? Does it fit with the mood and style of the film?

EDITING

- Find the cut. Consider where the editor decided to make the cut between two shots. Use slow motion, sometimes it helps you better understand the edits.
- What comes next? Look at the shot that comes next. How is it different from the one you've just been looking at? What does the new shot bring to the story? Does it show the same thing filmed differently, or does it show something new?
- How does the scene go together?
- How are the shots edited? Are they joined with simple cuts (where one shot goes straight to the next one), or are there more complicated transitions, like dissolves or fades?

 If so, what are the transitions telling us?

 How does the edit point fit with the action, the dialog, the soundtrack or the actors' performances? Do the sound and picture change together, or at different times (split edits)?

- Pacing. Is the editing fast or slow? Does it get faster? How does this match the mood or the action?

TIME

- How does the scene represent time? Is it in real time – where things take as long as they would in real life? If not, is it compressed time where they leave things out? If so, what's been left out and what's been kept in? Or does it use stretch time, where things take longer on screen than they would in real life? If so, why? How have they extended or compressed the time?
- You might also see *cross-cutting* or *parallel editing*, where the film cuts between action happening in two or more places at the same time. If the film uses this, how have they managed to do this without you getting confused? How do you know which location is which?
- Does the scene use *flashbacks* or *flash forwards*? How can you tell? Do they use some kind of visual device to signal that it's a flashback/flash forward?

AUDIO

- What can you hear in the scene?
- If the voice-over is the narrator, is it a reliable narrator (telling you the truth all the time) or is it an unreliable narrator (distorts the truth, usually for their own benefit).
- Play some scenes, or the whole movie, listening only to the soundtrack. What different kinds of sound can you hear? Can you list them all?
- Now watch it over again with the sound on and think about what the sound brings to the story. If there's a voice-over, who's speaking? How does their voice make your feel? Are they a character in the story or an impartial, third-party narrator?
- With natural sounds that were recorded on set, do they sound realistic or are they exaggerated? Do they come from things you can see on-screen, or do they give you information about things that are off-screen? Do you think they were recorded live, or added later as sound effects?
- What kind of music is used? Does it seem appropriate to the mood and tone of the scenes? Does it help the pacing of the scene? Does it match the pace of the scene or provide a contrast?

 Is it an original score or existing music? Rock, country, classical? Try to understand why that particular piece of music was chosen for that scene.

 Is the music loud over the scene, or very subtle underneath the dialog; does this change during the course of the scene?

Resources

There is a wealth of material available to help you learn and grow as a filmmaker. Here are some noteworthy sources of information.

BOOKS

The Director's Team. Alain Silver and Elizabeth Ward
Cinematography: Theory and Practice — For Directors and Cinematographers. Blain Brown
Making Movies. Sidney Lumet
On Screen Directing. Edward Dymytryk
Rebel Without a Crew. Robert Rodriguez
Adventures in the Screen Trade. William Goldman
In the Blink of an Eye. Walter Murch
Screenplay: The Foundations of Screenwriting. Syd Fields
Motion Picture and Video Lighting. Blain Brown
The Filmmaker's Guide To Digital Imaging — For Cinematographers, DITs and Camera Assistants. Blain Brown

MOVIES ABOUT MOVIE MAKING

Ed Wood
Day For Night
The Player
Sullivan's Travels
State and Main

GREAT MOVIES MADE ON ABSURDLY SMALL BUDGETS

El Mariachi ($7,000) Robert Rodriguez
Following ($10,000) Christopher Nolan's first movie
Eraserhead ($10,000) David Lynch
Pi ($60,000) Darren Aronofsky
Killer's Kiss ($75,000) Stanley Kubrick's second feature.
Assault On Precinct 13 ($100,000) John Carpenter
Halloween ($325,000) John Carpenter

SHORT FILMS WORTH SEEING

Electronic Labyrinth: THX 1138 4EB
 (George Lucas' student film)
The Red Balloon
The Phone Call
Session Man
Hotel Chevalier
Small Deaths
Glory At Sea
Eight

Crossroads
A Dog's Life
Six Shooter
The Music Box
It's Always Sunny On TV
Thunder Road
I'm Here
Trip To The Moon
Kung Fury

Before I go off and direct a movie, I always look at four films. They tend to be *The Seven Samurai, Lawrence Of Arabia, It's A Wonderful Life,* and *The Searchers.*

Steven Spielberg
(*Saving Private Ryan, ET, Indiana Jones, Empire of the Sun*)

Movies To Watch To Learn About Filmmaking

Every film teacher in the world has a list of 100 moves you've got to watch. This is just mine. It's not necessarily the 100 greatest movies ever made, just films that I think will help you learn what makes a good movie work. If you don't watch classic movies, your chances of being a good filmmaker are greatly reduced. The symbol ★ means you absolutely, positively must watch this classic. Not kidding. Just do it.

12 Angry Men★	Gladiator	Pulp Fiction
12 Years a Slave	Godfather Part II, The★	Raging Bull
2001: A Space Odyssey	Godfather, The★	Rashomon
400 Blows, The★	Good, the Bad and the Ugly, The	Rear Window★
8 1/2	Goodfellas★	Red Shoes, The
A Clockwork Orange	Grand Illusion★	Rocky
A Walk Through H	Gun Crazy	Rules of the Game, The
Alien★	Halloween	Saving Private Ryan
Aliens	Hearts of Darkness	Schindler's List
Amélie	High Noon★	Searchers, The
The Apartment	Hot Fuzz	Se7en
Apocalypse Now	How Green Was My Valley	Seven Samurai★
Apu Trilogy, The	The Hustler	Shadows
Assault On Precinct 13	In the Mood For Love	Shaun of the Dead
Bicycle Thief, The★	It Happened One Night	Shawshank Redemption, The
Big Combo, The	It's A Wonderful Life	Shining, The
Big Lebowski, The	Jaws★	Shop Around the Corner, The
Birds, The	Ju Dou	Some Like It Hot
Blow Up	Julius Caesar	Spotlight
Brazil	Jurassic Park	Stagecoach
Breathless	Kansas City	State and Main
Casablanca★	The Killing	Sullivan's Travels
Cat People (1942)	Kiss Me Deadly	Sunset Blvd.
Chinatown	LA Confidential	T-Men
Children of Men	Lady Eve, The★	Taxi Driver
Chungking Express	Lady From Shanghai, The	Terminator, The
Citizen Kane★	Lawrence of Arabia★	To Be or Not to Be
Conversation, The★	Malcolm X	Favourite, The
Day For Night	McCabe and Mrs. Miller	There Will Be Blood
Dial M for Murder	Memento	Thing From Another World, The
Do the Right Thing	Midnight In Paris	Third Man, The★
Double Indemnity★	The Miracle of Morgan's Creek	To Live and Die In LA
Dracula (the Spanish version)	Mirror, The	Tokyo Story
Drive	Mr. Smith Goes to Washington	Touch of Evil
Duel in the Sun	North by Northwest★	Trial, The
Empire of the Sun	Oldboy (2003)	Unfaithfully Yours (1948)
Exorcist, The	On The Waterfront	Usual Suspects, The
Faces	Paths of Glory	Yojimbo
Fight Club	Player, The	Vertical Features Remake
Get Out	Psycho★	Vertigo★

Websites for Filmmakers

Of course, the usual caution: don't believe everything you read on the internet — that's how World War I got started!

No Film School

An excellent website for all aspects of filmmaking. They also have an email newsletter that is worth the time.

Art of the Title

Often we take title sequences for granted or ignore them completely as we finish adding more salt to our popcorn. But this website — through video, images, and interviews — deconstructs the titles of well-known films and TV shows to reveal what they really are: masterpieces of short form storytelling.

CineVenger

Evaluations of modern cinematography are indispensable to furthering your own career and understanding of how lighting influences film.

Frugal Filmmaker

The Frugal Filmmaker sums up his mission quite succinctly on his site: "Make Movies! Don't Go Broke!" What Scott does is teach you how to make the movies you want to make without spending all your money keeping up with endless amounts of gear.

Crews Control Blog Central

Besides providing extensive film and video services, Crews Control has a busy blog and social media presence. They are perpetually sharing helpful tips and advice on filmmaking that often cater to filmmakers who work with clients.

Cinematography.com

Covers all aspects of cinematography and its use in filmmaking. A wide range of articles, tutorials and resources.

The Black and Blue

Excellent website about the life and work of the camera assistant. Humorous and down-to-earth look at the real world of working on the set.

How to Film School

Covers wide range of topics in filmmaking.

F-Stoppers

A photography website, but useful to anyone who is shooting with a DSLR.

Creative Cow

Tons of tutorials about every area of filmmaking, from lighting and cinematography to editing, Adobe After Effects, Motion and any type of software used in filmmaking.

IndieWire

For both filmmakers and film fans. Reviews, film festivals and topics such as production, distribution and festival strategies.

Negative Spaces

Ben Cain's blog about working as a DIT. Talks about workflows, color spaces, and all things related to working with video on the set.

Vimeo Video School

The video sharing site shares videos about making videos that will be good to share.

Film School Rejects

Casting news, box office figures, and script purchases. But they also sneak in a featured article every now and then worth checking out — such as a series of film directing tips.

Videomaker

The magazine is now online, so you can browse through decades of back issues.

JOB SEARCH

Creative Cow Jobs

From how-to videos, to a strong community, to podcasts. Creative Cow also has a jobs board which is very active. And because it's been around for a while, it's a name familiar to many professionals.

Film and TV Pro

Film and TV Pro has a clean design that makes it easy to navigate, plus crew/talent can register for free (and see job listings for free). Though most of the listings I come across are LA and New York based, it's worth keeping an eye on these job boards as they potentially grow larger.

Film Crew Gigs

What Film Crew Gigs might lack in features it makes up for in a variety of listings. One thing I always check on job boards is if they are even listing for camera assistants, grips, electricians — all those below the line gigs. Sure enough, Film Crew Gigs does.

Film Sourcing

Film Sourcing promises to help connect filmmakers with everything they might need — crew, costumes, gear, funding, etc. The only problem is, it's still in beta testing. But applying for an invite is easy and looks to be worth the wait for this ambitious project to fully launch.

Mandys

Job listings, search for crew. A well-established site.

ONLINE CLASSES IN FILMMAKING

Yale Film Studies Film Analysis

Classes in how to analyze and think about films.

MIT's Free Online Film Courses

Classes in various aspects of filmmaking.

University of Reddit: Introduction to Filmmaking

Crowd sourced and oriented to the practical, built from experience, by working professionals who are willing to share their knowledge.

Filmmaker's Master Class with Milos Forman

From Columbia University Film School where Forman used to teach. The emphasis is on script writing and casting.

Digital Film School by The Open University

A seventeen part audio podcast about digital filmmaking. At a beginner level, but you can pick and choose areas to study (i.e. editing or producing).

Indy Mogul

An excellent YouTube channel for filmmakers, focused on DIY effects, filmmaking tips, and showcasing creative work.

NextWaveDV

A YouTube channel covering topics from lighting tutorials to what to wear on set.

Quick FX

Filmmaking tutorials, DIY builds, props, DSLRs, short films and a lot more.

DEDICATION

This book is dedicated to Ada, Kelly, Yellow, and Blue.

ABOUT THE AUTHOR

Blain Brown has been in the film business for over 30 years, working as a director of photography, director, screenwriter, producer, and editor. Before becoming a DP/Director, he worked as a lighting technician, gaffer, and grip. He has written, directed, and photographed feature films, commercials, music videos, and corporate videos.

He has taught at several film schools in the Los Angeles area, including Columbia College, Los Angeles Film School, and AFI. He was educated at C.W. Post College, MIT, and the Harvard Graduate School of Design. His other books include:

- *Cinematography: Theory and Practice — For Cinematographers and Directors*. Third Edition. Available in 12 languages. Focal Press.
- *Motion Picture and Video Lighting*. Available in 4 languages. Focal Press.
- *The Filmmaker's Guide to Digital Imaging: For DITs, Camera Assistants and Cinematographers*. Focal Press.

CONTACT

The author can be reached through is website: www.blainbrown.com. Comments and suggestions are welcome.

THE WEBSITE

The website that accompanies this book has video examples of scene directing methods, continuity and coverage, working with the camera, lighting, audio, color balance, exposure, and editing. There are also downloadable production forms you can fill out and use for your projects: www.routledge.com/cw/brown.

index

Page numbers in italics refer to figures.

act one 10, *11*, *15*

act three 10, *13*, *15*

act two 12, 12, 14, 15

action 17, 71, 74

action edits (movement edits) 145

activity 71

actors: action verbs, use of 71; blocking 72; "hitting their marks" 98; rehearsals 72; working with 71

ADs *see* assistant directors (ADs)

additional second second ADs 46, 54–55

ADR (automatic dialog replacement) 134, 135

aerial shots 95

Alien 3, 6, 11

Altman, Robert 7, 20

ambient light 105, 106, 112

Amélie 14

American shot *91*

amps *109*, 112

angles of view 82, *83*

answering shot 90, *91*, 144

antagonists 3, 4

aperture 82, *82*

Apocalypse Now 6, 17, 145, 147

apparent focus 83

arc move 96

Aristotle 6

armorers 116

art departments 114–114; armorer and pyro 116; art director 114; building sets *119*, 114; costume designer 117; location breakdown list 116; look of the film, finding 116–119; makeup and hair 119; production designer 114; prop master 116; set decorator 115; team 114; wardrobe 117–119

art directors 114

aspect ratios 81, *81*

assistant directors (ADs) 23, 29, 44, 66; additional second second 46, 48–49; blocking rehearsal 72; creating the schedule 48; duties 47; organizing the scenes 48; production assistant 46, 49–50; running the show 46; second AD 46, 48; second second AD 46, 48–49; strip boards 48, *48*, *49*, 50; team 46–50; *see* also first assistant directors

associate producers 22

atmosphere inserts 92

attitude 71

audio basics 132–134; boom operator 133, 135, *135*; dialog overlapping 132; fundamental principles 134–136; getting clean dialog 132; headphones 135; mixing audio 136–137; sound (double system vs. single system) 132; sound recordist 132–133, 136; syncing 138; timecode slate 138–139, *139*; *see* also microphones; recording audio

audio utility 133

authority 40

auto volume control, problems 136

available light 105

Baby (1000 watt light) 109, 112

back-cross keys 106, *107*, 112

back light 105

background plates 100, *100*, 130

backlight technique 108

backstory 7

backups 97

barndoors 108

Bates connectors 110, 112

Bay, Michael 96

bead board 104

The Bicycle Thief 14

big head CU shot 90, *91*

Birdman 103, 147

bird's eye view 95

bite/body/tail story structure 14, *14*

blimps *135*, 136

blocking: for camera 72; meaning of 72, 73; notes on 69; rehearsal 51, 72, 98

blown takes (false takes) 127

boom mics 81, 132–133, 134, *135*, 136

boom operators 133, 135, *135*

bounce boards 104, 108, 112

box rentals 24, 26

branchaloris 120

breakdown pages 28, *28*, 48

Bridesmaids 13

Brown, Blain 86, 102, 109

budgets: categories 24; details 26; expendables 24; forms 24, *26*; kit fees 24, 38; making 24; rentals 24; script marking 27, *27*; top sheet summary 25

C-47 110, *110*

C-stands (grip stands) 109

cable pullers 133

call-backs 68

call sheets x, 46, *52–53*

camera departments: clapper/loader 80; digital imaging technician (DIT) 80; digital management technician (DMT) 80; DP (director of photography) 80; first AC 80, 98; operators 80; second AC 80; second unit 80

cameras: angles 95, *95*; blocking for *72*; digital 97; DSLR 133, 139; eye level placement for 95; first assistant 80, 98; handheld 94; high-end pro 97; movements 95–96; second assistant 80; speed of 84; support 94, *94*

Campion, Jane 71

card stock covers 20

Cardellini clamps 112

cards 8, *9*

caricatures 7

casting directors 68

catchlights 105, 108

catering 36, 42

causation 2

CB radio codes 43

CF (compact flash) cards 80, 97

changes in direction: midpoint 12; plot point one 5; for story 5

characters: backstory 7; creating 7; main 4; need 4, 7; point-of-view 7; shots 89; typical shots 91

Chinatown 14

chokers 90, *91*

cinematographers *see* director of photography (DP)

cinematography 80–88; camera angles 95, *95*; camera department 80; camera movements 95–96; camera support 88, *88*; color balance 85; composition 86, *86*; connecting shots 86, *86*; exposure 84, *84–85*; focal length 82, *82*; focus and depth-of-field 83, *83*; focus practices *81*; framing people 81, *81*; inserts 86, *86*; iris/aperture 82, 82; marking 92, *92*; media management 97, *97*; point-of-view 81, *81*; prime directive 97; resolution 81, *81*; rule of thirds 86, *86*; shooting greenscreen 88, *88*; shots, types 88–86; terms (camera) 81; transitional shots 86

Cinematography: Theory and Practice (Brown) 85

circle move 96

Citizen Kane 10, 83, *83*

clapboards 128

clapper slates 80, 130, 138, *138*

classic editing 143

clean frames 75

clean shots 90

close-up (CU) shots 90, *91*, 92, 97, 142, 144, 146

clothes lining cables 109

Coates, Ann 142

color balance 85

color codes, for script pages 30, 122, *123*, *125*

Colpitts, Cissi 5, 11

combination edits 145

company moves *116*

composites, shooting 100

composition *86*, 86

concept edits 145

condenser mics 134

conflicts: as roadblocks 5; in stories 3, 3, 71; and tension 4, *4*

confrontations 3, 12, 14

connecting shots 92, 92

contact lists 35, *35*

continuity: 20% rule 60, *63*; 30 degree rule 60, *63*; changing two lens sizes 60; cheating angles 58; and coverage 58–58; cuttability 58; door and window match 62; editing 58, 143–44, 145; ellipsis 62; jump cuts 60, *62*,

63; "the line" 58; location stitching 63; matching and 62, 132; on-screen movement across the line 59–60; on other side of the line 59, *60*; point-of-view 60; redressing 63–58; screen direction 58; true reverse *60*; types of 58; wardrobe *58*, 118, 118

continuity supervisors *see* script supervisors (scripty)

contracts 38, 40

The Conversation 6

Coppola, Francis Ford 6, 144

costume designers 117

cover sets 48

coverage 74–75, *75*; and continuity 58–64; slate numbers for 127

crab move 96

craft services 24, 36, 42

cranes 94, *94*, 150

crisis climaxes 10, 13

critical focus 83

Cronenberg, David 19

cross-cutting 148

CTB (color temperature blue) 112

CTO (color temperature orange) 112

cuttability 58, 76

cutaways 90

cuts 127, 142–143; on action 146; motivations for 145; *see also specific entries*

cutting points (edit points) 146

dailies 74

daily production reports 37, *37*, 128, 126

Dancyger, Ken 145

The Dark Knight Rises 7

data wranglers *see* digital management technicians (DMTs)

Day Out of Days report 35, *35*

day players 29

daylight 85

deal memos 38–39, *38*, *39*

deep focus 83

department production assistants 46

departments: makeup and hair 119; wardrobe 117–118; *see also* art departments; camera departments

depth, and separation 108

depth-of-field (DOF) 83, *83*

developing masters 76, *77*

dialog: ADR (automatic dialog replacement) 134, 135; clean 132; "on the nose" examples 16; overlapping 132; pass 78; scenes 61, 74; writing 16

DiCaprio, Leonardo 12

Die Hard 11

diffusion 104, 112

digital cameras 97

digital imaging technicians (DITs) 80

digital management technicians (DMTs) 80

direction of travel, in screen 58

directional mics 133

directors 23, 51; action, cut, circle that 68, *68*; block, light, rehearse, shoot 67, *67*; blocking the actors 66; casting 68; collaborations with team 66, 68; editor collaboration 142; freeform method 78, *78*; getting started 67; headphones for 135; in-one method 70, 71; invisible technique 78; location scouts 68; master scene method 68–69, *68*; overheads/storyboards, preparing 70; overlapping method 69–70, *69*; in phases of filmmaking process 66; preparing for shooting 69; preproduction 68; and producer 66; responsibilities 66, 69; script, importance of 67; setups, measuring 69; shooting methods 68–78, *69–78*; shot list preparation 69; sketches, adding 69–70; walk-and-talk method 70, *70*; work of 66–78; working with actors 71

directors of photography (DPs) 23, 29, 30, 31, 51, 60, 72, 80, 116, 129, 143

"dirty single" shots *see* over-the-shoulder (OTS) shots

dissolves 144

distro (distribution) boxes 109

Django Unchained 19

documentaries: as non-narrative fiction 2; style 24

dollies 81, 94, *94*

dolly marks 98

door flats 119, 120

double scrims 108

double system sound 132, 133

DP *see* director of photography (DP)

drones 95, *95*

drops 120

DSLR (digital single lens reflex) cameras 133, 139

Dutch tilts 81, *81*, 95

Duvall, Robert 152

dynamic mics 134

Edison plugs 109–110

edit points, finding 145–146

editing 58, 78; continuity cutting 143–144; meaning of 143; postproduction 143; process 143; reasons for 142; six elements of 144–142; six steps of 142–143; types of 145

editors 142

electric department expendables 110

electricity 109

Electronic Labyrinth: THX 1138 -4EB 152

elevator pitches 20

elliptical cutting 62, 148

emotion, in story 147

emotionally satisfying endings 14

empathy 4, 14

emphasis inserts 92

end of day reports *see* daily production reports

Ephron, Nora 11

equipment transportation 36

erasable markers 128

establishing shots 88–89, *89*, 144

establishing the geography 89, 146

executive producers 22

existing light 106

expendables 24, 110, 119

exposition 17

exposure and focus, in cinematography 83–84, *83–85*, 102

external conflicts 3, *3*

extreme close-ups (ECUs) 90, *91*

eye level placement, for camera 95

eye marks 99

eye traces 147

eyelight 105, 106, 108

eyeline match 144

fade out/fade in 144

false takes 127

Fellini, Federico 117

field mixers 136

Fields, Syd 10; diagram of *The Shawshank Redemption* 10

50-50 shots 90, *91*

fill lights 105

film design 116

film schools 152

filmmaking: audio recording in 74; challenges in 27; ellipsis in 142; invisible technique in 72; joys of 114; point-of-view (POV) in 7, 60, 27, *27*, 142; reshoots xi; rules in xi; stages of 66; telling stories with pictures 2–4; three act structure in 4; tool for 42; *see also* stories/storytelling

final cuts 143

final rehearsals 51

Finding Nemo 4

fine cuts 143

fire extinguishers 150

fires 150

first aid kits 150

first assembly 142

first assistant cameras 80, 98

first assistant directors 46; blocking rehearsal 51; calls for "last looks" 51, 118; creating schedule 48; final rehearsal 51; lighting stand-ins 51; responsibilities in preproduction 47; rough in 51; running the set 51

first cuts 143

fixed shots 96

flags 108, 112

flash pans 96

flashbacks 6

flat front lighting, avoiding 102, 106, 107, 112

flat lighting 108

flat spaces 72, 76, 93

flats *119*, 120

flood/spot control, of light 108

fluorescent lights 85, 103, 112

fly pages 20

foam covers *133*, 136

foamcore 104, 108

focal length 82, *82*, *83*

focus, and depth-of-field 83, *83*

focus, in cinematography *see* exposure and focus, in cinematography

focus pullers 80, 98

foley (sound effects) 135

footage: recording 40; rights to 40

foreground plates 100, *100*, 130

form edits 145

Forman, Milos 142

forty-footers 36

4K 81

frame lines 135

frames per second (FPS) 81

framing shots 88

framing up people: headroom 93, *93*; nose room 93, *93*

free run timecodes 138

freeform methods 78, *78*

Fresnels 103, *103*, 112, *112*

f/stops 82, 83

Full Metal Jacket 17

full shots 89, *91*

function shots 88

fuzzy covers *133*, 136

gaffers 23, 24, 29, 72, 129

gimbals 94, *95*

Gladiator 4, 14

Glazebrook, Andrew 117

Goddard, Jean-Luc 62

The Godfather 6, 108, 148

God's Eye shots 95

gofers *see* production assistants (PAs)

Goldfinger 12

Goodfellas 76

greenscreen shots 100, *100*, 130

grip stands 109

grip trucks 36

Groundhog Day 3, 6, 14

guide tracks 134, 139

hair department 119

hair light 105

handheld cameras 94

The Hangover 19

hard light 104, *104*, 106, *108*

Harron, Mary 152

Harry Potter 13

Hawks, Howard 132

head-to-toe/five T's *89*, 91

headphones 135

headroom 93, *93*

heroes 4

hidden cuts 146–147

high angles 95

high def (HD) 81

high-end pro cameras 97

high ISO 84

hip level shots 95

histograms 84, *84*

Hitchcock, Alfred 4, 69–70, 146

hog troughs *119*, 120

honey wagons 36

In the Blink of an Eye (Murch) 147

Iñárritu, Alejandro 147

inciting incidents see plot points

informational inserts 92, *92*

inserts 92, *92*

insurance 40

internal conflicts 3, *3*

invisible cuts 146–147

invisible editing 143

invisible marks 98

invisible technique 78, 146

irises see aperture

ISO (speed) 84

J and L cuts 146

jamming 128, 138

jib arms 150

jibs 94, *94*

jump cuts 60, 62, *63*, 146

Junior (2000 watt light) 109, 112

Kelvin scale 112

key grips 23, 29, 31, 55

key light 105

key set PAs 46

kickers 105

Kino Flo lights 103, 109

kit fees 24, 38

Kubrick, Stanley 71, 147

La La Land 8: The Revenge 137

lav mics 133–134, 136

LED (light emitting diode) lights *102*, 103, 109

lens(es): critical focus 83; focal length 82, *82*, *83*; personality of 82; speed 84; use for shot 135; zoom 81

Leone, Sergio 90

lighting 73, *73*; avoiding flat front 102, 100; basic *102*, 105; categories on productions 24; controlling 102–103; creating mood 102; definitions 106; direct attention 102; equipment 103; expendables 104; getting (electricity) power 103–104; for greenscreen 100; and grip 102–106; hard vs. soft 104, *104*, 100, 107, *102*; methods 100–102; need 102; order 104–105; practicals 103; principals 100; process 102; rough in 51; setting 103; shadows and 100; stand-ins 51; terms 105; through the windows 100; types of light 103–104; units 103; from upstage side 100, *100*; wall plugging 103

"The Line" 58–60, 59

line-level signals 134

line producers 22

lined scripts 122; coloring *125*; during editing process 123; sample 123, *123*

Linklater, Richard 2

Lion, Gang 7

loaders 80

location: checklist 33, 34; establishing 140; manager 68; release 40, *40*; scouting 23, 33, 68; stitching 63

locked scripts 30

logging 142

loglines 19

long focal length lenses 82, *83*

long shotgun mics 133

long shots *see* establishing shots

look books 116

look of the film 116–119

looking room 93, *93*

looping see ADR (automatic dialog replacement)

low angles 95

low ISO 84

Lt. Ripley (character) 4

Lucas, George 152

Lumet, Sidney 142

lunchboxes 112

mafer clamps 112

main characters 4; needs 4, *5*; obstacles 5, *5*, 10

makeup and hair departments 119

The Maltese Falcon 86

marked up scripts (MUS) see lined scripts

marking/marks: during blocking rehearsal 98; dolly 98; focusing on dial 98; invisible 98; scripts 27; tape 98, *98*

master scene methods 74–75, *74*

match cuts 145

match-on-action 144, 145

matching, and continuity 62, 132

The Matrix 3, 6

matte colors 100

McKee, Robert 6, 10

McLaren, Brian 56

media management 97, *97*

medium close-ups (three T's) 90, *91*

medium shots 90, *91*, 146

Memento 10

microphones 133–136; directional 133; foam cover for 136; getting into best position 135; vs. line input 134; mounts 133, *133*, 134, 135; phantom power 134; pointing in right direction 136; shotgun 133, *133*; types of *132*, 133; wireless 133–134

Midnight in Paris 78, 145

midpoint 10, 12

mistakes: avoiding -1; coverage 00, 04; on production side 0

mixers *see* sound recordists

montages 78, 145

mood 102

mood boards 116

MOS (mit out sound) scene 134

Motion Picture and Video Lighting (Brown) 102, 109

motivations, for cut 145

mouse 128

move in 81

movement edits *see* action edits (movement edits)

Movie*Slate 8 app *138*

moving plates 100

Murch, Walter 142, 144, 146–148

Murray, Bill 3

music videos, playback timecodes on 128

muslin 104

My Cousin Vinny 3

narrative stories 2

natural light, and windows 107

ND (nondescript) cars *52*

needs, of characters 4, *4*, 7, *11*, 14

nets/flags 108, 112

neutral axes 59

neutral density filters (ND) 84

neutral gray cards 85

nose room 93, *93*

objective POV 87, *87*

obstacles, overcoming 5, *5*, 10, 14

office production assistants 46

omnidirectional microphones 133

180 degree rule 144, 147

on-line casting services 68

on-set dressers 115, 118

"on the nose" dialog 16

opal (light diffusion) 104

open face lights 103, 112

operators, in camera department 80

outlines, cards and 8–9

over-the-shoulder (OTS) shots *62*, *64*, 69, 74, 78, 87, *87*, *90*, *90*, *91*

overheads 70, 95

overlapping method 75–76, *75*

page turn 47, 67

pan (panoramic) 81, 96

Paper Amps 112

parallel editing 148

PAs *see* production assistants (PAs)

permits, shooting 32

personal assistants 152

phantom power 134

phonetic alphabet *43*

pickup days 32, 127

picture cars 36

Picture Composition for Film and Television (Ward) 86

pictures, telling stories with 2–4

pigeon plates 112

pitching projects 20

place, creating sense of 116

plane-of-focus 99

playback 137; audio 128

The Player 7, 20

plot 2, 7

plot points 5, *9*; one 10, 11, *11*, 14; two 10, 13

Plural Eyes software 138

Poetics (Aristotle) 6

point of no return *see* midpoint

point-of-view (POV) 7, 60, 87, *87*, 142

post-production 66, 122, 143; supervisors 143

practical lamps 103

premises 6

pre-production 23, 47, 66, 68, 114

presentation, script 20

primary colors, in lighting 112

prime directives 97, 150

principal photography 23

producers 22, 66

production: assistant director 23, 23, 32; basic law of 24; breakdown pages 22, *22*; budget, making 24–27; contact lists 29, 29; craft services 24, 30, 36; executive producer 22; key documents 24; line producer 22; location release 34, *34*; locations 23, 27–34; mistakes xi; office 23; permits 32; pickup days 32; preproduction 23; putting a crew together 31; receipts 32; releases and deal memos 32, *32*; report 37, *37*; reshoots 32; script marking 27, 27; script pages and scene numbers 30; on the set 23; sides 41, *41*; stealing scenes 32; talent releases 33, *33*; team 23; tech scout 23, 27; transportation coordinator 23, 30; unit production manager 22; walkie-talkies 43

production assistants (PAs) 23, 46; department PAs 46, 146; duties 55; office PAs 46; second second AD work with 55; set PAs 46, 55; surviving as extra 56; ways to get fired 56; working as 146

production designers 68, 114

production office coordinators 23

production sound mixers see sound recordists

prop masters *62*, 64, 116

protagonists 4

pulling focus 99

pyrotechnicians (pyro) 116, 150

rack focus 83

radio phonetic alphabet 43

Raiders of the Lost Ark 9, 19

reaction passes 78

reaction shots 78, 90, *92*, 146

receipts 44

reconnaissance 29

record runs 138

recording audio: ADR 135; connections for *137*; foley 135; levels of 132–133; outside problem 136; room tone 135; rules in 134; scratch track 134; wild track 135

redressing 63–64

reels 152

Reeves, Keanu 11

reference notes 122

reflectors, bounce and 108

rehearsals 67; blocking 51, 72, 73, *73*; final 51

Reichardt, Kelly 16

releases, and deal memos 38–39, *38*, *39*

rentals, wardrobe 119

reports, production 37

reshoots/reshooting 32, 04, 130

resolution 13, 14, 81

reverse/true reverse 60, *75*

rhythm 147

right hand rule 109, *109*

roadblocks, overcoming 5, *5*

rolling shot 96

Romero, George A. 30

room tone 130, 135

Rope 147

rough cuts 142

Rule of Six 147

rule of thirds, in composition 86, *86*

runners *see* production assistants (PAs)

safety, on set 150

Saving Private Ryan 11

Scarface 14

scene(s) 144; building blocks of 88–91; framing up people in 93; intentions of 71; lighting 106; numbers 30, 128–

129; organizing 48; overhead plan for 70; sides and 41; stealing 32; strips 48; type of 48

scenic artists 114

schedules 23, 24, 46, 47; creating 48; from strip board 50

Schoonmaker, Thelma 60, 143

science fiction films, concept designs for *115*

Scorsese, Martin 86, 142

Scott, Ridley 17

scratch tracks 134, 139

screen direction: cross-cutting 148; in dialog scenes 61; types of 58

screen position edits 145

screenplays 8, 23

scrims 108, 112

script supervisors (scripty) 37, 64, 118, 122; end of day report *126*; headphones for 135; key 125

scripts: adding sketches to 69; breakdown 114; color code for pages 18, 116, *117*, *125*; for director 67; end of day report 120; formatting 17, *18*, 20; importance of 67; intentions of 71; as key document 18, 48; lined/lining 46, 116; locked 18; marking 27, *27*; notes 116, 118; notes key 125; outline (*Raiders of the Lost Ark*) 9; pages 18; during preproduction 23; presentation 20; revisions 18; sample notes 118; sample page 18; standard pages *27*; undercooked 16; understanding 67

SD (secure digital) cards 80, 97, *97*

second assistant cameras 80

second assistant directors 46, 54

second second assistant directors 46, 54–55

second unit shoots 80

secondary colors, in lighting 112

Sedgwick, Icy 7

Seidelman, Susan 67, 68

separation 92, 108

sequences 144

"Sergio Leone" shots *90*, *91*

series, takes and 127

set braces *119*, 120

set decorators 115

set dressers 115, 118

sets: building *119*, 114; construction 114; "lock up," reasons for 132; production 23; safety on 150

setups, measuring 69

Se7en 14

Sgt. Riggs (character) 3

shadows 106

shallow focus technique 83

Sharpies 128

The Shawshank Redemption 10, 14

The Shining (Kubrick) 147

shooting: director involvement in 66, 73, *73*; documentary style 78; with freeform method 78, *78*; greenscreen 100, *100*, 130; with in-one method 76, *77*; issues in 58; with master scene method 74–69, *74*; methods 74–78, *69–78*; with overlapping method 69–76, *69*; permits 32; to playback 137; preparing for 69; procedures 74; trailer 152; with walk-and-talk method 76, *76*; *see also* scene(s)

short films 2, 152

short focal length 82

shot lists 69, *69*

shot-reverse shot 144

shotgun mics 133, *133*, 134, *135*

Shotput Pro software 97

shots 88–92, 144

shoulder light 105

sides 41, *41*

single scrims 108

single system sound 132

singles/stingers 109, 112

sketches 69–70

slate/slating: anatomy of 127, *127*; bad *129*; bumping 130; clapper 80, 130, 138, *138*; numbers 127; rules 129–130; tail 130, *130*; takes and series 127; timecode 127, 128, *128*, 137, 138–139, *138*, *139*; VFX plate 130

Sleepless In Seattle 12, 13

sliders 94, *94*

slug lines 27, 144

smart slates 127, 128, *128*

smilex 120

snoots 108

soft light 104, *104*, 107; overhead 108

solids 108, 112

Sorkin, Aaron 4

sound: double system vs. single system 132; effects 135; report 137, 139–140

sound recordists 132–133, 136–137

specular light *see* hard light

Speed 11

speed, camera 84

Spielberg, Steven 66

spot/flood control, of light 108

stage directions 88

standard def (SD) 81

standby wardrobe *see* on-set dressers

static/fixed shots 81, 96

Steadicam 81, 94, *95*

stealing scenes 32

step outline 8, *9*

sticks 94, *94*

stingers/singles 109, 112

Stoppard, Tom 8, 13, 14, 16

stories/storytelling: act one 4, *5*, *9*; act two 6, *6*, *9*; act three 4, *7*, *9*; based on conflicts 3, *3*; basic elements of *9*; bite/body/tail (structure) 2, *2–9*; cards and outline *2–9*, *9*; changing direction 5; characters, creating 7; composition and 32, *32*; dialog, writing 4; editing 93; emotion of 93; exposition 5; with focus 11; general idea of 7; intentions of 71; logline 13; main character 4; midpoint 4, 6; needs (main character) 4, *4*; obstacles/roadblocks, (character) 5, *5*; with pictures 2–4; pitching 2; plot point one 4, 5, *5*; plot point two 4, 7, *7*; premise 6; presentation 2; protagonist vs. antagonist 4; rising action *2*; script, formatting 5, *12*; step outline 2, *9*; story points 5, *2*, 5; structure 2, *2–9*; synopsis 2, 13; themes 6; three act structure 4; timeline 62; in traditional order 4; treatment 13; writing 2–2

story days reports 118

storyboards 70

straight cuts 144

strip boards (production boards) 48; colors for *48*; on computer 50, *50*; other schedule considerations 50;

sample page 49

strongbacks *119*, 120

subjective POV shots 60, 87, *87*

subtext 16

swing gangs *see* on-set dressers

swing trucks 36

swish pans 96

synchronization, audio and video 138

synopses 8, 19

table reads 67

tail-lights 33

tail slates 130, *130*

takes 127, 144

talent releases 38, 39, *39*

talkies 138

Tarantino, Quentin 143

Tascam DR60D *139*

teamster captains 36

tech scouts 29, 33; checking access 29; checking power supply 29; walk through 29

telephotos 82, *83*

telling stories, with pictures 2–4

Tentacle Sync timecodes 138–139, *139*

Thelma and Louise 4

themes, of stories 6

The Third Man 81, *81*

30 degree rule 60, *63*

Thompson, Jim 12

three act structure 10

three A's, of acting 71

three-dimensional spaces 147

tight close-up shots 90, *91*

tilts 81, 96

timecode slates 127, 128, *128*, 137, 138–139, *138–139*

Titanic 12, 14, 19

title pages 20

top sheets 25

Touch of Evil 76

Towne, Robert 8

track left/track right 81

tracking marks 100, *100*

tracking moves 96

tragedy 14

trailers, shooting 152

transitional shots 92

transitions 144

transportation, cast and crew 36

transpo (transportation coordinator) 29, 36, *53*

traveling shots 32

treatments 19

trial and error method xi

triple-take method 75–76, *75*

tripods (sticks) 94, *94*

true reverse 60

true subjective POVs 60, 87, *87*

tungsten lights 85, 112

turnaround (reverse) 60, *75*

12/3 cables 109

20% rule 60, *63*

two-dimensional place on screen 147

two shots 89–90, *90*, *91*

2001: A Space Odyssey 16, 145

ultra high def (UHD) 81

unit production manager (UPM) 22

unity(ies) 6; of action 6; of place 6; of time 6

upstage side, lighting from 106, *106*, *107*

The Usual Suspects 10

VFX plate 130

video white balance 85

voice over (V.O.) 17, 135

Vonnegut, Kurt 7

walk and talk method 76, *76*

walk throughs 29

walkie-talkies 43, 55

Wall-E 4

Ward, Peter 86

wardrobe: assistants 118; continuity *58*, 118, 118; department 117–118; designer *53*; makeup and 50, 51, 54, 67, 72, 117–118; making decisions about 68; mistakes in 64; on-set dresser 115, 118; rentals/purchases 119; supervisor 118

whip pans 96

white balance (color neutral balance) 85

wide focal length lenses 82, *83*

wide shots 88, 97

wiggly lines 122

wild tracks 135

wild walls 120

Willis, Gordon 108

wind noises 136

window flats *119*, 120

windows, in film lighting 107–108, 108

Winslet, Kate 12

wireless lavs 133–134

Wise, Robert 76

Wizard of Oz 19

wooden clothes pins, for lighting 110, *110*

writing: dialog 16; story 2–20; treatment 19; *see also* stories/storytelling

XLR connectors 132, *132*, *134*, *138*

zebras 84, *85*

Zoom F4 recorder *137*, 138

Zoom H4n recorder *138*

zooms 81, 96

If you want to go deeper into filmmaking techniques, you might want to look at these books by the same author:

- **Cinematography: Theory & Practice for Cinematographers & Directors — Focal Press**
- **Motion Picture and Video Lighting for Cinematographers, Gaffers & Lighting Technicians — Focal Press**
- **The Filmmaker's Guide to Digital Imaging for Cinematographers, Digital Imaging Technicans and Camera Assistants — Focal Press**

https://www.amazon.com/s?k=blain+brown&ref=nb_sb_noss_1

9 780367 026066